THE HAND OF THE MASTER

THE HAND OF THE MASTER

CRAFTSMANSHIP, IVORY, AND SOCIETY IN BYZANTIUM

(9TH–11TH CENTURIES)

Anthony Cutler

PRINCETON UNIVERSITY PRESS

Copyright © 1994 by Princeton University Press

Published by Princeton University Press, 41 William Street, Princeton,
New Jersey 08540

In the United Kingdom: Princeton University Press, Chichester, West Sussex

Editor Timothy Wardell

Production Coordinator Anju Makhijani

Designer Heidi Haeuser

Library of Congress Cataloging-in-Publication data

Cutler, Anthony, 1934–
 The hand of the master : craftsmanship, ivory, and society in
Byzantium (9th–11th centuries) / Anthony Cutler.
 p. cm.
 Includes bibliographical references and index.
 ISBN 0-691-03366-8
 1. Ivories, Byzantine. I. Title.
NK5872.C88 1994
730'.09495—dc20 93-14332
 CIP

This book has been composed in Garamond #3

Princeton University Press books are printed on acid-free paper and meet the
guidelines for permanence and durability of the Committee on Production Guide-
lines for Book Longevity of the Council on Library Resources

Printed in the United States of America

10 9 8 7 6 5 4 3 2 1

Contents

Acknowledgments *viii*

List of Color Plates *x*

List of Illustrations *xi*

INTRODUCTION *1*

I THE POWER OF IVORY

1. The Modern Response 7
2. The Byzantine Response *19*
3. Varieties of Experience *29*

II CONDITIONS OF PRODUCTION

1. The Quantity and Quality of Ivory *41*
2. "Colonial" Tusks and Domestic Bone *56*
3. The Question of Workshops *66*

III STAGES OF PRODUCTION

1. Cutting the Panel *79*
2. An Excursus on Tools *91*
3. From Panel to Plaque *94*
4. Carving the Figures *110*
5. Detailing *120*
6. Finishing and Assembling *141*

IV THE MASTER IN CONTEXT

1. Craftsman, Designer, Client *153*
2. Artistic Identity in Byzantium *158*
3. Signs of the Master *163*
4. The Guidance of the Hodegetria *174*

V PROBLEMS OF CLASSIFICATION AND CHRONOLOGY

1. "Groups" and Individuals *185*
2. Toward a History: Datable Works and Minimal Clusters *197*
3. The Implications of Contemporaneity *219*

Contents

VI IVORY IN BYZANTINE SOCIETY 1. Users and Uses 227
 2. The Culture of the Clientele 239
 3. Conclusions 246

 Abbreviations 253
 Frequently Cited Works 254
 Notes 259
 Glossary 286
 Sources of Illustrations 287
 Index 288

To the students who disagree

Acknowledgments

Given that one of this book's main theses is that direct, "hands-on" examination of Byzantine (and other) ivories as against "knowing" them only through photographs is indispensable to their understanding, I must start these expressions of gratitude by acknowledging generally the curators and other officials of the museums, libraries, and private collections represented in the pages that follow. It is not possible to list all these persons individually, but thanks are especially due to Margaret Frazer, formerly of the Metropolitan Museum, New York, who first encouraged me to study the objects in her charge; Susan Boyd and Stephen Zwirn at Dumbarton Oaks; Gary Vikan of the Walters Art Gallery; David Buckton and Chris Entwistle at the British Museum; Paul Williamson of the Victoria and Albert Museum; D. Gaborit-Chopin, J. Durand, and J.-P. Caillet, Paris; H.-G. Severin, A. Effenberger, and D. Kötzsche, Berlin; and V. Zalesskaja of the Hermitage Museum, St. Petersburg.

I gained access to a variety of "difficult" objects through the kindness of Valentino Pace, Irmgard Hutter, and Joseph Connors. A special debt is due to the last of the great Parisian ivory sculptors, Émile Bréjoux, who taught me much that I have learned; and to Ioli Kalavrezou who is able to distinguish personal affection from professional dissent.

Eric Van Tassel, formerly of the Princeton University Press, was the first to ask if a book such as this could be written; Elizabeth Powers and Timothy Wardell then took it in hand and have patiently and tactfully guided it to this conclusion. Terry Grabar was a most civilized copy editor, tolerant of the foibles of an Englishman in exile.

A first draft was finished at the Institute for Advanced Study, Princeton; much of the second was written at Dumbarton Oaks. Funds for travel to collections were provided by the American Philosophical Society, the Deutscher Akademischer Austauschdienst, the American Council of Learned Societies, IREX, and the National Endowment for the Humanities. None of these institutions is responsible for the content of this book, yet without their help it could not have come about. Harry Schaefer of Silver Spring, Maryland, turned hundreds of my detail photographs, sometimes taken under the most diffi-

cult conditions, into prints of archival quality. Much of the documentary value of what follows is due to him.

At Penn State, aid was forthcoming (as always) from the Institute for the Arts and Humanistic Studies. I owe a lot to Margo Stavros, my indefatigable research assistant, and as much to my family who, almost uncomplainingly, endured the creation of "yet another book" amid clouds of pipe smoke.

Color Plates

I. Cortona, S. Francesco. Reliquary of the True Cross

II. Reverse of plate I

III. Arnhem, Gemeentemuseum. 15th-century binding with a Byzantine ivory of the Crucifixion

IV. Paris, Cabinet des Médailles. Christ crowning Romanos and Eudokia

V. New York, Metropolitan Museum. Crucifixion, lit from behind

VI. Liverpool Museum. Crucifixion triptych

VII. Munich, Staatsbibliothek, *Clm* 6831. Book cover with the Crucifixion, Deposition and Entombment

VIII. Quedlinburg, Stiftskirche. Four scenes from the life of Christ

List of Illustrations

1. Washington, D.C., Dumbarton Oaks. The Byzantine Collection (detail)
2. Milan, Duomo. Diptych, scenes from the life of Christ
3. Berlin, Staatliche Museen. Diptych, Christ and the Virgin
4. Oxford, Bodleian Library, MS Auct. T. inf. 1. 10. Christ Enthroned
5. Baltimore, Walters Art Gallery. Crucifixion
6. Reverse of fig. 5, detail
7. Washington, D.C., Dumbarton Oaks. Crucifixion
8. Moscow, Pushkin Museum. Triptych wings, obverse. Detail of fig. 77
9. London, British Museum. Crucifixion
10. Reverse of fig. 9
11. Munich, Bayerisches Nationalmuseum. Deesis
12. Reverse of fig. 11
13. Liverpool, Museum. John the Baptist
14. Reverse of fig. 13
15. Tbilisi, Historical Museum. Virgin Hodegetria
16. Reverse of fig. 15
17. Washington, D.C., Dumbarton Oaks. "Rosette casket." See also fig. 171
18. Trier, Cathedral Treasury. Portable altar with parts of two Byzantine triptychs, Detail, Dormition of the Virgin
19. Munich, Staatsbibliothek, *Clm* 22021. Book cover with fragments of a triptych of Christ, angels, the Virgin and John the Baptist, Peter and Paul
20. St. Petersburg, Hermitage Museum. Six scenes from the life of Christ
21. Madrid, Biblioteca Nacional vitr. 26–2, fol. 44v. Theoktiste teaching the daughters of Theophilos to venerate icons
22. Paris, Cabinet des Médailles. Romanos ivory, oblique view from right. See also pl. IV and fig. 115
23. London, British Library Add. MS. 19.352, fol. 117r. Stephen the Younger
24. Washington, D.C., Dumbarton Oaks. Diptych leaf with an emperor
25. Gotha, Schlossmuseum. Diptych leaf with Christ. See also fig. 241
26. London, Victoria and Albert Museum. Triptych wing (?). Visitation and Presentation of Christ in the Temple
27. Reverse of fig. 26
28. St. Petersburg, Hermitage Museum. Forty Martyrs triptych, open
29. St. Petersburg, Hermitage Museum. Forty Martyrs triptych, closed
30. New York, Metropolitan Museum. Virgin Hodegetria, detail of fig. 244
31. London, Victoria and Albert Museum. Six scenes from the life of Christ
32. Milan, Duomo. Detail of fig. 2. Anastasis
33. Hildesheim, Cathedral Treasury. Book cover with Crucifixion
34. Berlin, Staatliche Museen. Crucifixion, detail
35. Detail of fig. 36
36. Princeton University Art Museum. Crucifixion
37. Cortona, S. Francesco. Reliquary of the True Cross, detail of pl. I. Stephen
38. Cortona, S. Francesco. Reliquary of the True Cross, detail of pl. I. John the Evangelist. See also fig. 232
39. Berlin, Staatliche Museen. Entry into Jerusalem, oblique from right. See also fig. 138
40. Berlin, Staatliche Museen. Entry into Jerusalem, oblique from left
41. London, Y. Petsopoulos Collection. Triptych wing
42. Baltimore, Walters Art Gallery. Nativity
43. Erlangen, Universitätsbibliothek, cod. 9. Bookcover with half-length Hodegetria
44. Venice, Museo Archeologico. SS. Theodore

and George. See also figs. 106, 122, 123

45. Reverse of fig. 44
46. Switzerland, private collection. Christ Enthroned. See also figs. 103, 186, 224
47. Reverse of fig. 46
48. Venice, Museo Archeologico. John the Evangelist and Paul
49. Reverse of fig. 48
50. New York, Metropolitan Museum. Plaque from a Joshua casket: defeat of the Men of Ai. See also fig. 69
51. Reverse of fig. 50
52. Detail of fig. 50
53. Lyon, Musée des Beaux-Arts. Creation of Adam; Cain
54. Lyon, Musée des Beaux-Arts. Right half of fig. 53. Abel Stoned; Creation of Eve. See also fig. 162
55. Reverses of figs. 53 and 54
56. Berlin, Staatliche Museen. Entry into Jerusalem, reverse. See also figs. 39, 40
57. Washington, D.C., Dumbarton Oaks. Doubting Thomas
58. Reverse of fig. 57
59. Donauwörth, Schloss Harburg. Triptych with Virgin Hodegetria, angels and saints
60. London, Victoria and Albert Museum. Standing Hodegetria
61. London, Victoria and Albert Museum. Veroli casket, back, right side. See also fig. 128
62. Brescia, Museo Civico Cristiano. "Loving Couples" diptych, left leaf
63. Istanbul, Archaeological Museum. Plaque with sainted bishop
64. Baltimore, Walters Art Gallery. Box with warriors and putti
65. Darmstadt, Hessisches Landesmuseum. Box with Genesis scenes
66. Princeton University Art Museum. Bone plaque with John the Evangelist
67. St. Petersburg, Hermitage Museum. Bone plaque with warrior
68. New York, Metropolitan Museum. Box with John the Evangelist, Mark, Luke and Matthew. See also fig. 219
69. New York, Metropolitan Museum. Detail of fig. 50
70. Istanbul, Archaeological Museum. Bone plaque with saint
71. Bologna, Museo Civico Medievale. Bone plaque with Christ enthroned
72. Cleveland Museum of Art. Apostles pyxis
73. Warsaw, National Museum. Diptych, right

leaf. Dormition and scenes from the life of Christ. See also fig. 221
74. Paris, Musée Cluny. Right side of box with Herakles and a warrior
75. Detroit Institute of Arts. Box with animal battles and putti
76. Moscow, Pushkin Museum. Coronation of the emperor Constantine. See also figs. 164, 217, 218
77. Moscow, Pushkin Museum. Triptych. See also fig. 236
78. New York, Metropolitan Museum. Crucifixion, detail, oblique from below. See also pl. V
79. New York, Metropolitan Museum. Killing of the King of Hazor. See also fig. 163
80. Detail of fig. 79, oblique view from left
81. Berlin, Staatliche Museen. Washing of the Feet. See also figs. 83, 149, 211
82. Pesaro, Museo Civico, box panel. Expulsion
83. Reverse of fig. 81
84. Berlin, Staatliche Museen. Reverse of fig. 3, Christ leaf
85. Reverse of fig. 77, central plaque
86. Nuremburg, Germanisches Nationalmuseum. Crucifixion
87. Paris, Louvre. Nativity triptych, closed
88. Luton Hoo, Wernher Collection. St. Eustratios, oblique view from right
89. Reverse of fig. 87
90. London, British Museum. Ezekiel, bottom edge of fig. 127
91. Baltimore, Walters Art Gallery. Hodegetria triptych
92. Reverse of fig. 91
93. Stuttgart, Württembergisches Landesbibliothek. Box lid
94. Turin, Galleria Sabauda. Christ and Peter
95. Corinth, Museum. Trial piece (?)
96. Switzerland, private collection. Bottom edge of fig. 46
97. Switzerland, private collection. Right edge of fig. 46
98. London, British Museum. Ezekiel, reverse of fig. 127
99. Utrecht, Rijksmuseum Het Catharijneconvent. Virgin Hodegetria. See also figs. 119, 154
100. Reverse of fig. 99
101. Hanover, Kestner Museum. Crucifixion, reverse, detail
102. Princeton University Art Museum. Crucifixion, upper frame. See also fig. 36

103. Switzerland, private collection. Detail of fig. 46

104. Quedlinburg, Stiftskirche. Nativity and Baptism. See also pl. VIII

105. Vatican, Museo Sacro. Nativity

106. Venice, Museo Archeologico. Detail of fig. 44

107. Oxford, Ashmolean Museum. Oblique view of fig. 108

108. Oxford, Ashmolean Museum. Virgin Hodegetria

109. Washington, Dumbarton Oaks. Descent from the Cross

110. Dresden, Grünes Gewölbe. Chairete and Anastasis. See also fig. 147

111. Reverse of fig. 110

112. Hamburg, Museum für Kunst und Gewerbe. Virgin Hodegetria, reverse. See also fig. 228

113. Detail of fig. 112, left edge

114. Hanover, Kestner Museum. Crucifixion. Detail, John

115. Paris, Cabinet des Médailles. Romanos ivory, oblique view from left. See also pl. IV and fig. 22.

116. St. Petersburg, Hermitage Museum. Christ

117. Cambridge, Fitzwilliam Museum. Christ. See also fig. 180

118. Paris, Musée Cluny (on deposit). Christ. See also fig. 179

119. Utrecht, Rijksmuseum Het Catharijnenconvent. Detail of fig. 99

120. Dresden, Grünes Gewölbe. Box plaque with Meleager

121. Detail of fig. 120, oblique view from right

122. Venice, Museo Archeologico. Detail of fig. 44, Theodore

123. Venice, Museo Archeologico. Detail of fig. 44, George

124. Berlin, Staatliche Museen. Triptych, Crucifixion. See also fig. 159

125. Rome, Palazzo Venezia. Box, front. Scenes from the life of David. See also fig. 220

126. New York, Metropolitan Museum. St. Demetrios

127. London, British Museum. Ezekiel

128. London, Victoria and Albert Museum. Veroli casket, lid, central portion

129. Madrid, Museo Lazaro Galdiano. Copy of the Veroli casket, lid, central portion

130. New York, Metropolitan Museum. Oblique detail of fig. 126, from below

131. Berlin, Staatliche Museen. Detail of fig. 124

132. New York, Metropolitan Museum. Box plaque, Adam and Eve at the forge

133. Bamberg, Staatsbibliothek, Msc. Lit. 7. Paul plaque. Detail, head of Paul

134. Bamberg, Staatsbibliothek, Msc. Lit. 7. Paul plaque. Detail, feet

135. Bamberg, Staatsbibliothek, Msc. Lit. 8. The Virgin and Christ

136. Bamberg, Staatsbibliothek. Detail of fig. 135

137. Florence, Bargello. Apostles box. Detail, Christ. See also fig. 193

138. Berlin, Staatliche Museum. Detail of fig. 39

139. Vienna, Kunsthistorisches Museum. Andrew and Peter. See also fig. 161

140. Cortona, S. Francesco. Detail of pl. I, John the Evangelist

141. Naples, Museo di Capodimonte. Crucifixion

142. Leipzig, Grassi Museum. Crucifixion, detail of fig. 145

143. Arnhem, Gemeentemuseum. Detail of pl. III

144. Berlin, Staatliche Museen. Crucifixion

145. Leipzig, Grassi Museum. Crucifixion. See also fig. 182

146. Paris, Cabinet des Médailles. Crucifixion triptych, detail of fig. 222

147. Dresden, Grünes Gewölbe. Detail of fig. 110, Hades

148. Tskhinvali, Museum of Southern Ossetia. Triptych

149. Berlin, Staatliche Museen. Detail of fig. 81

150. Vienna, Kunsthistorisches Museum. Detail of fig. 139

151. Dresden, Grünes Gewölbe. Paul's mantle, detail of fig. 226

152. Paris, Louvre. Harbaville triptych, reverse. See also fig. 170

153. Detail of fig. 152

154. Utrecht, Rijksmuseum Het Catharijneconvent. Detail of fig. 99

155. Munich, Staatsbibliothek, *Clm* 4453. Bookcover with the Dormition of the Virgin. See also fig. 212

156. Detail of fig. 155

157. Hanover, Kestner Museum. Crucifixion, detail of fig. 185.

158. Berlin, Staatliche Museen. Leo ivory, a. Christ between Peter and Paul; b. from above. See also fig. 227

159. Berlin, Staatliche Museen. Detail of fig. 124, left wing

160. Berlin, Staatliche Museen. Detail of fig. 124, right wing

161. Vienna, Kunsthistorisches Museum. Detail of fig. 139

162. Lyon, Musée des Beaux-Arts. Detail of fig. 54

163. New York, Metropolitan Museum. Detail of fig. 79

164. Moscow, Historical Museum. Detail of fig. 76

165. London, Victoria and Albert Museum. Detail of fig. 31

166. Oblique view of fig. 164 from left

167. London, British Library, MS Stowe 3. Book cover with half-length Hodegetria, angels, and saints

168. Munich, Staatsbibliothek, *Clm* 6831. Detail of pl. VII

169. Vatican, Museo Sacro. Triptych

170. Paris, Louvre. Harbaville Triptych. See also figs. 152, 227

171. Washington, Dumbarton Oaks. "Rosette casket," open. See also fig. 17

172. London, British Museum. Box plaque with hunting scenes

173. Reverse of fig. 172

174. Darmstadt, Hessisches Landesmuseum. Box panel

175. Venice, Treasury of S. Marco. "Mythological" bowl

176. Rome, Palazzo Venezia. Triptych.

177. Munich, Staatsbibliothek, *Clm* 6831. Detail of pl. VII

178. Munich, Staatsbibliothek, *Clm* 6831. Detail of pl. VII

179. Paris, Cluny (on deposit). Christ, detail of fig. 118

180. Cambridge, Fitzwilliam Musem. Christ, detail of fig. 117

181. St. Petersburg, Hermitage Museum. Triptych wings

182. Leipzig, Grassi Museum. Detail of fig. 145

183. Liverpool Museum. Detail of pl. VI

184. Liverpool Museum. Detail of pl. VI

185. Hanover, Kestner Museum. Crucifixion. See also fig. 157

186. Switzerland, private collection. Detail of fig. 46

187. London, Victoria and Albert Museum. Ascension

188. Munich, Bayerisches Nationalmuseum. Virgin Hodegetria with angels and donor

189. Munich, Bayerisches Nationalmuseum. Detail of fig. 188

190. Munich, Bayerisches Nationalmuseum. Detail of fig. 188

191. Copenhagen, Nationalmuseet. Crucifixion

192. Reverse of fig. 191

193. Florence, Bargello. Apostles box. Detail, John the Baptist

194. London, Victoria and Albert Museum. SS. John the Baptist, Philip, Stephen, Andrew, and Thomas

195. Donauwörth, Schloss Harburg. Virgin Hodegetria

196. Stuttgart, Württembergisches Landesbibliothek. Bookcover with Virgin Hodegetria

197. Padua, Museo Civico (formerly). Virgin Hodegetria, cut from a plaque

198. St. Petersburg, Hermitage Museum. Virgin Hodegetria, cut from a plaque

199. Berlin, Staatliche Museen. Virgin Hodegetria

200. Paris, Bibliothèque nationale, MS lat. 10514. Virgin Hodegetria

201. Jena, Universitätsbibliothek, cod. Elect. fol. 3. Bookcover with Virgin Hodegetria

202. Castagnola, Villa Favorita. Virgin Hodegetria

203. Bamberg, Historisches Museum. Virgin Hodegetria

204. Leipzig, Universitätsbibliothek, cod. Rep. I. 57. Bookcover with Virgin Hodegetria

205. Aachen, Domschatz. Virgin Hodegetria

206. Baltimore, Walters Art Gallery. Detail of fig. 91

207. Bamberg, Staatsbibliothek, Msc. Lit. 1. Bookcover with Virgin Hodegetria. Detail

208. Washington, Dumbarton Oaks. Virgin Hodegetria

209. Berlin, Staatliche Museen. Detail of fig. 199

210. Sinai, Monastery of St. Catherine. Icon, The Washing of the Feet

211. Berlin, Staatliche Museen. Oblique view of fig. 81

212. Munich, Staatsbibliothek, *Clm.* 4453. Oblique view of fig. 155

213. London, British Museum. Nativity

214. Paris, Musée Cluny. Bookcover with Latin Virgin and Child and fragments of a Byzantine triptych

215. Antwerp, Museum Mayer van den Bergh, a. Triptych fragment; b. reverse

216. Tskhinvali, Museum of Southern Ossetia. Detail of fig. 148

217. Moscow, Pushkin Museum. Detail of fig. 76
218. Moscow, Pushkin Museum. Detail of fig. 76
219. New York, Metropolitan Museum. Box with Philip and Thomas. See also fig. 68
220. Rome, Palazzo Venezia. Box with scenes of coronation and the life of David. See also fig. 125
221. Warsaw, National Museum. Diptych, left leaf. Annunciation and scenes from the life of Christ
222. Paris, Cabinet des Médailles. Crucifixion triptych. See also fig. 146
223. Hanover, Kestner Museum. Crucifixion and Deposition
224. Switzerland, private collection. Detail of fig. 46
225. Washington, D.C. Dumbarton Oaks. Seal of Constantine VII
226. Dresden, Grünes Gewölbe. John the Evangelist and Paul
227. Paris, Louvre. Detail of fig. 152
228. Hamburg, Museum für Kunst und Gewerbe. Virgin Hodegetria, detail of drapery
229. Dresden, Grünes Gewölbe, casket plaque. Two scenes from the youth of Joseph
230. Udine, Museo Diocesano. Bookcover, detail
231. Lyon, Musée des Beaux-Arts. Christ plaque. Detail
232. Cortona, S. Francesco. Detail of pl. I

233. Paris, Musée Cluny. Otto II and Theophano crowned by Christ with a donor
234. Houston, Museum of Fine Arts. Dormition of the Virgin, detail
235. Baltimore, Walters Art Gallery. Box plaque with an unidentified saint and John Chrysostom
236. Moscow, Pushkin Museum. Triptych wing, detail of fig. 77
237. Washington, Dumbarton Oaks. Casket lid, detail
238. Berlin, Staatliche Museen. Presentation of the Virgin in the Temple
239. Halberstadt, Cathedral Treasury. Diptych
240. St. Petersburg, Hermitage Museum. Presentation of the Christ child to Symeon
241. Gotha, Schlossmuseum. Reverse of fig. 25
242. London, British Museum. Borradaile triptych, closed
243. Liège, Trésor de la Cathédrale St. Paul. Virgin Hodegetria
244. New York, Metropolitan Museum. Virgin Hodegetria
245. Paris, Louvre. Box plaque
246. Xanten, Cathedral treasury. Box. Front
247. Munich, Prähistorische Staatssammlung. Box plaque

INTRODUCTION

The immediate purpose of this book is to discover how, when, and why the Byzantines carved ivory, and its ultimate aim to analyze and define the achievements of the sculptors who worked this material in this society. The fact that the first and last of these questions have scarcely been asked by the many art historians who have concerned themselves with the second is the reason for the book's existence. I am convinced that chronological questions can hardly be answered—indeed, are scarcely worth asking—without proper attention to matters of technique and function, and to the place that ivories held in Byzantine culture. All three questions are justified by the extraordinary quality of the finest of the objects treated below. Their very fineness, however, cannot be grasped without comparison with pieces of lower quality. Neither class can be understood unless both are seen in the context in which they were produced, and the way in which, and the reasons *for* which, they were made.

In setting out this program, I will have already displeased those who insist that the "quality" of a work lies in the eye of the beholder. Against such a notion, I suggest that judgments of this sort are grounded in (and say much about the quality of) the beholder's mind and the extent of his or her knowledge of the objects in question. A good deal of nonsense has been written about "quality" in art and, recently, even more about the perils of being "judgmental." At least at the level of craftsmanship, "quality" in ivory carving is a phenomenon that can be assessed. It has to do not with lifelikeness or the proportion of figures, the realism of their appearance or their setting, but with the way in which the material was understood and its potentials exploited by the sculptor. Such judgments arise from *our* awareness of ivory. To claim that they are groundless is to feign innocence, to pretend that we do not judge even as we look; to avoid them is an abnegation of our scholarly responsibility toward ourselves and our pupils. They may well disagree with our judgments (cf. the dedication of this book) but, if they do, we can ensure that they do so in the understanding that there are identifiable aspects of craftsmanship in ivory carving as there are, say, in making a fine lens. The lens-grinder who achieves a low level of diffraction knows what he or she is doing, has done it before, and is aware of the skills that it takes to do it again. The fact that this diffraction is quantifiable, while proficiency in carving is not, does not bear directly on the craftsmanship involved in grinding it.

Quantity here is the measure, not the source, of technical skill. The latter has its origin in the same expertise as right judgment of it: a direct familiarity with the material and of the means that it takes to work it.

Our knowledge of the past, then, is something that we possess *now*. And this seamlessness—the fact that we cannot examine the past or its creations "objectively"—underlies the way in which we look at them. This book therefore treats our responses to Byzantine ivories before it considers what we know of Byzantine responses (Chapter I). Middle Byzantine art proposes a view of the world *sub specie aeternitatis*, a perspective antithetical to the close examination of particulars that I undertake in the pages that follow. First, it is necessary to investigate how much and what sort of ivory was available to those that used it, to identify not only the sources of the material but the attitudes toward it that flowed from its exotic origin (Chapter II.1, 2). These conditions were valences of the means by which carved dentine was produced, an industry that arose in specifically Byzantine conditions and is thus misleadingly represented if we regard that industry simply as the Greek-speaking equivalent of the "corporations" that worked ivory in Republican Rome or Gothic Paris. The failure to recognize that ivory carving was one craft among many in tenth-century Constantinople, and subject to the same conditions as were others, has resulted in the uncritical assumption that craftsmen were organized in workshops—a term that has become something of a shibboleth. The grounds for postulating the historical existence of such entities are therefore subjected to new scrutiny (Chapter II.3).

At this point other aspects of vocabulary should be mentioned. I am concerned above all with the working of ivory and therefore generally refer to this practice as a *craft*. This does not mean that I do not regard many of its products as works of art. I am convinced that a work of art is, at least in part, constituted by its interpretation. Certainly it exists only in relation to an interpretation, and Arthur Danto may be right when he insists that it is interpretation that transforms objects into works of art.[1] Since I have argued that we can hardly distinguish between our responses and those of the Byzantines, and since I believe that all our responses (including matters of chronology and assessments of quality) are interpretations of one sort or another, I feel justified in referring (sometimes) to a carved ivory as a work of art and (less often) to practitioners of the craft as artists.[2] Secondly, I suppose that these practitioners were men. Apart from occasional indications that some weavers and a few scribes were women, the Byzantine sources for our knowledge of craftsmen refer to them in the masculine gender. At such time as evidence emerges for a female worker in ivory I shall be happy to change the form of my reference. Concerning ivory carving in particular, and despite recent attempts to standardize the lexicon,[3] a sizable body of diverse (and often mutually contradictory) terminology is in use, even among specialists. To explicate as clearly as possible the complicated business of cutting and carving a plaque (Chapter III and passim) I employ a uniform (and, I trust, unam-

biguous) vocabulary; technical terms are defined, where convenient, in the text and will be found assembled in the Glossary at the end of the book. Conversely, the fact that names do not exist for several of the physical phenomena and processes involved is some index to the state of our studies. Locutions (e.g., Kerbschnitt, step) that I use to fill these gaps, and the sense in which I use them, similarly appear in the Glossary.

One term that I employ, but which has no place in the Glossary, is "facture." Known but still ugly in English, it is commonplace in, say, French and Russian, where it refers to the way an object is made and, by implication, to how it feels in the hand. How heavy an ivory is (at least in relative terms: the weight of plaques of similar size varies remarkably), how its thickness varies from one edge to another, how smooth is its reverse or the spaces between figures or inscriptions on its front—all of these are parts of its facture and can be critical evidence for the relationship between one ivory, or one craftsman, and another. Except occasionally for the (maximum) thickness of a plaque, which I regard as an essential datum, information of this sort is not available in the various catalogues of collections. More seriously, it is not conveyed by the "head-on" photographs of obverses that are our stock-in-trade. For this reason and, where necessary to the explanation of one or more stages of an ivory's facture, this book includes a fair number of illustrations of the reverses and edges of plaques and some oblique photos—the only possible surrogate for the direct experience of a plaque that is essential to its analysis and classification. To focus on the relationship between material and technique is to run the risk of implying that these are of greater significance than other aspects of a culture in the creation of its artifacts (cf. below and Chapter VI). But so heavy an emphasis has been placed in recent years on the ideological basis of Byzantine art that the shoe is currently on the other foot. The danger now is the undervaluation of material and technical elements in acts of manufacture, and it is this balance that I try to redress.

If I am right in my description of the carvers' techniques, we now know more about the working of ivory than about any other aspect of Middle Byzantine craftsmanship. And until an equally detailed account of another manual skill becomes available, the nature, conditions, and ends of the tasks undertaken by the artisans considered here may stand as representative of their contemporaries working in other materials and trades. For this reason I have subtitled the book *Craftsmanship, Ivory, and Society in Byzantium*. The fact remains that we know precious little about the persons, and the relations between persons, involved at any stage in the production or use of ivory. By way of introducing the second half of this study, in the first two parts of Chapter IV I introduce the modicum that is known or can be deduced from objects and texts that lend themselves to a preliminary construction of this part of the puzzle. Chapter IV.3 consequently suggests some means by which the handiwork of different craftsmen can be discerned in ivories of various types; Chapter IV.4 reverses the direction of this analysis by examining differences between plaques of the *same* type and thus begins the task of discriminating between hands.

What is the *point* of recognizing one man's hand in different ivories? Quite apart from the intrinsic interest of a major sculptor's work, such a course allows us to plot the range and depth of a craftsman—this latter concept being often treated as if in Byzantium it were an oxymoron. It enables us to recover something of the connection between an individual's manual labor and the society for which he produced—a connection that Byzantium was especially good at concealing. And finally, the identification of even parts of one man's production allows us to approach that most tenuous of historical concatenations, the relations between work, behavior, and belief in a culture that has left us much information about the last member of this triad and all too little about the first two. I recognize that, as against the mountain ranges of ivory "groups" that have dominated our view of production since the 1930s (and which I criticize in Chapter V.1), the "minimal clusters" that I suggest were carved by one pair of hands can be only base camps. But within these we are still relatively secure and from these, if the desire is there, we can climb higher. Because an artifact is anonymous it need not be treated as impersonal. It may be that we have not yet learned to read the signs by which, willy-nilly, craftsmen betrayed their identities. To confuse our ignorance in this respect with Byzantine purposes has more serious implications than to deny to the sculptors the credit they would now receive if only they had names. I have no intention of introducing such names, no wish to attribute this or that ivory to Amico di Qualcuno.[4] But, in an age when the recognition of (nameless) hands is highly unfashionable, I should point out that, even with regard to ivories, such acts of identification are nothing new.[5]

Instead of anachronistically demanding absolute identity between two objects before allowing that they are the work of a single individual, we should direct our attention to their differences. It is the very *inaccuracy* of medieval copies[6] that allows us to posit the activity of one pair of hands. Lacking both any notion of "photographically exact" replication[7] and any sense of plagiarism, a craftsman could not help but rehearse ways of doing things that both he and others had used previously; and, in this innocence, he may be caught red-handed in the act of "copying." Even if, after handling Byzantine ivories for some twenty years, I delude myself into thinking that, blindfold, I can distinguish between sculptors by the feel, say, of the arrises on the Virgin's tunic (compare figs. 30, 228), no two craftsmen carved such details in exactly the same way—nor, of course, did one man necessarily repeat himself. Eventually, one comes to know these hands by their works as surely as one will never know their names or their precise life spans. The absence of such personal information does not mean that they lack identities; it means that their messages are conveyed in a code different from that of Renaissance (and later) artists, that their works are embodiments of their culture's values rather than differential creations intended to proclaim their heroic status or bravura. The all-but-total silence about craftsmen in Byzantine literature is a trap of the Byzantines' own devising.[8] Instead of accepting at its face value their disregard in this respect, it seems more useful to treat it, as is done below, as a convention of Middle Byzantine society.

No less notorious a "trap," and no less an aspect of convention, is the loving repetition of forms and motifs on our objects. Depending on how we interpret these or, rather, on the ways we set about our acts of interpretation, they can be taken either as contemporaneous variations on a number of set themes, which is the way I treat some of them in Chapter V.3, or as indices of dispersal over time, an argument that has repeatedly been made invoking perceived stylistic differences. I shall not anticipate here the complexities that await the reader who wants a sequential "history" of Byzantine ivory carving (Chapter IV.2) other than to say that, as I read the evidence, the horizontal diffusion of the craft, that is, different individuals working in the same place and within two or three generations of each other, is at least as likely as its vertical transmission, that is, over a succession of three or four centuries. My object is not to date, or even to consider, all the ivories that survive. Instead, in the "history" section, I examine only those that, in their content or epigraphy, or for other reasons, allow us to ascertain their dates and, where these exist, their relations with "undatable" pieces.

Neither chronology nor "localization" is the end of this book; rather, these are two factors taken into account in arriving at the aims set out in the first sentence of this Introduction. I am concerned less with individual pieces[9] than with ivory as a phenomenon in Byzantine culture (Chapter V.2). There is much that we would dearly love to know of the ways in which this material was acquired, sold, and used; and of course, in attempting to talk about the phenomenon as a entity rather than about its parts, we are engaging in what Carlo Ginzburg called "retrospective predictions."[10] Yet the lack of sources is a trite, though not entirely inappropriate, lament among Byzantinists and there is much that can be, but has not been, said, particularly since the information provided by our primary sources—the ivories themselves—has hardly been tapped. In the first half of this book I am concerned with the process as much as with the products of ivory carving; in the second I investigate not so much what these products "mean," as this question is posed in traditional iconographical studies, as *how* they mean. This is to say, I address the significance of the material as a witness to a determinate stage not only in chronology but in historical relations between commissioned imagery and the society that sponsored it. Far from seeing the ivories merely as expressions of Byzantine culture, I argue that they reinforced and, to an extent scarcely appreciated before, define that culture. If their material value cannot be precisely known, their imputed value, as well as the education and interests of the class that are stamped upon them and, in turn, determined the activity of those who made them, demonstrates more clearly than any other medium the reciprocity between the demand for and supply of a commodity, between ancient exemplars and contemporary interpretations, and between material production and the mental superstructure that it supported and embodied.

❖ ❖ ❖ ❖ ❖ ❖ ❖ ❖ ❖ ❖ ❖ ❖ ❖ ❖ ❖

THE POWER OF IVORY

1. THE MODERN RESPONSE

This book is about a literally untouched subject. Men and women of the latter part of the twentieth century hardly know ivory, much less the "Middle Byzantine" ivories that are my subject. The proportion of human beings who have had this experience can only diminish, given the prohibitions on import of the material that, even as this is written, are enforced by an ever-widening circle of nations. Whether these measures will save the African elephant (the source of much of the ivory carved in the Byzantine era)[1] is un- known; what is certain is that at least in the West, an era has ended. No longer will ivory be available for the making of devotional, ritual, decorative, and useful objects, the ends to which it was put in Byzantium, as in the wider world before and after the Byzantine era. With this increase in rarity will come an increase in ivory's perceived worth, both commer- cial and aesthetic, value systems that are inseparable since ivory has always been a com- modity. It was an imported luxury in Byzantium,[2] when no legal limits on its use existed; now it can become only more highly prized—a ripple effect in time as well as in space for, as ivory disappears from the modern world, traces of its ancient and medieval working will seem all the more precious.

Like the Byzantines, we keep precious things in treasuries and dispense simulacra of them. Our treasuries have glass cases, tantalizingly but insufficiently translucent (fig. 1); our reproductions are printed on glossy paper and circulate as austere photographs for scholars or, more widely and better reproduced, as pictures in expensive coffee-table books. Both means of distribution characterize our culture and both tend to deceive. Imprisoned within a vitrine or impaled (flatter than a butterfly) on the surface of a page, the image that we see is a two-dimensional illusion, a confidence trick in which we participate in the belief that museums exhibit only "authentic originals" and that photo- graphs never lie. Scholars and casual observers alike believe in what they see, or think they see. Exhibitions and photographs are great levelers: now that the age of great private collections is virtually over, all may come to be teased in the name of democratic access. If not inevitable, such arrangements are the price that modern men and women pay to protect the remnants of the past. Ivory, the hardest organic substance known,[3] still

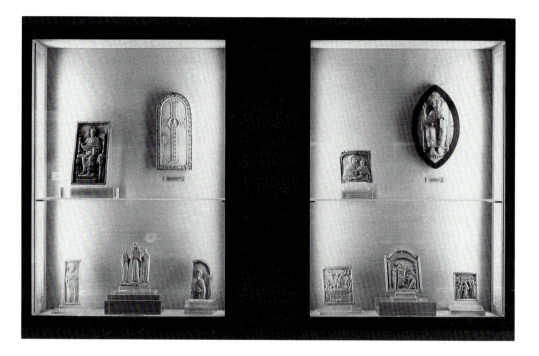

1. Washington, D.C., Dumbarton Oaks. The Byzantine Collection (detail)

wears—and we shall exploit this fact—when it is frequently handled (fig. 2). It can be, and often was, dropped and broken—and this fact too will serve our purposes. Curators *do* protect works of art and photographers *do* disseminate information about such objects. Problems arise when we fail to take into account not so much the limitations of these professional servants, who are our masters, as the limits or license that they suppose themselves professionally required to exercise. If photographers can be restrained from absurdly magnifying objects without regard for their original scale (and, conversely, publishers from reproducing them in no less disproportionate reductions), the way has yet to be found whereby an ivory can be exhibited so that it is, on the one hand, secure and unharmed by the amount of light falling upon it and yet, on the other, well lighted and visible from all sides.

These conditions for the display of ivories and other small-scale artifacts are rendered all the more important by our confidence in pictures and the authority that we delegate to them. The very scarcity of oblique photographs and other sorts of images that go some way towards reproducing the manner in which human beings—ourselves, like the Byzantines— view complex entities is documented by the history of this book. Even while its illustrations depart more often than most from the standard, head-on "likeness"—a point of view maintainable only by a worshiper or other observer in a catatonic trance—I confess myself generally defeated by the full-frontal uniformity imposed on ivories by museum photogra-

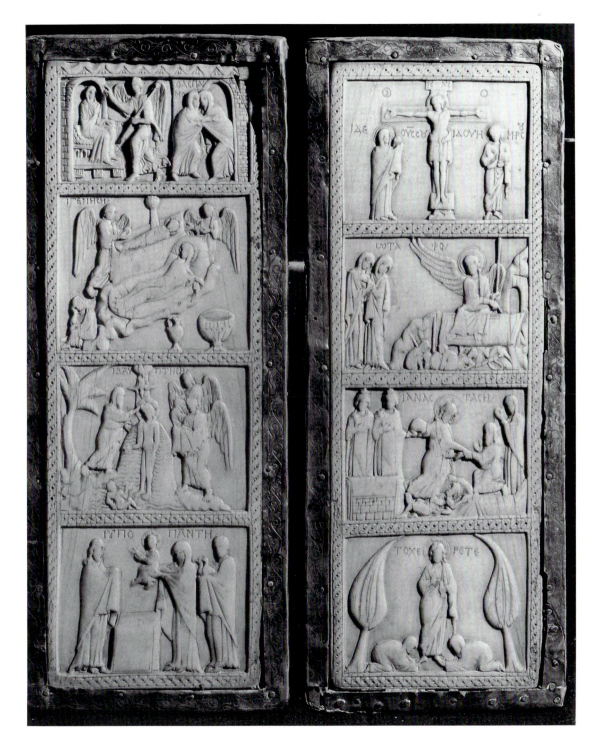

2. Milan, Duomo. Diptych, scenes from the life of Christ (31.0 × 10.7; 31.0 × 10.7 cm)

phers and, where I have been allowed to do the work myself, by the difficulty of photographing objects as they are normally perceived in situations that did not allow floodlights and other gadgetry. The fact remains that the standard sort of photograph offers only a jejune version of an artifact painstakingly fashioned in three dimensions and intended for use by creatures equipped with binocular vision.

Museums in which objects are associated by virtue of their medium and supposed period attempt to remove such limitations. Yet marching side by side in their cases (fig. 1), ivories appear more like found objects of natural origin, humanized only by the designs scratched on their surfaces, than artifacts designed from the start to follow culturally determined norms of size, use, and significance. Arrays of this sort are better suited (and sometimes purposefully designed as aids) to acts of comparison between examples of the

3. Berlin, Staatliche Museen. Diptych, Christ and the Virgin (29.0 × 13.0; 28.9 × 12.7 cm)

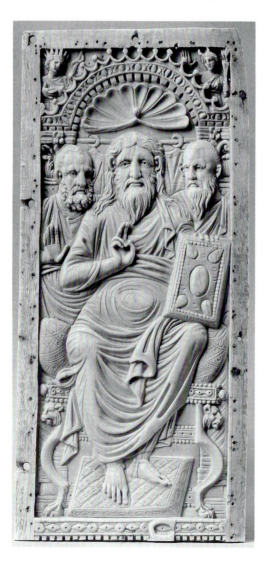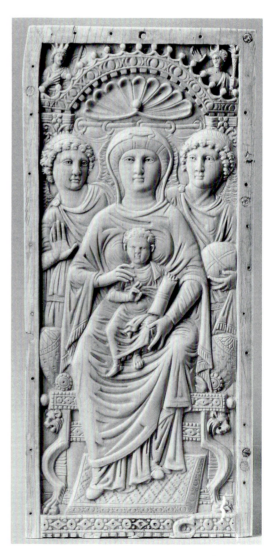

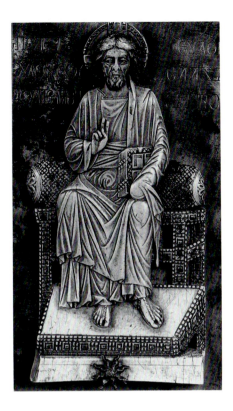

4. *Oxford, Bodeleian Library, MS Auct. T. inf. I. 10. Christ Enthroned (16.0 × 8.0 cm)*

craft than to the extended contemplation of any one representative of it. The uniqueness of the object is thus blunted and concomitantly the exclusive and protracted study of a single work. Opportunities for concentration of this sort are today available only to museum curators and a few specialists; others join the ranks of those whose perceptions are engendered *in vitro* and incubated amid photographs. Of course the lack of hindrance enjoyed by connoisseurs in the days before restricted access became the condition of security did not always make for nice judgment. Misused literary criteria and ignorance of comparable material—aberrations that have not entirely vanished from scholarship—led A. Didron, for example, into errors egregious even by the standards of his time. He first dismissed the great sixth-century diptych of Christ and the Virgin (fig. 3)[4] as a forgery on the grounds that Christ's gesture is Byzantine but his throne "Roman," and that the images of the sun and moon were a solecism, since the book of Revelation (21:22) described the City of God as lit by the Lamb alone.[5] Didron then went on to condemn the ivory Christ cut from a Byzantine plaque and imposed upon a modern bookcover in Oxford (fig. 4)[6] because the Lord "blesses in the Latin manner." So rigid a distinction belies the great variety of blessing gestures found on Byzantine ivories[7] and witnesses only to Didron's lack of experience of many of the monuments. The possibility that the Bodleian Christ could owe something to an ancient image like that in Berlin (fig. 3) did not occur to him.

The suspicion that things are not what they seem, or not what they are said to be, has become an intrinsic part of the modern response to ivories. This situation is all but

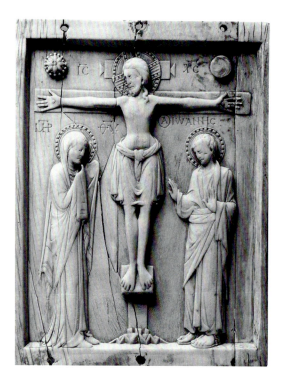

5. Baltimore, Walters Art Gallery.
Crucifixion (16.4 × 11.8 cm)
6. Reverse of fig. 5, detail

inevitable, given that plaques which brought £100 or so in Didron's day now sell for upwards of £600,000[8]—figures that rarely are, but should be, part of the record in that they affect the way ivories are cared for, exhibited, and above all regarded. "Questions of authenticity" depend as much on sociological as on art historical answers, but the art historian remains responsible for the reasoning that underlies such responses. The summary dismissal as forgeries of works that are perfectly respectable has today taken on something of the moral fervor of a crusade, perhaps because scholars have less confidence in opinions based on "quality." This notion has come under fire as "elitist." It would be more to the point to remark that judgments about quality are of course not eternal verities but opinions formed in the light, and as a result, of our training and acquired predispositions. This is at once their weakness and their strength: they may not be ineluctable but they are indispensable. So far as craftsmanship—the central concern of this book—is concerned, perceptions of quality are part of the data with which we operate, as essential to our studies as they were to those who made the works that we study. Of course there is no a priori reason why a clumsily made object cannot also be authentic; but once we have recognized the technical basis of high quality in Byzantine ivory carving, it should be harder to dismiss as inauthentic a work that displays such characteristics.

Awareness of technique and of the material basis of the craft is no less important to judgments of authenticity based on criteria other than quality. Rarely, however, are they

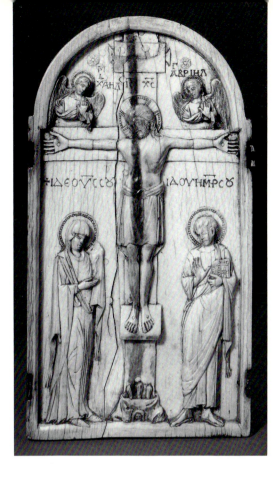

7. *Washington, D.C., Dumbarton Oaks.*
Crucifixion (*19.9 × 10.4 cm*)

offered with the even-handedness evident in Kurt Weitzmann's assessment of a worn and badly damaged plaque in Baltimore (fig. 5)[9] that I believe to be a mid-tenth century work. Without offering a final adjudication, Weitzmann was troubled by the gesture that John makes with his right hand[10] and especially by the patterns of the breaks in the material. Yet, as is evident, most of these fractures develop from holes in the upper or lower frames drilled by the carver to accommodate the wings that closed over this central portion of a triptych. Such breaks are entirely consistent with the process of desiccation that results from punctures: when and where the natural collagen of the ivory dries out, the material is weakened.[11] The directions that cracks then pursue are determined by the vascular system of the panel.[12] As will be seen, other breaks can occur along contours scored around figures or, quite independently of punctures or contours, whenever a plaque is subjected to repeated strains in a particular area. The lower corners of the Baltimore plaque have clearly been overtaxed in this way and I shall suggest the reasons why this occurred.[13] For now, it is only necessary to observe that the large areas of replacement material—the entire right side of the ivory and a lozenge-shaped portion between Christ and the Virgin—more easily read in a detail of the back of the plaque (fig. 6)—are scarcely likely to have been used if the entire plaque were a fake. I have elsewhere pointed to the improbability that a counterfeiter would employ flawed ivory of a sort that was often used (for want of better material) in Byzantium.[14] In this case, a Crucifixion in Washington (fig. 7), doubts had

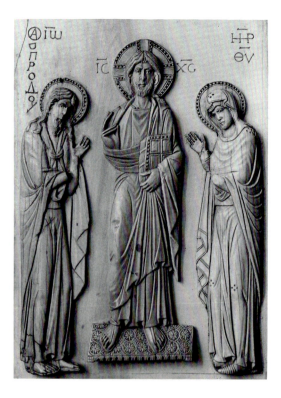

11. Munich, Bayerisches Nationalmuseum. Deesis (17.8 × 12.3 cm)

12. Reverse of fig. 11

which are not removed by polishing,[23] only strengthens my conviction that the ivory is a modern creation.

These observations, if not this inference, could be made by anyone who looks at the back of the plaque. But even this step would be in vain in the case of a Deesis ivory in Munich (fig. 11).[24] Here the urge to "improve," if not to deceive, extends even to the use of a panel that displays the "shadow" of the tusk's pulp cavity (fig. 12), a section that is found on perfectly authentic Byzantine ivories.[25] Against this nineteenth-century restoration material are imposed images of Christ, the Virgin, and John the Baptist that originally belonged to a plaque carved nine hundred years earlier. It is arguable that such detached vestiges, as in a similar group at Dumbarton Oaks,[26] no longer give a representative account of what was, after all, a relief and not a set of free-standing figurines. But there is a world of difference between minor repairs that help to strengthen the original material or aid the spectator to gain some idea of the piece's original form and wholesale substitution, especially when, as in the Munich Deesis, the attempt is made—by means of new (and bizarre) epigraphy—to suggest that the only damage to the ivory are the lost

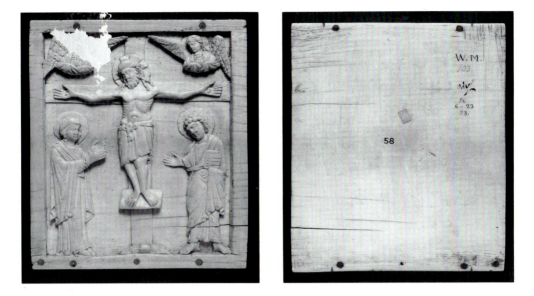

9. *London, British Museum. Crucifixion (13.7 × 10.7 cm)*

10. *Reverse of fig. 9*

Without it we have no basis for an act of discrimination as might be applied, for instance, to a Crucifixion in the British Museum (fig. 9).[19] To my knowledge the propriety of its inclusion in a catalogue of Byzantine ivories has not been questioned, even though Weitzmann saw in its style features that led him to ask whether it might not have been made in "Belgium." Even more disconcerting than these are Christ's great meaty legs and his Hasidic locks cunningly crossed below the left ear. Christ's huge Cyclopean navel further strengthens one's suspicions that the carver was no Greek but, still at the level of appearance, it is the proportion of the plaque—much wider (10.7 cm) in relation to its height (13.7 cm) than is normal—that should have occasioned skepticism. Up to this point, however, I have done no more than argue in terms of the Crucifixion's insufficiency. Corroboration of such an argument depends upon readings in terms of craftsmanship, an aspect which, in this case, springs to mind as soon as the ivory is turned over. The concentric ellipses on the back of the plaque (fig. 10) leave no doubt that it is of elephant ivory.[20] But these, like the striations that mark the upper and lower edges of the reverse,[21] run the wrong way. No medieval ivory carver chose to carve *across* the direction of the grain, a step that entails the "picking up" (as woodworkers say) of the material. Of course vertical figures on plaques that are wider than they are tall (e.g., figs. 50, 53, 54, 61) are carved transversely in respect to this axis. But in the case of the London Crucifixion, as we have seen, the craftsman chose to cut a panel taller (though not much taller) than it is wide. The fact that he excavated the ground[22] of the obverse with a pick, the marks of

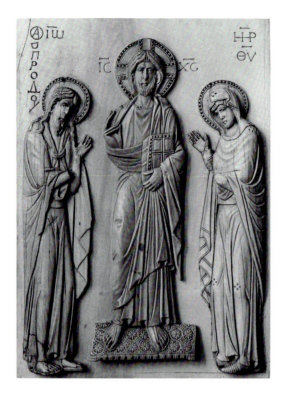

11. Munich, Bayerisches Nationalmuseum. Deesis (17.8 × 12.3 cm)

12. Reverse of fig. 11

which are not removed by polishing,[23] only strengthens my conviction that the ivory is a modern creation.

These observations, if not this inference, could be made by anyone who looks at the back of the plaque. But even this step would be in vain in the case of a Deesis ivory in Munich (fig. 11).[24] Here the urge to "improve," if not to deceive, extends even to the use of a panel that displays the "shadow" of the tusk's pulp cavity (fig. 12), a section that is found on perfectly authentic Byzantine ivories.[25] Against this nineteenth-century restoration material are imposed images of Christ, the Virgin, and John the Baptist that originally belonged to a plaque carved nine hundred years earlier. It is arguable that such detached vestiges, as in a similar group at Dumbarton Oaks,[26] no longer give a representative account of what was, after all, a relief and not a set of free-standing figurines. But there is a world of difference between minor repairs that help to strengthen the original material or aid the spectator to gain some idea of the piece's original form and wholesale substitution, especially when, as in the Munich Deesis, the attempt is made—by means of new (and bizarre) epigraphy—to suggest that the only damage to the ivory are the lost

7. *Washington, D.C., Dumbarton Oaks. Crucifixion (19.9 × 10.4 cm)*

offered with the even-handedness evident in Kurt Weitzmann's assessment of a worn and badly damaged plaque in Baltimore (fig. 5)[9] that I believe to be a mid-tenth century work. Without offering a final adjudication, Weitzmann was troubled by the gesture that John makes with his right hand[10] and especially by the patterns of the breaks in the material. Yet, as is evident, most of these fractures develop from holes in the upper or lower frames drilled by the carver to accommodate the wings that closed over this central portion of a triptych. Such breaks are entirely consistent with the process of desiccation that results from punctures: when and where the natural collagen of the ivory dries out, the material is weakened.[11] The directions that cracks then pursue are determined by the vascular system of the panel.[12] As will be seen, other breaks can occur along contours scored around figures or, quite independently of punctures or contours, whenever a plaque is subjected to repeated strains in a particular area. The lower corners of the Baltimore plaque have clearly been overtaxed in this way and I shall suggest the reasons why this occurred.[13] For now, it is only necessary to observe that the large areas of replacement material—the entire right side of the ivory and a lozenge-shaped portion between Christ and the Virgin—more easily read in a detail of the back of the plaque (fig. 6)—are scarcely likely to have been used if the entire plaque were a fake. I have elsewhere pointed to the improbability that a counterfeiter would employ flawed ivory of a sort that was often used (for want of better material) in Byzantium.[14] In this case, a Crucifixion in Washington (fig. 7), doubts had

13

been raised not only on account of the flaw running down the middle of the plaque[15] but also because of the uneven way in which the names of the archang[...]ael and Gabriel, are inscribed.[16] Such irregularity may be a sign of incompeten[...] overreaching on the part of the carver—normally either the archangels *or* the sun and moon[17] are shown above the Cross—but it is not sufficient reason for which to reject the plaque. Similar epigraphical irregularity occurs on other ivories of less than first-rate quality, for example on the wings of a triptych in Moscow (fig. 8).

This sort of plea—the presentation of a *comparandum* for an element that is presumed to be abnormal—goes some way towards a refutation of what might be called the insufficiency argument. Doubts cast on the Bodleian Christ (fig. 4), and the Baltimore and Washington Crucifixions (figs. 5,7), while varying in their subtlety of expression, all rest on the supposition that these works present features that are unparalleled elsewhere. A more thorough knowledge of the corpus of ivories could obviously blunt the thrust of such objections. But criticism leveled from the diametrically opposite position—the argument from superfluity—is harder to engage. Such strictures characteristically observe that a particular ivory too closely resembles another, as in the case of a Crucifixion in the Cabinet des Médailles in Paris.[18] The problem with the superfluity argument is that it lacks a theoretical underpinning: it generally fails to take into account the normative tendencies of Byzantine art and, in particular, the means whereby ivories came into being. Any argument that ignores the social and technical factors that bear upon the production of works of art is ipso facto inadequate.

I do not claim that awareness of either Byzantine society or Byzantine craftsmanship can serve to validate the authenticity of an object. Rather, I suggest, any judgment must be based on intimate knowledge of the material and, thus fortified, direct scrutiny of the particular work in dispute. Connoisseurship at this secondary stage is far from a liability.

8. Moscow, Pushkin Museum. Triptych wings, obverse. Detail of fig. 77

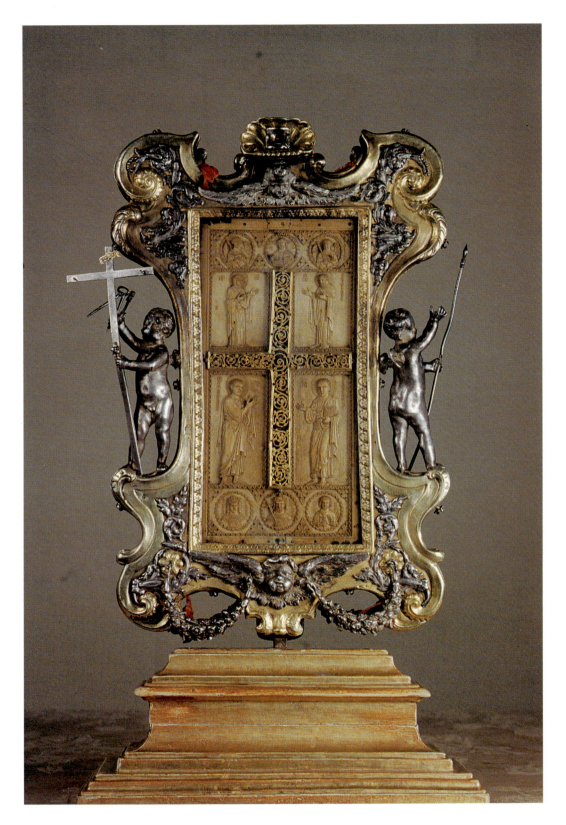

I. *Cortona, S. Francesco. Reliquary of the True Cross (30.2 × 14.5 cm)*

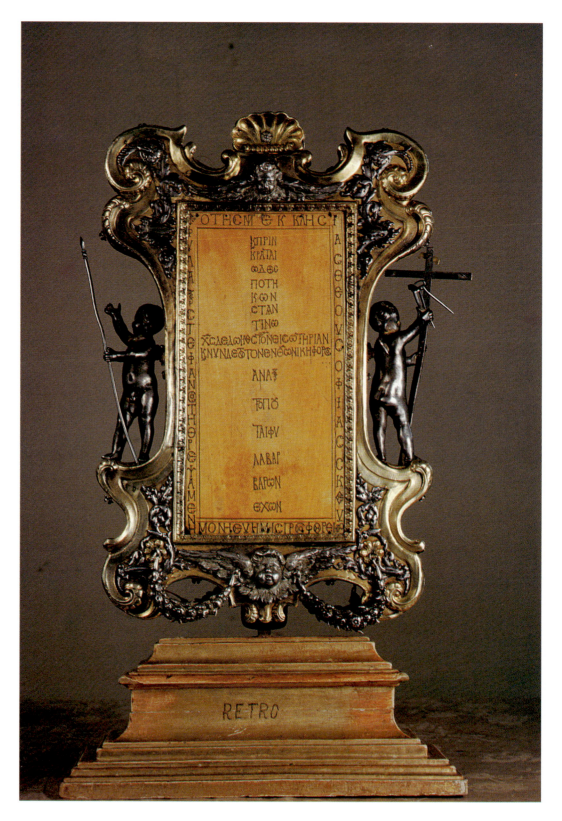

II. *Reverse of plate I*

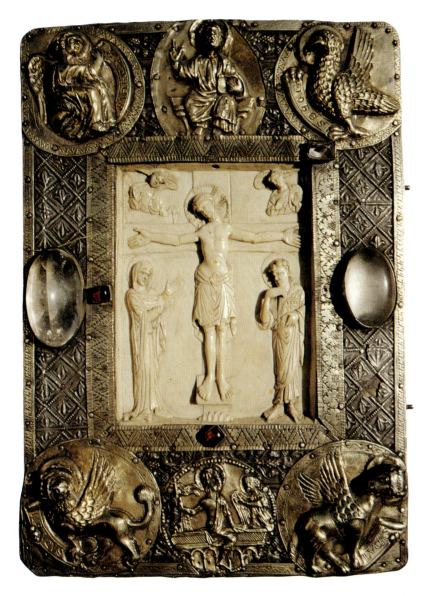

III. *Arnhem, Gemeentemuseum. 15th-century binding with a Byzantine ivory of the Crucifixion* (12.4 × 9.4 *cm*)

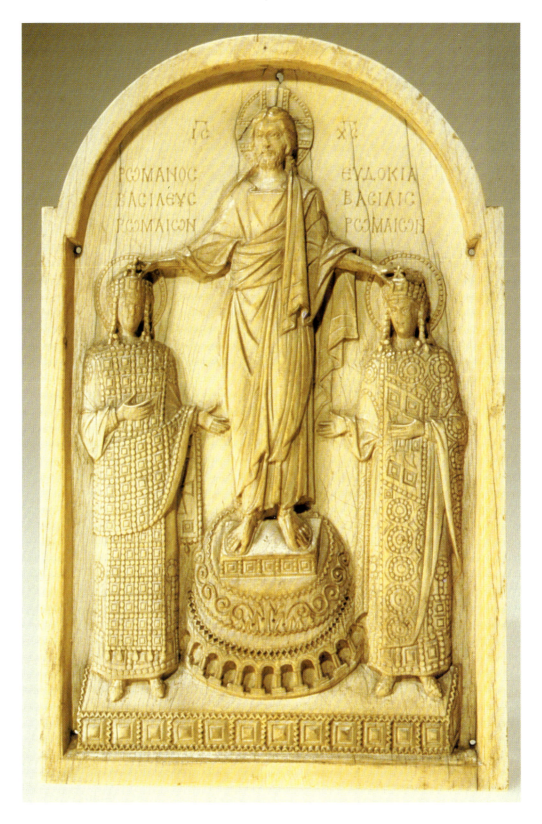

IV. *Paris, Cabinet des Médailles. Christ crowning Romanos and Eudokia (24.4 × 15.4 cm)*

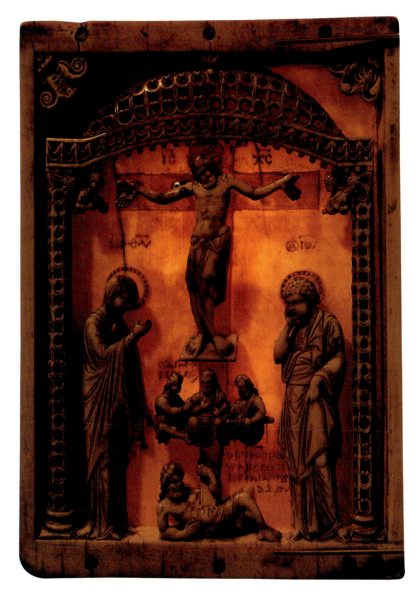

V. *New York, Metropolitan Museum. Crucifixion, lit from behind* (12.3 × 8.6 *cm*)

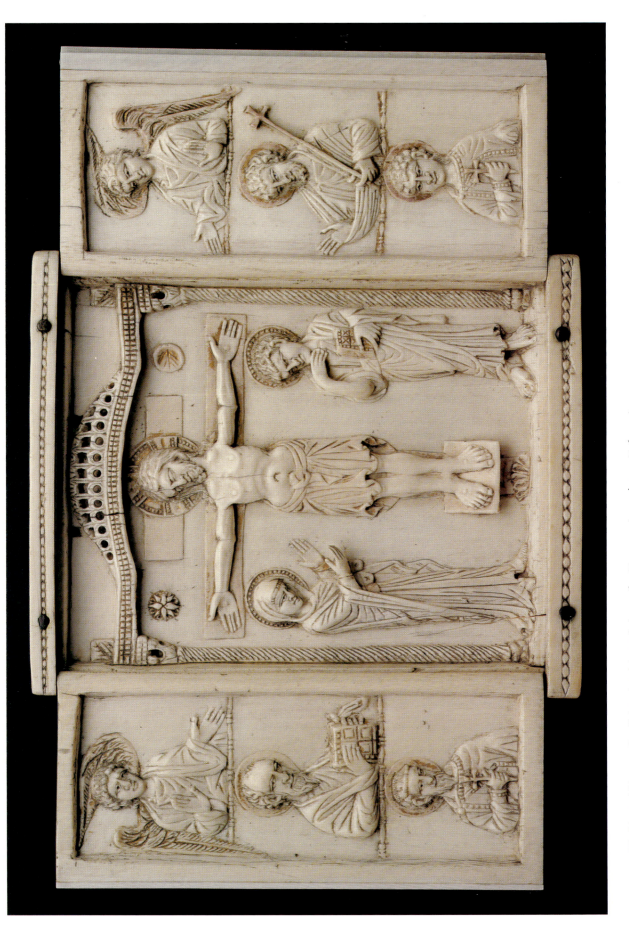

VI. Liverpool Museum. Crucifixion triptych (central plaque 16.1 × 12.4; wings each 14.1 × 6.2 cm)

hands of the flanking figures. Not all such restorations are so blatant. While a figure of the
Baptist in Liverpool (fig. 13)[27] is displayed against a modern ground that is framed in an
utterly un-Byzantine manner, its reverse (fig. 14)—although this is not evident as the
object is exhibited—confesses to the reconstruction. Even here, however, the impulse to
"correct" the medieval master is apparent: some modern pedant saw fit to pepper with
breathings and accents the scroll that John holds, in the belief that it was necessary to
update the message that the Lord removes the sins of the world. And donnish compulsive-
ness drove him to make an *omega* of an *omicron* in the fourth line in an effort to repair this
typical example of Byzantine insouciance regarding matters of spelling.[28]

13. Liverpool, Museum. John the Baptist (24.1 × 10.2 cm)

14. Reverse of fig. 13

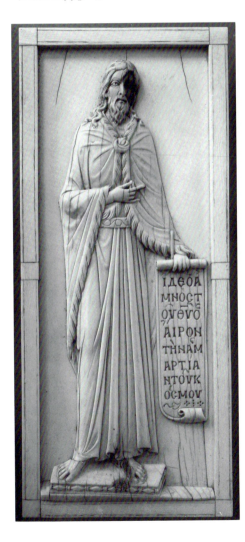

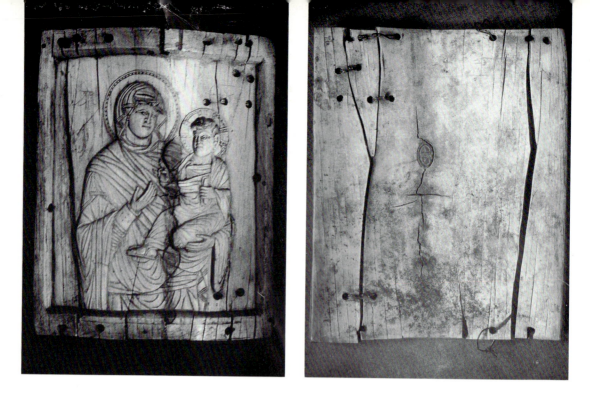

15. Tbilisi, Historical Museum. Virgin Hodegetria (14.4 × 11.6 cm)

16. Reverse of fig. 15

Emendations of this sort and especially the replacement of portions of material lost from boxes and plaques are, in a sense, thoroughly medieval. Icons were frequently touched up or overpainted,[29] silver vessels mended,[30] and frescoes "restored"[31] through-out the history of Byzantium. The difference, however, between the modern enterprises that I have described and such Byzantine repairs is that the latter are aspects of a mentality that lacked any developed sense of periodization. They may be no less guilty of artfulness but they are innocent on any charge of commercially motivated duplicity. Byzantine renovations are easily detectible; and, of course, we cannot assert the opposite of modern falsifications that have not yet been detected. Yet, at least as far as ivory is concerned, restorations from the seventeenth century onward are hardly less apparent. They reveal themselves in clumsy reconstructions (figs. 15, 16),[32] more interestingly in anachronistic epigraphy and iconography[33] and most revealingly in attempts to improve upon the original. In this last category fall the replacement of bone with ivory, as in the case of some of the rosette borders and filler strips on a "casket" at Dumbarton Oaks (fig. 17),[34] and the relining of such boxes, effectively turning them into Italian Renaissance objects.[35]

To a greater or less extent, every ensuing era has left its marks upon our ivories, physical exponents of the mental image that each has had of what Byzantium was, or should have been. In some instances this may be no more than the prominent registration of inventory numbers on the obverses of plaques;[36] in another, the loving addition of a smiling head of Christ (fig. 60) in a situation in which he rarely smiles (cf. fig. 99).[37] The

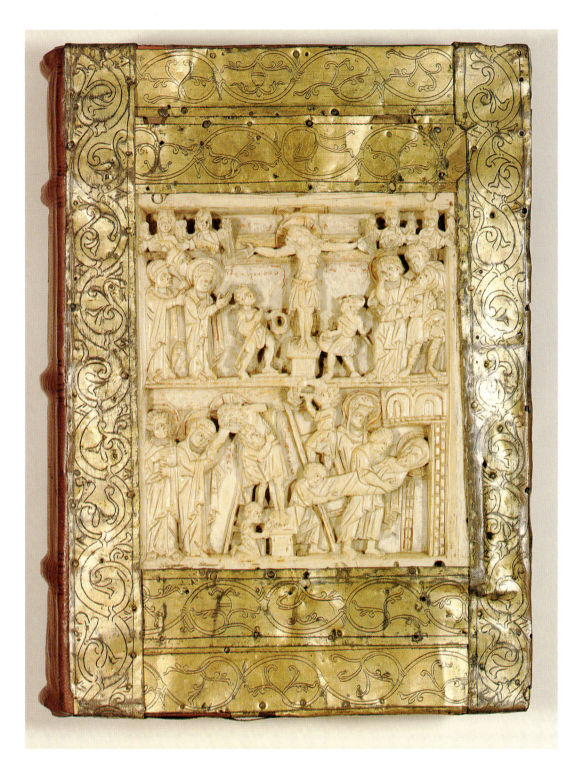

VII. *Munich, Staatsbibliothek, Clm 6831. Book cover with the Crucifixion, Deposition and Entombment (15.8 × 13.8 cm)*

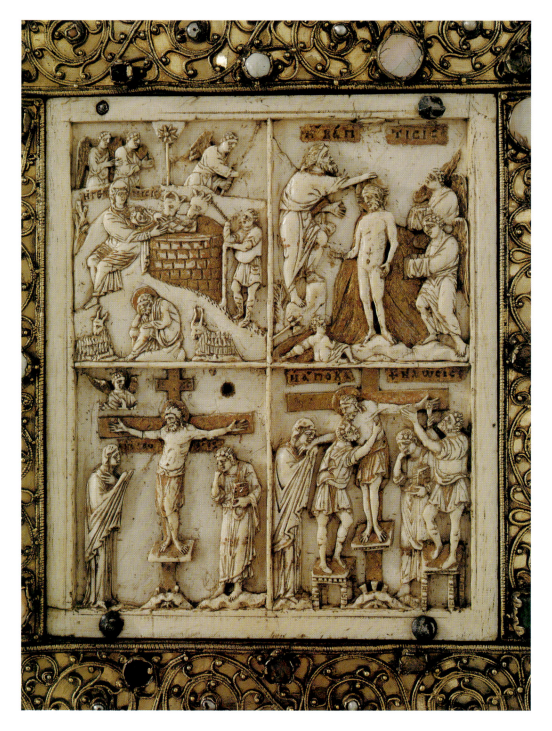

VIII. *Quedlinburg, Stiftskirche. Four scenes from the life of Christ* (15.0 × 12.4 cm)

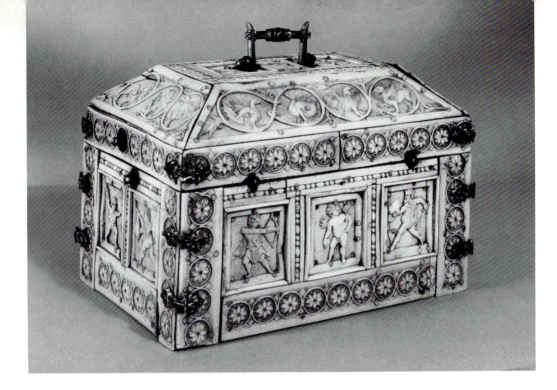

17. Washington, D.C., Dumbarton Oaks. "Rosette casket" (15.7 × 23.0 × 16.1 cm). See also fig. 171

history of art could be tellingly written in terms of the restorations that successive "presents" have visited upon the past; it is not my intention to do so. Merely to understand how the Byzantines thought about their creations, and in particular, those in a medium that they favored, is a hard enough task.

2. THE BYZANTINE RESPONSE

Ivory is all but invisible in Byzantine texts. In contrast to the multitude of Roman historians, poets, letter-writers *et al.* who relate (sometimes fantastically) the sources of elephant dentine and its roles as a store of wealth in temples, as an instrument of tribute and booty, and as a raw material for artifacts,[38] Greek references to ivory after the sixth century are few and almost embarrassingly trivial; almost all involve evocations of or comparisons with antiquity, qualities that in themselves suggest the change in the availability and image of dentine after the "Dark Age" of the seventh and eighth centuries. Thus the round ivory table in the childhood home of St. Philaretos, said to be sheathed in gold and so large that it could seat thirty-six people, is specifically described as an "antique" (*archaia*).[39] So lavish a use of dentine is virtually inconceivable in the Middle Ages and no allusion to anything similar is made until the Ivory Gate in the Daphne, part

of the Great Palace in Constantinople, known from the early ninth century onward.[40] Given the status accorded this door and its chronological and topographical isolation, this too would seem to have been a product of late antiquity. It is as if ivory, like the animal from which it comes—both are called *elephas* in Greek—had become a wonder whereas, in late antiquity, both the pachyderm and its tusks were familiar aspects of the battlefield and the circus on the one hand or of civil and religious ceremonies on the other.

After the Ivory Gate, all is silence until the second half of the eleventh century when Symeon Seth mentions the ancient practice of softening ivory in beer.[41] This observation is drawn from Dioskorides and appears in the setting not of working ivory but of the medicinal value of beer. Less pragmatically but still in the vein of allusion to a lost world, Eustathios, the twelfth-century archbishop of Thessalonike, laments how in Homer's day men had used elephants' bones liberally.[42] This sense of the paradigmatic value of the classical past invests the words of his contemporary, Anna Komnene, who, in an attempt to convey the grace of her mother's hands, describes them "as if wrought in ivory by some artificer."[43] The sentiment is ancient but the language modern. Anna uses the word *technites,* the generic Byzantine term for craftsman, rather than *elephantourgos,* that is, a specialist in working ivory, the word employed (as the equivalent of the Latin *eborarius*) in the classical world. I shall suggest that this change in vocabulary reflects realities of the twelfth century.[44] Certainly by this time the elephant had become a prodigy to be marvelled at[45] and ivory, in its turn, a rarity even in those lists of material possessions[46] so assiduously drawn up by monks and other archivally minded treasurers and so precious to the art historian. I know of only three references to our material in Byzantine inventories, of which the first probably describes a late antique pyxis reused as a *lipsanothek.* This is "a round container worked out of ivory, white, having inside 4 pieces of relics and 2 pieces of flesh."[47] A reference to the head of St. Paul in a catalogue of the treasures of Hagia Sophia in Constantinople, drawn up in October 1397,[48] could indicate a reliquary made at any date in the previous millennium. Only the "ivory carving of the Dormition and the Nativity" and "another, smaller one decorated with the Dormition," cited in the will of Maximos, *hieromonachos* of the monastery of the Virgin at Skoteine in Lydia in 1247, allow us to suppose that these were medieval creations.[49]

Wills tell us nothing and inventories next to nothing about how such objects were used—a more serious lack of information than the silence about how they looked, for their appearance can generally be inferred from hundreds of surviving examples. Indeed there is only one Byzantine ivory the present state of which may roughly suggest how it was originally displayed. The great cross-reliquary which has been housed at Cortona (pls. I, II) for at least 400 years, and possibly much longer,[50] was probably exhibited much in the manner that it is now, even though its elaborate ebony and silver frame is a work of the seventeenth century. The long and revealing inscription carved on its reverse[51] required that it be displayed in Hagia Sophia in Constantinople in a way that showed both its front

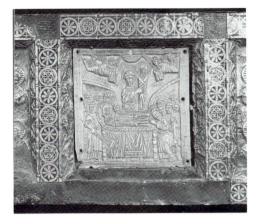

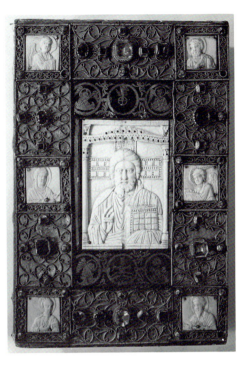

18. Trier, Cathedral Treasury. Portable altar with parts of two Byzantine triptychs. Detail, Dormition of the Virgin (11.4 × 10.9 cm)

19. Munich, Staatsbibliothek, Clm 22021. Book cover with fragments of a triptych of Christ, angels, the Virgin and John the Baptist, Peter and Paul (Christ plaque 13.1 × 8.9 cm)

and back. One side exhibited the saving fragment of the True Cross; the other, scarcely less important, imperial testimony to the wonders that the precious particle had worked. Of the scores of other Byzantine ivories exported to the West in the Middle Ages, most are now as naked—and therefore no more informative about their original context—as those that arrived later. Examples that have been mounted as book covers (pls. III, VII, VIII)[52] and on portable altars (fig. 18),[53] while often serving as parts of what are splendid arrangements in their own right, are of even less use to us if we wish to understand the ivories' original setting. Even while some of these book covers were constituted less than fifty years after the plaques were carved,[54] neither texts nor archaeology require us to suppose that ivories were used in this way in Byzantium.[55] On Latin book covers, triptychs were chopped up, with their parts rearranged and distributed without regard for their original arrangement (fig. 19).[56] Unhelpful as this may be to the Byzantinist, this attitude is thoroughly consistent with antique and Western medieval use of elephant dentine as one luxury among many, an equal of the gems and precious metals that were similarly attached to the words of God and his saints.[57] In Byzantium, by contrast, ivory seems to have been used not as an adjunct but a material employed for its own sake and in the maximum dimensions available.

The medieval West, which revered ivory imported from the East yet severed it from its original form and context, can nonetheless aid us in reconstructing one part of the

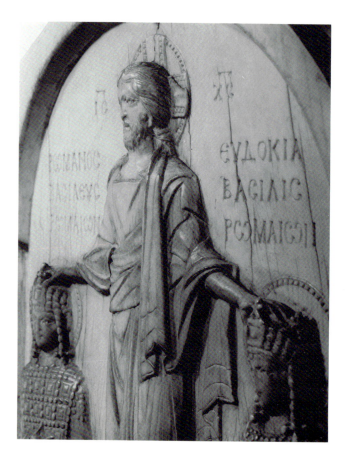

22. *Paris, Cabinet des Médailles. Romanos ivory, oblique view from right. See also pl. IV and fig. 115*

its lower corners cupped in the hands while the thumbs play freely over its surface as depicted in a twelfth-century miniature (fig. 21).[69] The passage in the Chronicle of Skylitzes illustrated by this image will be of considerable interest to us in a moment. For now, it is only necessary to note how normal is this manner of holding an image: it is the way anyone handles a small picture. Of course abrasion of the St. Petersburg ivory could have occurred in modern, and not necessarily devotional, use: we learn from an inscription on the back that in 1631 it was presented by a Bavarian man to his wife on her saint's day. But so consistent are the wear marks on plaques that have been known for centuries that to suppose all such marks are recent defies belief. Certainly far more wear occurred in Byzantine times than under modern museum conditions: the very circumstances that today inhibit familiarity with the feel of ivory are equally responsible for arresting the process by which it is abraded.

One of the most striking examples of wear on a well-known ivory is that which has been visited on the Romanos and Eudokia plaque in the Cabinet des Médailles (pl. IV).[70] Here, as in the Baltimore Crucifixion (fig. 5), it is not the most salient surfaces of the ivory that are rubbed but the heads of the three figures, and particularly those of the imperial couple on either side. Once again, this is best seen not when the plaque is observed *en face*,

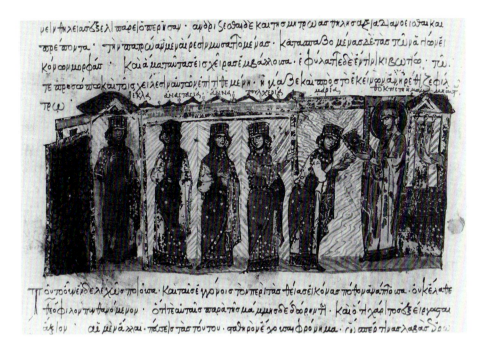

21. *Madrid, Biblioteca Nacional vitr. 26–2, fol. 44v. Theoktiste teaching the daughters of Theophilos to venerate icons*

responses in other writers can be counted on the fingers of one mutilated hand. In his *Life of Theoktiste of Lesbos*, Niketas Magistros compares with linen the ashlar masonry of a church destroyed by the Arabs,[65] a simile that obviously derives from experience and, for our purposes, invaluable in that it issues from the pen of a member of the early tenth-century elite.[66] Anonymity, however, surrounds the eleventh-century description as stiff and rough of the hair shirt that Barlaam wore when he taught the Prince Ioasaph;[67] tactile as the image is, we have no knowledge of the social status of the Greek who invented (or translated) it.

Scanty as the literary testimony is, it is by no means our only witness to the belief that the Byzantines loved to manipulate ivory. The best evidence is provided by the objects themselves, although it is evidence that can be properly judged only when one takes them in hand—as, I am convinced, their first possessors did. One ivory clearly marked by the abrasion that comes from use is an icon in St. Petersburg of six scenes from the life of Christ (fig. 20).[68] This has suffered not overall wear, like the Christological plaques in Milan (fig. 2), but quite localized rubbing: the most worn parts of the plaque are those towards its edges and particularly those in its lower quadrants. The angel to the left of the Nativity and the faces of all three figures in the presentation of the Child are worn despite the fact that they project no farther than elements nearer the center of the ivory. Below, it is again the flanking figures—the Baptist and the Baptized at left and Lazarus in his shroud at right—that are especially rubbed. These areas coincide with a way of holding the plaque,

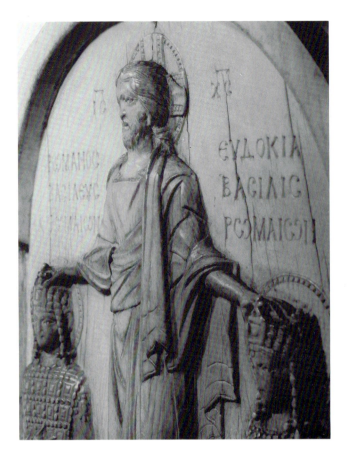

22. *Paris, Cabinet des Médailles. Romanos ivory, oblique view from right. See also pl. IV and fig. 115*

its lower corners cupped in the hands while the thumbs play freely over its surface as depicted in a twelfth-century miniature (fig. 21).[69] The passage in the Chronicle of Skylitzes illustrated by this image will be of considerable interest to us in a moment. For now, it is only necessary to note how normal is this manner of holding an image: it is the way anyone handles a small picture. Of course abrasion of the St. Petersburg ivory could have occurred in modern, and not necessarily devotional, use: we learn from an inscription on the back that in 1631 it was presented by a Bavarian man to his wife on her saint's day. But so consistent are the wear marks on plaques that have been known for centuries that to suppose all such marks are recent defies belief. Certainly far more wear occurred in Byzantine times than under modern museum conditions: the very circumstances that today inhibit familiarity with the feel of ivory are equally responsible for arresting the process by which it is abraded.

One of the most striking examples of wear on a well-known ivory is that which has been visited on the Romanos and Eudokia plaque in the Cabinet des Médailles (pl. IV).[70] Here, as in the Baltimore Crucifixion (fig. 5), it is not the most salient surfaces of the ivory that are rubbed but the heads of the three figures, and particularly those of the imperial couple on either side. Once again, this is best seen not when the plaque is observed *en face,*

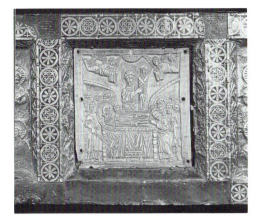

18. Trier, Cathedral Treasury. Portable altar with parts of two Byzantine triptychs. Detail, Dormition of the Virgin (11.4 × 10.9 cm)

19. Munich, Staatsbibliothek, Clm 22021. Book cover with fragments of a triptych of Christ, angels, the Virgin and John the Baptist, Peter and Paul (Christ plaque 13.1 × 8.9 cm)

and back. One side exhibited the saving fragment of the True Cross; the other, scarcely less important, imperial testimony to the wonders that the precious particle had worked. Of the scores of other Byzantine ivories exported to the West in the Middle Ages, most are now as naked—and therefore no more informative about their original context—as those that arrived later. Examples that have been mounted as book covers (pls. III, VII, VIII)[52] and on portable altars (fig. 18),[53] while often serving as parts of what are splendid arrangements in their own right, are of even less use to us if we wish to understand the ivories' original setting. Even while some of these book covers were constituted less than fifty years after the plaques were carved,[54] neither texts nor archaeology require us to suppose that ivories were used in this way in Byzantium.[55] On Latin book covers, triptychs were chopped up, with their parts rearranged and distributed without regard for their original arrangement (fig. 19).[56] Unhelpful as this may be to the Byzantinist, this attitude is thoroughly consistent with antique and Western medieval use of elephant dentine as one luxury among many, an equal of the gems and precious metals that were similarly attached to the words of God and his saints.[57] In Byzantium, by contrast, ivory seems to have been used not as an adjunct but a material employed for its own sake and in the maximum dimensions available.

The medieval West, which revered ivory imported from the East yet severed it from its original form and context, can nonetheless aid us in reconstructing one part of the

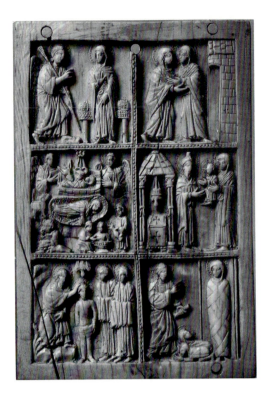

20. St. Petersburg, Hermitage Museum.
Six scenes from the life of Christ (14.5 × 9.8 cm)

Byzantine experience that is almost never considered. So divorced are we from the *feel* of dentine, and so uncommon in medieval literature, Eastern or Western, is evidence of a tactile response to it, that its sensuous properties have passed beyond our ken and, with this disappearance, any reason to suppose that the Byzantines may have reacted differently to the substance. Byzantine authors did not readily confess to a pleasure in touching things. When they dealt with the senses at all, most followed the admonitions of St. Jerome concerning the temptations that sight, hearing, smell, taste and feel presented to the soul.[58] Hard as it may be to believe that a culture that produced the epic *Digenês Akritas*, with its many responses to the smell of flowers, the physical beauty of young men and women, and sexual passion,[59] lacked a sense of feel, the nature of most medieval Greek literature is such that one must look hard for evidence of delight in touching. There is no Byzantine equivalent to Bernard of Clairvaux's negative witness as he thundered to William, Abbot of St.-Thierry, against statues that are pleasing to touch (*tactu placentia*),[60] or the horror that he expressed at the way people ran to kiss and shower money on beautiful images of male or female saints.[61]

The nearest thing that the Greeks have to offer is Niketas Choniates' report on the "palpable" nature of a statue of a woman among the images destroyed by the Crusaders in 1204.[62] Describing a battle, he also spoke of "darkness that can be felt."[63] But these are exceptions in an exceptional author. More characteristic is his criticism of those who argue that after the resurrection we shall have the sense of neither touch nor sight.[64] Less abstract

as in the vitrine, but when it is viewed obliquely (fig. 22). The worn areas correspond to the position of the beholder's thumbs, if he or she held the ivory at the sides in the manner that I have suggested would be ordinary. Such support does not, however, explain the abrasion of the face of Christ which is worn to the point where it appears almost concave in profile. This, I suspect, was caused by repeated kissing of the image, although, as we have seen with regard to the matter of touching in Byzantium, the evidence for this practice is diffused and therefore neglected.

In Greek Orthodox ritual today several images may be kissed when the worshiper enters or leaves a church. These include icons on *proskynetaria* in the narthex, panels on the iconostasis, and Feast icons on the lectern. The icon of the Theotokos is kissed at the end of Great Complines and at the Lenten Vespers of Contrition; so too at the end of the Paraklesis and Akathist services. The corpus of Christ is processed and kissed during matins of Holy Friday as, on the same day, is the *epitaphios* embroidery that represents his shroud.[71] It would be illegitimate to deduce Byzantine behavior from modern practice. But this list suffers a worse defect: it omits the kissing of icons,[72] in church or at home, stimulated by personal rather than prescribed veneration. And it is this domain—the realm of personal piety and affective instinct—that is most resistant to investigation. Absent an oral history of sentiments more than a thousand years old, we can proceed only on the basis of such documents, literary and especially artifactual, as we have. The touching and kissing (*aspasmos*) of relics and their containers was, it is clear, an essential aspect of the experience of early Byzantine pilgrims.[73] At some time before the eighth century, the word *aspasmos*—the salute or mutual embrace of the Virgin and Elizabeth (figs. 2, 20, 26)— became the normal term for the veneration of images. The desire to greet an icon by kissing it is recorded by John of Damascus[74] and this conduct was sanctioned by the Second Council of Nicaea in 787.[75] The effects of this practice, which surely preceded the Council's ruling, are to be seen on thousands of later icons,[76] ivories, and manuscripts.[77] And beyond this passive role as object of the believer's desire, images themselves can *represent* such feelings: a wooden box in the Museo Sacro in the Vatican, painted probably in the tenth century with a picture in which the Virgin kisses Christ's feet, has been connected with feelings attributed to her by George of Nikomedeia.[78] Addressing her Son in the first person, in the verbal equivalent of a lover's breathless osculation, she declares that she kisses "your cross, your nails, your pierced limbs, your sponge, your shroud . . ."[79]

Art historians like to believe that pictures are more revealing, because they are more specific, than words. But this is not true of the homily just cited and assuredly not of the tale in Skylitzes that gave rise to the image of Theoktiste and her granddaughters (fig. 21). The entire incident, ostensibly a story of the Empress Theodora's resistance to the icono-clastic policy of her husband Theophilos, is in fact a paradigmatic account of the way patterns of behavior are inculcated in children and of the role that women had in such

rarer diptychs, such as one now divided between Gotha[87] and Washington[88] (figs. 24, 25). Because of the cuttings in their edges,[89] and perhaps because of the rarity of surviving diptychs, it has been suggested that these plaques were hinged as a diptych only in secondary use and the hypothetical presence of a third member, showing the empress as a counterpart to the Washington plaque, mooted.[90] The miniature in the Theodore Psalter shows that icons existed as bipartite compositions in which one figure, however asymmetrically, turned towards the other in the same manner as the emperor directs his raised hands towards the frontal Christ on the Gotha plaque.

For our present purposes, of greater moment than the content of the miniature is the demonstration that icons were *held*. Of course this is a polemical image, the political implications of its exposition being of larger concern than the way in which it is displayed. Unlike the manner in which Theoktiste holds her icon (fig. 21), we should attach no great importance to Stephen's fingers apparently curled around the bottom of the left panel.[91] Even so, the picture may help to rectify the erroneous notion of images as too holy to touch, as objects hung rather than handled. Indeed, the manipulation of ivories is documented by the condition in which many have come down to us. One or both lower corners of a dozen plaques are broken;[92] in some cases these fractures have been trimmed;[93] in two instances broken corners have been replaced by modern material.[94] It would be absurd to insist that in every instance these losses are due to medieval handling (rather than, say, to curatorial clumsiness), but no less so to suppose that the way they were used did not contribute to these plaques' damaged state.

Just as kissing sacred objects in the Byzantine world was not confined to icons,[95] so we cannot be sure that ivories were touched only in a ceremonial context. They may have been

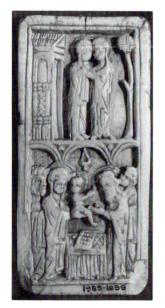 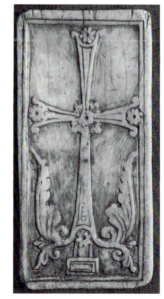

26. *London, Victoria and Albert Museum. Triptych wing (?). Visitation and Presentation of Christ in the Temple (11.4 × 5.0 cm)*

27. *Reverse of fig. 26*

shows a half-length figure of Christ, an embodiment of the doctrine that such images were legitimate precisely because the Incarnation had occurred.[82] Such a figure is the subject of more than half a dozen ivories (figs. 4, 116–118),[83] as it is of the insignia that Stephen the Younger, the sainted defender of icons who died in 764, is shown holding in numerous later pictures.[84] In the Theodore Psalter, for instance, Stephen, dressed as a monk, carries a diptych with a bust of Christ on its left leaf and an image of the Virgin turning towards him on the right (fig. 23).[85] Their conjoint presence signifies the "truth" that the Psalmist declares "with my mouth to all generations" (Ps. 88 [89]: 2); it asserts the historicity of God in human form.

But the significance of this and similar images is not confined to ideology. The two images that Stephen holds are arcuated at the top, like many ivories of which the only example considered up to this point is the Romanos plaque (pl. IV). Later, I shall suggest the impact of their material upon the form that icons took.[86] For now it is only necessary to note not so much the triptychs (figs. 85, 99, 124) that assumed this shape as the much

24. *Washington, D.C., Dumbarton Oaks. Diptych leaf with an emperor (28.8 × 13.3 cm)*

25. *Gotha, Schlossmuseum. Diptych leaf with Christ (29.0 × 13.6 cm). See also fig. 241*

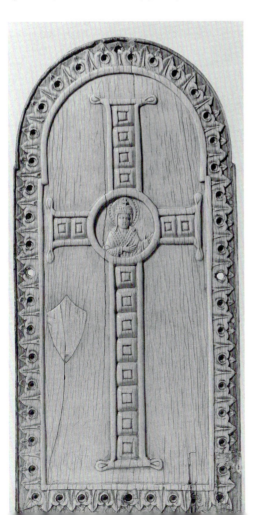
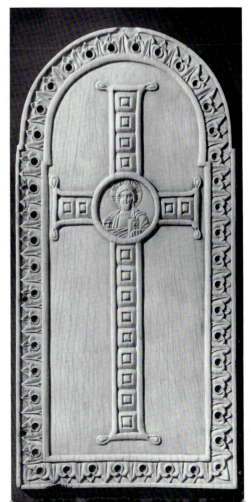

rarer diptychs, such as one now divided between Gotha[87] and Washington[88] (figs. 24, 25). Because of the cuttings in their edges,[89] and perhaps because of the rarity of surviving diptychs, it has been suggested that these plaques were hinged as a diptych only in secondary use and the hypothetical presence of a third member, showing the empress as a counterpart to the Washington plaque, mooted.[90] The miniature in the Theodore Psalter shows that icons existed as bipartite compositions in which one figure, however asymmetrically, turned towards the other in the same manner as the emperor directs his raised hands towards the frontal Christ on the Gotha plaque.

For our present purposes, of greater moment than the content of the miniature is the demonstration that icons were *held*. Of course this is a polemical image, the political implications of its exposition being of larger concern than the way in which it is displayed. Unlike the manner in which Theoktiste holds her icon (fig. 21), we should attach no great importance to Stephen's fingers apparently curled around the bottom of the left panel.[91] Even so, the picture may help to rectify the erroneous notion of images as too holy to touch, as objects hung rather than handled. Indeed, the manipulation of ivories is documented by the condition in which many have come down to us. One or both lower corners of a dozen plaques are broken;[92] in some cases these fractures have been trimmed;[93] in two instances broken corners have been replaced by modern material.[94] It would be absurd to insist that in every instance these losses are due to medieval handling (rather than, say, to curatorial clumsiness), but no less so to suppose that the way they were used did not contribute to these plaques' damaged state.

Just as kissing sacred objects in the Byzantine world was not confined to icons,[95] so we cannot be sure that ivories were touched only in a ceremonial context. They may have been

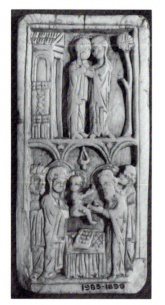
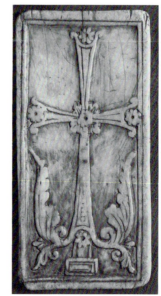

26. London, Victoria and Albert Museum. Triptych wing (?). Visitation and Presentation of Christ in the Temple (11.4 × 5.0 cm)

27. Reverse of fig. 26

as in the vitrine, but when it is viewed obliquely (fig. 22). The worn areas correspond to the position of the beholder's thumbs, if he or she held the ivory at the sides in the manner that I have suggested would be ordinary. Such support does not, however, explain the abrasion of the face of Christ which is worn to the point where it appears almost concave in profile. This, I suspect, was caused by repeated kissing of the image, although, as we have seen with regard to the matter of touching in Byzantium, the evidence for this practice is diffused and therefore neglected.

In Greek Orthodox ritual today several images may be kissed when the worshiper enters or leaves a church. These include icons on *proskynetaria* in the narthex, panels on the iconostasis, and Feast icons on the lectern. The icon of the Theotokos is kissed at the end of Great Complines and at the Lenten Vespers of Contrition; so too at the end of the Paraklesis and Akathist services. The corpus of Christ is processed and kissed during matins of Holy Friday as, on the same day, is the *epitaphios* embroidery that represents his shroud.[71] It would be illegitimate to deduce Byzantine behavior from modern practice. But this list suffers a worse defect: it omits the kissing of icons,[72] in church or at home, stimulated by personal rather than prescribed veneration. And it is this domain—the realm of personal piety and affective instinct—that is most resistant to investigation. Absent an oral history of sentiments more than a thousand years old, we can proceed only on the basis of such documents, literary and especially artifactual, as we have. The touching and kissing (*aspasmos*) of relics and their containers was, it is clear, an essential aspect of the experience of early Byzantine pilgrims.[73] At some time before the eighth century, the word *aspasmos*—the salute or mutual embrace of the Virgin and Elizabeth (figs. 2, 20, 26)—became the normal term for the veneration of images. The desire to greet an icon by kissing it is recorded by John of Damascus[74] and this conduct was sanctioned by the Second Council of Nicaea in 787.[75] The effects of this practice, which surely preceded the Council's ruling, are to be seen on thousands of later icons,[76] ivories, and manuscripts.[77] And beyond this passive role as object of the believer's desire, images themselves can *represent* such feelings: a wooden box in the Museo Sacro in the Vatican, painted probably in the tenth century with a picture in which the Virgin kisses Christ's feet, has been connected with feelings attributed to her by George of Nikomedeia.[78] Addressing her Son in the first person, in the verbal equivalent of a lover's breathless osculation, she declares that she kisses "your cross, your nails, your pierced limbs, your sponge, your shroud . . ."[79]

Art historians like to believe that pictures are more revealing, because they are more specific, than words. But this is not true of the homily just cited and assuredly not of the tale in Skylitzes that gave rise to the image of Theoktiste and her granddaughters (fig. 21). The entire incident, ostensibly a story of the Empress Theodora's resistance to the icono-clastic policy of her husband Theophilos, is in fact a paradigmatic account of the way patterns of behavior are inculcated in children and of the role that women had in such

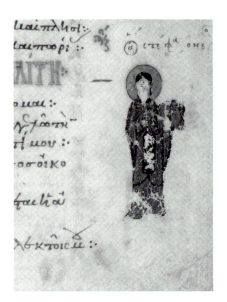

23. *London, British Library Add. MS. 19.352, fol. 117r. Stephen the Younger*

conditioning.[80] Far more telling than the simple scene depicted in the miniature, it deserves to be told in full:

> When Theodora was crowned with the diadem, her mother Theoktiste was raised to the dignity of *zoste* and patrician. So this Theoktiste regularly invited the daughters of Theodora (they were five in number—Thekla, Anna, Anastasia, Pulcheria and Maria) to her own house, which was situated close to the Gastria monastery, and welcomed them with gifts with which girls are naturally attracted, and then took them aside privately and beseeched them not to be cowardly nor to remain women, which they were, but to be manly and think worthily and as befitted their mother's upbringing [lit., "nipples"]; they should loathe the heresy of their father and reverence the forms of the holy icons. At the same time she put icons in their hands (she kept them in a box) and, holding them to the girls' faces and lips, blessed them and roused them to love icons. Her persistence in doing this and in kindling in her granddaughters a longing for the holy icons did not escape the notice of Theophilos. He asked them what presents they had received from their grandmother and what she had done that called for gratitude. The other girls, who had firm minds, stoutly circumvented their father's questions as traps. But Pulcheria, in the childish fashion of her age, recounted the number of fruits [she had been given] and mentioned the adoration of the revered icons in her simple-minded way, saying that her grandmother had many dolls in a box and that "she holds them to our heads and our faces with kisses."[81]

Among the many implications of this passage, not least important is the light that it throws on the extra-liturgical use of icons; without the narrative mise-en-scène, the figurative version of the story (fig. 21) fails to convey the power of images. Yet the Skylitzes miniature supplies one detail that the text does not. The icon held by Theoktiste

handled in liturgical practice in the home, or as talismans. This last role would seem to have been played by a little (11.4 cm high) ivory of the Visitation and Presentation in the Victoria and Albert Museum (figs. 26,27).[96] Rather than the "selective" abrasion that we have seen on other plaques (figs. 5,22), all surfaces on both the obverse and the reverse of this piece are worn down as if it had been carried in the pockets of successive generations. Given the subject matter, it is not inconceivable that the plaque served as an amulet to be rubbed by barren women. Its iconographical connotations would then reinforce the magical potential of the material's rarity and the tactile pleasure that it offered. Be that as it may, the very portability of these ivories implies that they were handled. How they functioned as palpable, three-dimensional objects remains to be considered.

3. Varieties of Experience

I have suggested that in Byzantium ivory was touched, held, even caressed. Yet, if such behavior represents that part of the medieval response which is the farthest removed from ours, it was by no means the only form of reaction to ivory at the material level. Like gold, silver, and gems—and as against marble, wood, and other less precious substances— ivory was *weighed*. Although we have no statistics reporting how many elephant tusks were imported, their market price, or that of the panels that were cut from them in the Middle Byzantine era, long before and long after this period ivory was sold by the pound, as it is today in East Africa and wherever the trade continues. In Diocletian's Edict of Maximum Prices (A.D. 301), the cost of ivory is given in this way—a figure that allows us to observe its low price vis-à-vis other luxuries.[97] "Denti di liofante" were available in the markets of fourteenth-century Venice, according to Pegolotti,[98] although the figures that he provides in this context are only for the expense of weighing them. Since in this procedure, tusks are lumped in with both grain that was very cheap in relation to its weight and pepper that was very expensive, we have no way of knowing their cost. For Byzantium between the ninth and the twelfth centuries, the only traces of ivory's economic trajectory are the lead tokens of the *kommerkiarioi,* the officials who sealed and levied duties on the sacks containing such goods when they were taxed at Abydos on the Hellespont and other ports en route to Constantinople. The seals give no information that is useful in respect to ivory.

Nonetheless, precisely because humanity perceives a close relationship between quantity and cost on the one hand, and between price and value on the other, we have a powerful (if unquantifiable) index to the worth of dentine in the objects that were carved from it. The absence of statistics does not require us to avoid informed suppositions, among which one of the safest is the assumption of some correlation between the weight of an ivory artifact and its imputed value in Byzantium. By extension, an object's mass may clearly have a bearing upon the way in which it was worked and the ends to which it was

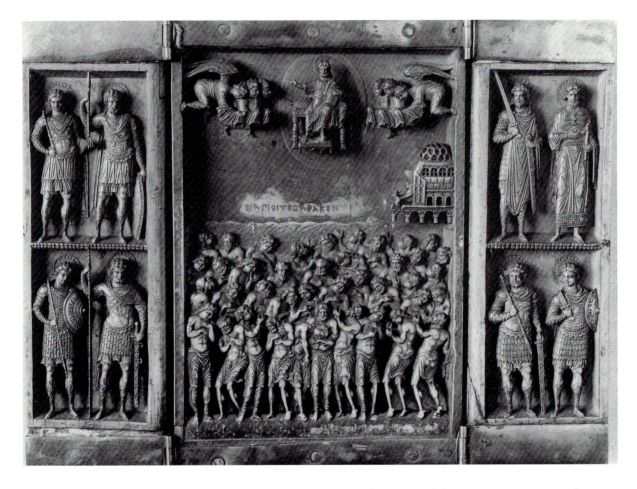

28. St. Petersburg, Hermitage Museum. Forty Martyrs triptych, open (central plaque 18.7 × 12.1; wings each 16.8 × 5.9 cm)

put. Those who have not handled ivory plaques, or know them only through their equivalents in wood, might be surprised by their variety in this respect. For example, a half-length Virgin and Child in the Ashmolean Museum, Oxford (fig. 108),[99] measuring 16.8 × 10.1 × 1 cm, weighs 302 gr; absent its lower right corner, we should perhaps add a conservative 5% to obtain its original weight. This figure is put in perspective by comparison with the central (and thus the largest) plaque of what was once a triptych now in Washington (fig. 109)[100]—a few millimeters taller, nearly three centimeters broader, and only one millimeter thinner—which weighs 198.3 gr.

Similarly unexpected by anyone who has not lifted it from its case in the Hermitage, the weight of the St. Petersburg Forty Martyrs (fig. 28)[101] is a sure guide to the carver's

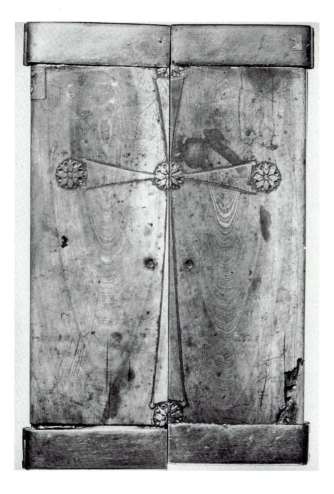

29. St. Petersburg, Hermitage Museum. Forty Martyrs triptych, closed

intention to create an object that was as satisfying in its heft as in its content. Since the top and bottom edges of both the central plaque and the wings are now reinforced with bronze strips, the raw weight of the piece is not a useful datum. But the experience of handling it is an indispensable prerequisite to its understanding. This sensation is best conveyed by the triptych when it is shut (fig. 29)—the way in which it was carried and observed when not actually "in use." Closed, the object is more than 31 mm thick[102] and in this state offers a gratifying combination of mass and smoothness in obvious opposition to the fragile, minuscule forms that inhabit its interior. This difference is furthered by the contrast between the hard-edged frames of the main plaque and the chamfered edges of the wings, evident when the triptych is opened (fig. 28). These rounded inner edges

become voluptuously curved outer limits when the wings are folded over the central portion of the triptych (fig. 29).

Words are too weak to describe such effects and language too ill attuned to sensation to evoke the velvet smoothness of the material on which the craftsman imposed his sharp and soft edges. We must content ourselves with recognizing that this texture is due to the density of ivory, the same quality as is responsible for its weight. And just as the density of the substance remains constant whether or not it has been worked, so too its nacreous luster is present in sections cut from the tusk even before the craftsman turns them into carved plaques. We shall examine later the ways in which ivory was polished in order to enhance its luminosity.[103] But this procedure was undertaken only to intensify the natural sheen of the material. A portion of the Virgin, cut from a plaque and now in the Metropolitan Museum in New York (fig. 30)[104] shows how the ivory glistens not only on the projecting surfaces of her tunic and feet but *between* the arrises of the drapery: these pans,[105] varying in their width and depth, coruscate variously as a function of the light that is reflected off the collagen in the dentine. This gelatinous protein is diffused throughout the tusk and therefore secreted equally in all parts of a panel, regardless whether these constitute the furthest plane of a plaque or its most prominent features. It is therefore by

30. New York, Metropolitan Museum.
Virgin Hodegetria, detail of fig. 244

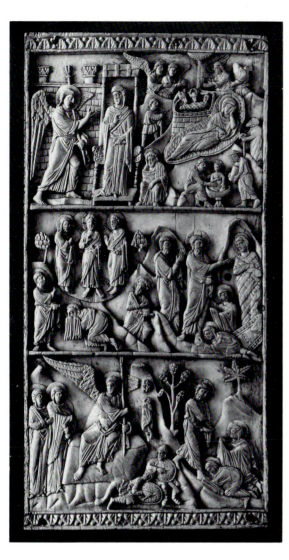

no means only the figures that gleam. In the right light—which is to say the conditions under which a plaque in London with scenes of the life of Christ (fig. 31)[106] was photographed—the ground itself is sometimes as reflective as the forms in front of it. Over the Nativity in the uppermost register and particularly behind Christ greeting the Marys in the lower right corner, the opalescent sky changes as fitfully as if these scenes had been rendered by Giorgione.

Such variety is, however, exceptional and, in modern experience, differing degrees of brilliance within a single plaque derive from the amount of wear that it has received and the distance from which it is viewed. Even the casual observer can see that the diptych in the Milan Duomo (fig. 2) is heavily rubbed. Yet only close inspection discloses the diffused luminosities that convey how general this abrasion is. Reflections from a detail of the Anastasis on the diptych's right wing (fig. 32) glance not only from the heads and hands of Christ and Adam but also from the latter's knee and especially from the head of Hades,

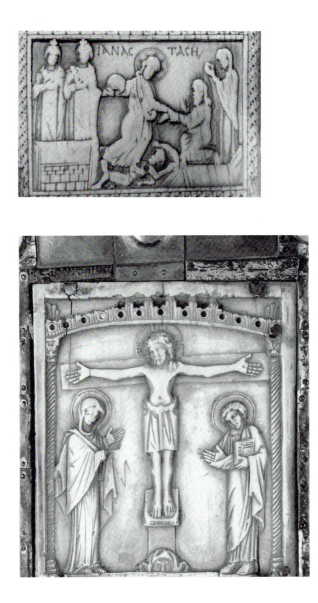

32. *Milan, Duomo. Detail of fig. 2.*
Anastasis

33. *Hildesheim, Cathedral Treasury.*
Book cover with Crucifixion (10.8 ×
9.2 cm)

worn down to a point where it is all but unrecognizable. By contrast, wear patterns on most ivories are much more "selective." Some obviously result from the rubbing of such salient surfaces as the face and arms of Christ on a plaque reemployed on the cover of the so-called Small Gospelbook of Bernward of Hildesheim, still in the cathedral treasury of that city (fig. 33).[107] But wear resulting from the book being laid face downward cannot account for the abrasion of Christ's feet or the fact that Mary's face is much more worn than John's. This is to be attributed to the sort of devotions that I have described above.

The Hildesheim plaque also exemplifies one aspect of the medium that has received little attention. In its carved, and even in its worn, state, ivory remains much closer to its

origins than most materials used by Byzantine craftsmen. It is worked "cold," being neither fashioned when liquid, like gold and pigment, nor alloyed like bronze. It is not transformed by firing, as are enamel, glass, and clay. Even though the extent to which Byzantine plaques were adorned with color remains disputed,[108] they were certainly not entirely overpainted as wooden panels were. Their dimensions were largely determined by the size and, as we shall see, to some extent by the shape of the tusk. In Byzantium, unlike the ancient world and the medieval West, ivory was rarely used as an adjunct to other substances or to itself. The prospect of huge surfaces sheathed in this material, as they were by mosaic tesserae, can be all but ruled out for practical if not for economic reasons. As a result of this fidelity to its beginnings, what might be called the burden of artistic proof rested more directly on the worker of ivory than on other sorts of craftsmen. The way in which he adhered to the inherent form of dentine is declared even in so modest an example as the Hildesheim Crucifixion (fig. 33). The concentration of grain along the axis of the composition is a direct effect of the craftsman's desire to maximize the width of his plaque.[109] But he used this datum to emphasize the centrality of Christ—in particular, by exploiting the natural arcs of his material to suggest a podium for the base of the cross. It will be noticed that the grain is nowhere apparent on Christ's body. Yet an experienced artist could predict, and therefore profit from, the occurrence of these forms which embody the growth process of ivory. This is evident when we examine closely a Crucifixion in Berlin[110] (fig. 34): the grain here describes a full ellipse, pressed into service to suggest the form of the thorax. In the hands of a master, like the one who carved the Princeton Crucifixion (fig. 35),[111] the bilateral structure of the chest, the shape of the abdomen, the swelling of the hips, and even the form of a kneecap could be indicated by such means.

Let it be clear that this is no argument for attempted realism. Rather, I am talking of a skill akin to that which, much later, would enable a Bernini to convert the natural properties of marble into textures as different as lace, skin, metal, and silk. Because of the difference in scale, however, the analogy is imperfect. While Bernini's illusionism can be appreciated when regarding from a considerable distance one of his busts or even more the sculptures in the Cornaro chapel, the beholder's remoteness from an ivory plaque virtually prohibits recognition of its carver's achievement. If the grain on the chest of the Princeton Christ can still be made out when it is looked at as a whole (fig. 36) a meter away, other nuances of the piece disappear. From a greater distance the plaque could as well be of plaster, wood or alabaster.

It follows that not only autopsy but propinquity is a necessary condition for the proper reading of carved ivory. If this is a truism, its implications for both the medium and scholars who write its history have not always been grasped. Just as every gram of an ivory is an integral part of its overall mass, so—if I may use the concept of weight in a figurative sense—all details of a plaque's cutting and carving are relevant to its assessment. And it is precisely these subtleties that are lost, more often than not, when an ivory is studied from

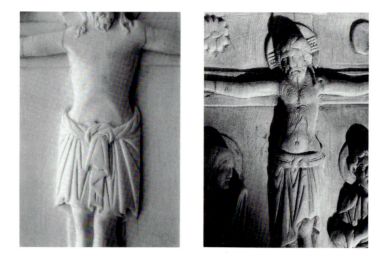

afar or even in photographs of its entirety. Considered as a resplendent whole, for example, the ivory of the Cortona reliquary (pl. I) appears to be a classic expression of Byzantine formal balance and thematic unity: the upper triad of busts in medallions—Christ between two angels—is matched by the lower group, Constantine the Great flanked by his mother Helena, who is said to have found the True Cross, and Longinus, the spear-bearer

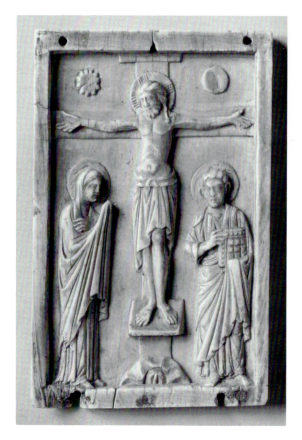

34. Berlin, Staatliche Museen. Crucifixion (17.9 × 14.9 cm), detail

35. Detail of fig. 36

36. Princeton University Art Museum. Crucifixion (13.4 × 8.1 cm)

at the Crucifixion. Between these horizontal strata, the vertical shafts that are Mary and the Baptist turn in the pose known to scholars as the Deesis[112] towards the relic itself, while their gestures are rehearsed by St. Stephen and St. John the Evangelist in the quadrants below. Yet so bald a description of the content—the verbal equivalent of an overall view—ignores for example the identity in all but gesture of the two saints. Why the facial features, hairstyle, dress, and stance of Stephen (fig. 37) should so closely resemble those of John (fig. 38) is a question that has direct bearing on both the working methods of the artist and the mentality that could conceive an elaborate theory of likeness[113] yet depict distinct saints with so little differentiation between them.

We are concerned, in other words, with two facets of experience, quite apart from our own: first, that of the craftsman, discharging a commission or at least making an image intended to satisfy its purchaser; secondly, that of the client, who acquired an object that answered his or her requirements. These facets are of course not unrelated but two sides of the same coin—what Gilbert Dagron has called the "collective imagination"[114] of Byzantium. For Dagron, the result of this shared experience is the "disappearance" of the artist. This astute insight into the situation of craftsmen in Byzantine society is borne out by the meager references to their names in literature.[115] Yet, at the material level, the level at which objects must first be examined, the differences between individual carvers, their products, and their achievements are marked in ways the significance of which deserves scrutiny. Throughout the corpus of Byzantine ivories one finds examples of high and low quality. More objectively, they exhibit very different approaches to sculpture, a diversity that is in part dictated by their functions. Plaques carry lengthy or brief inscriptions, or none at all. Their backs could be worked smooth or crudely chopped, their obverses highly

37. Cortona, S. Francesco. Reliquary of the True Cross, detail of pl. I. Stephen

38. Cortona, S. Francesco. Reliquary of the True Cross, detail of pl. I. John the Evangelist. See also fig. 232

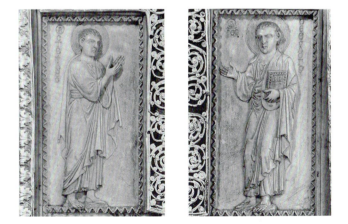

39. Berlin, Staatliche Museen. Entry into Jerusalem (18.4 × 14.7 cm), oblique from right. See also fig. 138

finished or left in one of several stages of roughness. Concern for and attention to detail differ greatly. Such variations indicate not the date when the ivories were carved but the amount of care that went into their creation,—which is to say the way they embody the responses of their makers to the demands of their clientele. This diversity is the more interesting in that it occurs within a set of clearly defined roles for the material, applications that were determined not by those who executed the ivories but by those who bought them. Variety flourishes within norms laid down in traditions of both craftsmanship and social utility.

These norms, of means as well as ends, will be examined below. But before we leave the consideration of reactions to ivory—our own as much as the Byzantines'—to investigate how such responses are engendered by the material, it would be well to ask whether in fact we do not engage the plaques in a fashion utterly different from that of a millennium ago. The attitude of the museum-goer, when it is not purely casual, is one of reverence. He or she stands before the case studying in sequence each of the objects on parade. This dutiful attitude, one might suppose, is the modern equivalent of medieval piety, a similacrum in which Byzantine dread in the face of transcendent reality[116] is replaced by the awe we are trained to display in the face of what is rare, ancient, or expensive. The embodiment of this attitude is frontal scrutiny of objects contemplated *en face* by the

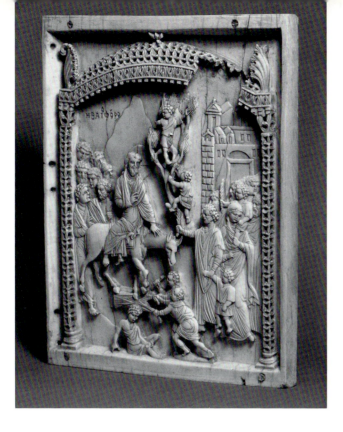

40. *Berlin, Staatliche Museen. Entry into Jerusalem, oblique from left*

stationary observer, and institutionalized in scholarly photographs and museum displays. I have already suggested that the Byzantines touched and kissed their icons, that they *participated* in the scene in a manner today prevented by the vitrine and unlikely to occur even were the glass barrier not there. But more than immobility separates the modern beholder from the way in which the image was originally regarded. The frontal view may be an optimum position for the most "iconic" of icons, the Christ who observes and blesses the worshipper (figs. 4, 116–118) or the *augusti* who face the beholder, pointing to the object of their devotion and thus demonstrating the source from which their authority derives (pl. IV). But it is entirely inadequate to an appreciation of the movement that is not merely implicit but realized in narrative images. To the Greek mind this *energetike kinesis* was a proof of life[117] and witnessed to the truth of its re-enactment in art. Even to attempt a simulation of this experience vis-à-vis an ivory we must assume a viewpoint that is neither head-on nor static.

Lacking the actual presence of an ivory (or any other Byzantine artifact), we may go through the motions by setting up *two* representations of our chosen image, the Berlin Entry into Jerusalem,[118] seen obliquely from the right (fig. 39) and the left (fig. 40). One could object to such an arrangement by arguing that there is no evidence that the Byzantines looked askew at their images. The truth is that we do not know how they

looked at them; the one improbability is that they stared at them only from the fixed and frontal position of the scholar or the well-behaved museum visitor. Disposed in duplicate in the way that I have suggested, the photographs yield results as close as we can come to the situation of a person who, first, being human, moves his or her eyes, and secondly, being a Byzantine, believed that the scene was an authentic creation of the climactic events of Palm Sunday. Immediately the "two" images are regarded in this way, the gaze falls on different parts of the scene. Looking first from the left (fig. 40) we focus on Christ, followed by his disciples, advancing towards the right. Seen from the right, the crowd at the gate that marks the Lord's destination is of greater importance than his seven associates. In both cases, Christ, being at once nearest to the center of the picture and its most distinct form, dominates the setting, a prominence emphasized by the direction of the gaze of the two groups on whom the beholder's mobile vision settles, and by the fact that the riding figure is carved in deeper relief than any other element in the picture. This is best perceived when the ivory is viewed obliquely and is, in turn, emphasized by the fact that Christ is silhouetted against the mountain, itself in higher relief than the sky on either side.[119]

The effect of motion is heightened by incident light which, depending on the turn of one's head, is reflected first by Christ's right arm and then by his left. At one moment his head is in profile, at the next he is almost full face. The leader of the Jews seems to revolve on his own axis; the boy in the tree precariously turns to salute the Lord; the children below launch into action, seeming actually to throw the garments[120] over which the ass trots on its divinely ordained mission. One does not have to be a mystic to see the apostles conversing among themselves, the excitement of the children, or the diversity and distractions of the crowd at the gate of the city. What the faithful could sense, the pragmatist can analyze and, with results that will vary according to the subject matter of the plaque and the method of analysis, any image may be assessed with a view towards understanding both its facture and its power. Of course, an ivory like the Berlin Entry that has been masterfully worked may enable us to recognize the hand of a craftsman in a way that a quickly created piece never can. But this latter, negative result does not rule out the possibility that it was made by a sculptor whose idiosyncracies are concealed by his summary carving. Even a master sculptor followed the "rules," which is to say that at least in the early stages of his work he proceeded along lines determined by the conditions and methods of production of his day. To these we must now turn.

II

CONDITIONS OF PRODUCTION

1. THE QUANTITY AND QUALITY OF IVORY

Judged by the number that survive, and of the fineness of many of these, Byzantine ivories rank among the most impressive and coherent bodies of work in this medium produced before the Gothic era. Exceeding in quantity those preserved from late antiquity,[1] medieval Islam,[2] and the Carolingian and Ottonian empires,[3] approximately 400 Byzantine plaques, box revetments, and other objects made from dentine are known.[4] They are surpassed in number only by those of Romanesque Europe, which, unlike Byzantium, employed, in addition to elephant ivory, whalebone, narwhal, and especially walrus tusks. So exclusive was the Byzantine obsession with true ivory and so large the number and variety of examples that have come down to us that three questions, unanswerable with any exactitude but highly important if this phenomenon is to be understood, suggest themselves. What relationship is there between the number of pieces that survive and the size of the original body of production? What do such numbers imply for the distribution of ivory among the Byzantine population? What system was responsible for the working of ivory and what was its impact on the objects it produced and their means of distribution?

It is often assumed that some vast proportion of the Byzantine artistic patrimony has been destroyed and such destruction is used as the premise of hypotheses concerning vanished monuments and lost "models." This assumption is self-evidently true of Constantinople's palaces and churches, probably true of objects made from materials such as gold and silver that had high exchange value, and possibly true of books and other works in flammable materials. But it is not necessarily true of ivory. Even when they have been subjected to fire, the remains of objects in this medium, like a triptych wing in a private collection in London (fig. 41),[5] survive to grace the statistical if not the aesthetic record. Anyone who has pursued the trail of missing ivories—notably pieces formerly in private hands such as J. J. Marquet de Vasselot in Paris and Count Stroganoff in Rome—knows not to equate disappearance with destruction. Objects go underground for political, economic, or personal reasons, to emerge decades later, usually with new addresses.[6] Only one ivory (G-W I, no. 107) listed in Goldschmidt's and Weitzmann's corpus is known to have been destroyed in the Second World War. Yet spoliation of the property of the most

likely owners of ivory in Byzantium is an incontestable fact. On 19 April 1042, for instance, a popular uprising destroyed private houses and chapels in Constantinople and besieged the Great Palace where Michael V was living.[7] Nonetheless, not all its possessions were lost: within forty years a *staurothèque* (container of a fragment of the True Cross) from the palace, lodged inside an "ycona," was presented to the monastery of Montecassino by a rich Amalfitan merchant resident in the capital.[8]

Even if we assume that ownership of ivories was not limited to the powerful in Constantinople, the size of the sample that we have is imposing. The inhabitants of the capital probably never exceeded 400,000,[9] a figure that in itself may be too high. Since almost four hundred Middle Byzantine ivories are preserved, even if the population had reached this size in the year 1000 (which is unlikely) and if, no matter what their social station, every man, woman, and child possessed one (which is highly improbable), we would have one piece for every thousand inhabitants. A concentration of ivories in the hands of wealthy individuals and institutions is a more likely pattern of ownership. We would then have to reduce our figure of one ivory per thousand residents of the capital by a factor of as much as one hundred. In this case there would be preserved one in ten of all ivories manufactured in Constantinople by the start of the eleventh century.

Speculations of this sort are vitiated not only by the woefully inexact numbers that we have for the population of the city and our almost total ignorance of its distribution by social class but by the absence of figures for the price of raw ivory and the cost of its working. Some reading of the desire for ivory and of its relative rarity can, however, be made on the basis of the material itself, a domain that has remained largely unexplored.[10] While huge amounts of ivory were imported, much of what was worked is demonstrably of less than first-rate quality. This does not mean that no dentine of a standard that other societies found acceptable reached Byzantium; it does suggest that the demand for ivory was so great that craftsmen, with at least one eye on the purchaser, chose to cut tusks, or to

42. *Baltimore, Walters Art Gallery. Nativity (13.6 × 12.4 cm)*

43. *Erlangen Universitätsbibliothek, cod. 9. Bookcover with half-length Hodegetria (12.7 × 11.6 cm)*

carve sections of them, of a caliber that elsewhere was often unworked. I have already referred to the flaw running down the obverse of the Washington Crucifixion (fig. 5). This is by no means exceptional. On a Nativity in Baltimore (fig. 42),[11] for example, a similar black line passes through the Christ child not once but twice—in his crib above and in his bath below. This natural phenomenon—a portion of the nerve canal that runs from the end of the pulp cavity to the tip of the tusk[12]—was evidently not considered sufficiently disfiguring to prevent its association with the Lord; on other occasions his mother is bisected in the same manner (fig. 43).[13] Such judgments are put into perspective by comparison with decisions made in other cultures: I know of no late antique ivory the face of which is marred in this way.

Even after he had decided to use a panel from the core of a tusk, a craftsman could still disguise the fact by carving that aspect of the plaque which faced away from the nerve canal. This decision was made in the case of a St. Theodore and St. George in Venice[14] where the only trace of defective material on the obverse (fig. 44) is the area now missing from the center of the bottom frame; its reverse (fig. 45), however, shows at the top the runnel of the nerve canal and, at the bottom, the weakening effect this has had on the ivory, broken through where the ground is especially thin to the left of Theodore's shield. The fact that both the front and back of the Baltimore Nativity display this blemish

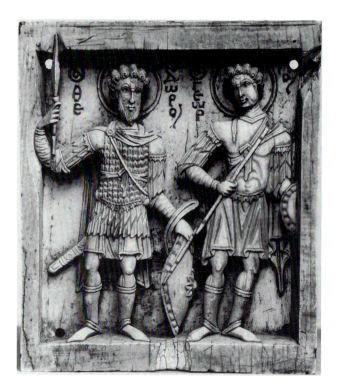

44. Venice, Museo Archeologico. SS. Theodore and George (11.1 × 9.4 cm). See also figs. 106, 122, 123

represents a willingness to make use of a section of material taken from the very center of the tusk, something that most craftsmen (even in Byzantium) avoided.[15] A close relationship existed between the choice of a panel and the manner in which it was worked: with the exception of the ivory in Venice, none of the flawed plaques cited to this point is an especially distinguished piece of carving. This implies an artisanal intimacy between the division of a tusk and the pains taken to work the chosen section and, more broadly, an economic connection between material and the labor invested in its working.

Yet even large and pretentiously carved ivories may involve such compromises. The back of the well-known Enthroned Christ (fig. 47),[16] formerly in the Hirsch collection and now back in Switzerland, displays not only the characteristic semi-elliptical arcs that are one hallmark of elephant dentine but, in its uppermost quarter, the final portion of the pulp cavity as it diminishes towards the nerve canal. The disappearance of this latter feature is explained by the inordinate girth of the plaque. Seventeen millimeters thick, the canal vanishes into the body of this ivory. Equally invisible on the front of the piece (fig. 46), the course of the canal may be traced on the reverse both by the direction of the grain that traverses its vertical axis and by the curvature of what, on the reverse, reads as its left edge. Just below the point at which the pulp cavity ends the Christ plaque also reveals one of the commonest blemishes found in Byzantine ivory, a "pearl" or excrescent material

45. *Reverse of fig. 44*

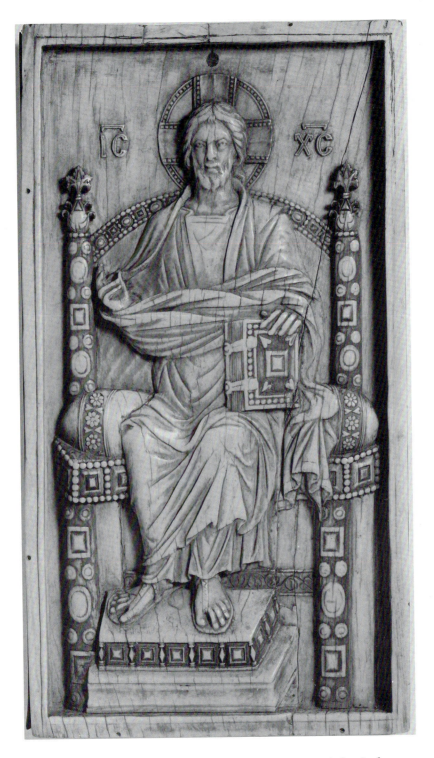

46. Switzerland, private collection. Christ Enthroned (24.8 × 13.2 cm). See also figs. 103, 224

47. *Reverse of fig. 46*

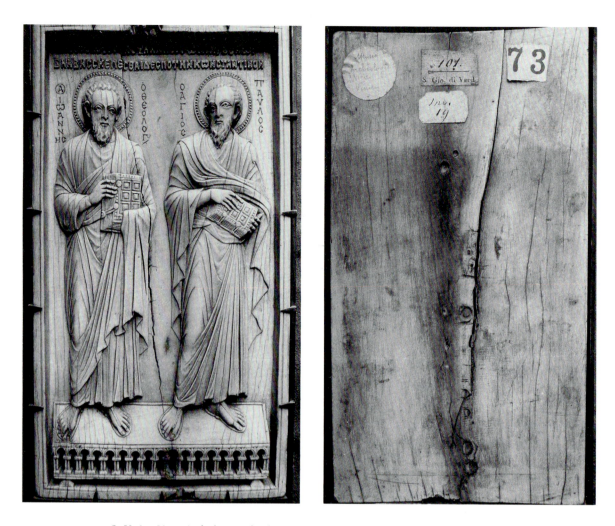

48. Venice, Museo Archeologico. John the Evangelist and Paul (24.8 × 13.3 cm)

49. Reverse of fig. 48

which has here been excised. The presence of such a flaw on the back of the plaque again emphasizes the choice made with respect to the aspect of the panel chosen for carving. Because such excrescences tend to grow nearer the core of the tusk, more often than not it was the face turned away from the cavity that was worked. The same decision was made in the case of a plaque in Venice depicting St. John the Evangelist and St. Paul.[17] Even while the obverse (fig. 48) is less marred than its back the experienced eye can predict the trouble fully in evidence on the reverse (fig. 49) simply by the nature and relative position of the injuries it has undergone. Both the upper and lower frames have lost material while the middle of the apostles' footstool has suffered in a way that ivory rarely displays, save where weaker material from the area of the pulp cavity has been exploited. This situation is confirmed by the daggerlike "shadow" of the cavity as it appears on the reverse pockmarked with pearls, some of which run through to the front of the plaque.

48

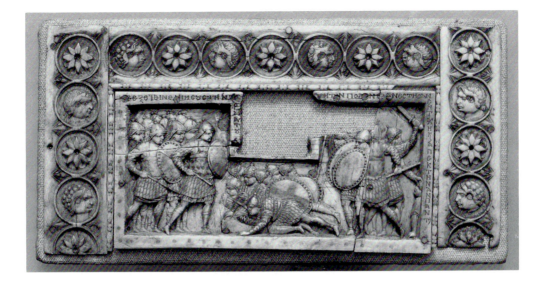

50. *New York, Metropolitan Museum. Plaque from a Joshua casket: defeat of the Men of Ai (9.4 × 18.9 cm). See also fig. 69*

51. *Reverse of fig. 50*

For unknown reasons, pearls tend to be grouped in clusters. Several occur (barely visible in Fig. 4) on the neck of Christ in the Bodleian bookcover and many more along the bottom edge of the back of a plaque in New York that originally decorated a box with scenes from the story of Joshua (fig. 51).[18] Since they coincide with the projecting frame of the plaque their presence in no way harms the figures on its obverse (fig. 50). A more obvious indication of the constraints that bore likewise upon the finest carvers is apparent even without inspection of the back. The trapezoidal section to the right of the plaque is, as a black and white photo indicates, a separate piece of material. The ivory here is not only of a different hue but is turned through ninety degrees. Both a detail-photograph of this

49

52. Detail of fig. 50

portion of the plaque (fig. 52) and the general view of the reverse show that here, unlike
the main part of the ivory, the grain runs vertically. Yet it is quite clear that this vertical
section is not a later replacement. Indeed, it was carved by the same hand as the other: the
further legs of both the soldiers at far left and far right are carved in the same sort of *rilievo
schiacciato*. Nor should we suppose the juxtaposition unique, a chance occurrence when the
craftsman accidentally ran out of material of sufficient length. The same dilemma faced the
carver of a Genesis ivory, now in Lyon,[19] when he needed a plaque more than 28 cm long
(figs. 53,54). The latter craftsman, however, solved his problem more elegantly by joining
the two plaques at the trunk of the tree.

53. Lyon, Musée des Beaux-Arts. Creation of Adam; Cain (13.1 × 6.7 cm)

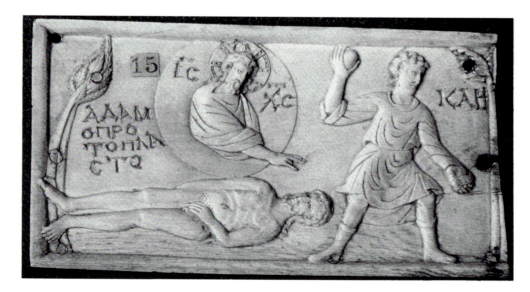

As the reverses of the Lyon plaques (fig. 55) demonstrate, they do not come from the same panel, for both the grain and the signs of the husk[20] describe different patterns in the two portions. We shall have occasion in the next chapter (III, 1) to see how useful the presence of the husk can be in determining the ways in which panels were cut. For now, it is more important to notice that the marks of this older material are evident not only on the back of the plaques but sometimes on the front. Below the body of the supine Adam and between Cain's legs, the surface of the material is coarse-textured in a manner not ill-befitting the representation of earth. That this was not the craftsman's motive, however, is indicated by the absence of equivalent roughness in the corresponding area of the right plaque (fig. 54). Rather, he did what he could with unpromising material—a panel in which the amount of first-rate dentine was limited. By no means is this the only Byzantine plaque to exhibit the husk that marks the outermost edges of the tusk. Usually, however, as on the Baltimore Nativity (fig. 42), it is confined to the frame of the ivory.

Beyond this oldest and most friable portion of the dentine in a tusk is the cement, a bony substance that in antiquity, as in modern times, was generally removed. On late antique objects it is normally found only on the bisected and therefore relatively thick sections of tusk used for furniture ornaments and medicine boxes.[21] In photographs the cement reads as a whitish margin, a differentiation of color that makes this layer instantly recognizable on the edges of Byzantine plaques such as the Berlin Entry into Jerusalem (fig. 56). By leaving the cement the craftsman retained its naturally rounded contours, a feature that made the plaque more pleasant to handle. At the same time, he economized on the labor involved in stripping the tusk and strengthened the vertical edges of a plaque.

54. *Lyon, Musée des Beaux-Arts. Right half of fig. 53. Abel Stoned; Creation of Eve (15.2 × 6.7 cm). See also fig. 162*

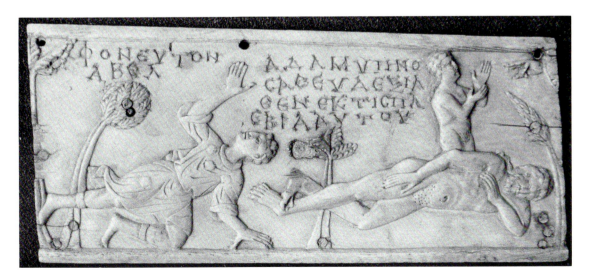

Thus the right sides of the Doubting Thomas at Dumbarton Oaks (fig. 57)[22] would be much weaker had the cement on its reverse (fig. 58) been removed. This outermost layer was retained for the same reason as the husk was exploited: it maximized the width of a panel cut from material that is inherently much longer than it is wide.

Although such steps can be justified in terms of craftsmanship, they are ultimately to be explained by the same factor as dictated the use of ivory from the area of the pulp cavity and the nerve canal. All point to the need to conserve ivory. It is pointless to ask whether this aim was determined by its high price or by the strong demand for a material that was in short supply: these explanations are not alternatives but coefficients. Certainly those at the social level at which ivory found favor spent lavishly on manufactured goods. The widow Danelis whose gifts to Basil I have ensured her a place in history,[23] or Constantine IX whose largesse towards his mistress Skleraina and the fortune that he spent on building

55. Reverses of figs. 53 and 54

56. Berlin, Staatliche Museen. Entry into Jerusalem, reverse. See also figs. 39, 40

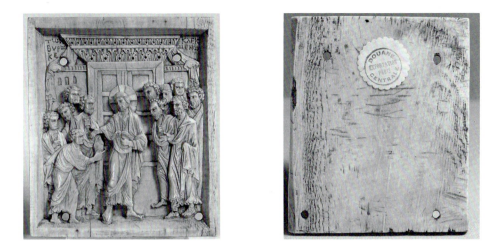

57. *Washington, D.C., Dumbarton Oaks. Doubting Thomas (10.6 × 8.9 cm)*

58. *Reverse of fig. 57*

excited Psellos' hostile witness,[24] would not have been deterred from acquiring ivory whatever its cost. Not a shortage of funds but limits on the availability of tusks underlie the scarcity of material. This is brought out not only by the edges and reverses of plaques—necessary evidence that has been overlooked, but of marginal concern to their Byzantine beholders—but also by the acceptance in this society of ivory of a quality that elsewhere and at other times would have been shunned. A triptych now at Schloss Harburg near Donauwörth (fig. 59)[25] consists of dentine so pitted with black flecks that it looks like bone. The grain apparent on the necks of the main figures and the reverses of the plaques leaves no doubt, however, that they are ivory, just as the permeation of the flecks shows that these are no later incrustation but a feature of the ivory even before it was cut into panels. As we shall see, this unpromising material was carved no less lovingly than a dozen other triptychs. No amount of cunning workmanship, however, could transform this gritty unpolishable material into the lustrous substance of which similar pieces are composed.

The fact that dentine of inferior quality was used in this and numerous other objects says much about the desire for, and shortage of, ivory in tenth- and eleventh-century Constantinople. Especially difficult to obtain were tusks of sufficient girth to allow the cutting of huge panels which, in late antiquity, had been used for consular diptychs issued, it seems, in hundreds.[26] The average size of such sixth-century creations was 36 × 12 cm; the entire corpus of Middle Byzantine ivories yields not a single ivory of these dimensions and only half a dozen that approach it. The smaller size of Byzantine plaques was due not to their dependence on miniature painting but to the absence of large sections

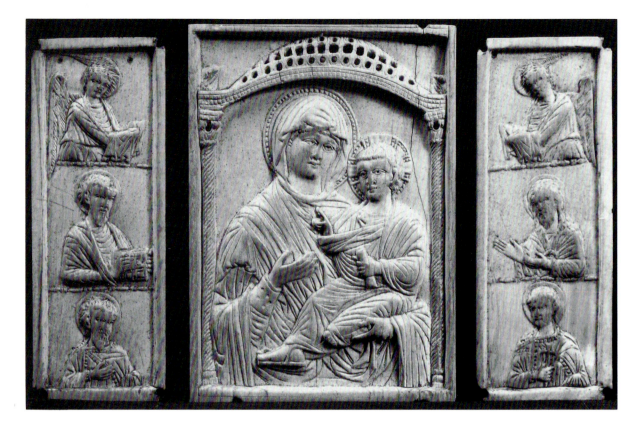

59. *Donauwörth, Schloss Harburg. Triptych with Virgin Hodegetria, angels and saints (central plaque 15.8 × 11.1; left wing 15.4 × 5.6; right wing 15.3 × 5.7 cm)*

of ivory. And the same constraint may have limited the size of the one surviving example of a free-standing statuette. At 32.1 cm high, the Standing Hodegetria in the Victoria and Albert Museum (fig. 60)[27] could represent, if not the maximum, then the normal size of tusks reaching Constantinople. Among Byzantine ivories, it is exceeded (slightly) in height only by a plaque with scenes of the Passion in the same museum. Numerous Gothic statuettes are considerably taller than 40 cm. The absence of massive tusks, in turn, implies the lack of choice that late antique and late medieval craftsmen enjoyed and, since ivory was sold by weight, an overall reduction in the amount of material available.

As the number of extant plaques demonstrates, much ivory did reach Constantinople. I have tried to show, nonetheless, that some of it was of low quality and that it must always have been expensive. These are not independent phenomena. Although commercially imported material may on occasion have been supplemented by booty,[28] such turns of fortune could not guarantee the craftsmen of the capital the majority of the ivory that they needed; the effect on commerce of military and diplomatic reverses would make short supplies even shorter. We know how subject to fluctuation were commodities, the cost of which could increase or decrease dramatically. The decline in the price of olive oil,

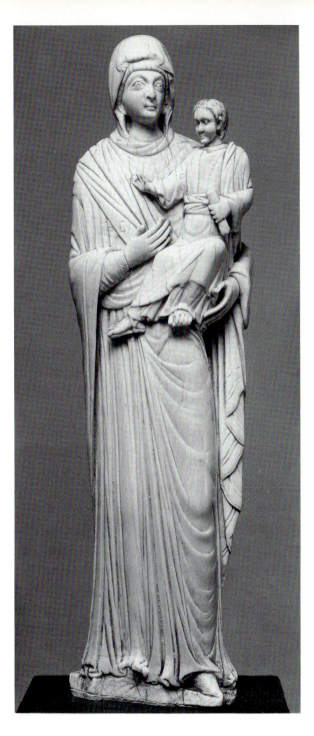

*60. London, Victoria and Albert Museum.
Standing Hodegetria (h. 32.1 cm)*

following the capture of huge amounts of this staple of lighting and cooking by the imperial fleet in the reign of Basil I, is well documented.[29] Luxurious imported materials like ivory were surely no less subject to variation in price and availability. Behind these economic factors lies the political fact that the provision of material to one of the major industries of Byzantine art depended on commerce with colonies that had been lost to the Empire in the middle of the seventh century.

2. "Colonial" Tusks and Domestic Bone

Today, almost fifty years after the disintegration of Mussolini's overseas empire, Italians still use the term *coloniali* for spices and similar goods that arrive from lands that were once their possessions or those of other European nations. Similar thought-patterns are preserved in the German *Kolonialwaren* and modern Greek *apokiaka*; in Russia a grocer's shop is (or used to be) called *kolonial'yi magazin*. To the Byzantines, ivory was no less powerful an expression of nostalgia for empire. It bespoke the splendor of a past that was at once lost and recoverable through diligent imitation of antiquity.[30] The impact of this attitude on Byzantine art has been studied many times and the classical and late antique sources drawn on by the makers of ivory- and bone-clad boxes have been duly classified.[31] The antique costumes, gestures, and settings in which scriptural and secular figures appear were both utterly alien to current Byzantine experience and thoroughly conventional. And their very conventionality is the symbol of, and perhaps the reason for, the endurance of this mimesis. The dallying lovers on the Veroli casket (fig. 61)[32] are as faithful a reproduction of their counterparts on a fifth-century plaque (fig. 62)[33] as an artist half a millennium

61. London, Victoria and Albert Museum. Veroli casket (11.2 × 40.4 × 16.0 cm), back, right side. See also fig. 128

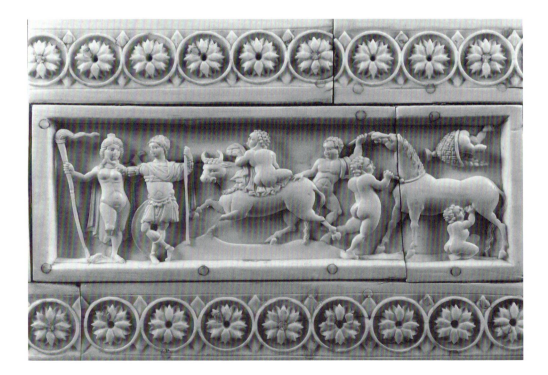

later could manage. But more than the style and subject matter of such replicas marks Byzantium's willing enslavement to its past. Against a background of commercial difficulties, diplomatic bargaining, and military adventure, ivory was *chosen* by the élite of Constantinople as a favorite medium for personal possessions. And most of the material employed in this industry could come from nowhere else than the places in which antique dentine had originated. Geographical as well as literary and visual sources demand our attention.

The width of the most elaborate plaques and diptych leaves of late antiquity exceeds 11 cm. This is no less true of the major ivories of the Middle Byzantine period. Since the diameter of no Asian tusk, even before its husk is removed, surpasses this dimension[34], such pieces can only have been carved from tusks of African origin. It is true that, as yet,[35] we cannot determine the source of ivory artifacts of less than 11 cm wide, but so preponderant in the corpus are wider plaques[36] that it seems reasonable to suppose the same origin for many of the narrower pieces. The use of Asian ivory cannot be excluded entirely. Some Indian tusks may have arrived with the gold that Byzantium obtained from the Caliphate in return for the silver that it sent to Baghdad.[37] Abbasid trade with Sri Lanka,

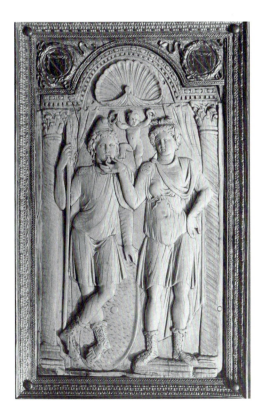

62. *Brescia, Museo Civico Cristiano. "Loving Couples" diptych, left leaf (24.5 × 7.2 cm)*

with extensions to China, was fully established by the early ninth century and possibly as early as the reign of Harun al-Rashid (786–809).[38] Yet at least some of the ivory available to the Arabs came from Africa. In 836 the caliph Mu'tasim sent a message to the Nubians reminding them of their customary tribute of slaves, baboons, giraffes, and elephant tusks in language which suggests that these emoluments had only recently been discontinued.[39] And a century and a half later (in 991), the presents sent to the caliph Hisham II by a Berber prince included "eight thousand pounds of the most pure ivory."[40]

Wherever Islam got its ivory, it is remarkable that Arab texts of all sorts are far more informative than Greek documents about this trade. The reasons for the difference are cultural and beyond the province of this book. The Byzantines, much as they enjoyed its products, affected to disdain commerce;[41] the Abbasids, by contrast, made literature and history out of it. In just the sort of document for which Byzantinists would give their eye-teeth, Jāhiz of Basra (d. 868/869) reports that elephants (he does not mention ivory) were imported from India, along with tigers, ebony, and other exotica. From Byzantium, he reports, came gold, silver and copper utensils, brocades, female slaves, "unbreakable locks, lyres, hydraulic engineers, agronomists, marble workers, and eunuchs."[42] If the apparent ingenuousness of the list makes one smile, Jāhiz can bring rejoicing to the heart of the historian of Byzantine culture. Naive chronicler that he might have been, he records elsewhere what students of the Iconoclastic era have surmised but failed to prove: that the arts did not die when religious imagery was banned in Constantinople. The Christian Greeks, he writes, have neither science nor literature nor profound opinions but are famed for their manual skills, their carpentry, cabinet work, sculpture, and silk weaving.[43] Some of the raw materials of these trades were domestic. Ivory most certainly was not and, though Jāhiz had nothing to say of its provenance, a little more than a century later the Ziridite rulers of North Africa received theirs from the Sudan.[44] From there, or in all likelihood the Horn of Africa to the east, ivory traveled to Byzantium in Arab (or Venetian?) vessels. *From* East Africa, too, Indian ivory was re-exported.[45] Only the width of the plaques that resulted from this trade can tell us the origin of the tusks that allowed such carving.

Given the volume of ivory carving that we have seen in Constantinople, it might seem strange that not a single Byzantine document refers to this commerce. Part of the answer lies in the aristocratic psychology already alluded to, but another part in the way ivory was handled. From antiquity through at least the fourteenth century, it was but one commodity among many shipped in small boats that sailed in convoys. The second-century (?) *Periplus maris Erythraei* tells of ivory exported, with Italian wine, from East African ports to India.[46] At the end of the Middle Ages "denti d'allefanto" were carried from Alexandria, along with indigo and gum arabic, by Venetian merchants.[47] Except to the merchant concerned with his accounts, a sack or two of tusks would have been insignificant; and we have no such accounts from Byzantium. Ivory, then, was a marginal commodity, the by-

product, so to speak, of more valuable cargoes, just as it was in the nineteenth century when it traveled in ships that carried slaves from West Africa; only when it accumulated in the workshops of the Lower Connecticut River—where 20,000 pounds per month were used for piano keys, combs, and billiard balls[48]—did ivory come to be regarded as significant.

The role of Alexandria as a main port, or entrepôt, is indicated by the legend of the two Venetian merchants who, with two Greek priests, obtained St. Mark's relics there in 828/29 and shipped them home. The Egyptian city's more pragmatic importance lay in its commerce: this was important enough for Leo V to order an embargo on trade with Egypt and Syria in 817.[49] From Venice a *cathedra elephantinis sculpta tabulis* was sent by Doge Peter II Orseolo to Otto III, the Holy Roman Emperor, resident in Ravenna in 1001.[50] And an even rarer African commodity, raw hippopotamus ivory, found its way to Germany between the late tenth and the early twelfth century, where it was processed, along with antler, at Tilleda Castle, near Erfurt.[51] In the light of this long-distance trade in *coloniali,* the arrival of large numbers of elephant tusks in Constantinople, and even in Chersonese on the Black Sea,[52] seems less remarkable.

Once in the capital it presumably fell into the hands of those who knew how to work such material. The activities of bone carvers were generally too humble to be documented. But in precious, if passing, testimony of the end of the eighth or beginning of the ninth century, Theodore, abbot of the Stoudios monastery, includes ivory and bone cloak-buckles among the objects of which he disapproved when they were brought into his monastery by novices.[53] Bone and ivory had been worked together no later than the early Roman Empire, as we know from the finds at Corinth, which included pins with lathe-turned shafts and ivory heads.[54] From this city's Byzantine period pins entirely of ivory, and many more of bone, have turned up, a coexistence confirmed by the furniture components, beadings and mouldings, plaques, and gaming pieces unearthed at Saraçhane in Istanbul.[55] The mass of fragments from this recent excavation in the capital indicates, nonetheless, a distinction between the two materials, which, if unsurprising in itself, documents the commonsensical view that bone would have been employed for practical and/or unpretentious purposes and ivory for more elaborately worked objects. None of the buttons or "pyxides" (cosmetic containers?) are ivory, and all but six (of thirty-one) counters and gaming pieces and eight (of thirty-nine) plaques are bone.[56] Beyond these predictable quotients, a more interesting distinction is apparent. The only overtly religious piece, a plaque with the bust of a sainted bishop (fig. 63)[57] is carved of ivory while fragments bearing birds, animals, and an archer[58] are of bone. The conclusion that ivory was reserved for objects with sacred figures or scenes while secular imagery was generally depicted in bone is borne out by the distribution of materials among the boxes. With the exception of the Veroli casket (figs. 61, 128) and a few similar objects, all boxes bearing mythological and comic incidents, hunts, non-biblical warriors (figs. 17, 64), animal

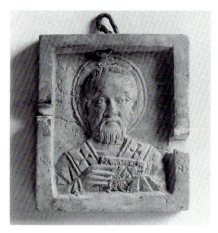

63. Istanbul, Archaeological Museum.
Plaque with sainted bishop (3.8 × 3.3 cm)

64. Baltimore, Walters Art Gallery. Box with warriors and putti (12.4 × 18.0 × 12.6 cm)
65. Darmstadt, Hessisches Landesmuseum. Box with Genesis scenes (12.3 × 46.0 × 19.7 cm)

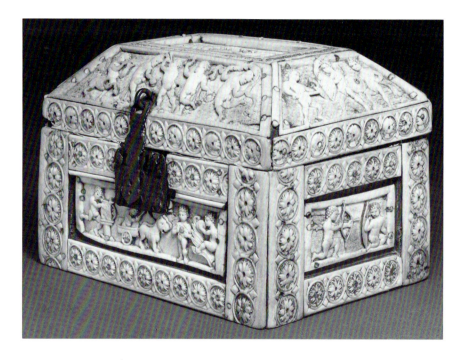

battles, and circus scenes are clad in bone, while those with scriptural (figs. 50, 65) and other Christian subject matter almost invariably have plaques of ivory.

So strict is the equation between sacred iconography and ivory on the one hand, and between bone and what the Byzantines deemed to be "outside [holy] wisdom" (*exo sophia*) on the other, that one might presume it imposed by ecclesiastical authority rather than mere social convention. But rules generate exceptions and there exist casket plaques with images of the apostles carved in bone. One such, in Princeton, depicts John the Evangelist (fig. 66).[59] In technique, size, and epigraphic characteristics it so closely resembles a bone plaque of St. Luke in St. Petersburg[60] that, if they do not come from the same box, one must suppose the sometime existence of a class of religious caskets revetted in this material. Besides the fact that ivory has always been more treasured, one reason for the disappearance of bone artifacts is the faster rate of decay to which they are subject, no matter whether their zoological source was a sheep, cow, horse, or camel. A bone plaque in St. Petersburg (fig. 67)[61] shows the tendency of the material to fracture along lines that radiate from punctures in the fabric: the breaks in the right forearm and the loss of the lower portion of the right leg are due to human intervention of this sort after the figure had been carved. In this respect, bone resembles ivory (figs. 91, 114, 137, 206). Yet most Byzantine ivory plaques are in not nearly so bad a shape as the bone examples in Princeton and St. Petersburg.

It is possible that craftsmen were aware of these varying degrees of durability, although more pressing factors in their choice of material were surely the relative ease of access to bone—available wherever animals were slaughtered for their meat or skins—and, above all, their clients' economic propensities. Yet there can be little doubt that, at

66. *Princeton University Art Museum. Bone plaque with John the Evangelist (5.8 × 4.0 cm)*

67. *St. Petersburg, Hermitage Museum. Bone plaque with warrior (6.1 × 4.1 cm)*

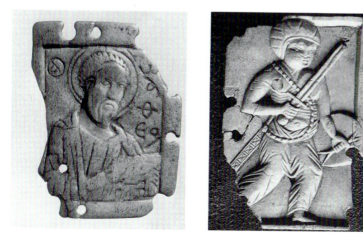

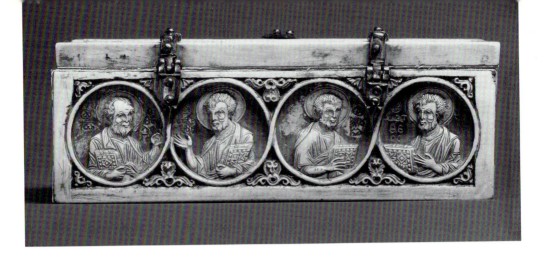

68. *New York, Metropolitan Museum. Box with John the Evangelist, Mark, Luke and Matthew (6.5 × 11.6 × 9.9 cm). See also fig. 219*

least in the capital, the same craftsmen worked both materials. Strikingly similar in appearance to the Princeton John (fig. 66) and especially the St. Petersburg Luke are the Evangelists on the back of an ivory box in New York (fig. 68),[62] even if, because of their softer material, the bone plaques have lost much of their highly mannered physiognomical detail. Yet their rare three-quarter poses, holding books enclosed in covers decorated with dentils and asterisks—details preserved only on the St. Petersburg plaque—reinforce the relationship suggested by the manner in which their names are inscribed. Till recently, epigraphy has been neglected in the study of ivory carving.[63] Here the words, broken up to fit the space around the figures that they identify, share an unusual form of *alpha*; on the box and on the plaque in Princeton, John's name is spelled in the same abbreviated fashion, while that of Luke in both St. Petersburg and New York uses a type of ligature customary in manuscripts but otherwise unknown in our medium. The casket in the Metropolitan Museum, which measures 18.5 × 9.9 × 6.5 cm, is one of the very few carved from solid ivory rather than revetted with thin plaques attached to a wooden core with pegs. It emerged, nonetheless, from a milieu in which ivory and bone plaques were produced by the same craftsmen and sometimes applied to the very same box.

This is especially true of the "rosette caskets" (fig. 17), so called for the floral ornament in the broad strips or bands that surround the figural scenes. On the Joshua boxes (fig. 50) the figurative scenes, as we have observed,[64] are of ivory. But the strips with rosettes and profile heads are of bone, a fact rarely recognized[65] but evident in the *foramina*, the network of vessels diffusing nervous sensation and nutrients that reads in cross-section as black spots or holes.[66] Such vessels form a vascular system—and, from the point of view of preservation, a much more porous surface—utterly different from the complex tubules that turn in three dimensions through the denser substance that is dentine and constitute what we call its grain. Since the growth pattern of these tubules varies greatly, it is easier to recognize the appearance of bone. Thus in a magnified detail of a Joshua plaque in New

York (fig. 69) the *foramina* can be seen as a dark spongelike texture surrounding the heads and rosettes in the framing bands[67] but are missing from the ivory frieze of soldiers. Enlargements of this sort allow two other observations about craftsmanship in the two materials. First, it will be noted that, contrary to some opinions, bone can take a polish as well as ivory. Thus the heads and flowers in the bands are no less lustrous than the scene that they surround. Secondly, it seems more than likely that the same hand carved the heads in the framing bands as worked those of the Israelite soldiers. The jutting brows, small chins, and above all the fleshy, aquiline noses with somewhat misplaced nostrils are common to both fields of decoration. This identity of carving is by no means true of all the rosette caskets. On the box in Washington (fig. 17) the strips of irregular length, sometimes arbitrarily bisecting the roundels that enclose the rosettes, suggest a difference in workmanship, a substitution of production in series for the careful carving of ivory and bone alike on the Joshua plaques and the Veroli casket (figs. 61, 128).

Not steatite, with its markedly different physical characteristics,[68] but bone offered craftsmen an acceptable substitute in the face of the shortage of ivory. On the rosette casket in Washington (fig. 17) only one plaque, the smallest, bearing a snake,[69] is of ivory. How convincing the substitute material is may be deduced from the fact that nowhere in the fullest description of the object[70] is this fact mentioned. More noteworthy is the absence of

69. New York, Metropolitan Museum. Detail of fig. 50

commentary on the role of bone in Byzantine manufacturing methods. While many ivories adhere to the same subject matter (above all the Crucifixion and the Dormition of the Virgin),[71] they vary greatly in size, and the techniques and quality of their carving. The only "ivories" that show signs of being "mass produced" are those that use bone, and use it prolifically, in association with the imported material. Among plaques with sacred subjects, made as *unica* rather than in series, bone is almost totally absent. The exception that again proves the truth of this rule is a fragment of a half-length saint found in Istanbul in 1959 (fig. 70).[72] Probably no larger in its original form than 7.5 × 3.5 cm, it subscribes to the type, established in ivory, of a figure in three-quarters holding a book and directing his attention to a figure or group to his left, as John the Evangelist and Theodore do on the left wing of the Harburg triptych (fig. 59).[73]

Given the ubiquitous presence and surely lower price of bone, the fact that virtually no icons survive in this material makes a remarkable point about the relationship between piety and economic choice in Byzantium. While it is always possible that examples other than the one in Istanbul will come to light, such an event would not upset the conclusion that, for holy imagery, bone was considered inappropriate: ivory carried with it a meaning that was not limited to the subjects that it was used to represent.

This understanding, one would think, if not the limited merits of the "insufficiency argument,"[74] should have sufficed to demonstrate how ludicrous an object is a huge bone plaque in Bologna, depicting the enthroned Christ (fig. 71) and all too often held to be a genuine Byzantine creation.[75] Its material aside, the proportions of the piece—much too wide in relation to its height—remove it from the norms of Byzantine relief. Nor is the

70. *Istanbul, Archaeological Museum.*
Bone plaque with saint (h. 6.7 cm)

reason for this bloated expanse hard to discern. The utterly un-Byzantine rinceaux in the margins serve to separate this plaque from the Hirsch Christ (fig. 46), the exemplar without which the Bologna version is inconceivable. From this ivory, the bone carver directly derived the broken fingers of Christ's right hand, the unusually rich drapery of the sling in which this hand rests and, above all, the ratio of the parts of the figure—much longer from the head to the waist than from the waist to the feet. Despite its variations in ornament, the bone plaque, cunningly equipped with the remnants of mortices to suggest that it once belonged to a box, is a tawdry, somewhat simplified imitation of the ivory now in Switzerland, carved by someone unaware of the nuances with which the Byzantine master shaped Christ's fingers holding the book or the subtle relationship that he gave to the feet. The Hirsch plaque formerly belonged to the Trivulzio family in Milan and was included in a large exhibition of their collection in 1874.[76] The bone Christ in Bologna closely resembles this very well known piece and is to be dated after (perhaps quite soon after) this first public exposition of the ivory; it is superfluous and inadequate at the same time.

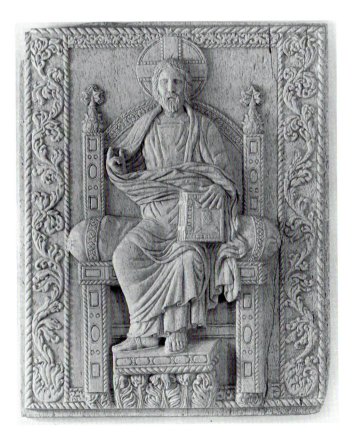

71. Bologna, Museo Civico Medievale. Bone plaque with Christ enthroned (24.2 × 18.5 cm)

3. THE QUESTION OF WORKSHOPS

A far greater challenge than the existence of forgeries to our understanding of how Byzantine ivories were produced is the nature of the material circumstances from which they issued. Because ivory carving is a complicated procedure involving, as we shall see (Chapter III), many stages, it was not a skill that was continually re-invented. The techniques involved had to be learned, and the most likely context of such learning would be the workplace where pupils assisted and, at the same time, imitated their master.[77] This in turn implies that, at least initially, students would adopt their master's ways of handling the material. Some might persist in these methods throughout their working lives. Others would adapt them to produce forms that responded to the changing demands of clients whose concerns varied over time as functions of the office they held, their cultural interests, and the purpose to which they put their acquisitions. The very variety of size and subject matter—portraits, images from Old Testament and Gospel narratives, complex assemblages involving a changing repertoire of saintly figures, boxes decorated with mythological, theatrical, or other recreational scenes—argues for a multifarious body of production, likely to have been divided among specialists in these different genres who were also competitors for the most important commissions.

The picture just drawn is (give or take a detail or two) probably the image that most people have (if they have any at all) of how works of art came into being in Byzantium. In truth, neither the artifacts themselves nor any texts that we have support this view. It would better characterize the system of production in *quattrocento* Florence or fourteenth-century Paris. The extent to which such a picture fairly describes Constantinople four or five hundred years earlier is a matter that has never been investigated. Even so, explicitly or implicitly, it has served as the premise of all who have written about the end products of the industries of art in Byzantium. One could equally well construct an utterly antitheti-cal hypothesis, pointing to the similar content of these products, the largely unchanging beliefs of those who bought them, the rigorous regulation of commerce in tenth-century Constantinople, and so on. Theoretically, the producer whose activity we can identify need not have been an individual. The collection of signs that we find assembled and imposed on a particular plaque is simply an abstract of that object's primary characteristics and could be the expression of a craftsman working with one, two, or twenty assistants. In practice, however, the small size of most Byzantine ivories, the tacit contradiction be-tween the nature of mass production and the use of a rare and expensive raw material, and the lack of any intrinsic evidence that ivory plaques (as against their contemporaneous bone-clad boxes or, in late antiquity, the consular diptychs)[78] were mass produced, make it unnecessary to suppose that more than one craftsman, possibly with the aid of a pupil or a member of his family, worked on any piece with which we are familiar. Even the assistant, learning his trade at the foot of the bench, figures in this alternative picture only

as the recipient of technical expertise and as the minimal means required for its transmission. For practical reasons, then, I refer to the author of any one object in the singular; in recognition of his achievement in many instances, I call him the master. There is no point in trying to make a Phidias or a Titian out of him. But there is also no reason to presume that, because he is now nameless, his work is without identifiable characteristics.

Precisely because proper caution has attended the desires of historians of ivory to distinguish among given works, they have resorted to the notion of a "workshop," a term that entails almost as many problems as the concept of the artist and no less bound, I have just suggested, to an economic and esthetic model derived from other periods. The term "workshop" implies a degree of organization, more or less extended transactions involving materials bought and personnel employed,[79] a competition to find and retain clients, and the diffusion of artisanal skills. The individual craftsman, on the other hand, suggests little more than one man's manual ability, a workbench, a minimal toolkit, and the wherewithal to buy his stock in trade. He would need customers who might, if he wore several hats, buy his products in a variety of media—bone, steatite, hardstone, wood. If he worked in still other materials—metals, marble or other stone—he would need different equipment and a bigger workplace.

More than seventy years ago, Rudakov suggested that large-scale factories did not exist in Byzantium. Drawing on saints' lives, he suggested that the norm was "small-scale production at home, performed by the master with one, two, or three assistants or apprentices."[80] Obviously this view is too limited, too concentrated on what used to be called handicraft: its world is that of an icon of St. Sabbas in which the mountains around the dying ascetic are peopled with monks weaving baskets, copying manuscripts, and carving wooden spoons with adzes.[81] Rudakov ignored the sarcophagi that continued to be produced,[82] the sometimes huge building campaigns that were undertaken, the decoration of some of these buildings in mosaic or fresco. He neglected the evidence of other sorts of texts and seals that record many an *archon ton ergodosion* (master of the works). Yet, so far as our material is concerned, Rudakov's picture need not be entirely misleading. Unlike the production of sarcophagi, handling ivory does not entail heavy loads or a division of labor—chiselers, drillers, polishers, each succeeding the other on a series of half-finished products.[83] No ivory carver needed someone to hold a ladder for him or to pass up hods of raw material—bricks, tesserae, buckets of paint.

He could live, moreover, where he practiced his craft. The *Book of the Eparch* specifically forbids goldsmiths to work at home rather than in an *ergasterion* on the Mese,[84] the main commercial street of Constantinople. Like much late antique legislation, the order is tacit recognition of an ongoing contrary practice, but it is thoroughly Byzantine in its attempt to regulate transactions in a strategic material. For obvious reasons, the manufacture of weapons took place under government control.[85] Silk embroidery and some jewelry, useful in negotiations with foreign rulers, were likewise produced in state work-

shops.[86] But there is no reason why ivory, lacking immediate military or diplomatic application, should have been carved directly under the eye of the emperor. The notion of a culture's finest workshops being attached to the ruler's court is derived from a feudal model and a context such as that of Tilleda in Ottonian Germany.[87] And it is pure speculation to suppose that an ivory atelier existed in the Great Palace.[88] On the contrary, we know that the most celebrated icon painter of his day, the early eleventh-century Pantoleon, was engaged upon an imperial commission in his own home,[89] a practice followed by others.[90] In such provincial cities as have been excavated, even glass factories—a much more industrial undertaking than ivory carving—were situated in private houses.[91]

A domestic setting for the craft would help to explain why it is not mentioned in the *Book of the Eparch*[92] or the scant amount of other information that we have on industries in tenth-century Constantinople. Another reason may be that it was not widely practiced in the city. Given that the identification of hands is in its infancy,[93] it makes no sense to try to estimate how many ivory carvers were at work at any one time. But it is worth remembering that after World War I, in Paris—a city of more than two million people which produced billiard balls for much of Europe—there were only about fifty shops involved in this mechanically complex enterprise. What does seem fairly certain, given the diversity of size and quality of the surviving body of ivories, is that far from being an imperial monopoly, many were distributed from retail outlets, the spots probably where they were produced. This appears to have been part of the commercial pattern of Middle Byzantine Constantinople[94] and remains true of artisanship in many Near Eastern countries today. It is easy, however, to fall into the trap of "orientalism" by equating rudimentary economic organization with a lack of technical sophistication. The prime argument against this is the workmanship of the ivories themselves (Chapter III). But, even before making such an analysis, it is worth recalling that while we have no Byzantine handbook on this craft, other sorts of documents—those concerned, for instance, with siegecraft—suggest a different picture. The so-called *Anonymus de obsidione toleranda*,[95] an early tenth-century example of the military manuals insufficiently exploited by cultural historians, lists the craftsmen needed during a siege—including bronzesmiths, saddlers, bridle-makers, builders of portable shelters, rope-makers and makers of sword hilts—as well as the products that would be required of them—bows that can fire many bolts, bronze arrow tips, and so on.[96] In a slightly later section but in no less detail, the merits of various types of wood (oak, cornel, etc.) used in spearmaking are discussed.[97] All of this implies an awareness of and concern for material technology that is normally not suspected of the Byzantines. Yet it goes some way towards an explanation of the achievement that the "unsuspecting" world attributes to Byzantine craftsmen.

Two aspects of the organization of modern technology—specialization and standardization—are, it is true, missing from the production of carved ivory. We shall see how those who produced a fair number of the finest plaques of the tenth century were also responsible

72. Cleveland Museum of Art. Apostles pyxis (h. 9.5; max. diam. 13.1 cm)

for the bone and ivory revetments of many of the so-called caskets.[98] No a priori reason exists why a "workshop" should choose to specialize in "full-length frontal saints" rather than "feast cycle icons."[99] There is neither historical evidence nor justification in terms of workmanship for such a distinction. While the successful production of one sort of image might well have generated demand for other such works, this sort of hypothesis is feeble in comparison with the probability that the author of the only surviving Middle Byzantine pyxis (fig. 72) was also responsible for a much better-known box in Washington.[100] Neither the artifacts nor such documents as we have offer grounds for confusing tenth-century Constantinople with fourteenth-century Paris where the workers in ivory were classified by their products or, more accurately, by the type of merchant ("cymiers," "ymagiers," "tabletiers," and "peigniers"), who sold such goods and was often also their maker.[101] Even in this more specialized culture, where craftsmen were defined in terms of their métier rather than the material in which they worked, Girard d'Orleans, the painter of King John the Good, is known to have made a set of ivory chessmen, the marble sculptor Jean de Merville bought ivory for the Duke of Burgundy, and another, Giovanni Pisano, carved the great ivory Virgin and Child in Pisa Cathedral.[102]

French (and Italian) Gothic ivories are marked by their standardized sizes,[103] an objective factor in the determination that most are the product of the workshop system. The very absence of such norms in Byzantium further strengthens the belief that our objects did not originate in this way. Plaques that have not been cut down range from a pair of triptych wings in Berlin, each no larger than 6.0 × 5.5 cm,[104] to a huge ivory in the Victoria and Albert Museum, depicting the Crucifixion and Deposition that measures 32.5 × 13.5 cm.[105] Between these extremes, they occur in a virtually infinite variety of sizes. Even if this were not the case, differentiations by size would not help us to distin-

guish *between* workshops. When a panel is cut from any portion of a tusk, at least two of its edges rehearse the natural curvature of that member. Beyond a certain point such curvature is intolerable in a plaque intended to be rectangular. The remaining material may be oddly shaped but was certainly not wasted. From it were cut smaller plaques (as well as the spools, spindles, and other objects that we know from Corinth[106] and Saraçhane[107]). In other words distinct orders of magnitude among plaques might suggest that they are products of workshops but would not be in themselves hallmarks of such shops.

Standardization of *content* is even less useful an index of methods of manufacture than standardization of size. The "interchangeability of gestures and poses from figure to figure"[108] is the mark not only of products issuing from a single workshop but of a culturally sanctioned frame of reference in which human emotions were represented by a limited range of attitudes.[109] The fact that the same modes of rhetorical expression are to be found in mosaics, frescoes, miniatures, and icons in all materials shows that they were no peculiarity of carvers of ivory or steatite. What binds these craftsmen together is not their vocabulary of expression but their coexistence in the market place. It has been observed of the Parisian "yvoiriers" that the concentration of many artisans, working in the same material in a single city and responding to a huge demand for their products, allowed and perhaps even required a constant exchange of ideas and models; the texture of interconnections, both technical and economic, suggests regular contact between them.[110] The extent to which motifs and techniques were shared in the smaller society that was Byzantium suggests the socialization of individual carvers, working in close proximity to each other, rather than the self-enclosed and structurally autonomous communities that are large and organized workshops. Indeed the existence of such complex units cannot be shown to have existed, if by the term workshop is meant a school or atelier rather than the worksite.

In the absence of artifactual or textual documentation, the "workshop" hypothesis is merely a pretentious apologia for normal scholarly caution, a deceptive cloak wrapped about the ambiguities that attend any investigation of the past. There is nothing shameful about such uncertainty and therefore no need to disguise it. What is deplorable is the thrall that such an idea exerts on art historians, who, in other aspects of their investigations, insist on evidential and even probative testimony. Where Byzantine ivory carving is concerned, the notion is mere obfuscation. Like "ateliers" and "schools," workshops are a construction based on nothing more substantial than perceptions of formal likeness. The products of an atelier have been held to possess a degree of similarity short of total identity, while the output of a school apparently displays even less coherence.[111] The amorphous quality of such reified hypotheses is exceeded only by that of the logic that gives rise to them.[112] I must make clear that I have no objection to the search for and recognition of formal resemblances. This approach has been, and will remain, the essential contribution of art historians who, I believe, are right in insisting (overtly or implicitly) that visual

evidence *is* evidence. But evidence of what? *Inter alia*, surely of the probability that two or more objects can be attributed to the same hand. But fifty or five hundred such pieces would still not require the existence of a workshop. A group of ivories carved by one master remains just that; the moment when the signs of this hand begin to be indistinct is the time to cease proclaiming a connection and not an invitation to invent a larger organizational order in the hope that it will sustain, and explain, these more tenuous relationships.

I prefer to postpone consideration of the problems surrounding the classification of ivories (Chapter V) until the palpable nature of the objects themselves and the demonstrable identity of some of their authors have been dealt with. But since the notion of workshops is a notion central to the two most important set of reflections on taxonomy written after the just-cited fantasies concerning ateliers and schools, it seems proper at this stage to comment on the nature of the connection between the predicate and the subject of such propositions. The authors of the corpus took the style and content of a particular group as signs that determined its origin: "Stilgruppen" became "Werkstattgruppen" within the space of three lines. [113] Since they identified five basic groups, it followed that these ivories emerged from five workshops. As has been rightly pointed out, this is to argue from effect to cause. [114] Yet it is no more satisfactory to define a workshop in terms of "the subject matter, size and composition" of its productions. [115] I have already shown the limited utility of some of these criteria. More serious is the failure to demonstrate the necessity of postulating workshops in the first place. It is hardly helpful to insist that a "single workshop can produce icons of high and low quality" [116]—individual craftsmen did, and still do, this. The quality of an ivory carving was determined first by the carver's choice of material and thereafter by the effort that he put into his work: an inscription in relief, for instance, involved more, and more painstaking, labor than one that was incised. Both of these choices were presumably affected by the "patron," [117] even if his or her intervention can hardly be traced today.

One last condition affecting production—and one no less bound up with the workshop hypothesis—must be examined before we can turn to the way in which our artifacts came into being. This is the belief that a varying and therefore indeterminate number of ivories—always of perceived low quality—were carved in the "provinces," [118] these localities either being left unnamed or, occasionally, specified as the Caucasus. [119] When such a suggestion is based upon the provenance of a given ivory, it has something—although, in view of the portability of plaques, not much—to recommend it: an argument of this sort takes into account at least one aspect of the object's history. But the idea that such a view can be founded on grounds of esthetics or literacy deserves little more than the response that its proponent has obviously never tried to carve ivory. At best, what such propositions mean is that, in their authors' view, the craftsmen did not attempt the technical complexity of pieces that these authors considered to be superior. Once again, it must be said, there is nothing wrong with taking "readings" of quality. The problem, as in

73. *Warsaw, National Museum. Diptych, right leaf (22.2 × 9.8 cm). Dormition and scenes from the life of Christ. See also fig. 221*

74. *Paris, Musée Cluny. Right side of box with Herakles and a warrior (11.5 × 17.5 cm)*

the case of formal analysis just discussed, is the sort of inference that may legitimately be drawn from such a reading.

Writing of the "Frame Group" (G-W II, nos. 197–219), for example, Keck and Morey took a dim view of the homophonic spellings and iotacisms frequently found on these ivories. These they described as "faulty to an extreme not even found in the most careless Byzantine work."[120] This statement manages to be at once philologically misleading, snobbish, and wrong. Orthography of this sort appears on the diptychs in the Milan Duomo (fig. 2)[121] and in Warsaw (fig. 73).[122] Each of the spellings to which they objected is found in manuscripts of the tenth and eleventh centuries and is, besides, a useful guide to the extent to which, by this time, Byzantine pronunciation had approached that of

modern Greek. The splendidly prepared collection of works on military tactics that is Milan, Ambros. B 119 sup.,—a book datable to 959–60, issuing from one of the most cultivated milieux of the capital[123]—is full of such "errors." Homophonic spellings are common on tenth-century seals, including imperial examples.[124] And among the mosaics lavished on the decoration of Daphni the inscription identifying the Washing of the Feet,[125] for instance, is "misspelled." These are no more "faults" than are the differences in spelling between the first folio and the first quarto of *Hamlet*. Now that it has been recognized that the personal element in the scribal decoration of tenth-century manuscripts and, more importantly, that such idiosyncracies, formerly believed to be provincial, are indeed Constantinopolitan,[126] it is not too soon to reject orthographic diversity as an index of "provincial" origin.

Where among the outlying regions could the carving of elephant dentine have been anything more than an anomaly? Neither Abydos, where commodities from Africa were first taxed,[127] nor ports such as Attaleia and Trebizond, where spices and perfumes from the Arab world entered the Empire, have yielded evidence of ivory workshops or finished goods in this material. Theodosioupolis and other caravan towns in central Anatolia are equally silent. No ivory artifacts datable later than the sixth century have come from such systematically excavated cities as Sardis and Ephesos in Ionia, or the less well-explored but major centers of Thessalonike and Thebes in Greece. The only positive results to date have come from Corinth. Here in addition to pins either entirely of ivory or, as we have seen, in combination with bone and datable on stratigraphic grounds to no later than the eleventh century,[128] pieces of worked antler and a group of ivory combs seemingly of the same period have been brought to the surface.[129] The most interesting of these are those carved with lions heraldically disposed on either side of a "chalice" or confronted peacocks. Nothing in this iconography or the context in which they were found requires that they "were intended for liturgical purposes."[130] Be that as it may, of larger concern to our present enquiry is the related find of what seems to be a trial piece (fig. 95).[131] If this is its proper explanation, the probability that ivory was not only used but carved in Corinth is considerably strengthened.

Caution is, however, in order. Both the size and manner of decoration of these combs from Greece relate them to another found at Sarkel in the Crimea the year before the finds from Corinth were published.[132] The "older" comb is decorated on one side with a peacock and on the other with Herakles, or Samson, and the lion. This subject occurs on a number of bone-clad caskets[133] where, however, it is worked in quite a different manner. On one of these, at the Cluny Museum in Paris (fig. 74), save for a peg through the body of the lion, the figures are left undecorated. Those on the Sarkel comb, by contrast, are dotted with punctures, drilled apparently in a spirit of adornment. Iconographically, too, there are differences. While on the boxes Herakles is always classically nude, he is clad in a long tunic on the comb. There is no reason, therefore, to connect these examples. But the

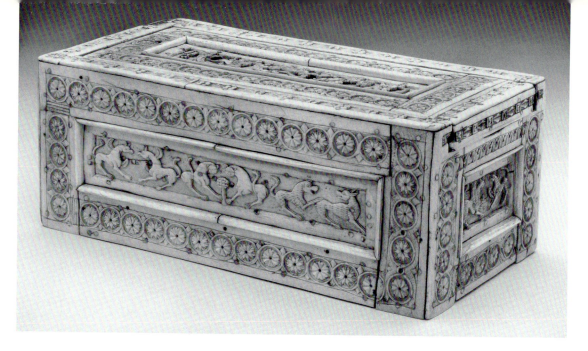

75. Detroit Institute of Arts. Box with animal battles and putti (11.1 × 28.6 × 14.3 cm)

similarities between the comb from the Crimea and those at Corinth allow a choice of hypotheses. Either they were made at the same center and, as desirable objects in a precious material, were exported, or they were carved quite independently, employing motifs (Herakles, peacocks, lions) that were part of the widely diffused heritage of late antiquity.

Bank proposed that ivory was worked at Volkovysk in Belarus because a triptych found there was accompanied by many fragments.[134] Insufficient proof that this is, finds of this sort on east European soil have been ignored by Western scholars who, in recent years, have increasingly assigned Mediterranean, and often Adriatic, sources to ivory and bone carvings that are generically Byzantine. One such is a "rosette casket" in Detroit with battles between fantastic animals on its sides and (on the lid) putti playing musical instruments (fig. 75),[135] tentatively attributed to southern Italy on the grounds that so many boxes of this type were first recorded in Italian collections.[136] As a fact, this is indisputable. But the excavation of fragments of a very similar box, depicting battles between a menagerie of winged or otherwise exotic quadrupeds, at Chersonese in the Crimea[137] deserves attention if only for the reason that archaeological discoveries represent an earlier stage of provenance than acquisitions by individual or institutional collectors. Similar objects have turned up across a wide swath of the former Soviet Union, including Smolensk and Novogrudok (in Belarus), and in the Caucasus.[138] The case for an Italian source for the rosette caskets is far from having been proved.

Much the same objection must be levied at the belief that Georgian or Armenian workshops were responsible for half a dozen ivories that were first reported in churches or

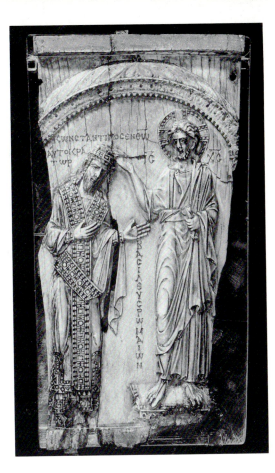

76. *Moscow, Pushkin Museum. Coronation of the emperor Constantine (18.9 × 9.3 cm). See also figs. 164, 166, 217, 218*

77. *Moscow, Pushkin Museum. Triptych (central plaque 20.0 × 11.9; left wing 18.4 × 5.8; right wing 18.3 × 6.0 cm). See also figs. 85, 236*

private collections south of the Caucasus. Among these are the famous plaque displaying the Coronation of Constantine (fig. 76),[139] a triptych from a church in the village of Okona (in the district of Znauri in Georgia; fig. 148),[140] and another, now in Moscow (fig. 77), to the relatives of which I allude below.[141] In each case the reason advanced for their Caucasian production is its findspot. We have not yet reached the point where technical analysis of their manufacture will allow us to adjudicate the issue. For now, suffice it to point out that the Constantine plaque has been found insufficiently different on grounds of style to distinguish it from numerous other ivories,[142] while the supposedly non-Constantinopolitan epigraphy on a "Georgian" plaque in Baltimore[143] has equivalents in the inscriptions on several Byzantine works of art.[144]

It is of course impossible to *disprove* theses concerning the Georgian or Italian origin of any particular piece in a manner that would satisfy a positivist. The fact remains that, with the exception of the combs found at Corinth and Sarkel, there is insufficient reason to suppose that any of the objects we have considered were carved outside the capital; evident differences in facture and content between the plaques and the figured combs will not have escaped the reader. Still, a final word is in order regarding Venice, which for more than half a century has in various ways been promoted as a locus of "Italo-Byzantine" ivory work-shops. The first and most sweeping proposal to this effect was to attribute to this commer-cial and artistic center the more than twenty ivories that Weitzmann would later call the Frame Group.[145] The essence of Keck's approach was to label these objects "provincial" and then equate provincial with his "Italo-Byzantine" style.[146] Unlike Ebitz's more recent and cogent thesis, which rightly recognizes saints especially cultivated in the Northern Adriatic and then exploits this fact to suggest the Venetian origin of a book cover the parts of which are now dispersed to various museums,[147] Keck offered no reason why the many more ivories with which he was concerned should be attributed to this region at all, other than Venice's unquestionable commercial links with Byzantium[148] and the likelihood that artists from the Empire resided there. Directed towards plaques like the six scenes from the life of Christ in the Victoria and Albert Museum (fig. 31), his judgements are couched in such terms as the "crude hacking of the cheek and jaw which speaks of provincial work" and "the complete loss of the Byzantine spirit."[149] If the latter, metaphysical intuition is inherently unanswerable, the other may be met with the response that the facial forms are indeed different from those encountered in many Byzantine ivories. This no more proves them to be Venetian than do such iconographical variants as Lazarus's emerging from a cave rather than a coffin[150] or, in the Nativity, Mary's and Joseph's common gesture of a hand raised to their cheeks. For every apparent divagation in content, countervailing parallels to "normal" Byzantine ivories can be found. The Nativity, for example, shows the swaddled child raised on an ashlar crib above the exhausted Virgin, lying on a hatched and freeform mattress—all details that appear in an ivory of uncontested Byzantine origin, the scenes from Christ's life in St. Petersburg (fig. 20).

78. *New York, Metropolitan Museum. Crucifixion, detail, oblique from below. See also pl. V*

More noteworthy than shuttlecock arguments about style and iconography is the scarcity of technical observations in Keck's thesis. He failed to remark on the way the tree, suspended in mid-air between the Transfiguration and the Lazarus scene, manages to stay in place now that its trunk is broken off. This is achieved by the same sort of strut that supports Christ's hands in the deeply undercut Crucifixion in the Metropolitan Museum (pl. V and fig. 78).[151] It is, of course, true that a Constantinopolitan ivory-carver, removed to Venice, would be unlikely to abandon techniques that he had practiced at home. It is also true that nothing would have prevented him from using such devices anywhere that he might have worked, if indeed the plaque in London is not a product of the capital. Of the group as a whole, Keck did observe that even when profiles are shown, the features are carved on the concealed side of the head, and that they lack the "natural indentation between bridge and nose."[152] This is apparent not only on a Nativity in the Vatican (fig. 105) that is not part of Keck's group and an ivory with which we shall be much concerned below,[153] but also in such purely Byzantine works as a casket plaque in

79. *New York, Metropolitan Museum. Killing of the King of Hazor (8.8 × 7.2 cm). See also fig. 163*
80. *Detail of fig. 79, oblique view from left*

New York depicting the slaying of the King of Hazor.[154] When looked at straight on, the further eye of both the executioner and his victim is invisible (fig. 79); examined obliquely (fig. 80) this feature comes into view; I have suggested above that the Byzantines did not necessarily look at their ivories in the way we regard them in the vitrines of museums. Neither the frontal nor the oblique view of this plaque suggests that its carver sought to give either figure anything but an unbroken, "Aryan" profile.

Keck's contrast between his "Venetian" works and Byzantine ivories was predicated upon the Constantinopolitan origin of an oliphant in the British Museum, depicting scenes of the Hippodrome,[155] which few scholars now believe to be Byzantine. Models from the capital, in his view, accounted for the fidelity of these "provincial" versions. Why such models should not have been exploited in Constantinople itself is never explained. That techniques and exemplars were imported into Venice there is no doubt. Glass paste medallions imitating both Byzantine and Western European models were exported eastwards across the Adriatic and northward over the Alps.[156] In the second half of the thirteenth century Venice manufactured luxury items, including shield covers, saddles, objects carved in or set under rock crystal or glass specifically for sale in the Levant.[157] But commodities of this sort issued from crafts long established along the lagoon. There is a world of difference between the handiwork of the *fiolarii* (glass makers) and *cristellarii* on the one hand, and the no less sophisticated products of Byzantine carvers on the other. The Venetians may have had access to ivory to work in a Fatimid manner in the late eleventh and early twelfth century. That they similarly aped Byzantine ivories[158] and then, in the manner of modern Asian craftsmen, exported the results to these models' homeland, is not inconceivable, but it is attested neither in documents nor in the artifacts. It is time to turn to what can be known, information that is furnished (though not readily) by the objects themselves.

III

STAGES OF PRODUCTION

1. CUTTING THE PANEL

Byzantine ivories do not easily reveal the artistry that has gone into their creation. So fundamental a matter as the relation of a plaque to the tusk does not disclose itself to casual inspection. Even the grain, the most characteristic and therefore perhaps the most celebrated quality of elephant ivory,[1] is rarely apparent in overall views of a plaque's surface, although detailed examination (fig. 30) will sometimes suggest the complexity and beauty of this phenomenon. Among plaques viewed as a whole, a rare instance in which the grain is readily obvious is one in Berlin, depicting the Washing of the Feet (fig. 81). Here a column of inverted and concentric arcs descends from the architrave almost to

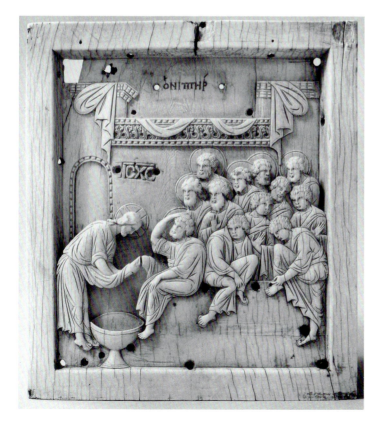

81. Berlin, Staatliche Museen. Washing of the Feet (16.0 × 13.8 cm). See also figs. 83, 149, 211

82. Pesaro, Museo Civico, box plaque. Expulsion (8.3 × 17.1 cm)

Peter's head. It is possible that the craftsman arranged his organization of the panel so that this natural phenomenon would call attention to the apostle who cleaved so to Christ that he asked that more than his feet should be washed. We shall see that carvers did take advantage of the grain to model human and other forms.[2] But in this case, the texture is more likely to be a happy accident than something deliberately planned. Manifestations of the grain are irregular in elephant ivory and their presence within the body of the plaque is by no means predictable from their appearance on the surface of a panel. When they occur, as on a plaque from a box now in Pesaro (fig. 82), they were obviously delighted in. But, again, the infrequency of such examples suggests that they were hard to contrive.

Nonetheless, these two instances do help us to understand our first concern—the relation between the carved object and the material mass from which it was cut. It will not escape the reader that on the vertical plaque in Berlin (fig. 81) the grain runs vertically, while on a horizontal plaque (fig. 82) it reads horizontally. Since this concordance is true of the vast majority of Byzantine ivories where the grain is detectable, it allows us to presume an act of choice on the part of the craftsman. This surmise is borne out by other physical aspects of finished ivories. The back of the Berlin Footwashing (fig. 83), like those of other pieces we have looked at (figs. 49, 55, 58) and many more as yet unconsidered, shows at its vertical edges both the striations of the older ivory that is pushed by new growth at the core towards the outside[3] and, beyond these, the cement—the bony coating that is not dentine but which sheaths every tusk.[4] If the plaques had been cut from horizontal rather than vertical sections of the tusk, these features would appear on the short rather than the

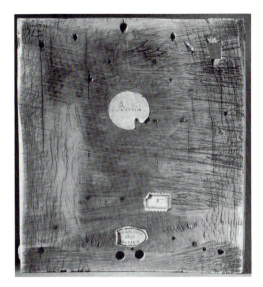

83. *Reverse of fig. 81*

84. *Berlin, Staatliche Museen.*
Reverse of fig. 3, Christ leaf

long edges of the plaques. So consistent is this preference—some of the few exceptions will be mentioned below[5]—that we are justified not only in asserting that the principal axes of most Byzantine ivories follow the longitudinal axes of the tusks from which they derive but also in assuming that this practice represents the craftsman's preference. Indeed, there is evidence, both ancient and medieval, to support the belief that ivory carvers, like woodworkers, elected to carve with rather than against the grain.

This is true, for example, of the sixth-century diptych in Berlin (fig. 3), even though the texture of the ivory is much more apparent on the reverse (fig. 84) than on the figured sides of these plaques. We now know that in late antiquity panels were cut so that their long axes paralleled the direction of the tusk;[6] it is no less true of medieval ivories in general and one example of the reasons why an understanding of technique, though indispensable in matters of classification and connoisseurship,[7] is not very helpful in

matters of chronology. Since such techniques represent solutions to problems of facture, and therefore often coincide with the beginning of a medium's history, continuity is more evident than originality. Conversely, in the history of technology innovation is more likely to be associated with the development of new and, in our day, often artificial materials. Indeed, one of the defining qualities of craftsmanship is the perpetuation of enduring skills. Knitting, for example, whether mechanical or manual, is a method of attaching material to itself so that an area is formed out of what was originally a line: modern knitters might be surprised to know that many of their stitches were used in late antique Egypt. Similarly millennial in character are the skills of net-making and basket-weaving.[8] Our ivory plaques likewise demonstrate the principle that the nature of a material dictates constants in the way that it was worked. Just as the reverse of the Berlin Christ (fig. 84) has a diminished upper left corner, so the tallest of Middle Byzantine plaques—a huge image (32.5 × 13.5 cm) of the Crucifixion, Deposition and Mourning of Christ in London[9]— shows such reductions at both its upper and lower edges. These corners are not man-made but expressions of the tusk's curvature and of the craftsman's desire to maximize the length of the panel that he cut from it.[10]

Study of the backs of plaques can thus tell us how uncarved panels and the slabs of ivory of which they are sections relate to the tusk as a whole. But these normally uncon-sidered surfaces have more information to yield. Since the concentric arcs, or sometimes ellipses (fig. 82), of the grain represent the vascular system of the dentine in its youthful, healthy state, it is most often found around the pulp cavity and the nerve canal that extends from the end of the cavity to the tip. In other words, the grain is most apparent in the central portion of the tusk. When this datum is related, first to the situation of the grain pattern at the middle zone of many wide plaques (fig. 85), to the evidence that we

85. Reverse of fig. 77, central plaque

have just considered for the use of the extremities of the ivory, and to the use of imperfect ivory discussed above, we have further confirmation of the hypothesis that the material was in short supply in Byzantium.

Analogies between ivory carving and the working of wood will surface again when we return to the more difficult matter of the tools used by craftsmen. But in one revealing fashion the procedures of the two trades differed markedly. Even plaques cut from the thickest tusks show no sign of coming from quarter-sawn sections. This painstaking and expensive technique, used in the production of fine furniture in the nineteenth century, involved the division of a log into quarters along its length, sections that in turn were sawn into boards of equal thickness; in Byzantium quarter-sawn (or -split) logs were used in the sixth-century construction of Hagia Sophia, Constantinople, and in many Palaiologan churches.[11] It could be argued that as ivory plaques were not required to support heavy weight, there would be no need of such a technique. But a more likely explanation is that the procedure is extremely wasteful since the squaring up of members leaves unused much material in the form of wedge-shaped ends near the husk. The retention of the cement on many plaques shows that ivories were not produced in this way. But even more telling is the absence of "odd" bits of ivory and wasters from the production process.[12] In principle, one may presume that virtually every workable piece of ivory from a tusk was put to use. When surplus material was of the wrong shape to allow a craftsman to exercise his preference for carving with the grain, maximum utilization of the tusk was obviously the more important consideration. Few in number, preserved examples run counter to the normal agreement between the axis of the plaque and that of the tusk. A Crucifixion in Nuremburg (fig. 86),[13] for instance, clearly displays figures cut across the grain. What is no less interesting is that this defiance of one of the rules of Byzantine carving is here associated with remarkably poor workmanship. John and the Virgin are unusually heavy-set, one of the apostle's sandals is several sizes too large for him, and the column beside him seems to be made of licorice rather than masonry. The craftsman, moreover, has left tool marks all over the plaque. We shall see in a moment how rare such telltale signs are.

For all its anomalies, the Nuremburg Crucifixion adheres to the norms of carving in one important way. It has a maximum thickness of eight millimeters, a measurement well within the normal limits of plaques. Very few Byzantine ivories exceed eleven millimeters in thickness or are thinner than seven. Since this is equally the range of late antique examples, we may conclude that these dimensions represent a gamut extending from the minimum perceived as necessary to support relief carving to a maximum for pieces intended to be especially impressive while still conserving precious material. Plaques with larger areas tend, of course, to be thicker while smaller surfaces could (notionally) be less bulky without running the risk of breaking. These norms, nonetheless, allowed for considerable diversity and especially on pieces with carving of lower quality the thickness at the top of the edge, or at one side, may be three to four millimeters more than at the

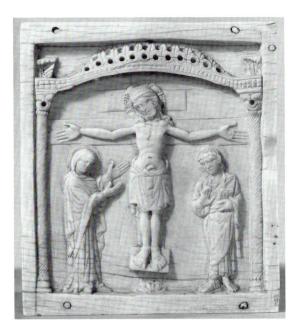

86. Nuremburg, Germanisches Nationalmuseum. Crucifixion (12.9 × 11.2 cm)

corresponding edge. There is no general correlation, however, between the mass of a plaque and the excellence of its workmanship. The Christ formerly in the Hirsch collection (fig. 46)[14] is, as we have seen, an extraordinary seventeen millimeters thick yet displays a grossly disproportionate figure whose upper body is one and a half times as long as the distance from waist to feet. On the other hand, the Joshua plaques both in New York (figs. 50, 52) and London,[15] which rank among the finest such casket fittings, merit this title in part because of their maker's ability to suggest multiple planes of relief within a compass of no more than five millimeters.

Before we scrutinize how such virtuoso achievements were created, however, more is to be gleaned from the backs and edges of our plaques. It is only these normally neglected surfaces that can answer the question whether plaques associated with each other in their final state (for instance, as the leaves of diptychs or triptych wings) were cut from the same tusk. An argument to this effect has been made only in the case of a pair of plaques in the Louvre, an insufficient basis for generalization especially since the authenticity of these pieces is not above suspicion.[16] There are, moreover, *prima facie* pragmatic reasons to presume that ivories prepared for a single commission or purpose would originate in this way: consistent with the small-scale model of production that I have proposed,[17] it presupposes both simplicity of operation and a minimal amount of capital tied up in stored raw material.

Still, it would be unwise to make inferences from practices about which we know as yet so little, especially when an answer to the question is available from close inspection of

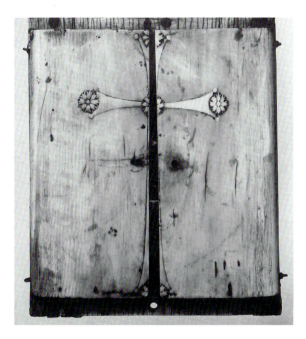

87. *Paris, Louvre. Nativity triptych, closed*
(12.0 × 10.2 cm)

the limited amount of physical evidence at our disposal. The irregularity of grain patterns within any given tusk has already been noted. This means that it is as hard for us to "reconstruct" sections of ivory larger than the plaques that we now have as it was for the craftsman to predict the occurrence of such patterns as he divided and subdivided his material units. Nonetheless, as this process of partitioning progressed and he approached the form of the panels that he would eventually carve, he could gain an ever more detailed view of their properties. So too, as we scrutinize his finished product for these same properties, we are able to reject mismatches (as he may have done) and to recognize a "fit" on those (admittedly rare) occasions when it presents itself: the very irregularity of the grain, moreover, lessens the chance that we err in our perceptions when strikingly similar patterns appear in two parts of a single object. This is the case when, on the wings of the Forty Martyrs in the Hermitage (fig. 29), the arcs present themselves both as complete concentric ellipses and as formations that occupy approximately the same area and situation *vis à vis* the plaques as a whole. Much the same sort of deduction can be made when other unusual but palpable features are displayed by two or more members of a composition. Both the obverses and reverses of the plaques that make up the Harburg triptych (fig. 59) manifest a gritty appearance that is unique in my experience and therefore, I believe, the characteristic feature of a single tusk. When not only the grain pattern but distribution of the striations of the husk and its adjacent cement agree, as they do on the wings of a Nativity triptych in Paris (fig. 87),[18] an even stronger case can be made for the craftsman's employment of what was originally one piece of ivory.

If it is generally true that panels that were related in their use were cognate also in their source, did the carver prefer to work one side of the ivory rather than the other as he turned his panel into a plaque? The problem suggests itself to anyone who has handled a large number of late antique and Byzantine ivories, some of which have "warped" to the point that they present a more or less concave section. Explanations of this phenomenon range from the assumption that such a shape represents the original form of the tusk to the attribution of such distortion to the greater degree of human intervention on the figured side. Reduced to its essence, this secondary question comes down to whether the evident curvature preceded or followed the carving of the plaque. Assuming that both faces lacked "pearls" or other local defects, they would present to the craftsman surfaces identical save perhaps for the amount of grain they exhibited. Why then, in the great majority of instances, did carvers choose to work the inner face of the panel—that is, the side originally turned towards the pulp cavity—and to reserve the outer face for simpler jobs (such as the crosses on triptych wings) or to leave it undecorated? The fact of, though not the reason for, this decision is evident on the little plaque of St. Eustratios (fig. 88) now at Luton Hoo.[19] Its reverse (fig. 89) shows not only a median strip of concentric arcs, indicating that this zone lay not far from the core of the tusk, but also portions of cement from its outermost surface. The juxtaposition of these apparently contradictory symptoms is easily explained: the diameter of the tusk, or at least that part of it from which the

88. Luton Hoo, Wernher Collection. St. Eustratios (10.8 × 5.8 cm), oblique view from right

89. Reverse of fig. 87

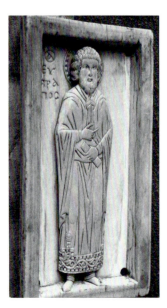

90. *London, British Museum. Ezekiel, bottom edge of fig. 127*

Eustratios was cut, was not much greater than twice[20] the maximum thickness (7.5 mm) of the plaque. In this case it is important to observe that the cement (which reads as the lighter areas in our half-tone photo) is not confined to the lateral borders of the plaque but is found even on the outer edges of its vertical median. We have already recognized the rounded edges of some triptych wings (fig. 29), chamfered to make them pleasing to the touch.[21] The reverses of a sizable number of ivories[22] are not smoothly planed to lie flush against a wall but chamfered to fit comfortably in the hand. Approaching the form of a flattened half-cylinder, the Luton Hoo plaque is simply a pronounced example of the type. Since these reverses preserve either something of the tusk's curvature or traces of its cement, or both, it follows that they correspond to the outer part of the tusk; conversely, their figure-bearing faces were zones turned towards it center.

One might suppose that this deduction could be confirmed by observing plaques on which bowing is evident and then comparing the instances in which the figures are carved on the concave or convex surface. But two objections may be raised to such an empirical approach. First, it is obvious that no craftsman would choose to create elaborate relief on the inside face of a curving surface if the other were equally fit to carve: this would only compound difficulties of access and working. Secondly, and consequently, the bowing that is apparent must have occurred *after* the figures were carved. Indeed most such curvature is an expression not of the tusk's pristine form but of the physical state—above all the relative humidity and the position in which it has been kept—of its subsequent environment. A much surer guide to the craftsman's preference is the disposition of the grain as it appears in transverse section at the top or bottom edge of a plaque. This is not always in evidence, being sometimes visually preempted by the marks of subsequent workmanship (fig. 96). But on the bottom of the London Ezekiel (fig. 90), for example, the reduction in the diameter of the ivory's concentric strata leaves no doubt that the carving took place on the belly of the plaque;[23] in other words, the face that the craftsman chose for his image was originally turned towards the core of the tusk.[24]

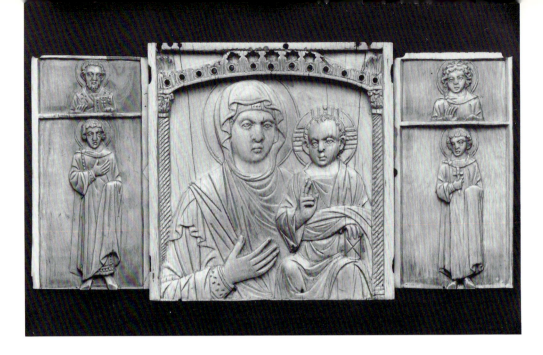

91. Baltimore, Walters Art Gallery. Hodegetria triptych (central plaque 14.0 × 13.6; left wing 12.8 × 7.7; right wing 13.1 × 7.7 cm). See also fig. 206.

The arguments involved in this demonstration of the way a tusk was made to yield a panel and this panel, in turn, prepared for carving have unavoidably been complicated and involved many different ivories. By way of summary and in anticipation of the stages that follow, it might be helpful to retrace our steps in terms of a single object. The triptych of a Hodegetria flanked by unidentified saints in the Walters Art Gallery (fig. 91)[25] does not offer an easily readable example of every nuance noted above. But, for all that it has suffered from wear and excessive restoration,[26] as a representative product of its time it does provide a useful résumé of some of the main points. Thus, the obverse of the central plaque shows no indication of its source in the original tusk, just as those of the wings— beyond their similar cloudiness—do not suggest a relationship to each other. Once the triptych is turned over, however, the centrality of the arcs on the main plaque, together with the striations at either side, show that the craftsman chose to exploit the full width[27] of the panel (fig. 92). So intent was he on maximizing this dimension that he did not strip its borders of cement—a body of weaker material that probably accounts for the failure of the original set of hinges.[28] The front of the plaque is a milky-coffee color—the hue that is often called "ivory"—except for a darker central area visible in our photograph over the Virgin's breast. Since this matches the area of the most pronounced grain on the reverse it probably represents a darkening near the core of the tusk; however this may be, it shows that the plaque's maker was unable or unwilling to use a section of ivory at once broad enough for his purposes and uniform in tone. A further economy is indicated by the fact that while the central plaque is eight millimeters thick at the level of the canopy, it tapers toward the bottom. This reduction may represent the diminution of the panel toward the

92. Reverse of fig. 91

tip of the tusk: because it was not quarter-sawn it would have been cut not parallel but obliquely to the axis of the tusk.

Narrower in width, the wings of the Baltimore triptych came perhaps from the same tusk as its main plaque. This cannot be proved but what is sure is that these two flanking members had a common origin. Once again this is made clear by their reverses (fig. 92) which display a fairly similar eccentric grain pattern running through and to the left of the uprights of the carved crosses. Both of these crosses retain areas of cement, showing that these surfaces lay close to the exterior of the tusk and that the saints, on their obverses, were carved on the faces turned towards the nerve canal. Since the vertical edges of both wings are chamfered, it is likely that these panels came from the rounded outer sides of a narrow section of tusk, cut in all probability from an area close to its tip.

In this connection, one final (and often asked) question remains. Given that in most figural compositions the center of the spectator's attention is at or slightly above the middle of a plaque, did the carvers choose for this focus an area of the plaque nearer or further from the tip of the tusk? Was one part of a panel considered superior to another? Always excepting the natural flaws to which any piece of ivory is subject, there is no evidence that one end of a panel was regarded as better. Craftsmen do not seem to have displayed any preference—and with good reason, for as long as they avoided the husk and the actual tip, where the most friable material lay, and the soft ivory immediately around the pulp cavity,[29] there was nothing to choose between the upper and lower parts of a plaque in terms of quality of material. On the generally rectangular panels that they cut, they arranged their figures with apparent equanimity. Christ could be represented in the

upper portion of a box lid in Stuttgart (fig. 93)[30] where a distinct diminution towards the tip is visible. His head, blessing hand, and accompanying apostle could occupy the broader zone on a plaque in Turin (fig. 94)[31] where both the reduced width and regularly diminishing grain show that the lower portion of the ivory was that which was closer to the tip of the tusk. In some cases a consideration independent of the hierarchical values of iconography may have prompted craftsmen to dispose figures so that their heads were directed towards the tip. Numerous plaques, freestanding as well as members of diptychs (figs. 24, 25, 73) and triptychs (figs. 7, 77, 99), have arcuated tops. This is a shape unknown on late antique ivories and seems to have been a Byzantine invention.[32] While no doubt it became canonical and therefore self-perpetuating, the notched tops that characterize many (pl. IV, figs. 73, 221), might originally represent an aesthetic virtue made out of the need to reduce the width of a plaque when this was demanded by the natural reduction of the tusk.

93. Stuttgart, Württembergisches Landesbibliothek. Box lid (16.2 × 8.8 cm)

2. AN EXCURSUS ON TOOLS

To this point I have tried to refrain from labeling the tools used by the craftsman as he divided his tusk or cut the panels that are its subdivisions. I shall continue this policy when, in the next section, we proceed to a discussion of the more complicated business of carving. The reason for this restraint is simple, if somewhat embarrassing: we do not know what the implements used in these tasks were, or what they would now be called. The furthest one should venture in this direction is to speak, for example, of a pick-like or chisel-edged tool; beyond this point lie such questions as the size, substance and range of application of the "pick" or, more specifically, whether the "chisel" was mallet-driven (which could imperil the material being fashioned) or drawn towards him by the craftsman (which would make for much slower work). Of course, one can find in the handbooks what tools were known in the Roman period, the Dark Ages, or the Middle Ages,[33] or seek

94. *Turin, Galleria Sabauda. Christ and Peter (16.4 × 7.9 cm)*

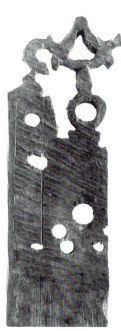

95. Corinth, Museum. Trial piece (?)
(h. 8.2 cm)

analogies in more discursive, if more specialized, studies.[34] But these are concerned with the practice of woodworking, which overlapped but was not coextensive with ivory carving;[35] and in these Byzantium is rarely mentioned.

The reasons for this silence are not hard to find. The information that we need is offered by neither the literary nor the archaeological record. There is to my knowledge no Byzantine counterpart to the catalogue of tools attributed to Leontichos, a carpenter of the third century B.C., in the *Greek Anthology*[36] and, even if there were, to assign modern equivalents to the Greek terms would be anachronistic where not simply in error (as is the Loeb translator's "screwdriver"). From late antiquity there do survive references to crafts-men and the tools they used, such as Theodoret of Cyrrhus' *tektones* who work a plank with string and a plane.[37] But, anticipating attitudes in all but the most banal Byzantine documents (for example, the agricultural implements of the archives of Mount Athos), the imagery here is allegorical describing not tools to be used but "rules" for personal conduct.

Of the results to date of archaeology, perhaps the most charitable summary would be that offered long ago by Philip Grierson: "It has been said that the spade cannot lie, but it owes this merit in part to the fact that it cannot speak."[38] Field work at Byzantine sites has yielded domestic instruments whose function is self-evident from their form,[39] and the diligent application of anatomical knowledge to archaeological discoveries has led to the identification of a variety of surgical instruments.[40] But the fact remains that we would probably not recognize a tool as one used to carve ivory unless it were found, as at Olympia,[41] in the setting of a workshop. The excavations at Corinth, where an ivory waster was found (fig. 95)[42] apparently turned up no tools associated with its working.

Archaeological contexts have proved fruitful in the case of tools for quarrying and stone cutting;[43] because of their scale, however, their application to our concern is

questionable. At best one may recognize analogues between the rough cutting found, for example, on the backs of sarcophagi and the deep uneven runnels that cross the Corinth piece transversely. The shallower vertical marks towards the bottom of the ivory were certainly imposed with a finer, more file-like tool. The holes in the body of the panel were made not with a punch but, like the freeform cavities above them, with what in modern terms would be called a keyhole or coping saw.

Pictures of tools in Byzantine works of art—the last resort of the historian of material culture—provide little more help. Apart from ubiquitous instruments of torture (including a chisel driven with a hammer into the head of St. Julian of Emesa[44]), the Menologion of Basil II gives us spades and picks used by gravediggers and the occasional two-handled bow saw, operated once by one man and, on another occasion, by two.[45]

External aid, then, is all but totally lacking if we wish to identify ivory workers' tools. We are forced back on their creations but, even here, direct evidence is missing. One mark of excellent workmanship seems to have been the elimination of those signs that would tell us how it was carved: we can catch, as it were, only the craftsman's slips, that is, those occasions when he neglected to remove such marks. Before we begin this ghost hunt, it is worth while reflecting for a moment on the implications of the chase. The very lack of toolmarks—those signs of how an object came into being and of the individual who made it (for they are *his* marks, imposed by his hands)—is itself characteristic of a social order that did not single out the sculptor, a manual worker like any other, for special recognition. In Byzantine society, art was essentially the concealing of art, of toil, of process. That signs of workmanship are conspicuous by their absence is more than a negative intimation concerning the mechanics of production. It is an index to the culture from which it emerged and of the relative value that it attached to products and their producers.

Much in the way that one can infer the identity of particular sculptors from the ivories that they carved (as I attempt to do in Chapter IV.3), so we can (painstakingly) deduce something about the tools they used from the objects that they shaped. In both cases it is pointless to give names to such discoveries. Just as self-effacement on the part of craftsmen is not merely a problem for historians of Byzantine art, but (at least until the twelfth century) symptomatic of Byzantium as a whole, so the craftsman's obliteration of the evidence for the way he worked is a phenomenon that says much about the ends he had in mind—not least his posture of insignificance vis à vis both his creations and the society that these express. Denial of self on the part of the artist is not unconnected with denial of artifice: most toolmarks and those who made them have alike been polished off.

One may immediately object that, even on ivories already considered, it is possible to recognize traces of tools. The Nuremburg Crucifixion (fig. 86) shows deep vertical scratches between the Virgin and her adjacent column, below the left edge of Christ's loincloth, and to the right of John. These grooves run, as we have seen, across the grain and could represent one stage in the shaping of the ground between the figures and the

architecture. But such abrasions are rarely so conspicuous: they could well be signs of some crude, and modern, cleaning. The only way to decide this point is to see if similar marks occur in similar circumstances on other pieces, to test if this was one way in which carvers removed the mantle of ivory that lay between them and their objectives. Even if this is so, it is less misleading to describe their technical aims—cutting, modeling, polishing, and so on—than to assert that a hole was made with, say, a bow drill or an auger. Our aim is to recognize the sculptors' achievements, to know them by their deeds. We are concerned with the means they employed only to the extent that these illuminate their results.

3. FROM PANEL TO PLAQUE

The attention evidently paid on the majority of our ivories to the removal of tool marks means that it is not possible to trace each step of the production process in terms of a single piece. As in the demonstration of the relation of a panel to the tusk, so to indicate the stages by which a panel was cut, trimmed, carved and, where appropriate, inscribed, ornamented, and joined to another, requires the testimony of numerous witnesses. Since, however, most ivories exhibit more than one of these procedures, diligent study of the illustrations will reveal many more of the steps undertaken by the craftsman than are noted in the text. I shall signal one, or at most a few, instances of each stage. These, nonetheless, may be taken as representative examples and the techniques involved as normal in the carving of Byzantine ivory.

We have noted on the bottom of the London Ezekiel (fig. 90) the concentric strata that represent the tusk's growth process. They are not often so evident on objects in good condition, for this clearly visible separation of layers is an image of the ivory's desiccation. As the collagen in the material dries up, its strata tend to come apart—in cross section as here, or laterally in the longitudinal section that is the front (fig. 24) or back of a plaque.

No less uncommon on the edges are signs of how these were cut. The bottom of the Hirsch Christ (fig. 96), however, shows the mark of some sort of saw, its oblique tracks discernible on the surface. In this short section almost all of the marks are in parallel—the sign of a smooth cut. But down the long right side of the plaque (fig. 97), the marks are not all parallel to each other, suggesting that, as he moved through the cement at this edge, the craftsman had to raise his saw several times and reapply it at a slightly different angle. (It will be recalled that the plaque is an exceptional seventeen millimeters thick). Perhaps the best-known ivory on which such marks occur is the magnificent central plaque of a triptych in Utrecht (fig. 99).[46] Here, clearly distinguishable from the craquelure which runs almost vertically, the traces of the saw's teeth run in several directions across the apex of the arch, diagonally beside the upper right hinge cutting, and again in the

96. *Switzerland, private collection. Bottom edge of fig.* 46

97. *Switzerland, private collection. Right edge of fig.* 46

98. *London, British Museum. Ezekiel, reverse of fig.* 127

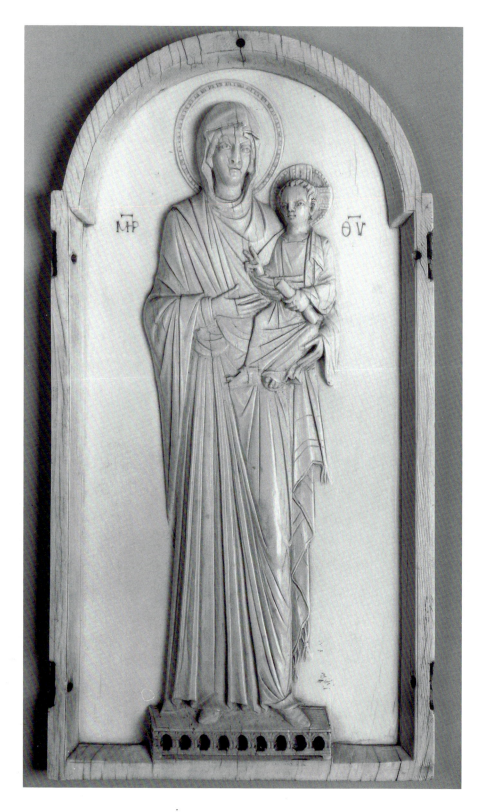

99. *Utrecht, Rijksmuseum Het Catharijneconvent. Virgin Hodegetria (26.3 × 13.3 cm). See also figs. 119, 154*

100. Reverse of fig. 99

lower right corner of the frame. Better evidence could hardly be found that even the finest Byzantine artists did not remove all traces of their craftsmanship.

Since the edges of plaques were sawn, we may presume that the larger surfaces of the panel's obverse and reverse were similarly cut. In fact, traces of such a procedure are rare: in these areas carvers were evidently more attentive to their removal. On the backs of some, such as the Ezekiel in the British Museum (fig. 98),[47] we find rough-hewn irregular facets that suggest the use of an adze. Sometimes these surfaces present a veritable patchwork of toolmarks (figs. 45, 55, 58), running at right angles or obliquely to each other: it would be foolish to suggest which belong to the original facture of the object. Others are planished so smooth that in the right light they reveal the traces of fine-toothed, file-like instruments. On the reverse of the Venice apostles (fig. 49), such a tool may have been used to erase the projecting surfaces of pearls. But sets of similar, ladder-like marks traversing the axis of a triptych plaque in Hanover (fig. 101),[48] suggest that it may have been smoothed with a succession of progressively finer files. Were these the only examples, one could dismiss them as traces perhaps of a later cleaning. But they are found in almost the same situation on the reverse of a triptych now in Castagnola,[49] beside the cross on the back of the Constantine wing at Dumbarton Oaks,[50] and on the back of a larger Crucifixion in Hanover.[51] The combination of coarse and fine file-like forms also occurs on the upper edge of the frame of the Princeton Crucifixion (fig. 102).

It is perhaps to be expected that in such places toolmarks have been neglected. More surprising is the fact that they have been overlooked on the obverses of quite well-known ivories. A "ladder" of the same sort runs horizontally (and was thus applied vertically)

101. Hanover, Kestner Museum. Crucifixion (16.4 × 13.3 cm), reverse, detail

102. Princeton University Art Museum. Crucifixion, upper edge. See also fig. 36

103. Washington, Dumbarton Oaks (loan).
Detail of fig. 46

under the left arm of the cross on the Crucifixion in New York (pl. V, fig. 78). Again, later intervention or an accident can be ruled out as its cause, for marks of the same tool occur around John's feet in the lower right corner of the plaque. A small file would fit conveniently into such crannies; indeed, it would be appropriate wherever the craftsman had to remove material from a confined area yet wanted to work faster than he could with a pick. This is clearly the case around Christ's sandals on the footstool of the Hirsch plaque in Switzerland (fig. 103). But the method would be no less useful in the spandrels of an arch or the framed corners of a plaque—in any area, in short, where the carver lacked the space for the long sweeping movements of a plane.

The use of a file to smooth the surface of a footstool belongs of course to a much later stage of manufacture—to the detailing that follows the drafting, blocking out, and carving of the ivory's subject matter. Yet it is important to note at this point since, like the adze or drawknife that was sometimes employed to shape figures (fig. 144), it shows that the same implement could be used repeatedly. The urge to recognize a different instrument in each stage of production presupposes the huge toolchest of the modern cabinet maker, equipment that is far from certain in the case of medieval craftsmen. The conditions under which they worked more likely imposed a limitation on their gear no less pressing than that on the amount of raw material at their disposal. The skilled carver would have been as competent in making do with little as he was in conserving effort: there is more than an etymological connection between proficiency and efficiency.

These kindred talents come to the fore in the means whereby a smoothed panel was converted into a carved plaque. The first step in this procedure must have been a rough sketch drawn on the surface that had been chosen for carving. Whether this was done with ink or with a graver is, given the silence of the Byzantine sources on the subject of ivory working, unknowable and unimportant. The result, a draft setting out the elements and their approximate proportions, would be the same. We shall see that by no means were these guidelines always faithfully observed. But, for the moment, the point is that even

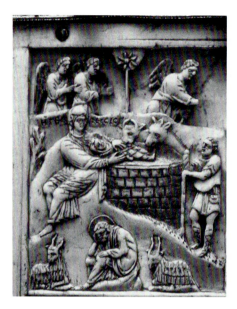

104. Quedlinburg, Stiftskirche, detail. Nativity. See also pl. VIII

105. Vatican, Museo Sacro. Nativity (17.3 × 14.2 cm)

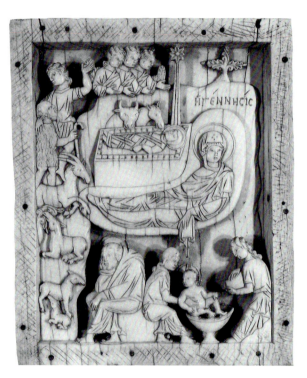

the most familiar subjects—the Crucifixion, the Dormition, saints standing or *en buste*, alone or in groups—would have required a preliminary sketch be it never so schematic. It seems fair to suppose that the amount of detail it contained varied as a function of the subject's rarity and the sculptor's experience. But in principle the utility of this step may be argued on two grounds. First, no iconographical topic was as fixed as those only cursorily familiar with Byzantine art might suppose: a Nativity, for example, might have the Virgin seated (fig. 104) or lying (fig. 105), below, to the left, or to the right of the crib; she could gaze at the Child or turn away from him (fig. 198); shepherds, or midwives, might (fig. 42) or might not (fig. 2) be present. Independently of a model, any craftsman could presumably draft any of these varieties. But precisely because he was so adept and would carve not one but scores or hundreds of Nativities in his lifetime, often fitting them into the context of a larger cycle, he would lay out what he was about to carve. I suspect

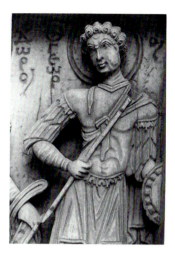

106. Venice, Museo Archeologico. detail of fig. 44

that this step was less an act of homage to a previous version of the scene (as is commonly supposed) than a sensible precaution, working as he was with expensive material.[52]

Be that as it may, the most important medieval Latin handbook on craftsmanship prescribes preparatory drawing of this sort:

> When carving bone, first trim a piece of it to the size that you want, and then spread chalk over it. Draw the figures with lead according to your wishes, and score the outlines with a sharp tracer (*cum gracili ferro*) so that they are quite clear. Then with various chisels (*ferris*) cut the grounds as deeply as you wish and according to your ability and skill carve the figures or anything else you want.[53]

In place of the pragmatic details that Theophilus provides, the Byzantines offered allegory; characteristic as this transformation is, it is nonetheless useful. The mid-ninth-century Ignatios the Deacon, for example, reports that master painters first make a sketch in black, announcing their design; with assistants, they then complete their work in color.[54] So large is the number and range of reference in Byzantine authors to outlines (*ektypotheisa*) drawn by icon painters that, however different their purpose, there can be no doubt that they reflect actual practice.[55] And if those painting a wooden panel observed this step, workers of ivory would be all the more likely to conform. A preparatory sketch would have been in order whether the carver depended on an icon, a miniature, verbal instructions, or simply his own memory.

With his schema ready, the carver was ready to begin its translation into three dimensions. This would be done by striking through the outlines that he had drawn, first perhaps with a straight-edge chisel. A fairly simple composition such as the Theodore and George in Venice (fig. 44) would at this stage consist merely of two vertical shafts connected at the level of George's right elbow with an undifferentiated mass that ran down

to the bottom of the plaque. Only later would would the complex interplay of the saints' forearms, Theodore's shield, and the lower portion of George's lance have been realized. The right shaft might well have continued to the right edge of the plaque: the ground between his head and the frame (fig. 106) bears more marks of a pick, or a similar instrument, than the broad space between the two heads or that to the left of Theodore. Horizontal masses projecting in this direction would have accommodated Theodore's right arm and the tip of his sword hilt. At this stage, the tip of his lance and his right forearm would still have been one with the left frame.

It is important to note that the frame is an integral part of this design. It was not cut in advance of the outlined saints for, as we shall see on other ivories, physical bonds between it and figures and other elements of subject matter were sometimes (and rightly) deemed essential to their security.[56] Nor was the frame an afterthought, an ornament, like the star and dentilated border of Theodore's shield. Its presence was more than a matter of "tradition." (Almost every plaque, and different scenes on the same plaque, are circumscribed by a border). It contributed materially to the sense of substance, to the illusion of reality which is the raison d'etre of Byzantine ivory sculpture. It shields the figures and at the same time animates the ground against which they stand with a chiaroscuro that shifts according to the direction of the light source and the angle at which the plaque is viewed.

Particularly when the height of the relief is no greater than that of the frame (figs. 22, 39, 40, 97), the latter will protect it from abrasion. But even when, for whatever reason, the relief projects beyond the border (fig. 107), this frame at once allows the image to be handled and defines the boundary between the realm of humanity and that of the icon. At a material level, an image that did not extend beyond the frame would have been less expensive: the plaque needed to be no thicker than the part of its content in highest relief. It is therefore scarcely surprising that most Byzantine ivories lack such salience. On the other hand, projecting areas would have been easier to work. For this reason, perhaps, protruding imagery of this sort was generally limited to large single figures or simple groups like the Virgin and Child (fig. 108). The extraordinary weight of the Oxford half-length Hodegetria has already been noted;[57] our concern now is with the implications of the contrast between this mass and a plaque of approximately the same size and appearance. The Descent from the Cross in Washington (fig. 109) was once the central portion of a triptych, as is indicated by the dowel holes in its frame prepared for the attachment of wings.[58] Such holes are missing from the Oxford ivory, but this is scarcely the most telling difference between the two objects. Where the ivory around the affecting scene at the center of the Dumbarton Oaks plaque is translucent,[59] that of the Hodegetria is utterly opaque. This is achieved not by different overall dimensions—at its frame the Oxford ivory is only one millimeter thicker—but by the quite different treatment of the ground. That of the Hodegetria is nearly five times as thick as the ground of the Washington Deposition which, between Christ's knees and at the back of Joseph of Arimathaea, is a

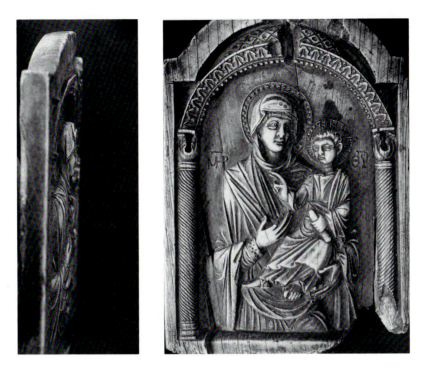

107. Oxford, Ashmolean Museum. Oblique view of fig. 108

108. Oxford, Ashmolean Museum. Virgin Hodegetria (16.8 × 10.1 cm)

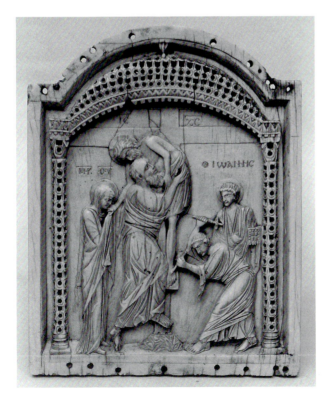

109. Washington, Dumbarton Oaks. Descent from the Cross (17.1 × 12.8 cm)

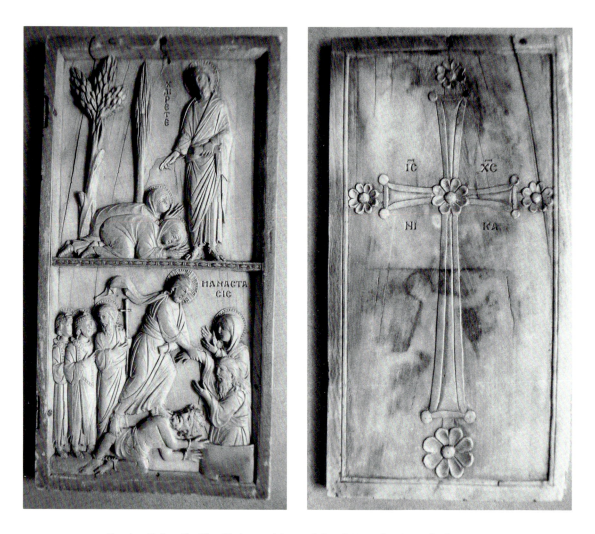

110. Dresden, Grünes Gewölbe. Chairete and Anastasis (22.8 × 11.6 cm). see also fig. 147

111. Reverse of fig. 110

scant one millimeter. Hence the diaphanous quality of the one as against the opacity of the other.

The craftsman's intentions (and achievement) in this respect may be conveyed by the dimension that I call the "step."[60] This is the distance between the plane of the frame and that of the ground. It acts as an objective measure of the extent to which he has reduced the latter by removing material below the level of the frame and may also point to the working methods of an individual. For example, the magnificent Chairete (the resurrected Christ greeting the Marys) and Anastasis in Dresden (fig. 110)[61] has been recognized as the pendant to a plaque in Hanover showing the Crucifixion and the Deposition (fig. 223)[62] on the basis of their stylistic resemblance and iconographic coherence. The rightness of this *aperçu* is borne out by our technical benchmarks: the plaques are both ten millimeters thick and share a step seven millimeters deep. Their grounds are consequently very thin. In fact, the leaf in Dresden provides the most spectacular example of transparency of any

112. Hamburg, Museum für Kunst und Gewerbe. Virgin
Hodegetria (21.6 × 6.5 cm), reverse. See also fig. 228

113. Detail of fig. 112, left edge

Byzantine ivory: seen from the rear (fig. 111), which is decorated like its counterpart in
Hanover with an elegant cross, the head and torso of Christ in both scenes is visible
through the ivory, like a miniature on the verso of a parchment page.

We shall return to the matter of translucence when we come to discuss the uses to
which ivory plaques were put.[63] But it is worth observing immediately that the eggshell
fineness of the Christological plaque in Dresden and the Washington Deposition are
perhaps not unconnected with their roles as parts of diptychs and triptychs. The ground of
the Crucifixion in New York,[64] the frame of which shows similar provisions for wings,
varies in thickness from two to three millimeters; its pellucid quality is evident imme-
diately it is returned to what may have been one manner in which it was originally
illuminated (pl. V). There exists a number of ivories[65] that, in their present state, survive
only as figures in varying degrees of relief. That these once belonged to plaques, the
grounds of which extended as was normal to the usual frame, may be demonstrated in
the light of two lessons we have already learned from the way panels were cut. One such is
the Standing Hodegetria in Hamburg,[66] on the back of which the grain describes a
beautiful cascade of arcs (fig. 112). This feature, as we have seen, characterizes the central
axis of a vertical plaque. No craftsman would have used *only* this middle portion of a panel:

to do so would leave him with two pieces of material neither of them wide enough for a normal plaque.

It therefore follows that the Hamburg Virgin and Child stood in the middle of a ground which may have borne other figures, as on a group in Washington where they are flanked by SS. John the Baptist and Basil.[67] At its thickest, the left edge of the Hamburg Virgin (fig. 113) measures twelve millimeters across; of this, less than three are occupied by the ground which is clearly distinguishable from the head by the file marks and traces of a saw that it displays. One cannot be certain that each of the ivories in which the ground has disappeared was, in its pristine condition, part of a triptych. But this is sure in the case of the Hodegetria between saints in Washington, which retains its original base, drilled with holes to accommodate the dowels of the wings that once closed over it. Such protection was in vain: in all probability the ground around the figures was cut away because the sculptor had reduced it to the fragile and translucent plane that convention, if not function, dictated in that situation.

The impact on thin grounds of deeply incised outlines obviously entailed the risk of cracking. It is this scoring and not the fanciful notion of the relative "weight" of the parts of a plaque[68] that causes it to break. This has happened beside John's right leg in one of the two Crucifixion plaques in Hanover (fig. 114).[69] It is a tribute to their makers' *savoir faire* that this sort of fracture is found so rarely in the corpus of ivories. Normally, when he used them, the craftsman's guidelines define long and complicated contours like those running from Christ's girdle to his footstool on the plaque in Turin (fig. 94) and from his right shoulder to his wrist on the Romanos ivory in Paris (fig. 115). Here, however, caution is in order, for these troughs may pursue the same path as lines scored around a figure at a later stage to heighten (both literally and figuratively) the relief that the sculptor had carved: its purpose and effect are not unlike those of the ribbon of shadow with which Manet

114. Hanover, Kestner Museum. Crucifixion (23.0 × 14.7 cm). Detail, John

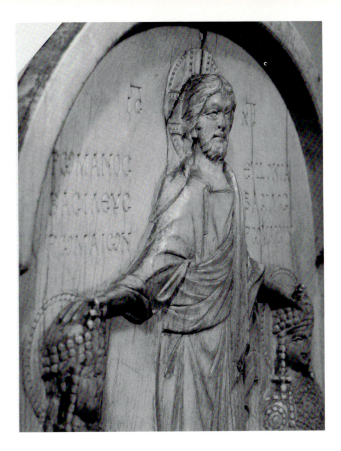

115. *Paris, Cabinet des Médailles.*
Romanos ivory, oblique view from left.
See also pl. IV and fig. 22.

surrounded his *Olympia*. Such emphasizing lines are evident in our oblique photo of the Romanos not only along the Lord's right arm but also down the right leg.

Both forms of outline belonged to the technical repertoire of the Byzantine carver and their presence or absence will prove to be one symptom among many of his handiwork. But in themselves they are insufficient indicators of one and the same craftsman, for he might decide for or against their use and, if he chose to use them, they could be more or less conspicuous on different ivories by the same individual.

The difficulty may be illustrated in terms of a frequently found and compositionally simple type of the half-length Christ. These generally belong to the class of enthroned figures like the cut-out on the Bodleian book cover (fig. 4). The type—and it is one of the most uniform among all Byzantine ivories—is defined by Christ's direct gaze at the spectator, by his cross without a nimbus, by the closed book, shown from the rear, that he holds with an uncovered left hand (as against the apparently amputated and bandaged limb in Oxford), and above all by the gesture made with the right hand which rises vertically out of the sling of his mantle. On the version in St. Petersburg (fig. 116),[70] the contour to Christ's right is clearly apparent, at least from the level of the collar bone down to the huge break in the ivory beside his right hand. On its counterpart in Cambridge (fig. 117)[71] which, I shall argue,[72] was carved by the same man, the trough is similar but somewhat further from the shoulder. Finally (although this by no means exhausts exam-

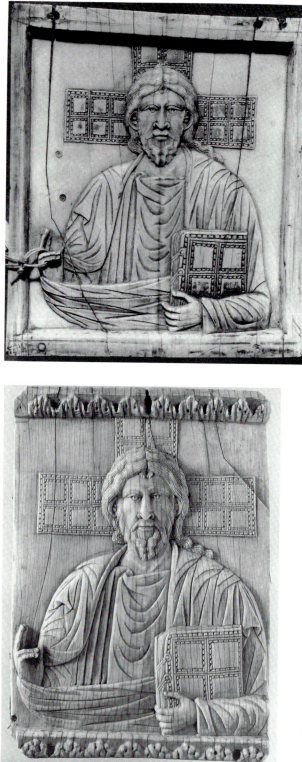

116. *St. Petersburg, Hermitage Museum.*
Christ (12.8 × 11.1 cm)

117. *Cambridge, Fitzwilliam Museum.*
Christ (13.6 × 9.5 cm). See also fig. 180

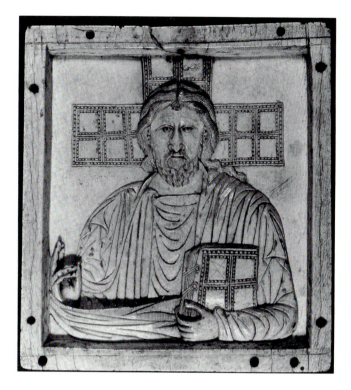

118. Paris, Musée Cluny (on deposit). Christ (12.2 × 11.3 cm). See also fig. 179

ples of the type), the furrow all but disappears on a very similar plaque in Paris (fig. 118). (It is in fact present, but too shallow to show up in a straight-on photograph).

For the moment the problem is not one of the sculptor's identity but of determining the stage at which he cut a particular line. I have already suggested that the same tool was used at different moments in the sequence of carving; the same effect therefore may have been created early or late in the production process. There is, however, one way to determine whether a contour was created at an early stage in the blocking-out that has preoccupied us—and, as so often, the observation depends upon the craftsman's inadvertence and our oblique point of view. When a figure in its final form is carved at some remove from the trough, as is Christ's left arm in the Berlin Entry into Jerusalem (fig. 40), we may infer that it is an early guide and not a later modeling stroke. Had the arm in question extended as far to the right as the preparatory line, it would have been disproportionately bulky. Evidently the sculptor changed his mind and cut the limb so that it would read as narrower and closer to Christ's body.[73] Such corrections occur even on the finest ivories, as is shown by the tracks that run down the right side of the Child and a fold of the Virgin's mantle on the Utrecht Hodegetria (fig. 119). These were ignored by the sculptor who, when he came to complete his carving, preferred a subtle indentation below Christ's elbow that helped to make both this joint and the drapery below it seem more plastic.

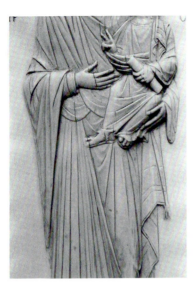

119. Utrecht, Rijksmuseum Het Catharijnenconvent. Detail of fig. 99

4. CARVING THE FIGURES

By moving from the incision of an external contour to the shaping of the garments of the Virgin and Child (fig. 119) we have already progressed from the stage at which the craftsman laid out his schema as a set of discrete masses projecting from the ground to that in which he began to impose representation on these blocks. The simulation of human form, like the evocation of distinct aspects of drapery, architecture and ornament, entailed variety, complexity and, where appropriate, the suggestion of animation. Yet all these qualities were elicited from the same material, worked with the same set of tools and directed towards the same end. It is therefore quite artificial to divide the process into "stages" as if they were conceptually discontinuous. We do so only for the purposes of inquiry so that as observers we do not ignore the painstaking business of creation, as did Byzantine commentators when they saw beauty or horror but always lifelikeness in the finished product.[74] Those who understand that we can never look at any ivory as the Byzantines did will grant that the impact of the result is in no way reduced by an analysis of its causes.

No less artificial or necessary is a division of the ways in which a carver fashioned his figures, the most difficult and impressive part of his brief. The rounding of the forms in the detail now under consideration is the most obvious and therefore, not coincidentally, the last of these major steps. Before this stage came the shaping of those masses that would become limbs, clothes, the scroll, and so on. This was achieved by three sorts of cut, each distinguishable from the other but generally used in conjunction. Our ability to discrimi-

nate between these techniques should not be confused with the notion that they character-ize different plaques (or carvers). They represent different *parts* of a plaque and thus, ultimately, different tasks within the same commission. Not all three strokes were used on every ivory. But no ivory of which I am aware makes use of only one of these methods.

Testifying to the dearth of technical studies in this area, no term exists in English for the sort of cut used most commonly by Byzantine carvers. This is the stroke employed (repeatedly) to evacuate material from behind the tail of the sleeve over the left wrist of the Utrecht Virgin, as to a lesser extent from within the drapery that falls from her right forearm (fig. 119). To denote this cut I shall use the word Kerbschnitt,[75] a term used by some German medievalists with reference to monumental sculpture. That many Anglo-American scholars would describe these areas as "undercut" is itself tacit recognition of the sculptor's achievement for, when seen from the front, portions deeply excavated with Kerbschnitt look as if they were undercut. True undercutting is, as we shall see, a more elaborate and difficult undertaking: our carver consequently saved himself much toil. Kerbschnitt removes less material than undercutting, entering into the ivory but ending against a wall, either the ground itself or the rear of the form that the sculptor wished to create. It may be deep (as at the left wrist of our Hodegetria) or shallow (as below her right arm) but in either situation remains a cavity, not a passage connecting two voids. Finally, it could be used both internally or externally. The further side of Christ's head on a detail that we have previously examined (fig. 32) is cut with a slanting stroke back from the (now) flat surface of the face to the plane of the nimbus. The volume of Adam's head, on the other hand, is suggested by a cut that is similarly oblique but directed outwards to the ground behind it.

The difference between Kerbschnitt and true undercutting as well as their coexistence within a single object, is, as in other demonstrations we have undertaken, best grasped in terms of a simple composition (fig. 120).[76] This example is no less important, for all that it may have been one plaque among many to adorn a casket. It thus once again suggests the commonality of techniques used in the production of boxes and icons and across the supposed differentiation between "sacred" and "profane" art. The plaque, said to depict Meleager, belongs to a series preserved in the Grünes Gewölbe and other museums that may have displayed Old Testament iconography juxtaposed with classical subject matter. The depth of the step is six millimeters, excavated in a plaque that is no more than seven, thus, albeit in miniature, emphasizing the sculptural quality of the figures. In fact, while the hero's entire right arm, as well as his right ankle and left wrist, are undercut, every other part of his body is cut back in Kerbschnitt to the ground behind him. So too the little divinity (if he is that), dancing on a rocky outcrop to the left, appears in frontal view to be free of the ground. An oblique photo (fig. 121) shows how (deliberately) misleading such a view is. Only the wreath-bearing left arm is undercut, while his head, neck, torso and legs are obliquely connected either to the ground behind or the frame around him. The outcrop

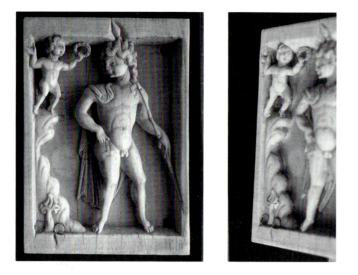

120. *Dresden, Grünes Gewölbe. Box plaque with Meleager (6.4 × 4.7 cm)*

121. *Detail of fig. 120, oblique view from right*

which, seen head-on (fig. 120), reads as a complex projection secured only at the frame, can be seen, when viewed diagonally from the right, to be firmly attached to the body of the ivory.

If we turn to a much more complex plaque, the Berlin Entry into Jerusalem, but retain those oblique views (figs. 39, 40) that have proved of use in understanding the depiction of motion,[77] the distinction between Kerbschnitt and undercutting proper should become clear. The more radical technique is used for the branches of the tree, the ass's right foreleg, Christ's feet, the right arm of the Spinario and the legs and left arm of the child who throws the nearer garment in Christ's way. Elsewhere, Kerbschnitt is used even where it is not readily visible. Thus, seen from the left (fig. 40) or frontally, Christ's raised arm appears to be free: a view from the right (fig. 39) shows that this is not so. From the right, the arm extended to the ass's mane seems likewise detached from the ground: seen from the left, the Kerbschnitt actually used here manifests itself. The body of the Spinario, the backs of the cloth-throwing boys, the Jews at the gate, the foliage of the tree, Christ's head, and those of the foremost apostles are all obliquely cut. Indeed the loss of only two major portions of the plaque—the right side of the canopy and the right forearm of the boy high in the trees (both, significantly, undercut areas)—shows the extent to which Kerbschnitt is responsible for the preservation of a plaque that at some time in its history obviously suffered several rude shocks.

Damage can of course occur on any ivory. Unless kept under conditions of controlled humidity, the collagen which is the source of dentine's resilience will dry out, leaving the material brittle and ever more fragile. Whether or not our carvers were aware of the effects of time, they evidently knew how to protect their creations from the pious but clumsy. Part of the reason why the Utrecht Hodegetria (fig. 99) is in relatively pristine condition is the amount of Kerbschnitt, and the correspondingly minimal use of undercutting, in its facture. Even a richly undercut plaque like the military saints in Venice (fig. 44) shows the

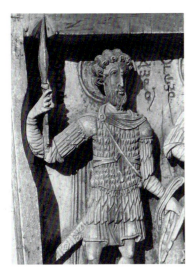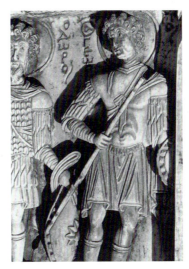

122. *Venice, Museo Archeologico. Detail of fig. 44, Theodore*

123. *Venice, Museo Archeologico. Detail of fig. 44, George*

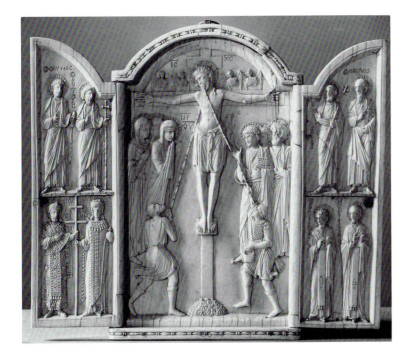

124. *Berlin, Staatliche Museen. Triptych (central plaque 23.3 × 14.3; wings each 21.5 × 7.0 cm), Crucifixion. See also figs. 131, 159, 160*

reserve that craftsmen felt towards wholesale employment of this technique. Theodore's neck and left forearm, awkwardly outstretched towards his shield, are undercut (fig. 122), as are George's spear-bearing forearm and his legs (fig. 123). But George's neck and shoulders and the upper arms of both figures are cut back obliquely and deeply to the ground. Seen from the front the effect is the same. But the price paid for leaving narrow strips of ivory unsupported over long distances is apparent in the loss of the major part of the haft of Theodore's lance and of the upper part of George's. (The ground exposed in both

these areas shows the marks of the pick used to remove material from behind the weapons). If true undercutting is a *tour de force*, the real wonder is that not more has been lost.

The other side of this technical coin is the minimal injury suffered by ivories more elaborate than the Utrecht Virgin but, like it, worked mostly in Kerbschnitt. This is the case with the Crucifixion triptych in Berlin (fig. 124), a work that has been described as provincial and of hybrid parentage.[78] It is not its stylistic genes, however, that have given it its physical staying power but the lack of undercutting. Even where a detail such as the sponge bearer's rod appears to be freestanding, it was in fact carefully grounded—in this instance, on John's upraised arm. Indeed, apart from the perennial threat that the hinges posed for adjacent areas,[79] damage to this triptych is largely confined to its right wing where Peter's cross has lost part of its staff and the scoring beside Chrysostom's right leg has developed into a nasty crack. As against Longinus' lance which is attached along its entire length, its tip ultimately passing *behind* the Lord's rib cage, the rod supporting the sponge rises ever higher so that it can overlie Christ's torso and face, the two most salient parts of the relief. It is this contrast between the prominent *corpus* and the slighter forms of the attendants that lends remarkable depth to the scene despite the shallow space within which it is housed: the step here is no more than six millimeters.

The impression of a deep cupboard disclosed when its doors are opened is furthered by the lower relief of these wings but more so by the plasticity of Christ's body. The swelling of his pectoral muscles and the volume of his calves as they recede from sharp shin bones are shaped with some arc-bladed tool which, even if not identifiable as a scorper, is quite distinct in its effects from the straight-edged facets of another Crucifixion in Berlin (fig. 144). Other plastic areas—Christ's arms, the upper part of the Virgin's body, and Longinus' buttocks—belie the Kerbschnitt that created them and connects their rounded edges with the ground behind. We shall return to this triptych when we come to consider the ways in which detail is imposed.[80] But the essential contribution to its "style" of the interplay of sharp and soft contours will already be clear. I can only hope that no less clear is the extent to which this often airy conception is grounded in matters of technique.

This much said, it remains to be recognized how the same technique in the hands of another craftsman can produce quite other results. Kerbschnitt was no less the manner in which the figures and landscape of the Vatican Nativity (fig. 105) were produced. The rounded edges of the cloud-like massif on which float the Christ child and his mother at the center of the image are, like the flock and its guardian to their left, cut obliquely back to the ground. They are no more free of support than are the animals from their narrow strip of pasture or the Virgin's mattress from the terrain on which it lies. The reason they appear undercut is the distance between the middle zone and the background. Like the step of the Berlin Crucifixion (fig. 124) this measures six millimeters: the difference is that in the triptych this space is before rather than behind the figures. Freestanding elements in the Nativity are limited to such small areas as the rays of the star, the raised arm of the

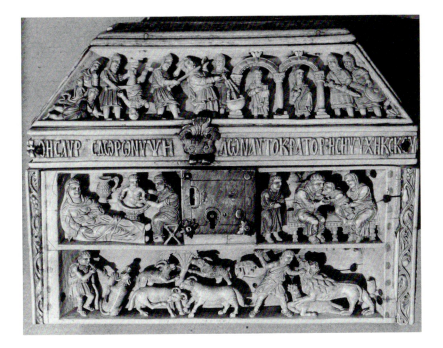

125. *Rome, Palazzo Venezia. Box, front. Scenes from the Life of David. See also fig. 220*

angel, and the foot of the basin in which Christ is bathed. The other figures are connected with the ground even while the huge shadows that they cast can induce the keenest observer to suppose that they are undercut.[81]

The impact of light upon the perception of bodies and other elements as shade-creating masses was evidently also a factor in the design of the thick ivory walls of a box in the Palazzo Venezia in Rome.[82] In this respect, the sequence that runs from David's birth to his struggle with the lion (fig. 125) resembles the Nativity in Rome. But far from being a series of silhouettes projected onto a flat screen hardly recessed behind the level of the frame, as are the figures in the Vatican plaque, those of the box are bulky entities that displace space; they are disposed in different planes between splayed coulisses that allow even more light to fall on the actions unfolding on these shallow stages. This very different effect is paralleled by the difference in cutting technique. Where Kerbschnitt is used in the Nativity and the amount of damage consequently minimal, almost every figure on the David box involves some undercutting. As a result it has suffered major losses, including everything above the lion in the lower right hand corner of the side illustrated here and the child's right hand in the register above. Other sides have missing (sometimes restored) heads and grounds that are frequently broken through. On plaques where the amount of undercutting is even larger (fig. 93), the destruction is proportionately greater.

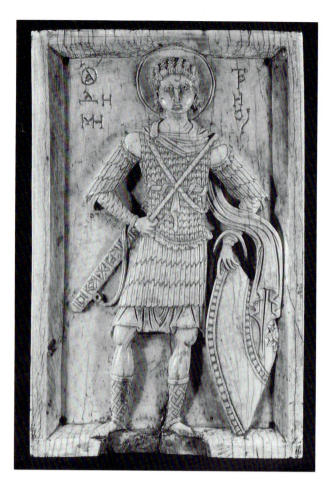

126. *New York, Metropolitan Museum. St. Demetrios* (19.5 × 12.2 cm)

127. *London, British Museum. Ezekiel* (15.1 × 12.3 cm)

What the sculptor exposed to harm by his choice of technique he opened wide to illumination by his beveling of the frames. Unknown in antiquity and again a Byzantine invention, these splayed walls came to be widely used on both box plaques (figs. 53, 54, 120) and icons (fig. 99, cf. fig. 3). They are often present even when architectural fantasy rather than these sober borders defines the limits of a scene (figs. 39, 40). The finest examples show that these oblique interior faces were cut not at the time the masses of the composition were blocked out but simultaneously with the carving of the figures: the rounded volumes of shoulders and buttocks on the Berlin Washing of the Feet (fig. 81) exploit the additional space that such beveling creates. The stage at which the frames were shaped is confirmed by ivories the frames of which are not splayed. To accommodate the point of Theodore's spear and the unnatural curve of the arm that holds it (fig. 122), the carver of the plaque in Venice had to cut notches both above and to the left of the figure; a similar recess allows a tip to George's weapon.[83] Without these amendments the image would be incomplete. Such elision might be acceptable for the right half of George's shield (fig. 44), although it is worth observing on a similar plaque in New York (fig. 126) that parts of the frame have been excised to make room for the nimbus of another fighting saint and the full swing of his mantle (fig. 126).[84] To truncate a saint's limbs or, worse, his weapons was inconceivable. What would be unexceptionable within the conventions of a Japanese print would be intolerable in a Byzantine icon.

Ideology apart, frames could serve thoroughly pragmatic ends. To them were anchored the heads of angels with (fig. 127)[85] or without (fig. 105) intervening haloes, wings,[86] or clouds.[87] On a badly damaged plaque, wings and feet fastened in this way remain extant, while the undercut body that belonged to them has vanished.[88] But from this functional point of view, the frame is only a special case within a much larger concern to "tie down" those parts of a carving most at risk—and the parts most at risk, as the Veroli casket[89] makes supremely clear, are those that are largely free from the ground. Perhaps because of its frame, this object—the most prodigiously undercut of all Byzantine ivories—may be responsible for the notion that *most* Byzantine ivories were cut in this way. The assumption is both wrong and neglectful of the very precautions that make the Veroli different from the majority of works in this medium. A detail of the central portion of the lid (fig. 128) displays the sculptor's ingenious device of securing the raised arms of the crowd to the frame by means of the stones they are about to hurl at Europa's abductor. Less obvious are the supports to which were attached the right forelegs of the two centaurs and the rear leg of the younger creature. Now mere functionless bosses, these were once the centaurs' hooves and therefore, unlike the hidden struts that sustain Christ's hands on the New York Crucifixion (fig. 78), iconographically justified. The fact that they did not suffice to protect the undercut limbs does not detract from their original purpose, just as their exact reproduction on a little-known version of the box (fig. 129),[90] taken in conjunction with losses almost identical to those that the Veroli has suffered, is, quite

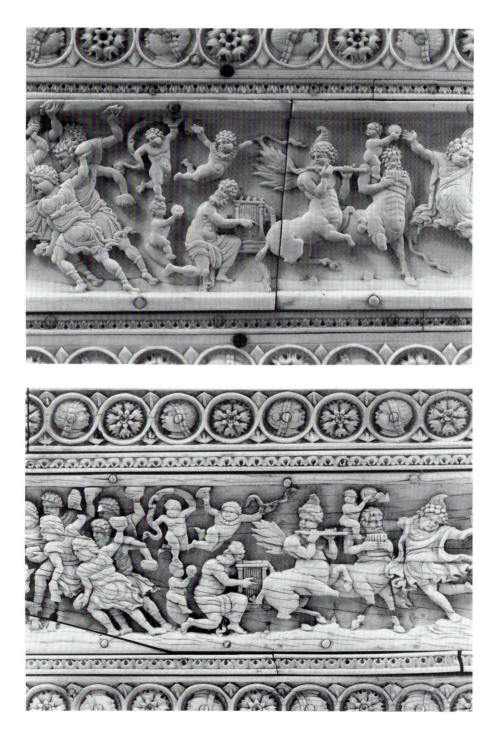

128. *London, Victoria and Albert Museum. Veroli casket, lid, central portion*

129. *Madrid, Museo Lazaro Galdiano. Copy of the Veroli casket (11.3 × 41.0 × 15.9 cm), lid, central portion*

apart from other considerations, sufficient proof that the box in Madrid is a modern copy. Pushing the argument from superfluity[91] to the wall, the possibility that both the injuries *and* vestiges of the Veroli could recur is beyond the realm of the credible. In the history of art there are no coincidences, only unrecognized anomalies.

Undercutting, then, entailed not only losses but attempts on the part of craftsmen to avert them, not least a much more infrequent use of the technique than is sometimes supposed. It has a good late antique pedigree,[92] but when it does occur on an ivory, like a Deposition in St. Petersburg[93] that is already questionable, it can only be grounds for confirming suspicions based on style and iconography. Properly used, as on the right forearm of the Demetrios in New York (fig. 126), undercutting is associated with the cautionary measures described above—in this case, anchored to the ground at his elbow and to the sword hilt at his wrist. But, as we have seen, normal practice also called for the combination of undercutting with other methods of carving. I have spent much time in this section on Kerbschnitt, a largely unrecognized technique, and left till last the third, and simplest, means used to shape figures. This is the straight stroke, cut back at a right angle to the plane of the ground and reserved, it seems, for plaques at least ten millimeters thick—perhaps because such plaques could better support a chisel blow. We find it on an ivory at Dumbarton Oaks, representing the archangel Gabriel.[94] Being only a fragment, it is hard to judge the extent to which straight cutting was used here: at least the contour of the one preserved wing is carved in this way. The cut is most obvious, however, on the Metropolitan's Demetrios, a massive section of ivory twelve millimeters thick. Our oblique photo (fig. 130) shows not only the undercut right forearm but the hem of his tunic and the border of his shield cut straight back to the ground.[95] These hard-edged forms do little to relieve the severity of an image marked by unyielding centrality and frontality. What interest it has from a technical point of view lies less in the way the figure was defined than in the details imposed on it.

130. New York, Metropolitan Museum. Oblique detail of fig. 126, from below

5. DETAILING

If we have found considerable diversity in the ways that plaques were prepared and their contents, figurative or otherwise, were shaped, it will be less surprising that greater variety is detectable in the sequence of steps that immediately followed these preparatory stages. The imposition of distinct physiognomies, clothing, armor, and other attributes on the figures, the architectural and landscape settings in which they are placed, and inscriptions both long or (more often) laconic are the domain in which the sculptor most clearly reveals his hand. These steps I group together as *detailing* to distinguish them, on the one hand, from the blocking out of the iconography and its broad carving and, on the other, from finishing—the subsequent polishing and (where called for) coloring of the plaques, and their joining as diptychs or triptychs, or their assembly to form the revetment of boxes. Like the blocking out and rough carving of a plaque's contents, its burnishing and coloration represent steps in large part dictated by the nature of ivory and the limited number of ways in which it could be treated if it was to serve its appointed end. These earlier and later stages allowed fewer options than the procedures to which we now turn, steps in which the craftsman was less constrained by purely technical considerations and therefore freer to heed the wishes of his client or his own sense of what was fitting. Detailing, in short, is the stuff of "style," as the term is commonly used. I would insist that techniques, too, constitute aspects of style, while granting that radical changes in this domain occur only over the *longue durée*. It is for this reason that we are able to describe the *characteristic* way of producing a Byzantine ivory even while we are unable to show—craftsmen being what they are—that the production of any one ivory faithfully observed every step in this ideal sequence.

It follows that an understanding of the technical means by which styles of carving came to be expressed is no less necessary to a comprehensive view of the craft than their recognition at the more "mechanical" stages of a plaque's preparation and its "post-production" embellishment. Although an art historian might differentiate, for example, between the long, attenuated form of the Metropolitan Demetrios' body (fig. 126) and the comparatively squat figure of Theodore on the icon in Venice (fig. 44, 122), the square-cut bridge of their noses and, above these, the semicircular scar tissue that does so much for their fierce appearance, were almost certainly carved with the same tools. Just so, the plump, almost infantile cheeks of the saint in New York would surely be distinguished from Theodore's gaunt jowls, but these puffy features must have been rounded with the same arc-bladed tool as not only his shoulders, knee caps, and calves but the corresponding parts on the bearded warrior. Similar blades shaped the curious rings of muscle or sinew in their necks and the same sort of straight-edged tool lent their feet pencil-point sharpness.

Identical tools, or at least identical effects, may be found across members of "groups" of ivories that are normally segregated. The short and shallow file marks that suggest the

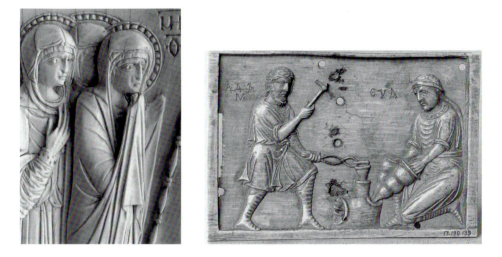

131. *Berlin, Staatliche Museen. Detail of fig. 124*

132. *New York, Metropolitan Museum. Box plaque, Adam and Eve at the forge* (6.7 × 10.1 cm)

plasticity of the material over Theodore's forearms (fig. 122) create a similar imbricated pattern on the sleeve of one of the women in the Berlin Crucifixion (fig. 131). The boots worn by Adam and Eve as they labor at the forge on a plaque from a Genesis box in New York (fig. 132)[96] are patterned with an instrument of this sort. It may be objected that such observations mean no more than that the number of carvers exceeded the number of types of tool at their disposal. But even this is worth establishing. Since tools were presumably made *ad hoc*, perhaps by the carvers themselves, their possession of similar instruments implies a shared sense of how a desired effect should be achieved and a community of craft practice underlying their more obvious stylistic diversity. Beside Eve's forehead and face on the Genesis plaque are clusters of punctures, traces of the pick that was used to remove material when a heavier tool might damage a head that had already been blocked out. The amount of evidence suggests that this was among the techniques most widely employed by Byzantine carvers at this stage in their work. Such holes recur on the nimbus of the Christ child held by the Baltimore Hodegetria (fig. 206) and find what is perhaps their most pronounced use around the heads of Peter and Paul (fig. 133) on a pair of plaques in the Staatsbibliothek at Bamberg.[97] In this instance it is clear that the pick was used both to detach surplus ivory from within a confined space and to define the contour of the head.

The small scale of the area in question[98] explains not only the craftsman's need for a fine instrument but his failure to notice its traces when he came to polish his plaque. As much is true of the irregular spaces between and around Paul's feet (fig. 134). Were it not

*133. Bamberg, Staatsbibliothik, Msc. Lit. 7. Paul plaque (27.7 ×
11.0 cm). Detail, head of Paul*

for the fact that such marks can be found (once one starts looking for them) on scores of
ivories more carefully carved, one could argue for a connection between sloppiness in this
final stage and incompetence shown at an earlier stage of work. The Bamberg master,
whose activity is as obvious in the Virgin and Christ diptych (fig. 135)[99] as in the Peter
and Paul, was far from a skilled draftsman. The cross-eyed stare that he gave to Christ
rehearses the awkwardness of Paul's abstracted gaze (fig. 133) but his maladroit hand
emerges most clearly in the Lord's gesture (fig. 136)—the superfluous digit, repented of
by the sculptor as soon as he realized that a blessing made with five fingers *and* a thumb
might not be effective. Solecisms of this sort could be erased with a blow of the chisel but
other errors—or rather what read as errors when judged from the point of view of
realism—were not so easily corrected. The Virgin who appears to elbow aside a column on
the Harburg triptych (fig. 59), or to need support from the frame as she makes her pleas to
Christ on the Hildesheim Deesis,[100] became "givens" that their carvers could hardly
change once they had completed the blocking-out of the figures.

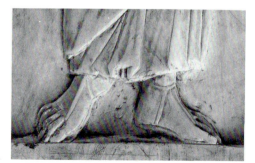

*134. Bamberg, Staatsbibliothek, Msc. Lit. 7. Paul
plaque. Detail, feet*

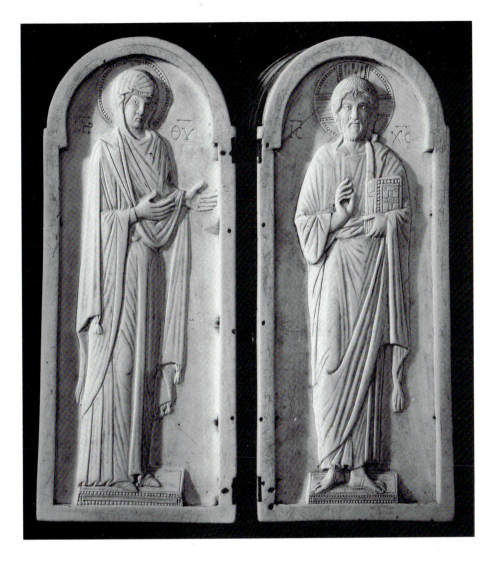

135. *Bamberg, Staatsbibliothek, Msc. Lit.8. The Virgin (27.8 × 11.4 cm) and Christ (27.7 × 11.1 cm)*

136. *Bamberg, Staatsbibliothek. Detail of fig. 135*

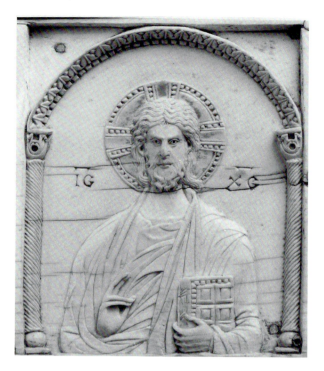

*137. Florence, Bargello. Apostles box
(12.1 × 49.0 × 15.2 cm). Detail,
Christ. See also fig. 193*

Equally predetermined were the ratios of major parts of the body. We have already remarked on the disproportionately small head of Christ on a plaque in Switzerland (fig. 46). No less diminutive is this feature on the Apostles box in Florence (fig. 137)[101]—a head so out of scale that the figure resembles those hopeful eighteenth-century attempts to restore acephalic Roman busts with heads that belonged to quite other worthies. The opposite situation obtained on the Cleveland pyxis (fig. 72) where the bodies read as atrophied appendages to the heads of the often identifiable apostles that they support.[102] It seems likely that the heads were carved independently of the bodies. Given that different sets of "portraits" were in simultaneous circulation in Byzantium,[103] we should perhaps not be surprised that physiognomies on the ivories differ sometimes markedly from each other.

Variants of this sort were a matter not simply of iconography[104] but of technique. The ways in which the limited range of hair styles was carved differed greatly from one ivory to another and transcended the established "groups" of plaques with apparent ease. Four of the basic types are distributed over the apostles who follow Christ's ass in the Berlin Entry (fig. 138, cf. fig. 154): two of them have flame-like clusters of hair, one has globules, another straight hair combed sideways from a central part, and two have chevron-cut locks that run backwards from the forehead. This chevron cut could also *cross* the head as on the

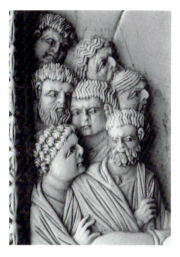

138. Berlin, Staatliche Museen.
Detail of fig. 39

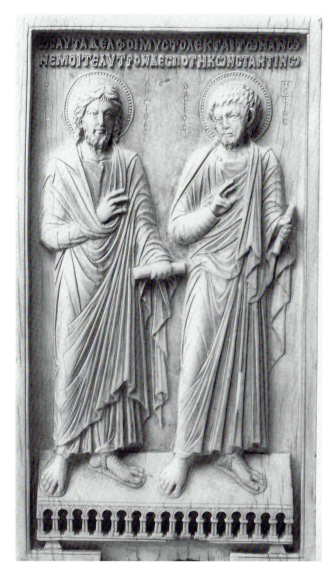

139. Vienna, Kunsthistorisches
Museum. Andrew and Peter (24.2
× 13.3 cm). See also fig. 161

seventh member of our group. Each type could be carved with a file; indeed the only style
that could not is the elaborate and identical "perm" sported by Theodore and George in
Venice (fig. 44, 122, 123). Yet the flame cut could be handled with much greater subtlety
(and the aid of a bladed tool) on Peter's head in Vienna (fig. 139).[105] And a fifth basic
type—a sort of cap with curls plastered to the forehead—frequently used for the young
Jesus (fig. 167), is treated with much more delicacy—that is to say, with much finer
strands of knife-cut hair—on the heads of Stephen and John the Baptist on the great ivory
in Cortona (pl. I, fig. 140).

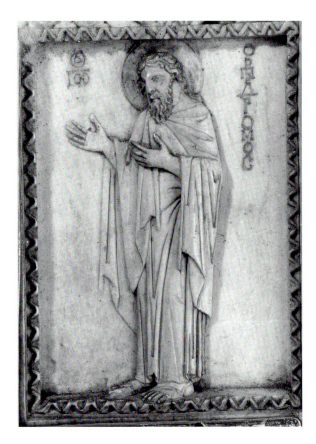

140. *Cortona, S. Francesco. Detail of pl. I, John the Baptist*

Three of the four full-length figures employ a treatment of the palm of the hand that has remained unnoticed, perhaps because so few scholars have been able to handle this reliquary. The joints between John's fingers and his exposed palm are represented not as discrete creases but as a single, unbroken line sharply struck with some sort of chisel. The line is cut identically on each of the palms visible on Bernward's gospelbook in Hildesheim (fig. 33) and on a Crucifixion in Naples (fig. 141).[106] The frequency with which Christ is shown on the cross with open hands, and angels, Mary, and other saints gesture with one or both palms exposed, makes the limitation of this feature to ivories of the so-called Nikephoros group [107] all the more remarkable, and tends to confirm the patterns of stylistic distribution on which Weitzmann's system of groups is based. But considered pragmatically for what it is—a shortcut (in all senses) used by a restricted number of craftsmen—it is instructive to track its incidence in relation to other technical characteristics of these same ivories. On the Naples plaque, for example, in addition to the line in question, one notices the *pentimenti* involved in the carving of the Virgin's left hand. The excision of the ground around the same hand on the plaque in Hildesheim, and the fact

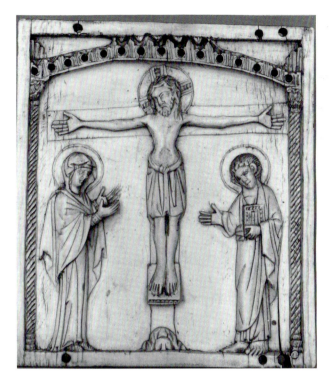

141. Naples, Museo di Capodimonte. Crucifixion (12.5 × 10.8 cm)

142. Leipzig, Grassi Museum. Crucifixion, detail of fig. 145

that the fingers are here carved in intaglio rather than projecting in relief, may indicate that the craftsman was attempting a similar correction. Changes of this sort and, in particular, a shortening of Mary's fingers, is found on a number of pieces, most notably perhaps in a Crucifixion in the Grassi Museum in Leipzig (fig. 142), a plaque that has been assigned to a quite different "group" of ivories.[108]

There is of course no reason why errors (and appropriate amendments) should be confined to any one set of carvers, clustered together on stylistic grounds. But the implications of a more conspicuous feature of the Leipzig Crucifixion—the Virgin's missing right hand—may show that palpable tricks of the trade are no less useful if we seek to construct not broad associations based on apparent resemblances but technical criteria that vindicate (or disqualify) groupings made on such a basis. The Hildesheim Crucifixion (fig. 33) shares with that in Leipzig evidence of both the craftsman's changing his mind regarding Mary's left hand and his carving of her right in such a way that it disappeared in the course of the plaque's history. The loss of a raised hand is by far the most common form of injury suffered by Byzantine ivories and one that discriminates neither by

"workshop" nor iconographical type: gestures of blessing, mourning, and supplication are all liable. In other words, the randomness of accident is at work,[109] operating generally because the limb was undercut.[110] In the case of Mary's right hand, however, this explanation is inadequate. To suppose that it would break at the wrist in the same way on a dozen images of the Crucifixion and the Deesis (figs. 11, 148)[111] is to exceed the bounds of probability.

The best way to approach the phenomenon is to start with a plaque that remains undamaged in this respect. Beside both the Virgin's hands on the Nuremburg Crucifixion (fig. 86)—to take an example on which, as we have seen, many traces of facture remain— are marks of the tool used to shape these members. Such marks are even clearer where the right hand has been lost: a detail of the Arnhem bookcover (fig. 143) displays not only visible outlines of the lost member and its digits but also the solid stump where the hand has broken off. The same portion of the Leipzig plaque (fig. 142) is, however, hollow, and contains vestiges of what may be restoration material. From the ghostly traces on the ground we may conclude that the right hand was shaped at the same time as the left. Yet a Crucifixion in Berlin (fig. 144) shows no such traces and the stump of Mary's forearm is a hollow tube designed to receive a dowel. Reason to believe that her right hand was separately carved and then inserted into a hole prepared for this purpose is strengthened by other examples where the hand has broken off and no traces of its working are evident on the ground behind it.[112] The addition of discrete pieces of material is well-known on French Gothic ivories;[113] till now Byzantine carvers have not been suspected of such artifice.

The greatest technical variety and perhaps the highest artistic accomplishments of our craftsmen are to be found in their modeling of the human body and the cloth with which it

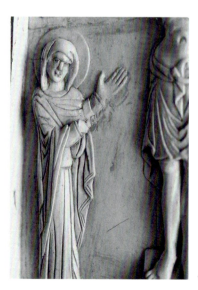

· 143. Arnhem, Gemeentemuseum. detail of pl. III

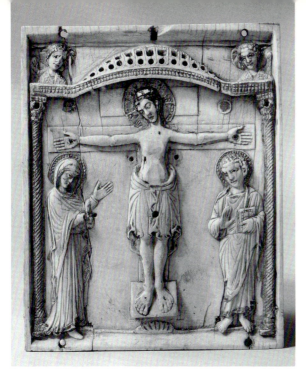

*144. Berlin, Staatliche Museen.
Crucifixion (15.1 × 12.0 cm)*

was normally draped. This judgment is based not on their success in imitating natural forms but on their ability to suggest what might be called an alternative reality. So, too, these achievements are not limited to one or more "groups" of carvers but found instead throughout the corpus of ivories. On the other hand, rather than being signs of independent geniuses haphazardly dispersed among the four hundred or so creations that we have from their hands, their performances are expressions of a shared aesthetic, a social model of what a plaque should look like. Long ago observed in matters of style and iconography, this community of intention and achievement is no less evident in the domain of technique. And, so widely distributed are the technical accomplishments that we are trying to recognize that these, no less than the content of ivories or the way they were organized, seem to represent ideals that linked one craftsman to another and these in turn to the buyers and beholders of their productions.

This ideal is evident in the demonstration that human flesh (and that of divine or infernal forms carved in the human image) is not something flat, inanimate, and uniform but the embodiment of process and diversity. The grain of the ivory on the Princeton (fig. 36) and Leipzig (fig. 145) Crucifixions, for example, was used to suggest a quite different sort of body structure from that on a triptych in the Cabinet des Médailles (fig. 146)[114] where the column of arcs creates an off-center axis to the torso. "Unrealistic" as accounts of the human body, each figure is energized by the grain, as are the balding cranium of a saint (fig. 8), and the arms, torso, and legs of Hades trampled by Christ on the Dresden Anastasis (fig. 147). The fact that the grain is a natural property of the ivory and not a creation of its craftsmen in no way minimizes his ability to exploit its contribution. Its

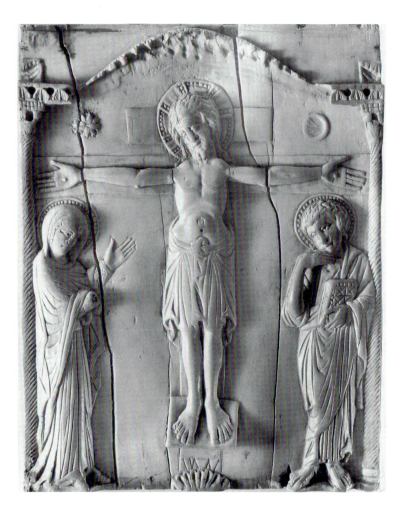

145. *Leipzig, Grassi Museum.
Crucifixion (14.1 × 10.9 cm). See
also fig. 182*

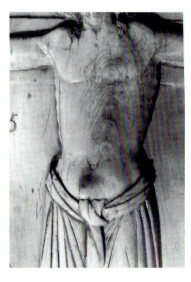

146. *Paris, Cabinet des Médailles. Crucifixion triptych, detail
of fig. 222*

147. *Dresden, Grünes Gewölbe. Detail of fig. 110, Hades*

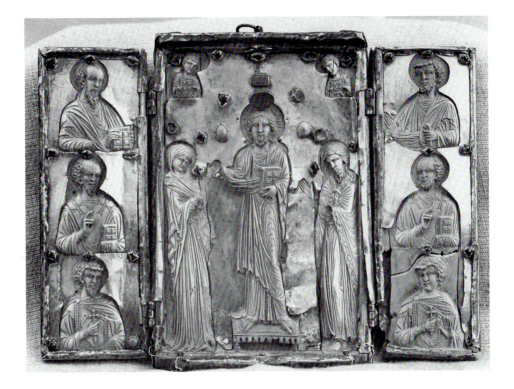

148. Tskhinvali, Museum of southern Ossetia. Triptych (overall 14.6 × 23.0 cm). See also fig. 216

occurrence is irregular—witness the way it inverts itself between the upper frame and the paneling of the door behind Christ on the Washington Doubting Thomas (fig. 57)—and only long experience of the material would lend some predictability to its manifestations and its formal potential.

The sculptors' purposeful use of the grain is made clear by the very infrequency of its appearance in areas representing cloth, where it would have proved much less useful than in depictions of bare flesh. Beautiful as are the rise and fall of the arcs on, for example, the tunic of the Virgin in the Metropolitan Museum's Hodegetria (fig. 30), it is evident how little they do to model its folds. Had they been available to him, one can imagine the carver of the Moscow Constantine (fig. 76) employing such forms in the drapery over Christ's right leg. But we have seen how rarely the grain describes these full ellipses. Where arcs of this sort were required, craftsmen preferred to depend on their tools as the carver did when shaping the Lord's left leg on a triptych at Tskhinvali (fig. 148).[115] Because panels were normally cut at an angle to the axis of the tusk, grain patterns appear erratically in any mass, such as cloth, that is carved to expose many levels.

Garments formed so as to convey a sense of depth are one of the supreme achievements of our ivory sculptors. This accomplishment lies very near the heart of the realism that contemporary beholders attributed to works of art;[116] for us it is not only proof of their

creators' mastery of illusionism but a distillation of the Byzantine system of signification. Even when figures suggest to the modern eye that they were conceived as little more than planar silhouettes to which undercutting, or more often Kerbschnitt, lends body, they imply the presence of internal lines that, in the very variety of their distribution, define the volumes contained within these contours. In the Berlin Footwashing (fig. 149), for instance, the repetition of folds between Peter's knees and behind his left leg denotes the looseness of the material in these regions and, at the same time, implies the space preempted by this material. Reciprocally, the minimal number of such lines over his upper arm and left thigh denotes the tautness of the fabric in these areas and connotes the masses of the limbs that here displace it. Their presence and absence, in other words, work synergistically to suggest substance. This is not to argue that every fold serves a single, volume-defining function: they differ as much in their length, depth, and shape as they do in their distribution. This saves them from reading as a homogeneous network impressed from the outside. Instead, they appear to be born of the movement of the limbs that underlie the cloth. Far from being elements used consistently within a schema of representation, they still refer to an understanding that entities behave differently in different circumstances. Thus below Peter's knee, and where his hip joins his torso, and where the fabric is gathered between the right arm and the chest of his neighbor, the folds are both deeper and broader than the lines in areas of lesser torsion.

Above all it must be stressed that no mechanical, mimetic system is in evidence: the semicircle on Peter's raised arm no more defines an actual fold than the inverted hollows, created by Kerbschnitt, at the hem of the other apostle's mantle represent the way in which material would hang in this situation. The forms are expressive rather than depictive, an approach shared by the more elaborate treatments of drapery to which we can now turn. In the Venice Apostles plaque (fig. 48) it is obvious that Paul's mantle is draped in a manner that differentiates him from not only that of John but those of his colleagues on any similar plaque (fig. 139, 226). Seen in this way, the baroque sweep across his chest is the high

stylistic gesture of a supremely confident craftsman. This much said, it is worth taking a moment to examine the means used to create this flourish and to recognize its kinship to other effects achieved with the same tools. The serpentine rush of folds is defined by overlaid pans[117] of greatly different depths, marshalled between rounded arrises that converge before they begin their cascade down Paul's left side. Drama is created by virtue of the contrast with both the more sober arrangement of John's costume and the shallow, classical catenaries that descend from the necklines of both their tunics. These disparate depths, like the converging furrows immediately below, could be achieved with the use of a scorper, or inshave, fitted with a curved blade that would hollow a flat or slightly rounded surface. The depth and width of the furrow excavated by the flexible blade of a modern woodworker's scorper (or scorp as it is often called) is determined by the amount of pressure applied and the angle at which it is held. If the Byzantine carver had no such flexible tool, the variety of results could be achieved with scorpers of different size.

In the hands of the master who carved the similar pair of apostles in Vienna (fig. 139), the instrument again works in terms of the oppositions it sets up. A detail-photograph of Andrew's costume (fig. 150) suggests the contrast, first, between the shallow pans over his right wrist and the deep folds that disappear under the rounded arrises of the cloth, and then between the width of these folds at their greatest point and their rapid diminution towards the points of convergence. On the third of these Apostle plaques, in Dresden (fig. 151),[118] the differences are even more deliberate. The regularity of the catenaries over Paul's abdomen is in striking contrast to the deep notches cut in the body of the fabric over his right arm. At the same time, both differ from the slightly rounded "flutes" in the columnar drapery over his legs. Disposed vertically or obliquely down the tunics of numerous standing figures, the shallow curvature of such pans, cut with a scorper or

150. *Vienna, Kunsthistorisches Museum. Detail of fig. 139*

151. *Dresden, Grünes Gewölbe. Paul's mantle, detail of fig. 226*

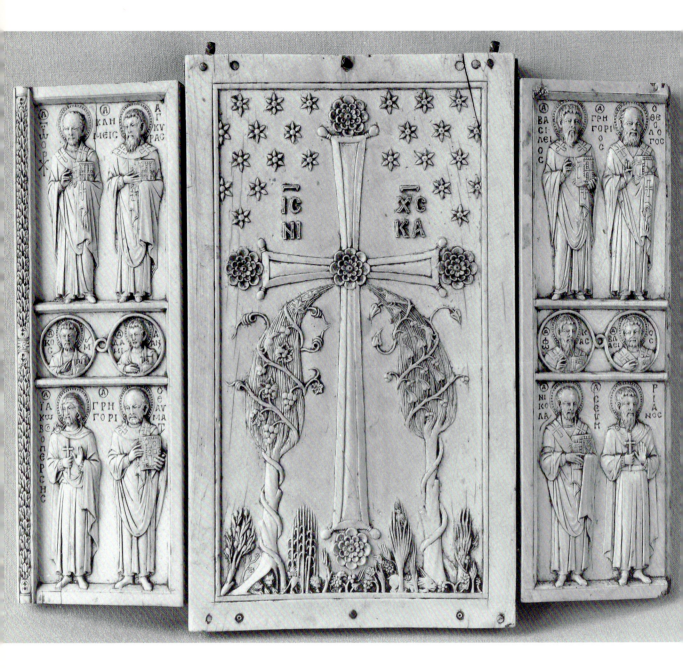

152. Paris, Louvre. Harbaville triptych, reverse
(overall 24.0 × 27.8; central plaque 23.5 × 13.8;
wings each 21.4 × 7.0 cm). See also fig. 170

153. Detail of fig. 152

similar tool and sometimes defined by much sharper arrises than those on the Apostle plaques, are a feature of plaques belonging to many different "groups" (figs. 8, 13, 39, 60, 94, 99, pls. I, IV).

It is vain to identify the tools used on other, smaller areas of plaques. If a drawknife shaped the shallow curves of the cross on the back of the Harbaville triptych in the Louvre (fig. 152),[119] the same tool or a small adze could have formed the trunks of the flanking trees—the facets on their surfaces (fig. 153) allow the use of either to be hypothesized. The incomparably delicate detail of the vegetation required a fine blade or needle file, a tool used earlier to form the threadlike bands of guilloche on the Leo ivory in Berlin (fig. 158b), while some sort of pick would have been indispensable in removing the material from around the creatures that cluster at the base of the triptych's reverse. As we have seen in the case of haloes and other details, carving at this minute scale in a confined area necessitated such an instrument and it is hard to imagine how material embedded deep behind the arcades of footstools (figs. 48, 139) could have been excavated without it. It makes sense to suppose that a tool used once on a plaque would have been used again in another area—an economy surely practiced in the arcades of the Utrecht Hodegetria where pick marks are in plentiful evidence around her feet (fig. 154).

The most spectacular examples of this sort of work are the columns and canopies that frame both narrative scenes and devotional images (pl. V, figs. 39, 91, 144). Because of the fragility of such openwork few survive in pristine condition; the baldachins, being further removed from the protection of the frames, have generally suffered more than the columns that support them. No two sets of this architectural ornament are identical. Although these forms were shaped at the time that the overall design was blocked out—as the angels' wings anchored to the modillions of the canopy on the Munich Dormition (fig.

154. *Utrecht, Rijksmuseum Het Catharijneconvent. Detail of fig. 99*

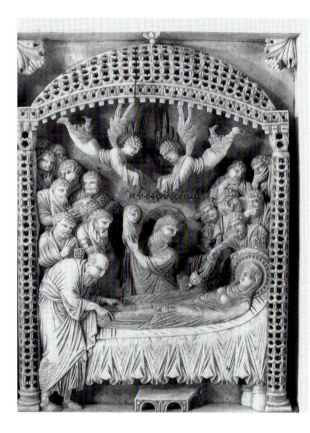

155. *Munich, Staatsbibliothek, Clm 4453. Bookcover with the Dormition of the Virgin (14.3 × 10.8). See also fig. 212*

156. *Detail of fig. 155*

156)[120] make clear—in their decoration carvers were limited only by their imagination and dexterity. Given the extensive amount of true undercutting on this plaque, it might be supposed that the canopy was produced in just this fashion. But the attachment of figures and particularly the size of the projecting area—the canopy in this case is more than two centimeters tall—prevented such a technique. Instead, as we can tell from plaques the baldachins of which are either entirely or partly lost, material from behind the curved surface was evacuated by means of picks. The first stage in such an operation was to pierce the semidome with punched, or more likely, drilled holes that were then enlarged to form a more or less complex network of cavities. The amount of labor involved may perhaps be inferred from the reduction in the number of holes on many ivories (figs. 43, 86, 91, pl. VI) or the practice of decorating rather than piercing canopies (fig. 108).[121] The painstaking procedure undertaken on the baldachin in Munich is part and parcel of this carver's attention to detail: if I am not mistaken, it is the only Dormition in which the features of the Virgin's face are carved on the manikin representing her soul (fig. 155).

Since the canopy in Munich is so well preserved, we have no exposed area to reveal traces of tools. But on the Berlin Entry (fig. 40), where a sizable portion of the baldachin is lost, the ground shows faint signs of a pick and what could be drill marks. The latter are more clearly registered on the small Crucifixion in Hanover (fig. 157)[122] and both appear

157. Hanover, Kestner Museum. Crucifixion, detail of fig. 185

above the head of Christ in the plaque in Leipzig that we have studied (fig. 142);[123] there may be a connection in terms of artisanal skill here between these signs of heavy-handedness and the pentimenti around the Virgin's raised hand.

For obvious reasons, lacy canopies were avoided on the lids and sides of boxes. On the one instance where they do occur—an iconographically mysterious object in Darmstadt (fig. 174)[124] now consisting of no more than two long and two short sides—they have suffered, like the reticulate columns on which they rest, as grievously as the undercut details of the scenes depicted and the openwork frames that surround them. Columns on boxes are also rare but when they occur (figs. 82, 137) it is as framing devices. Almost invariably they are carved not in filigree but with helical flutes and, again as often on plaques (fig. 59), they are out of plumb and support capitals perched at precarious angles. The labile columns flanking Christ and the apostles on the casket in Florence (fig. 137) suggest the disdain that Byzantine ivory workers felt for a straight-edge ruler once the panel had been cut.

Below the angels and above the head of Christ holding the Virgin's soul—in short, in the only available space—on the Munich Dormition (fig. 155) are four words, mostly abbreviated, identifying the scene. The relation, if any, between inscriptions on works of art and the contractions employed by scribes is an unstudied subject. Even the filiation between letter forms on sculpture and those used in books is a topic still in its infancy.[125] I am concerned here neither with the epigraphy in its own right[126] nor as a dating device. Consistent with the shape of this chapter, my concern is with the way inscriptions were used on ivories and when, in the course of production, they were carved. The second question can be answered categorically: they were the last step in the detailing of the plaque. This does not mean that on some ivories plans for accompanying text were not made at the stage of their initial design. On the David casket in the Palazzo Venezia, for example, one-third of the panel on the lid and a band running around all four sides (fig. 125) is reserved for inscriptions which express, if not the identity of its recipients, assertions about their piety and other noble qualities.[127] The verses on the sides of the box, composed for the occasion of its offering, are carved in relief on independent strips of ivory.

Provision for inscription was made on the Warsaw diptych, the left leaf of which (fig. 221) instructs the beholder how to respond to the pictures it bears, while the right (fig. 73) makes a self-conscious statement of the artist's humility *vis à vis* his creation and his hope of salvation.[128] Unlike the incised labels, crowded or expansive as space dictated, identifying the scenes on the strips between them, the sentiments raised in relief around the perimeter are visually well balanced and practically without abbreviation. Even more carefully planned is the relation of the texts to the overall design in the case of the Leo ivory, usually and wrongly identified as a scepter tip (fig. 158a).[129] As opposed to the identifications summarily incised on the columns and between the figures, the raised inscriptions on the lintels invoke the personages depicted immediately below them.[130]

158. Berlin, Staatliche Museen. Leo ivory, a. Christ between Peter and Paul (10.2 × 10.0 × 2.1 cm), b. from above.

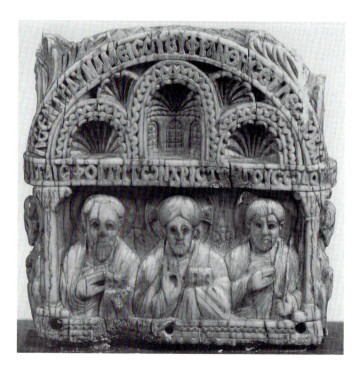

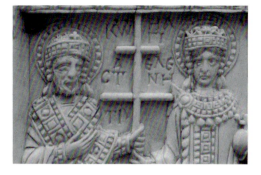

159. Berlin, Staatliche Museen. Detail of fig. 124, left wing

160. Berlin, Staatliche Museen. Detail of fig. 124, right wing

But fewer than a dozen ivories display such foresight. This number includes not only plaques (figs. 48, 139) and boxes (fig. 93) in which space was evidently left for sizable inscriptions but also those (pl. IV, fig. 152) where, to this criterion, may be added an execution as meticulous as the rest of the detailing. On the majority, nonetheless—even on a triptych as well laid out as that in Berlin (fig. 124)—the names of the saints tend to be squeezed into the interstices of the iconography. In the lower register of the left wing (fig. 159), for example, it is clear that the cross between Constantine and his mother was formed before their identifications were added. The letters of Helen's epithet are crowded to the point where there was space for the *alpha* of *hagia* only on the emperor's side of the cross, a transgression that seems to leave both figures aghast. The same triptych's right wing (fig. 160) shows not only the difficulty the carver faced in making rounded letters with a pointed tool but also the posteriority of the legends in the production process. The *iota* and *omicron* of Basil's name are both blocked by the contour of his shoulder while the terminal *C-sigma* actually penetrates the saint's sleeve. As in most but not all[131] book illustration, then, the physical evidence suggests that, on such ivories as are inscribed, this was done after the figures had been carved.

One reason for this sequence was the amount of detail required in lettering which, in terms of production, was the most time-consuming phase of ivory carving. At any stage in the operation a tool could slip and damage work already completed. Had the inscription been made first, any part of it could be injured by a tool skidding from elsewhere on the plaque: the "information" contained in a single letter is much more precise than that conveyed by a drapery fold or a detail of scenery. Mistakes or accidents in these areas, as we have seen, could be amended or ignored, but, even in a culture that lacked a standard

161. Vienna, Kunsthistorisches Museum. Detail of fig. 139

orthography,[132] damage to the text could destroy the effectiveness of the image as a whole. It is scarcely surprising that the majority of Byzantine ivories, and especially the box plaques produced *en série*, lack inscriptions of any sort. Of those that are embellished in this way, certainly the most labor-intensive were those with texts raised in relief. Unlike incised words, these required that the inscription zone be blocked out, like any other area to be carved. The upper and lower limits of each letter had to be defined. Traces of these scorings, which help to emphasize the projection of the relief, are visible in details of particularly painstaking inscriptions (fig. 161). The internal spaces of any letters more complicated than an *iota* had then to be picked out and, in many cases (figs. 48, 73, 139, 158), individually incised.[133] The results of such labor are more telling than the comparatively casual impression of incised work. The latter could achieve elegance, as on the reverse of the Cortona reliquary (pl. II), but this is a special case, carved at imperial behest.[134] At the other extreme lie the ragged letters of biblical paraphrases on caskets and plaques alike. These amply demonstrate the "picking up" that occurs when incisions are made against the grain of a plaque (fig. 162). Constraints of space could in some cases be compensated by diligent adjustment and abbreviation (fig. 159) but, in others, failure to observe the golden rule of craftsmanship—measure twice, cut once—necessitated the removal of large areas of the frame (fig. 127) to accommodate an inscription.

162. Lyon, Musée des Beaux-Arts. Detail of fig. 54

6. Finishing and Assembling

With his inscriptions ready, or even earlier if he decided to avoid this laborious task, the ivory worker could turn to finishing, a stage that involved almost always the burnishing of details on his plaque and sometimes the addition of paint. Our understanding of both these aspects of production is compromised by insufficient knowledge of virtually every ivory's provenance. The amount of polish on a carved limb or an article of clothing or furniture depends upon the use to which it was put during its life as a finished object, whether it served the role for which it was made or some other, unintended end. (The most we can assume is that objects like the Romanos ivory [pl. IV] which, after their removal from circulation, have been in museums for centuries, were not subject to the same wear as they endured earlier). Pigment, too, may well represent the fate of a plaque long after it was finished. The taste of a later age is as much a part of an ivory's "biography" as its production and purpose, even if this truth inordinately complicates the job of those who seek to write its history.

We know something of how ivory was polished in antiquity[135] but nothing of Byzantine methods (if these differed). In truth, apart from the objects themselves, our best witness to the practice of polishing comes from the late Middle Ages when Cennino Cennini instructed his pupils to smooth cornices and foliage made of gesso first "with rasps and then polish them as if they were an ivory."[136] What is patent are the reasons for this step. Despite the reconstruction of the working procedures that we have been able to infer from tool marks, the fact remains that, for the most part, these were polished off. Indeed, it is the ostentatious display of chisel marks, the signs of how material was removed from the ground, that leads one to doubt the authenticity of an object like the Deposition plaque in St. Petersburg.[137] Apparently tolerable when they appeared on surfaces that had already been worked (fig. 136) or overlooked when they occurred in small areas remote from the center of attention (fig. 134), in those rare circumstances when their value as evidence for a non-Byzantine hand is outweighed by other technical considerations (fig. 86), tool marks, by their nature or their absence, can constitute a prime criterion of authenticity. They are usually found, as the reader will have noted, on the unpolished ground beside figures as, for example, around the right shoulder of the executioner in the Hazor plaque in New York (fig. 163). But the second purpose of burnishing is indicated by the same detail-photograph. Far from indicating merely the luster of the blade (as Rubens might have treated it), polish was applied in differing degrees to hair, flesh, and clothing. It was used not to differentiate between textures but to sharpen the contrast between a variety of substances and the ground which, because of its lack of reflectivity, served as a foil to them.

It may be objected that the sheen is in the eye of the beholder who can be duped by the angle(s) at which the object is illuminated; to which the response is that the Byzantines

163. New York, Metropolitan Museum. Detail of fig. 79
164. Moscow, Historical Museum. Detail of fig. 76

were also beholders and that we have little idea how they lit their ivories.[138] What is sure is that the carefully "neutral" light in which the museum photographer posed, for instance, the Moscow Constantine (fig. 76) is probably no less a travesty of the circumstances in which it was originally observed than the chiaroscuro that enlivens the emperor's face, fingers, and gem-encrusted regalia in a deliberately sidelit view (fig. 164). The result is certainly not the inert arrest of the normal academic photograph; in turn we cannot be certain that it does not approach what I have called the alternative reality glimpsed by the Byzantines when they described their images.[139]

The essence of this vision was the actualization of Christian history, a heightened immediacy of figures and scenes from the past that demonstrated not simply their signifi-

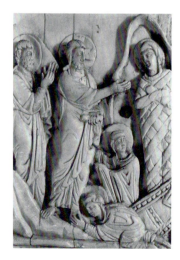

165. London, Victoria and Albert Museum.
Detail of fig. 31

cance for, but their immanence in, the present. This found artistic expression not in a simulation of the *observed* but in the realization of the *felt*. The actuality of an event like Mary's Dormition was effected by making the apostles present and palpable, despite their absence, much in the way that the Virgin's soul was incarnated as a doll-like form in her son's hands. Even flattened out in a standard photograph (fig. 155), but much more readily through direct experience of the ivory, the faces and hands of the apostles shine from the surrounding murk as if conjured by the expressive spotlighting of a tenebrist painter. It is important to note that these polished areas are far from the frontal plane of the icon. Looming out of the darkness, and their surrounding carapaces of worked hair and costume, they reflect almost as much light as more prominent details—the hips and shoulders of the angels, the rounded surfaces of Christ's body, Paul's bald pate, and the face and torso of the Virgin. This "unrealistic" lighting represents an application to the human figure of the technique of polishing remote surfaces that we have seen used on clothing (fig. 30). [140] At a material level the craftsman was doing no more than intensify the natural gloss of dentine. His artistry lay in his ignorance of the "laws" of perception. Instead of a simple binary opposition between salience and recession, he created a complex set of visual signals that connects the planes he had established at an earlier stage in his work.

The purpose of polishing, then, is a far cry from the role that white lead played in seventeenth- and eighteenth-century drawing, although an appreciation of the difference depends, as always in the study of ivories, upon the point of view assumed by the spectator. A frontal view of the plaque with six scenes from the life of Christ in London (fig. 31) suggests figures and settings caught by fitful splashes of light that function by virtue of their contrast to deep pools of shadow. Studied in detail, the light-bathed forms of the Raising of Lazarus (fig. 165) reduce to "half-tones" dotted with brilliant local highlights—on Christ's gesturing hand, the bridge of his nose, the cheeks of the women,

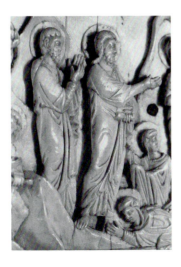

166. Oblique view of fig. 164 from left

etc. But a slightly oblique view (fig. 166) converts these foci into broader swaths of light that contribute powerfully to the rounding of shapes already formed by the scorper. Thus the nimbus of the apostle beside Christ emerges as a concave, enclosing shell, while the rock on which the Lord stands takes on a massive quality and a variety of contour only hinted at in the straight-on view. Because light now plays over large areas of both flesh and clothing these present volumes denied them in the chaste "studio" photograph. Without burnishing, the differences between such surfaces would be considerably smaller; with it, awareness of their activity and complexity—in short, of their substance—is heightened.

Precisely because polishing participates so forcefully in this illusion, one must approach with care the belief that broad areas of a plaque were painted. Zones of dark color would reflect light less brilliantly; regions covered with lighter pigment would lose their material kinship with other areas. Opaque color would cover the grain, so lovingly exposed on certain ivories. And paint of any sort would conceal polished areas which, as we have just seen, included faces, hands, clothing, architecture, and landscape in all its variety, making this penultimate stage of the craftsman's labor pointless. Such color as is preserved is found in areas left rough or worked to create a textured surface: one does not polish material to which one wishes paint to adhere. In contrast to what I once asserted on the basis of too small a sample of evidence,[141] color was applied to some Byzantine ivories, an observation that has recently been reinforced by findings made with the aid of electron microscopy.[142] The question now is not whether pigments were used but how extensively, and to what end? Were the traces still visible coeval with the plaques to which they attach?

Vestiges of paint are usually to be found in the same areas as toolmarks, that is, in the corners of the frame and in confined areas, overlooked or inaccessible to later attempts to clean them. They are evident, for example, even in a black and white photograph, in Christ's hair[143] on a Crucifixion in Hanover and on the rays that extend from the crescent moon above his left arm (fig. 157). On the other hand, much of the ground around the foot of the cross (not visible in our photograph) is stained green.[144] This last zone is distinguishable from the traces above by its extent and the way that it has entered into the body of the dentine. While all elephant ivory is hygroscopic and will therefore absorb pigment in solution, the paint on Christ's head and the moon is encrusted on the surface in a manner quite different from the matte region below. However unlikely, the use in Byzantium of two different polychrome techniques on a single object cannot be ruled out a priori. Rather, given the community of carving methods that we have observed, one can test the supposition that either or both are original by comparing them to the incidence of color on other plaques. This is not the place to attempt a catalogue of such traces: a quick look at some of the more outstanding examples should suggest the nature of both this sort of decoration and the problems that it entails.

One of the most elaborately painted of all Byzantine ivories is the Crucifixion triptych in Liverpool (pl. VI). On its central plaque the cross behind Christ's arms, the shell at its

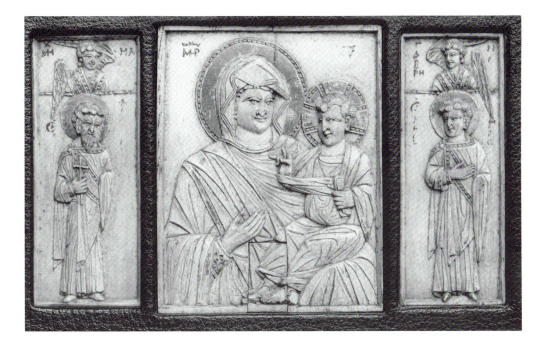

167. *London, British Library, MS Stowe 3. Bookcover with half-length Hodegetria, angels, and saints (central plaque 9.8 × 7.7; wings each 9.3 × 3.7 cm)*

foot, the Lord's loin cloth, Mary's *maphorion*, John's book, and the moon all have traces of gold laid over red, like the bole used by book painters. On the wings, the haloes of the saints as well as the angel's wings are similarly decorated, while the eyes of each of three figures on the right wing have blue pupils. Golden nimbi are far from rare and occur on ivories that differ widely in other respects. They are found, among many other instances, on the Cortona cross-reliquary (pl. I), on another plaque in Liverpool,[145] and on a triptych dismembered and reused on the modern cover of a tenth-century German gospelbook in the British Library (fig. 167).[146] This last example also has gold on the Virgin's outer garment, the Christ child's tunic, the wings and *loroi* of the angels, and the tips of the saints' mantles as well as on George's shoes on the right wing. His name and those of the other figures are indicated by red-painted but unincised inscriptions, of a sort that is also fairly widespread.[147]

In at least one instance it is clear that such legends do not date from the time the plaque was carved. Christ's words to his mother (John 19:26), below the cross-bar on the upper register of what is now an eleventh-century book cover in Munich (pl. VII)[148] could certainly not have been written when Longinus' lance was still in place; similarly, the instructions that Christ gives to John (19:27), inscribed in the corresponding spot under

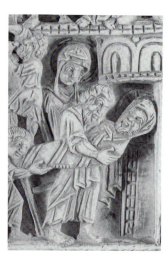

168. Munich, Staatsbibliothek, Clm 6831.
Detail of pl. VII

his left arm, could have been added only with difficulty while the staff was still attached to the sponge that remains on his chest. These are written in the same red letters, complete with breathings and accents, as the labels identifying the two scenes; all may be considered doubtful parts of the original decoration of the plaque. This being the case, one tends to be suspicious of the red paint on the cross-bar in the upper scene and on the arcades of the tomb in the lower (fig. 168). Traces of gold over red on Christ's nimbus and that of the Virgin in the Crucifixion, and on those of the principal figures in the other two scenes, differ from the normal gold foil or paint found on haloes in that they are here confined to their scored outlines. Gilding on their flat surfaces has possibly been removed by cleaning or abrasion.

It is obvious that some plaques have been excessively cleaned. Both the obverses and reverses of a Deesis in London[149] and a Crucifixion in St. Petersburg[150] seem to have been scrubbed with detergent. Their bone-white appearance exceeds the broad range of hues that ivory, even after years of exposure to sunlight, normally presents. On the other hand, some plaques may have been colored in response to eighteenth- or nineteenth-century "medievalizing" impulses. This would seem especially true of the red and blue paint lavished on the medallions and scrolls on a box in New York (fig. 68) and on the Forty Martyrs in the Hermitage (fig. 28) where blue is applied so thickly that it fills the inscription, making it difficult to read; color on the similar plaque in Berlin has been tactfully removed.[151] Since the pigment on the frames, nimbi and parts of the costumes of Symeon and the Virgin in the Hermitage Presentation (fig. 240) is the same dull gold as in the inscriptions from the Vulgate, it is obvious that the coloration here is not Byzantine. In other cases the age of the paint is unlikely to be determined until such traces of pigment have been physically or chemically analyzed, and even then there will remain the problem of interpreting the polychrome in terms of period taste. To equate such treatment of plaques with the impulse behind the brilliance of Byzantine enamels and textiles is naive.

146

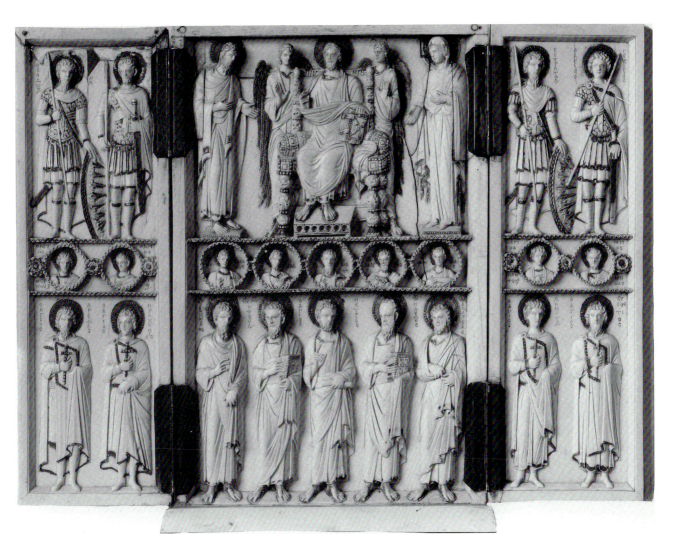

169. *Vatican, Museo Sacro. Triptych (central plaque 26.7 × 16.3; left wing 25.2 × 8.2; right wing 25.2 × 8.9 cm)*

In these media color was an intrinsic part of the material before it was worked; on ivory pigment is, by definition, an addition to the dentine after it had been carved.

A further difficulty lies in the part that colors played in the decoration of a plaque. Distinct from the polychrome detected on the Joshua plaques in New York (figs. 50, 69) and London,[152] are buff blotches both on their frames and on the armor of the Israelites. Implausible as part of the original decoration, these are possibly traces of glue or size on which gold was laid, or a base to lend body to the gold. This latter function seems to have been the role of much of the color on the large Deesis triptych in the Museo Sacro (fig. 169).[153] Haloes, wings, fighting skirts, sword blades, the cushion of Christ's throne, and more are all so decorated: with the exception of the hinges, virtually every area that reads as black in our photograph is, in fact, painted a dark green. To much of this green, nonetheless, flecks of gold adhere. Together with the improbability of dark green swords

147

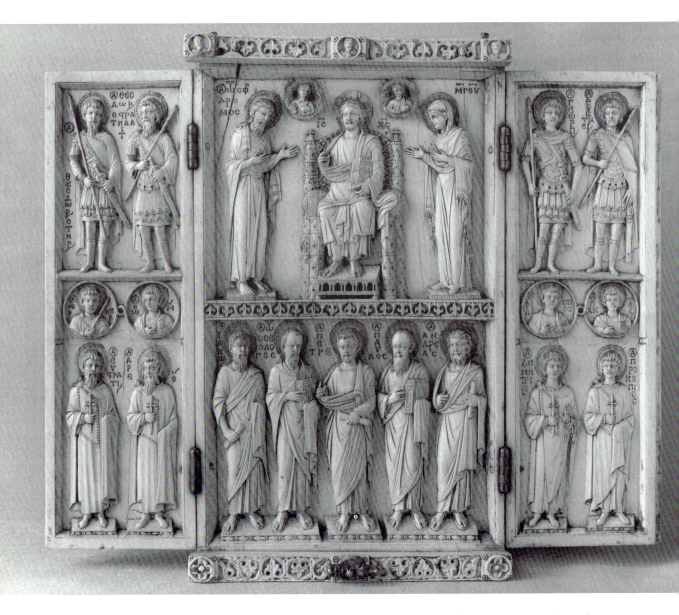

170. *Paris, Louvre. Harbaville Triptych (overall 24.0 × 27.8; central plaque 23.5 × 13.8; wings each 21.4 × 7.0 cm). See also figs. 152, 227*

and haloes,[154] this fact suggests that green, like red and other colors, was used on some plaques as an *intonaco* for gold.

Consistent with the elaboration of the carving—extending even to the tendons on the backs of hands—the inscriptions are incised and then infilled with red. This is equally true of the labels identifying the four scenes from the life of Christ on the Quedlinburg book cover (pl. VIII, fig. 104). Here, however, the legends are further heightened by the gilding of the ground around them. Gold over red is used on the Child's crib, the angels' wings, the river of the Baptism, and, in the lower scenes, for Christ's loincloth, both crosses, and the footstools of the Deposition. The total effect is surprising to one accustomed to the various mellow tones displayed by most Byzantine ivories—and most Byzantine ivories, it must be recalled, present no polychrome whatsoever to the unaided eye. Yet there can be little doubt that some, in their original state, had at least gold nimbi and red inscriptions. Given the number of pieces with very different provenances that retain traces of color on costumes, weapons, and other furnishings, it seems likely that pigments other than gold were used on occasion. A final assessment will not be possible till Byzantine products receive the same judicious scrutiny as have Anglo-Saxon ivories.[155] In this case, the amount of paint judged to be a later addition is as remarkable as the number on which it is arguably original.

If the age of some of the paint of Byzantine plaques is open to question, there can be little doubt about the originality, or lack thereof, of the hinges used to convert many into diptychs or triptychs. The modern appendages that now join the leaves of the Vatican triptych (fig. 169), represent one, albeit the worst possible, solution to a problem that our craftsmen never solved—how to connect the elements of an assemblage in such a way that they could move freely yet without coming apart. The two principal methods of attachment are represented by the pivots that allow the wings of a triptych to swing, like doors within a frame, between a cornice and a base as on the Liverpool Crucifixion (pl. VI), and metal butt-hinges of the sort found on the Harbaville triptych (fig. 170). While both these pieces are in good shape, the toll that continuous use has had upon many others is strikingly evident. The inner frames of the Berlin triptych's wings (fig. 124) have broken, and are partly restored with replacement material, near the points where they are doweled into the cornice and base of the central plaque. Hinges have done no lesser damage to the Hodegetria triptych in Baltimore (fig. 91) and the Warsaw diptych (fig. 221). Except in rare instances, neither means of attachment has stood the test of time, nor can either be considered a "solution" that replaced the other.

The study of such fittings has been bedeviled by assumptions that the butt-hinge was a later substitute for the pivot method[156] and that the choice of system is related to supposed distinctions between metropolitan and regional manufacture.[157] In truth, both mechanisms are broadly grounded in Mediterranean traditions of carpentry and metalwork. Hinges with doweled pins occur on such wooden objects as a box from Karanis in

Egypt now at Ann Arbor,[158] while butt-hinges were used on early Christian silver reliquaries.[159] The pivot method of forming a diptych or triptych is known on wooden panels no later than the sixth or seventh century[160] and the joining of wings to cornices and bases, as on the Liverpool triptych (pl. VI), was routine by the time of this object's construction, not only in ivory but also in wood.[161] Such devices represent a concept applicable to a wide variety of materials. This does not require, however, that workers in any one medium knew or used only one method. The fact that the hinges of the diptych now divided between Dumbarton Oaks and Gotha (figs. 24, 25) were set in the edges instead of the fronts of these plaques has been interpreted as a sign that these cuttings were not Byzantine and original but Western and later.[162] Yet mortices of this size and shape are found on both former diptychs (fig. 110) and triptychs (fig. 99); cuttings in their sides rather than on their faces are an insufficient basis on which to argue that the Gotha-Washington plaques were originally organized as a group of three (including a hypothetical lost member) rather than as a pair. Mortices, prepared for the reception of what we now call a piano-hinge and cut into the edges rather than the fronts of plaques, were the standard method of assembling consular diptychs in both East and West.[163] Many of these diptychs were reused in the Middle Ages for liturgical purposes and thus available as models to a craftsman interested in ancient ways of joining ivory.

The excellence of construction of the consular diptychs, as opposed to their often summary and mechanical carving,[164] brings up a problem that has hardly been faced with respect to the Byzantine ivories with which we are concerned: the discrepancy between their often first-rate sculpture and their frequently disastrous manner of assembly. In those few cases where the cornices and bases of triptychs survive, the slipshod manner of their attachment to the central plaque, and the results of this crude method of nailing, are unmistakable (fig. 148). At the best of times, the use of hardware in conjunction with dentine is an unhappy response to the need to join, fasten, or lock one piece of ivory to another. The only original lock surviving on any Byzantine box is that on the Veroli casket.[165] This hinged device is attached to one end of the sliding lid and fastens to a metal plate on the right side of the box; both fixtures obscure the ornament. But worse damage was caused by the bronze handle formerly attached to the box's left end.[166] Used to support the weight not only of the box's contents but of its massive wooden matrix (much heavier than the ivory and bone revetment that it supports), it broke both the rosette strip to which it was fastened and those that flanked it.

Such failure to calculate the effects of wear and tear may express a social mentality little concerned with the passage of time. More certainly it necessitated the widespread repairs that are characteristic of Byzantine works in many media.[167] Consideration of the boxes as manufactured objects rather than as vehicles of artistic style can tell us much about production in general and, in particular, of the craft with which we are here concerned. Their cladding, indeed, provides the only cogent evidence for fabrication in a

171. Washington, Dumbarton Oaks. "Rosette casket," open. See also fig. 17

workshop setting. If, as I have suggested, most ivory plaques indicate creation by independent craftsmen, this seems no less true of the bone revetment applied to the exterior of more than a hundred wooden boxes.[168] It is not their techniques of carving but methods of assembly that testify to a stage of production physically and aesthetically removed from the context in which they were originally worked. The lid and sides of a casket in Washington, for example, bear carefully worked plaques of mythical animals, old men and especially children depicted as warriors that are close to being caricatures (fig. 17).[169] These are joined to a wooden core by long bone pegs (fig. 171). So precarious a means of attachment seems to have been taken into account in the number of pegs used in many of the plaques. These are often at once redundant and destructive of the images through which they are driven with little regard for their physical or iconographical integrity. A few finely made caskets such as the Veroli (figs. 61, 128) and many with Old Testament scenes carved in ivory (figs. 50, 52–54, 132) show no signs of hasty workmanship. But the boxes clad in bone almost invariably witness to such sloppiness. One set of revetments in London, scarcely more than 20 centimeters long, has nearly eighty pegs or peg holes (figs.

172. London, British Museum. Box plaque with hunting scenes (9.6 × 31.6 cm)

173. Reverse of fig. 172

172, 173, cf. figs. 64, 75).[170] Even if not all are original, many are punched directly through the figures, damaging them and wreaking havoc on the thin ground against which they are set.

On these boxes, too, there occur plaques exhibiting clearly different standards of craftsmanship. A skillfully drawn battle scene, its ivory figures both undercut and rendered in Kerbschnitt, occurs on the lid of a casket the bone spandrels and sides of which are peopled with isocephalic, comic-opera versions of warriors.[171] The object that offers these contrasts of skill and substance has, like the majority of such boxes, been cobbled together in a modern restoration, but there could scarcely be a clearer case for the necessity of recognizing both the contribution of discrepant hands and their artificial agglomeration. Other than the serial production implied by the huge number of surviving boxes—many bearing all but identical figures or scenes—we have no evidence for the workshop production of carved ivory and bone in Byzantium. The contrast between the indifferent materials, manner of assembly, and durability of these boxes and those carefully put together with lids and walls of solid ivory (figs. 68, 93, 125) suggests that the latter are the creations of single craftsmen. It is time to return to these masters in their historical context.

IV

THE MASTER IN CONTEXT

1. CRAFTSMAN, DESIGNER, CLIENT

The techniques that I have just analyzed belonged to a world of craftsmen, a world the only record of which is the objects that they made. This was a realm of tools and materials rather than of written documents; hence it has gone undescribed and little regarded in the modern world. On its face, the way something is made is not a matter of immediate concern either to those who bought or commissioned objects or to those who planned the more elaborate specimens that have come down to us. Nonetheless, it is obvious that these techniques did not exist for their own sake. They pertain, in ways that remain to be examined, to the slightly less shadowy domain of the market[1] and the role that the craftsman played in society. Save for the artifacts preserved, and a few regulatory texts,[2] the world of Byzantine production remains largely obscure. Yet if the ivories, like other products, are to be understood in anything like their original contexts, we should pursue the connections between their makers and, on the one hand, the sources of the ideas that they executed and, on the other, the clients for these craftsmen's output. This chapter is devoted, first, to such human connections as can be inferred from the objects and then, still on the basis of the material evidence, to a sampling of the connections that can be established *between* objects to test if such relations are in themselves revealing. The techniques that we have examined were only means to an end. Reserving the *ends* of Byzantine ivory working till later, we are, for the moment, concerned with that which moved the hands in question—the minds of those who sponsored, stimulated, carved, and bought the artifacts with which we are concerned.

These factors represent, so to speak, a carpet, the overall pattern of social, economic, technical, and ideological circumstances that embrace individual acts of creation and consumption. Yet since (as we shall see in Chapter V), there is so little evidence for technical *change* in the period when we can be sure that ivory was being imported and worked in quantity, this pattern is more or less a set of constants. It circumscribes but does not define specific achievements. Seen only as a set of particulars, any work of art—indeed any human activity—is not fully comprehensible; it must be seen as part of a pattern. Conversely, because the pattern links and thus modifies the way in which its elements are

perceived, it limits the appreciation of those elements. The general texture subsumes and to some extent disfigures its components; it emphasizes connections at the expense of idiosyncrasies. Both approaches—attacks, as it were, on the problem from either end— are necessary if we are to see the carpet whole without losing sight of its constituent figures. These figures are the craftsmen who carved our ivories, those responsible for the intellectual design of the more complicated examples, and those who bought the finished products, complicated or relatively simple. Since social, economic, and ideological forces bore on each of these stages, it will be useful to consider the last two of these groups first. But more than a concern for context demands that we postpone consideration of the artists involved. We have looked at the methods they employed, means which open the doors but still do not give us entrée into the house of the craftsman. The problem of artistic identity is sufficiently difficult to merit separate treatment (chapter IV.2), and even then our investigation will not be complete until some of the prime testimony to such individuality—the artifacts that they made—has been heard (Chapter IV.3).

Yet to call the clients as our first witnesses does not mean that they will present simple, unequivocal evidence. The "patron," usually treated as the maker of a work of art in Byzantine documents, can be shown occasionally to have had some hand in its creation.[3] More often, he or she is invisible.[4] Indeed, so far as many of our objects are concerned, this person may as well have been nonexistent. The vast majority of ivories represent social, not personal, contracts. They suggest no reason why they should have been made according to the specifications of an individual, as against a collective, will. Knowing and sharing the latter, their makers seem to have carved them with an eye on broadly held preferences, tastes that expressed themselves in the marketplace. Even cases

174. Darmstadt, Hessisches Landesmuseum. Box panel (9.4 × 16.8 cm)

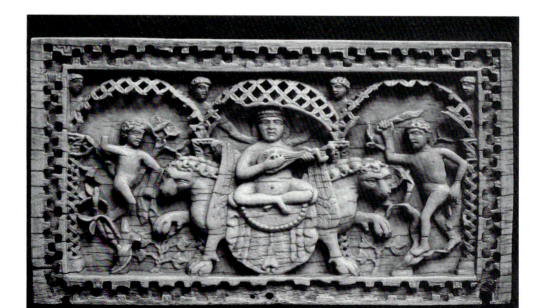

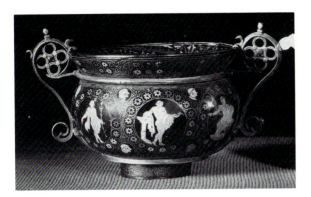

175. *Venice, Treasury of S. Marco.*
"Mythological" bowl

that are normally taken to be exceptional, such as the Darmstadt box panels (fig. 174),[5] suggest nothing about their client other than that he or she, for whatever reason, wanted a container that displayed snippets of classical legends, imperial imagery, and (to us) a vague, apparently archaizing orientalism. Such a gallimaufry is not unknown in tenth-century Byzantium: the famous "mythological" bowl in the Treasury of S. Marco in Venice (fig. 175)[6] offers a loose analogy. It is not likely that the Darmstadt panels or the Treasury bowl represent the taste of a solitary eccentric. But, given that we have from this period neither literary parallels for such eclecticism nor any basis on which to decide whether the imagery on the Darmstadt ivories constitutes a "program" or is purely ornamental, it is idle to speculate on the identity of their first possessor or the extent to which this person might have determined their content.

A literary equivalent of the Treasury bowl might suggest that it embodied a single, coherent theme. Its sequence of roundels seems to present a purely paratactic arrangement of classical motifs whereas works in other media, such as the Veroli casket (figs. 61, 128), demonstrably involve a syntax of scenes and figures that is at once complex and subtle. Unless in every such case we posit a patron with enough time to devise its scheme of decoration, and enough "contacts" at the artisanal level to arrange for its production, the relationship between client and craftsman requires a third figure, an intermediary with a foot in both worlds. The ability to invent and the capacity to commission such a creation is not an inconceivable part of the equipment of Byzantine dignitaries whose education and cultural ambience made them familiar with the classics of ancient Greek and Christian literature: there may well have been a Byzantine Jefferson or Lorenzo de' Medici. But far more likely candidates for the post of "programmer" were the swarms of intellectuals who haunted the houses of the élite. Such a person would be able, first, to translate into visual terms the ideas involved and then to convey them to the craftsman. Even if scholars have been unable to identify them by name, such figures had existed at least since late antiquity. They have been called "designers,"[7] an appropriate term the very ambiguity of which

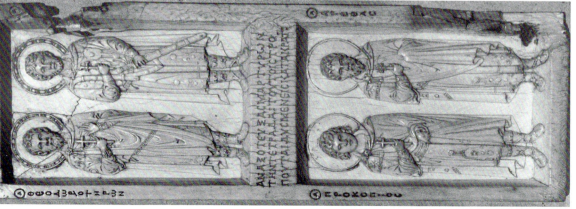

176. Rome, Palazzo Venezia. Triptych (central plaque 23.6 × 14.2; left wing 20.8 × 7.6; right wing 20.9 × 6.9 cm)

implies a concern with both the underlying idea and the object in which it could find expression.

A designer of some such sort must have been responsible for so intricate a work as the Palazzo Venezia triptych (fig. 176) in which images of martyrs and bishops, as well as an unusually long inscription, articulate the notion that the emperor is under divine protection.[8] Although it is composed of saints and composite units such as the Deesis, firmly grounded in both ritual and representation, as well as an ideology that binds its message to other works of the period, these have been manipulated to create a specific effect, a diachronic gallery of figures brought to bear upon a particular historical situation.[9] In contrast, no designer would have been needed for such standard images as the Nativity (e.g., figs. 42, 104, 105), the Crucifixion (e.g., figs. 7, 9, 86, 141, 144–45) and the Dormition of the Virgin (figs. 18, 155), three of the most common subjects of ivory carving as of other arts. Awareness of this sort of scene was part and parcel of the mental equipment and visual experience of every Byzantine. Even when iconography was adapted to reflect a particular nuance, as in the case of a Crucifixion in New York (pl. V),[10] given its fidelity to traditional compositions it is hardly necessary to postulate the intervention of a designer. But an ivory such as the British Museum's Ezekiel (fig. 127)—a miniature treasure house of biblical and Patristic allusions brought into play to support a typological equation between the prophet's raising of the Dry Bones and "national" self-consciousness in the tenth century[11]—is inconceivable without the intervention of someone adept at such purposeful associations. Even though the sculptor was ultimately responsible for the physical approximation whereby the Lord and Ezekiel are made to resemble each other, the meaning of this juxtaposition depends on the ideological plan of the entire schema. The role of a designer here would be all but indispensable.

Yet his presence is even more wraithlike than that of the patron. No written documents attest to the activity of the designer, though his or her existence may be postulated on the ground that exalted clients did not normally hobnob with men who worked with their hands. Certain emperors, notably Constantine VII, for whom the Palazzo Venezia triptych was probably made, are credited with the creation of works of art.[12] But these attributions occur in the context of imperial patronage and munificence and are thus hardly independent witnesses to direct involvement in the business of fabrication. The other side of this coin is the few explicit references that we have to artists' dealings with the court. At the beginning of the eleventh century Pantoleon the icon painter, and apparently also a miniaturist, is said, in a text already referred to, to have been "engaged upon an imperial commission,"[13] but the mechanism whereby such transactions were negotiated, let alone planned, is left unspecified. In light of the silence concerning this aspect of the behavior of an élite whose other activities constitute the main subject of Byzantine documents, it is scarcely surprising that the vast majority of those who executed their commands remain unidentified in such records. Until the twelfth century the names of

most of the artists that we know[14] come from founders' inscriptions preserved by chance in a few scattered churches. To this motley group, in the fourteenth century are added others named in encomiastic verses written to honor not them but those who commissioned objects that they had ordered.[15] In Byzantium, then, founders and funders receive occasional mention; artists' identities are almost never recognized for their own sake.

2. ARTISTIC IDENTITY IN BYZANTIUM

To be unrecognized is not to be unrecognizable. That painters and sculptors are not named is a signal characteristic of Byzantine culture in the tenth and eleventh centuries, yet we are not obliged to adopt the custom. Indeed, to do so would be to walk into a trap that the Byzantines themselves set[16] and to fall victim to the erroneous belief that, by accepting their conventions, we shall understand them better or "see" things in the Byzantine way. The delusion of objectivity is not a tenable position for scholars at the end of the twentieth century; for our purposes it is also an impediment in the way to a proper assessment of Byzantium's artistic achievements.

Nor is it useful to suppose that we should recognize only that which already has a name. In Byzantine art, Christ, the Virgin, most saints, and many scenes are frequently named in inscriptions but it would be absurd to insist that such captions were prerequisite to their identification. Rather, the value of the label lay in the fact that it completed the image and often enhanced its value.[17] When missing, as they generally are from icons of Christ alone (figs. 116–118) and the Virgin and child (figs. 15, 43, 59, 60, 99, 108, 195–96, 199–205), clearly their absence did not hinder their veneration. In the light of what we have seen of the relative "importance" of clients and craftsmen, it is not the absence of artists' signatures but of donors' names that is remarkable. Being inessential, inscriptions were regarded as increasingly dispensable in our period.[18] If Christ and the Virgin could "function" without labels, should those who "made," i.e., bought, their representations be identified? A donor is represented on only two (fig. 188)[19]of the hundreds of ivory plaques that survive, and only one (pl. II) is named.[20]

Craftsmen are even more elusive figures. Indeed in the entire corpus of ivories, only two are mentioned and one of these only by synecdoche. "While the hand and the chisel that carved the image (*typos*) of Christ were feeble . . ." begins the inscription that runs below the Lord on the Palazzo Venezia triptych (fig. 176).[21] The sculptor is to the patron as the chisel is to the sculptor—a tool, not a sentient being. Can one or should one seek therefore to identify a hand? My answer to this question is an all-but-unqualified yes. The only provisos are that this be done in the right way and for the right reason. The right way is to come as close as we can to the craftsman, to hold the ivory that he held and not to

depend, as the user of this book might be tempted to do, on reproductions. Two-dimensional simulacra of three-dimensional entities, photographs cannot lay claim even to the Byzantine justification for imitations. Mimesis worked for the Byzantines because, it was believed, a good copy shared all the essential qualities of the original.[22] Unless he or she is willfully naive, no modern observer can accept this theory. Chronologically, we are a millennium removed from the circumstances that allowed this view; philosophically, the gap is infinitely vaster.

This theoretical distance, in turn, vindicates the effort to distinguish one artist from another. By refusing the trap that is the absence of names, we reject the notion that "hands" (and a fortiori bodies and minds) are merely the undifferentiated instruments of a higher being. At least to my eye, sculptors can be seen to have worked in different ways, differences that are interesting in their own right and to which I shall turn presently. But the proper recognition of this range of manners is also one way to pierce the shell of a society that defined itself as homogeneous and therefore cohesive, ancient and therefore legitimate, orthodox and therefore divinely protected.[23] Self-perceptions are notoriously deceptive; as history shows in the case of Byzantium, they ultimately proved no defense. Until the twelfth century, nonetheless, this carefully forged armor served to protect this society from the outside world, even while domestically it stayed the dragon that was the individual will. *Hybris* was the essential characteristic of usurpers; something close to hybris could make a man set his name up where the names of God and his saints belonged. *Topoi* of modesty ("While the hand and the chisel . . . were feeble") served artists, scribes, and their clients as charms against this demon; rare on objects, such incantations appear regularly in manuscripts. It is no accident that the period which saw the undoing of the Byzantine state was also the time when the figures of patrons and artists appear to dot what might be taken for a largely unpeopled landscape.

I shall argue that this is the time, too, when ivory all but disappears from the mercantile and artistic commerce of Byzantium.[24] If this is true, it follows that the objects with which we are concerned were the expressions of people who, on the face of it, are as unknowable as the traders who furnished Constantinople with elephant tusks. The way to know them is not to invent them, to reify a "hand" by shrouding it with a disingenuous pseudonym as has been done with Italian Romanesque art.[25] Nor should we invent "careers," as some have done for ancient Greek potters and painters, claiming that the way in which a plaque is shaped is sufficiently close to that of another to allow us to see in it an adolescent or superannuated version of a particular master's hand.[26] Unlike red-figure artists, ours do not even have names. Being nameless, they can have no biographies and therefore we can plot no careers for them. Nor can we (if we presume that ivory sculptors worked on occasion outside the capital) trace a craftsman's removal to the "provinces" or his return to Constantinople with "exotic" ideas—those hypothetical movements beloved of art historians seeking to explain stylistic changes—as we can track the journeys to

Noyon, Paris, Limoges, and Solignac of the seventh-century goldsmith Eligius.[27] Even were there compelling evidence for ivory carving far from the capital, which there is not,[28] there would remain the assumption, recently shown to be unwarranted, that the provincial products of tenth-century craftsmen were isolated from tendencies in Constantinople.[29]

Although it is obvious, say, to a student of Cranach, that a youthful piece of work need not resemble one of the artist's maturity,[30] we know so little about the life expectancy of craftsmen in Byzantium that extrapolations backward or forward in time from the notional floruit of a master, whose main body of creation has yet to be demonstrated, would be ventures in an aesthetic wonderland. On the other hand, to insist in the spirit of positivism that the way in which two plaques are carved be identical before their common creator is admitted is not only a logical nonsense (we are faced with *two* ivories, not one) but a test that would be meaningful (in Byzantium as elsewhere) only if all other things were equal. Such variables as the nature of the commission, the quality of the material available, the impact of different models, and even the sculptor's mood—presumably even Byzantine artists had their Monday mornings—blunt the demand that total consistency be the test of authorial identity. The utility of the hypothesis that two or more pieces are by the same hand lies not in its certainty but in the establishment of criteria that enable us to discriminate one from another, superficially similar work.

How then, between the Scylla of free association and the Charybdis of infallibilism, should we proceed? The reader who accepts that the effort to distinguish between master sculptors is worth making is entitled to some description of a method by which this can be achieved. Even those who reject this end, and who presumably have by now abandoned this book, might agree that the only way to approach these unknown masters is by studying their creations, not ours—which is precisely the path we have taken to this point by refusing to endow them with names and curricula vitae. To the hardy survivor I suggest that the question cannot be begged by merely asserting that the notion of artistic identity did not occur to the Byzantine mind. Still, at this point I am less concerned with *mentalité* than with the pragmatic business of producing objects for display, devotion, and delight. And I have already argued that what the Byzantines professed to be interested in should not be allowed to limit our interest in them. If we reject medieval limitations on our approach to medieval objects, self-imposed modern prejudices are not ideas to be cast aside lightly; they should be hurled with great force. The notion, for example, that a craftsman produced his signs "unconsciously" is at once patronizing and incorrect. The fact that he did not have to think about every blow of his chisel (if this were his instrument) is a tribute to skills acquired through experience, not evidence of mindless activity. It is an illusion to believe that the movements of his hands are meaningless until we sort them into patterns and assign motives to his motifs. His techniques were no less purposeful for being unreflective[31] and were evident in the way the material was worked long before they became apparent to the modern beholder of any particular ivory. Indeed, learning by

160

observation [32] would have been one of the reasons why there are similarities between the products of different hands and one way in which working methods were transmitted from one generation of carvers to the next.

The nub of artistic identity lies in the relationship between technique and style. In Chapter III I tried to describe methods of preparing and carving ivory which, although not used by all Byzantine sculptors, were practiced by the majority. These techniques represent a reservoir of craftsmanship drawn on by many who varied in their talents. Yet questions of quality aside, similar methods could be used to produce quite dissimilar results. For instance, the figures on the plaque in Munich with three scenes of the Passion of Christ (pl. VII) all seem to press against a sort of glass screen. A similar plane is to be found on the Vatican Nativity (fig. 105), an invisible "surface" poised slightly higher than the level of the frame and against the inner side of which are pasted, as it were, the flat silhouettes of the Virgin, the child in the crib and other actors in the scene. Yet the net effect is utterly different. Mary's dropped hand and the tail of her *himation* point to the bathing child who, turned to our left, begins a steady movement that runs across the bottom of the plaque and up its left side, ending in the rays of the star that return us to the stable center. All is orderly, rhythmic, controlled. In contrast, the invisible window of the Munich ivory vouchsafes a glimpse into commotion. No less symmetrical than the Nativity and again dominated by the hierarchical enlargement of the most important persons, every movement is passionate and peculiar to the figure that makes it rather than part of a measured and coherent progress around the composition. There is no still center: in the ivory's original state—with the triangle formed by Longinus' spear and the rod of the sponge-bearer still in place to match that of the ladders in the register below—the Crucified would be less isolated from the hubbub about him, his splayed fingers and pathetic form resembling the suffering of all his witnesses. Yet the urgency of these scenes, like the calm of the Nativity, is displayed between two planes—that of the ground and that of the picture's surface, a mere six millimeters in front of it. If the "window" technique is common to both plaques, the visions it allows seem to belong to different worlds.

Conversely, different methods of figure carving could serve the same ends. Despite the impression conveyed by the photograph (fig. 105), shot straight on and lit from the sides, virtually all of the cutting in the Vatican Nativity is Kerbschnitt. Every form, with the exception of the arm of the youth demonstrating the star to the older shepherd, the rays of that star, and the child in the vessel below, is of a piece with the ground behind it but cut at such an angle that the figures appear to be freestanding. [33] The torsos of the angels in the Munich plaque (fig. 177), on the other hand, are fully undercut, independent of the ground and held in place only by the device that we have recognized whereby their extremities—heads, hands, and wings—are anchored to the frame. Were this not so, they would have been lost when the ground behind them broke through. (The dark zones

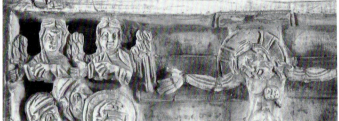

177. *Munich, Staatsbibliothek,* Clm 6831. *Detail of pl. VII*

178. *Munich, Staatsbibliothek,* Clm 6831. *Detail of pl. VII*

behind them are not another plane of ivory but the wooden board of the bookcover to which the plaque is attached). Elsewhere the ivory has suffered greatly for the master's daring: both undercut arms of the Crucified are broken at the wrist (fig. 178) while, as already noticed,[34] the staffs of those at the foot of the Cross have all but vanished. In one other way, too, the same end is achieved by quite different means in the Nativity and the Passion scenes. In the former (fig. 105)—although this is impossible to see in the photograph—the halo of the bathing child is incised into the ground. Yet in a general view, it appears to project in relief as clearly as that of Christ in the Crucifixion or Entombment (fig. 168).

Judgments in terms of style, then, are often judgments concerning results achieved by different means. Perceived similarities are made the basis of associations between one piece and another and, in turn, of groups that are understood as the output of distinct workshops. Yet, as we have seen, the existence of such units is lacking in historical foundation (Chapter II.3). The largest identifiable entity for which evidence exists is the production of one pair of hands. This evidence is the testimony of the ivories themselves, but it cannot be limited to apparent effects. Their causes, too, must be considered. When, in addition to a shared vocabulary of form, a group of objects exhibits a common attitude to the raw material and shares identifiable carving techniques, it becomes a candidate for recognition as issuing from the hand of one master. In short, a "Morellian" approach can be applied not only to aspects of style—the way hair, eyes, the fleshy portions of the chin and neck, garments, and other details are shaped—but equally to the craftsmanship that gave rise to these forms. When all are taken into account, this method can yield more information

than Morelli himself sought to acquire. Beyond its use as an analytical technique addressed to the definition of one man's work, it can throw light on the multiplicity of approaches to a common end. Something of the complexity of an urban industry thus comes into view.

3. SIGNS OF THE MASTER

A variety of means in the service of the same end—a half-length image of Christ, much like that which Theoktiste shows to her grandchildren in the Madrid Skylitzes (fig. 21)—is apparent in eight ivories that we possess of the so-called Pantokrator type.[35] Placed by Weitzmann in two different "groups," six are notable for the *croix carrée* rather than a cross-nimbus behind Christ's head; of these six, three (figs. 116–18) are distinguished by the right arm set within the sling of his mantle, but with the hand raised so that it surpasses the contour of the body. Indeed, at first glance and in general views, they look all but identical. Were these three carved by the same craftsman? This can be maintained on the basis of their stylistic and iconographical kinship. The angular forms of Christ's nostrils, the twin auricles within the ears, and the central parting of the hair, which descends to the nucleus of the cowlick on his forehead, are as alike as the manner in which the clavicles are shown on the neck (figs. 179, 180): especially telling, since they represent the same departure from normal human physiognomy, are the heavy eyelids that in each case are much wider than the eye sockets below them. It would be well to notice the difference between the forms of drapery over the chest. The catenaries in St. Petersburg (fig. 116) are

179. Paris, Cluny (on deposit). Christ, detail of fig. 118

180. Cambridge, Fitzwilliam Museum. Christ, detail of fig. 117

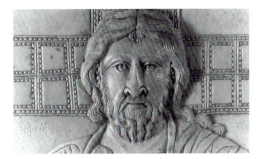

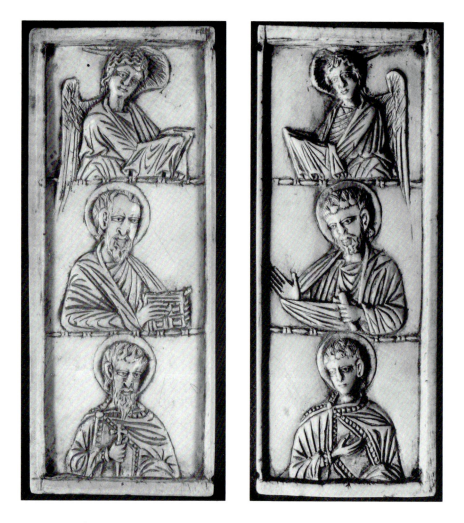

181. St. Petersburg, Hermitage Museum. Triptych wings (wings each 13.8 × 5.5 cm)

more deeply cut and more complicated than those in Paris (fig. 118), but neither approaches the plasticity achieved by Kerbschnitt in the Cambridge ivory (fig. 117). Yet the presence of this one sort of cut is insufficient to prove a different hand at work or grounds on which to exclude the Cambridge master as a candidate for authorship of the other plaques: we are—it is worth remembering—dealing with handmade objects, not pieces stamped out with a die.[36]

Another detail strengthening the case for a single sculptor at work, at least on the Paris and Cambridge versions, is the excessively articulated fourth and fifth digits of Christ's right hand. This gives the impression that the fingers are composed of more than the usual number of segments and is, like the unrealistic eyebrows noted above, evidence that is cogent precisely because it is abnormal. None of these observations would be beyond the power of any beholder who examined the ivories autoptically. Yet only direct

examination allows us to note those elements of craftsmanship that confirm the inference of common authorship made on the basis of style and reveal techniques which, at least to the present writer's satisfaction, prove that one master was responsible for all three plaques. Notable among these are the scored contours above Christ's right shoulder (fig. 180) which, in broader views (figs. 116, 117), can be seen to run down both arms. These lines are not missing from the Paris plaque (fig. 118), but are considerably less pronounced there. On the other hand, the Paris version shares the stepped treatment of the fingertips: cut back perhaps with a chisel, the nails of both the fingers and thumbs appear recessed to a degree not normally evident in nature. The raised right hand of each of the three ivories is, finally, excavated in an identical manner, creating the sort of rounded (rather than faceted) hollow best achieved with a scorper. The same tool would seem to have been used for the palm of Christ's right hand and the folds of his garments on a similar plaque in the Victoria and Albert Museum,[37] but the terrible condition of this piece and the use of a different model make an attribution to the same master less certain.

For the moment it would be well to stay with the recognition of one man's hand in cases where iconographical variation is held to a minimum. Thus the wings of a triptych in St. Petersburg (fig. 181),[38] the central panel of which is now lost, are worked in a manner so close to other ivories with similar subjects—above all the Liverpool (pl. VI) and Harburg (fig. 59) triptychs—that their common authorship cannot be doubted. Once again, the resemblances transcend matters of style, in this case the worried expressions on the faces of the angels, and wings that break through the astragals dividing them from the saints below. On all three ivories the angels' heads are set against upraised wings, pillows that have first been scooped and then incised with rather summary indications of feathers. Peter's hand (in the middle of the right wing) is partly incuse, with cuttings that extend beyond the fingers as do those of the Baptist at Harburg and Liverpool. Because of their recession, the saints in the lowest register of each set of wings are distinct from the lower frames, seeming to rest on them like busts on a plinth. The moldings are all drawn freehand, rather than ruled, and in many cases appear to buckle under the weight of the figures above. On the reverse of each set, the crosses, with lobed terminals and arms that intersect at a pelleted disk, are raised on steps that vary in number; otherwise they are identical. Any one or two of these resemblances could still be accounted for in terms of different craftsmen working from the same model. But in toto there are so many essential similarities that, despite the difference in the saints represented, this sort of explanation must be ruled out.

The Liverpool assemblage, in turn, is connected with a Crucifixion in Leipzig (fig. 145), the central plaque of what was once a slightly smaller triptych. Whereas such features as Christ's broad hips and the hem of his loincloth, shown much lower at the back than at the front, are common to many renderings of this scene, other qualities are not—among them, the Lord's penannular navel,[39] the deep clefts at the crooks of his elbows and

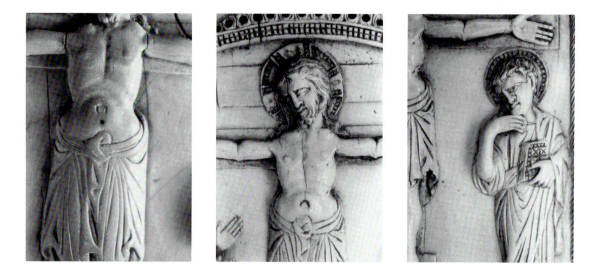

182. Leipzig, Grassi Museum. Detail of fig. 145

183. Liverpool Museum. Detail of pl. VI

184. Liverpool Museum. Detail of pl. VI

the enlarged fatty processes immediately below. In both cases the sculptor has left pick marks above Christ's nimbus and failed to polish off the marks of the tool used to model the drapery at the waist (figs. 182, 183). But the most telling guide to these ivories' cognate origin is the mixture of techniques employed in their figure carving and the reservation of true undercutting for John's upper right arm (fig. 184). Limp-wristed to the point of effeminacy, the limb is attached only at the chin and elbow. This pose is not limited to the two ivories in question—it looks more resolute in the Arnhem version (pl. III)—but recurs on ivories such as the smaller Crucifixion in Hanover (fig. 185), a plaque related to that in Leipzig by the Virgin's lost hand, and to the Liverpool triptych by, among other things, the astragal of its entablature and perhaps by the color in the concave shell of the moon.[40] If, as I believe, Leipzig and Liverpool issued from the same master, the remains of the triptych in Hanover likewise offer good reasons to be associated with his hand.

It should by now be clear that the use of a particular technique on two or more ivories is not enough to support the belief that they were carved by the same person. Both the dictates of the material and the community of those who fashioned it imply that craftsmen shared methods as they shared the ends toward which they worked. Only unusual conjunctions of stylistic and technical idiosyncrasies allow us to recognize the activity of one individual within the pool of craftsmen; generally the water is too murky and the flora that inhabit it too lush for us to do more than catch occasional sight of a remarkable specimen. The biological metaphor is useful if only because it reminds us that even remarkable fish

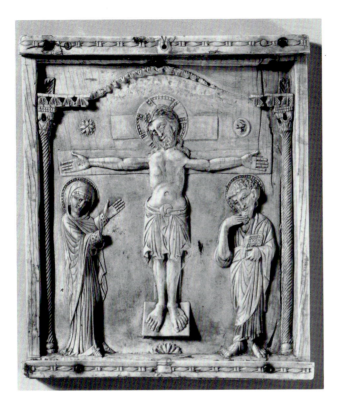

185. Hanover, Kestner Museum.
Crucifixion (16.4 × 13.3 cm). See
also fig. 157

do not *set out* to be remarkable, and because the behavior of any one member of a species is likely to be very similar to that of another. It would, for example, take more than the tool marks around Christ's sandals on the Hirsch ivory (fig. 186) and even the curious double lines by which the joints of his feet are indicated, features shared with the Christ in the Bodleian Library (fig. 4), to convince me that they are due to the same individual. By itself the chevron ornament on the thongs of their sandals is no more proof of their common authorship than the fact that both plaques depict the Lord enthroned.

The Morellian precept which dictates that "less important" parts of the body (such as feet) are likely to reveal the hand of the master more readily than parts (such as heads and

186. Switzerland, private collection.
Detail of fig. 46

167

hands) "consciously" formed might generally hold true. But its utility lies more in the contribution that it makes toward the minimum *quanta* of resemblance necessary to an act of recognition than in defining conditions that are in themselves sufficient to support such an identification. In other words, it may be possible to distinguish between masters by observing whether the feet that they carve appear either to enter the ground on which they stand (e.g., fig. 114) or fail to do so (e.g., fig. 185). But the presence or absence of such weighty members does not in itself guarantee that the man who shaped these feet was one and the same individual. The affinity between style and technique, at least insofar as the objects now under investigation are concerned, should also by now be somewhat clarified. The representation of Christ's loincloth is of course the result of one or more methods of carving, but whether or not its back hangs lower than its front is not in itself a decision dependent on technique. On the other hand, the impression of a foot sinking into the earth is contingent upon the ability to suggest the fairly complex relationship between a figure's stance, the sandals that he wears, and the depressions that these make in the soil. Observations of this sort are usually deemed to be "stylistic" (a term now used in some circles in a derogatory sense), but such compartmentalization is valid, if at all, only if it takes into account the priority of technical factors in the order in which our ivories were manufactured. Rather than see "style" as a mere fine tuning, a set of grace notes added after

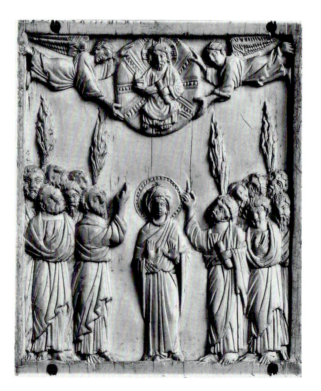

187. London, Victoria and Albert Museum. Ascension (13.4 × 10.9 cm)

a work has been composed, it is more useful to see it as the means whereby such *appoggiature*, and all that comes before them, are executed.

Just as any particular style is the result of some combination of the techniques that we have considered above, so it is perfectly legitimate to recognize styles in *choices* of technique. Too rigid a discrimination between these concepts can lead at best to confusion. They represent not distinctions made *a principio* by the sculptor but working categories that we apply *ex post facto* to his productions for purposes of analysis. Thus so apparently simple a matter as whether the feet of a figure project beyond (as well as sink into) the groundline—as, for instance, those of the apostles do in an Ascension in London (fig. 187)[41]—may be properly considered a matter of style. But from the point of view of its maker, and that of anyone who wishes to understand how such a style came into being, so that it can be compared or contrasted with some similar expression, the projection is better considered as a matter of technique: feet that extend into the space ahead of the groundline had to be planned when the craftsman blocked out his schema of discrete masses.[42] The fact that such foresight is evident on the Cortona staurothèque (pl. I), the wings of a triptych long since dismembered for use on a bookcover in Stuttgart (fig. 196), and, even though their projections have now been shaved off, on those of the Hodegetria triptych in Baltimore (fig. 91) will be of use when (in Chapter V) we come to suggest principles on

188. *Munich, Bayerisches Nationalmuseum. Virgin Hodegetria with angels and donor (13.2 × 11.7 cm)*

which ivories may be classified. Like many other features, overhanging feet alone do not serve to identify a particular master's hand. But they are signs that tell us about the sculptor's way of fostering the illusion of volume and especially about the level of technical sophistication that he brought to bear on this task.

By sophistication, I mean the largely unrecognized awareness shown by all masters of steps necessarily early in the carving process, the purpose of which would not emerge until much later. I do not mean the competence that allows the creation of forms that we find pleasing. This latter talent is possessed in abundance by many skilled forgers and particularly by modern restorers who seek to efface the toll that time has taken on ivories worked in accord with traditional Byzantine techniques. An example is offered by a plaque in Munich, showing the Virgin and child flanked by half-length angels and adorned by a prostrate donor (fig. 188). This has broken along the line scored by the sculptor down the right side of the Christ child, a contour that was surely incised as deeply as that beside the left shoulder, arm, and sleeve of the Virgin's mantle. Long ago, Weitzmann pointed to the fact that the right angel, and indeed the entire right side, was carved by a hand other than that responsible for the rest.[43] The contrast between the two parts of the assemblage is obvious: the right third of the plaque consists of ivory that differs both in color and texture. It is almost entirely lacking in grain and even where the inverted arcs of the dentine do show up (roughly at the level of the Virgin's knees), it has been planed to a smoothness far exceeding that of the plaque's original portion. The diversity of materials has resulted in angels that are worked in quite distinct ways, although the "tidiness" with which the newer piece was prepared is, in all probability, not unrelated to that of the half-

189. *Munich, Bayerisches Nationalmuseum. Detail of fig. 188*

190. *Munich, Bayerisches Nationalmuseum. Detail of fig. 188*

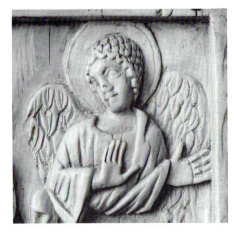

length figure that decorates it. The technical differences between the two angels brings out the Byzantine sculptor's method of work. Where the wing feathers carved by the restorer are smooth and imbricated (fig. 190), those of the left angel are left comparatively ragged (fig. 189). The unevenness of the wings is matched by the complexity of the garment over this angel's left shoulder and particularly by the clumps of cloth gathered over the creature's foreshortened left wrist; both protuberances exploit the concentric form of the grain in this area. By contrast, the modern angel's garments are neatly pressed, producing an effect as flat and vacuous as his pupilless eyes. His creator knew the Byzantine practice of drawing a line in the upper reaches of exposed palms (cf. figs. 33, 141), but failed to grasp that this was a substitute for, not a supplement to, the folds of flesh at the base of the fingers. He was aware of the guidelines that Byzantine sculptors sometimes scored around external contours but apparently oblivious to the fact that they are lacking around the wings of the medieval angel in Munich.

It may be argued that I have subjected the nineteenth-century figure[44] to much closer scrutiny than would most observers, interested either in an adequate replacement for the lost member of the group or the possibility of forgery. My concern, however, is with neither of these modern attitudes but with the ways in which the reproduction illuminates the qualities of the original. This sort of close examination can both restore to Byzantine masters work that, on grounds of supposed formal divagations, has been denied them, and call attention to the common properties of ivories that, on their face, look very different from each other. These two exercises in correcting insufficiently grounded stylistic responses will close a section devoted to demonstrating the various roles of technical analysis in the study of our ivories.

One specimen that, shortly after its discovery in 1931 in an old desk in Copenhagen, excited controversy out of all proportion to the quality of its carving, is a large plaque bearing an iconographically conventional representation of the Crucifixion (fig. 191).[45] Despite this normality, and the incontestable source of the ivory in an African elephant, on account of the runic inscription (Jesus) on the *suppedaneum* and a linear drawing of a woman (Mary beside the cross?) on the reverse (fig. 192) the piece has sometimes been called Danish or Danish under English influence. It is true that among Byzantine ivories it is hard to find equivalents for the etiolated bodies of Mary and John. But the plaque, in both the quality of the material and the way it is worked, adheres so faithfully to Byzantine norms that I find it impossible to impute to it any other origin. First, it conforms directly to the way several panels that we have examined were cut from an area very close to the center of the tusk: the shadow of the pulp cavity on the back is clear evidence of this. Because of this, the carver chose to work it on the "belly" side,[46] a stratagem insufficient to prevent the obverse from betraying its origin: the brown "vein" that runs vertically through the baldachin to Christ's nimbus represents the beginning of a weakness that caused the suppedaneum to split and, much later, the need for restoration material

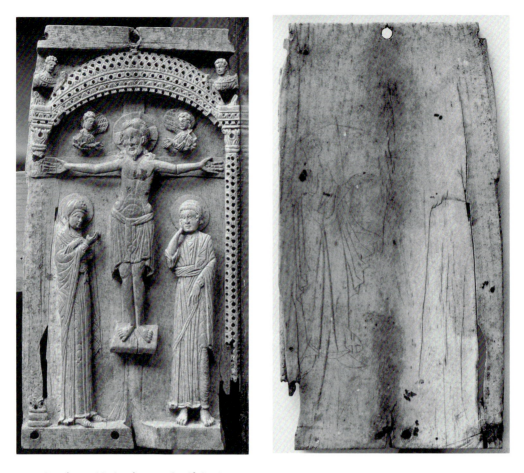

191. Copenhagen, Nationalmuseet. Crucifixion (23.3 × 12.0 cm)

192. Reverse of fig. 191

between this foot-rest and the lower frame. Here a portion of dentine has dropped out entirely (cf. fig. 44).

The manner of carving as much as the material of the Copenhagen ivory shows a detailed familiarity with an array of techniques that is (to say the least) improbable outside the community of Constantinopolitan craftsmen. The figures of John and the Virgin are cut straight back to the ground while Christ's corpus, quite flat on the surface, is treated in Kerbschnitt; his arms and legs, on the other hand, are fully undercut. If this rich combination is not accepted in itself as proof, details in the carving require its Byzantine origin. The upper and lower frames are beveled, the all but freestanding heads of the angels above the canopy are attached to struts, like Christ's arms in the Metropolitan Museum's Crucifixion (pl. V and fig. 78), and the ground (especially to Mary's left) rises and falls in a way that is unfamiliar to me in any Western European ivory. The capitals are

peculiarly Byzantine in form[47] and, as often, the way one of them carries the superstruc-
ture testifies more to divine providence than to any skilled mason (cf. fig. 109).

Precarious capitals and columns askew are the rule rather than the exception on the
Apostles box in the Bargello (figs. 137, 193) and quite irrelevant to questions of "quality"
in ivory carving. We have already noted how small are the heads in relation to the bodies
on this casket,[48] a disproportion that in no way detracts from its maker's achievement. His
commission was evidently for a thoroughly sumptuous object: unlike Veroli (figs. 61,
128) and even boxes with religious imagery (figs. 50, 65), all the plaques, including the
framing rosette strips, are of ivory. Taking advantage of fine material, he created eyes that
are convincingly set within heads, lips that look as if they are of a different substance,
tendons on the backs of hands that convey the complexity of a member all too often flaccid
in Byzantine carving, and properly jointed digits (cf. fig. 145). The box presents, in short,
an epitome of the paradox of realism in this culture: overall proportions may be imperfect,
architectural and other decorative devices frequently amorphous, but details of figure
drawing and especially physiognomy are lent a veristic, almost portraitlike quality. That
portraiture, in our sense of the term, was not intended is made plain by comparison with a
masterwork in London, the openwork plaque depicting the Baptist set among four
apostles (fig. 194).[49] John's head type differs greatly on these two ivories, yet the images
are connected by the extremely fine tool used to form the hair, beards, and inscriptions.
The letter forms of his name and epithet are identical and the implication of one sculptor at
work on both pieces is borne out by the apostles: exactly the same type is used for Andrew,
including the complicated gesture that he makes with his right hand. All the beardless
apostles display a hairstyle that is limited to these two ivories: left long above the center of
the forehead but cut so short at the sides that the ears appear especially prominent.
Polychrome is used in precisely the same way on both pieces. Traces of red and gold remain

193. Florence, Bargello. Apostles box.
Detail, John the Baptist

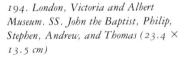

194. London, Victoria and Albert Museum. SS. John the Baptist, Philip, Stephen, Andrew, and Thomas (23.4 × 13.5 cm)

in the nimbi of each of the busts, their hair, and the inscriptions that identify them. Since this distribution of color occurs on two ivories with very different provenances, I conclude that it is original. If this is so, it further supports the belief that we can identify the peculiarities of one man's handiwork.

4. THE GUIDANCE OF THE HODEGETRIA

Frequently, to this point, I have referred to a community of carvers, of artists working toward a common end in ways that are sometimes individually distinguishable. By this I mean the shared purpose of producing ivories—generally, icons and boxes—for a society that prized such uses of a precious material. The "place" of ivory in Byzantine culture is a topic to which I shall return in the last chapter of this book. But before ending a chapter devoted to the part that technical characteristics can play in identifying idiosyncratic acts of craftsmanship, it would be well to test our findings against a more modest "common

end," a group of ivories that depict the same iconographical type. Can we, when their carvers' objectives were the same in the narrower sense, detect the hand of individual masters? For this experiment, I shall choose the subject which is among the most frequently represented in our medium—the half-length image of the Hodegetria, the Virgin "of the guides," revered in the Constantinopolitan monastery of the Hodegon and more widely diffused than any other Byzantine icon.[50] Let us invoke her guidance.

Twenty-five examples of the type are known,[51] roughly 10 percent of the total number of surviving ivory plaques. This fact alone attests to the importance attached to the image and suggests that to understand it simply as an abbreviation of the standing Virgin holding her child (figs. 99, 243)[52] is to substitute a misguided concern with "origins" for the much more interesting question of why, in the tenth and eleventh centuries, the close-up view surpassed that of the standing Hodegetria. Although we do not know the physical position that the faithful assumed before full-length statuettes of the holy couple (figs. 60, 99), a partial answer may be forthcoming from the posture of the worshiper depicted in the Munich plaque (fig. 188). Huddled in a traditional attitude of veneration, his very size and abasement convey his minuscule significance vis-à-vis the Virgin;[53] even while he clutches her foot, he is as remote from her face as he is from the Christ child. It is remarkable that while this posture of proskynesis is common in both book- and wall-painting, Munich offers one of the only two versions known in ivory.[54] In all other examples in our medium the believer's position is undefined. Culturally sanctioned norms of behavior would not have left him or her with freedom of choice in this respect. But the

195. Donauwörth, Schloss Harburg.
Virgin Hodegetria (13.5 × 13.5 cm)

*196. Stuttgart, Württembergisches
Landesbibliothek. Bookcover with Virgin
Hodegetria (11.3 × 10.3 cm)*

variety of poses and situations in which the half-length Hodegetria is found indicates that
the client could exercise certain options regarding the image commissioned or bought.
Quite apart from whether the Virgin and child constituted an independent plaque or
formed part of a triptych (figs. 59, 91, 167), they could appear beneath canopies of various
sorts (figs. 43, 108), flanked by angels (fig. 195),[55] the sun and moon (fig. 196),[56] or
remain unaccompanied. That this last type predominates may suggest a closer, more
personal relation between the icon and its beholder than obtained in other, more elaborate
images in ivory. And even within this more intimate class there were degrees of propin-
quity. Mary and her son could be viewed within their sanctuary, as it were, which the
spectator approached no more closely than to see her cut off by the frame at the level of her
thighs (fig. 108). In this case, and even more in an example in which the figures have been
cut from their moorings along the contours originally scored about them (fig. 197, cf. fig.
15),[57] cascades of drapery between the Virgin's waist and the frame below serve as a sort of
pedestal, protecting her from too intrusive a gaze. Such more-than-half-length versions
contrast with other, closer views in which the "plinth" rises to the Virgin's waist and
transects one of her hands (fig. 198).[58] Here the spectator is brought as close to a face-to-
face engagement with the Mother of God and her son as is offered by any Byzantine ivory.

197. *Padua, Museo Civico (formerly).*
Virgin Hodegetria (12.2 × 8.5 cm), cut
from a plaque

198. *St. Petersburg, Hermitage Museum.*
Virgin Hodegetria (13.0 × 9.8 cm), cut
from a plaque

But proximity, at least in a spiritual sense, involves more than the implied distance between worshiped and worshiper. Whether the latter's gaze was returned by the object of his adoration is no less part of the icon's impact and therefore no less germane to our investigation: did sculptors who made images in which the Virgin contemplates the spectator (e.g., figs. 195, 199)[59] also carve others in which her attention is fixed steadfastly upon the child (e.g., figs. 15, 135, 197)? This brusque distinction, tacitly implying an improbable degree of artisanal specialization, is blunted by the recognition that there are, in fact, not two opposing types but a range of variants hovering about and between these poles. Indeed, so broad is this gamut that it calls into question the very notion of "type," too often readily equated with the Byzantine term *typos*. For example, even in the light of the small sample reproduced here, it is evident that in most ivories where the Hodegetria regards Jesus rather than the beholder, she demonstrates the child to the latter with her raised right hand as if to point to the way of salvation. Conversely, where she looks toward the spectator, or at least into the space that the spectator inhabits, her right hand, like her left, instead of indicating her son, enfolds him in a maternal, supportive gesture. Yet these are no simple "either-or" categories, the craftsman having decided, say, upon the direction of Mary's eyes, then feeling constrained to treat her right arm in a necessarily consequent manner. On a plaque reused on the cover of a German, eleventh-century lectionary (fig. 200),[60] for instance, she points to Jesus yet contemplates a zone

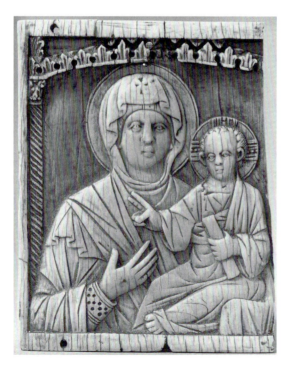

199. Berlin, Staatliche Museen.
Virgin Hodegetria
(13.6 × 10.7 cm). See also fig. 209

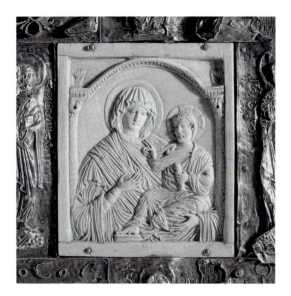

200. Paris, Bibliothèque nationale, MS lat. 10514. Virgin Hodegetria (12.7 × 10.2 cm)

somewhere between him and the worshiper. Alternatively, she may gaze toward (if not at) the beholder, yet still direct his or her attention toward her precious burden (fig. 196).

Stylistic disparity is no less apparent than iconographical variation. Head types include the Virgin with a short flat nose (fig. 91) or one half as long as her face (fig. 195). The Virgin may smile wistfully (fig. 59) or stare vacantly into space (figs. 198, 201) with pupilless eyes, as unsighted as the blind whom she rescued, according to an early-twelfth-

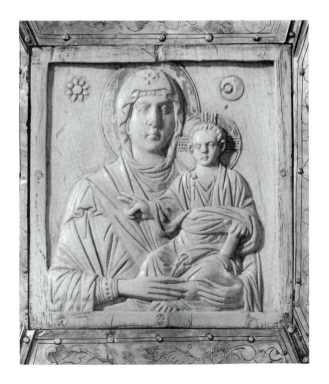

201. Jena, Universitätsbibliothek, cod. Elect. fol. 3. Bookcover with Virgin Hodegetria (13.0 × 11.8 cm)

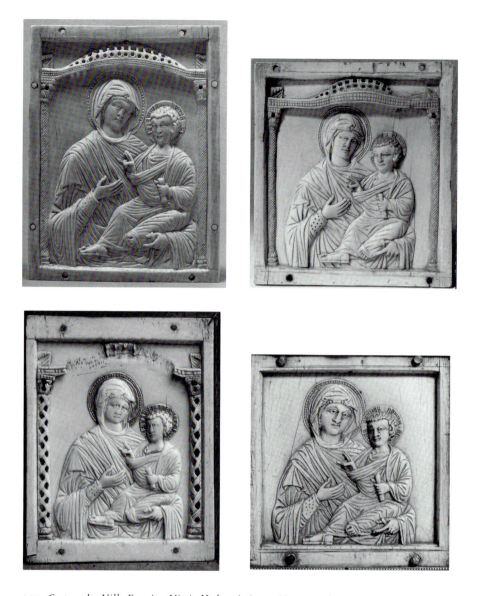

202. *Castagnola, Villa Favorita. Virgin Hodegetria (15.3 × 11.5 cm)*

203. *Bamberg, Historisches Museum. Virgin Hodegetria (12.1 × 10.2 cm)*

204. *Leipzig, Universitätsbibliothek, cod. Rep. I. 57. Bookcover with Virgin Hodegetria (15.3 × 11.6 cm)*

205. *Aachen, Domschatz. Virgin Hodegetria (13.4 × 12.7 cm)*

century account of the wonder-working Hodegetria.[61] Her drapery may be distributed with the almost classical regularity of deep, ridged folds, separated by broad pans, shaped by the underlying body (figs. 199, 208),[62] or it may autonomously go into spasm (fig. 200). Some of the images are sufficiently affecting to justify her later fame as the *schöne Maria*; in one (fig. 43), both mother and child are wooden enough to shake one's faith in the Incarnation. But it is not beauty as such that I am trying to recognize and, in any case,

the way the child is held on the majority of our examples is no more awkward than that of Raphael's *Sistine Madonna*. All in all, what, at the start of this investigation, must have looked to the untutored eye like a level plain dotted with similar monuments, under scrutiny turns into a jungle of diversity. Our Hodegetrias represent a problem in perception familiar in sciences as far apart as astronomy and botany: the more closely one looks at a phenomenon, the more exceptional it appears.

Is there a path through the jungle? Can a riot of observations be reduced to order, to patterns which make sense in terms of the design and fabrication of manmade objects? The problem is epitomized in ivories which at first sight seem, in their essentials, to be identical (figs. 202–205). All resemble the central plaque of the Harburg triptych (fig. 59), already noted for the gritty quality of its dentine.[63] This is slightly larger (15.8 × 11.1 cm) than the ivories now in question and varies in the way in which the Virgin elbows aside an obtrusive column. This movement is no more than a nudge on a plaque in Baron Thyssen's collection (fig. 202),[64] while the proportionately wider specimens in Bamberg (fig. 203)[65] and Leipzig (fig. 204)[66] remove the necessity for such a gesture. Where, on a version in Aachen (fig. 205),[67] the holy pair lack an architectural enclosure, the question of course does not arise. All five ivories, however, display features that distinguish them from the remaining twenty examples of the half-length Hodegetria. These idiosyncrasies include the loop into which Mary inserts the thumb of her cradling left hand in order to hoist up her garment[68] and the ample pleats, which I have called *Zangenfalten*,[69] at her right shoulder. This fold recurs on related ivories (e.g., figs. 15, 198), as does the touching contrast between Jesus' right foot parallel to the lower frame (which, in Aachen, it actually touches) and the infantile twist given his left leg. On all examples in our group the drapery spills on to the narrow stage that is the lower frame.

Depending upon the degree of technical similarity that one demands of an artist's works, the same individual could be responsible for each of the five plaques. I do not regard the difference between the opaque ground of the Castagnola plaque (fig. 202) as sufficient reason to distinguish its author from that of the Harburg triptych (fig. 59), the ground of which is translucent—indeed, eggshell thin around the Virgin's nimbus—, for they could have been made to serve different purposes. In all five, the ground rises and falls and they are linked by the absence of true undercutting. In terms of carving technique, I am inclined to reject Aachen (fig. 205): the complex fold, at the upper edge of the Christ child's tunic lacks the telltale Kerbschnitt applied to other members of the group; these, in turn, lack the vertical neck muscle just beside this fold. Similarly, the plaque on the Leipzig bookcover (fig. 204) is so abraded that the bow-shaped ends of the mouths, displayed by other members of the group, may have worn away. It differs, too, in the especially puppetlike character of the child's head. But even these rigorous exclusionary tactics will not allow me to separate the craftsman who carved the Thyssen ivory (fig. 202) from him who worked the plaque in Bamberg (fig. 203). It is true that alone among

Byzantine ivories, the child on the Castagnola plaque has a harelip, and that the defining contour above the Virgin's right shoulder is not as pronounced as on others in the group. But we have seen that this step was, as it were, optional on the craftsman's part.[70] To insist that it be there before we admit Castagnola to our company would be as fruitless as to search for meaning in the labial defect. It would also be to insist that every work of art is unique, a philosophical rather than a technical premise and one hardly helpful to an understanding of the realities involved in the production of carved ivory.

Castagnola (fig. 202) and Bamberg (fig. 203) treat the child in the same way, giving him garlic-clove locks of hair over the forehead rather than the mannered spitcurls found, for instance, on the Baltimore triptych (fig. 206), or the razorcut lobes of St. Petersburg (fig. 198) and the bookcover in the Bamberg Staatsbibliothek (fig. 207). The huge ears that he has in other versions (e.g. figs. 196–198), that may or may not signify his receptivity to prayer,[71] are likewise missing. If it is granted that negative observation—the recording of what is *not* there—can play a part in taxonomic distinctions, then the middle way between presence and absence—the recognition of what is present but *different*—may also be seen to contribute to the definition of classes of ivories and of the hands that carved them. To treat that which is different, especially that which is superficially so, as necessarily proof of a different maker is to deny to our craftsmen the very versatility that won them their livelihood. The dangers of the insufficiency argument[72] could scarcely be better demonstrated. Carried to its logical extreme, it would mean that any one anonymous artist can be shown to have produced only one plaque. Obviously the response to this absurdity rests not in criteria so loose as to allow him the authorship of almost any carving but rather in reasoning that enhances probabilities of identity normally founded on stylistic observations.

206. Baltimore, Walters Art Gallery. Detail of fig. 91

207. Bamberg, Staatsbibliothek, Msc. Lit. 1. Bookcover with Virgin Hodegetria (12.1 × 10.2 cm). Detail

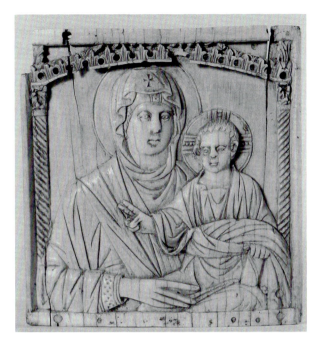

208. *Washington, Dumbarton Oaks.*
Virgin Hodegetria (12.5 × 11.5 cm)

Thus, to stay one last moment within our typologically defined class, is it arguable
that the sculptor who carved the Berlin Hodegetria fragment (fig. 199) was also responsi-
ble for that at Dumbarton Oaks (fig. 208).[73] Many of the iconographical varieties that we
have noted above differentiate the two plaques. In Washington, the axis of the Virgin's
gaze is deflected from that in Berlin; she indicates her son with her right hand but without
raising more than one finger to do so; her exposed shoulder is innocent of any *Zangenfalt*.
On the other hand, both figures in both ivories are endowed with broad noses, small
mouths, and thick lips. Christ's haloes are relief disks defined by by double outlines and
striated *croix pattées* containing rows of pellets. Like iconographical and stylistic discourse,
technical argumentation can theoretically support either side in the debate. For example,
as a detail-photograph of the Berlin piece (fig. 209) demonstrates, its author made loving
use of the grain in Mary's cheek and right hand, in Jesus' right wrist, and his lap. Such
virtuoso execution is absent from the Washington plaque, a waxy, lustrous bit of dentine
quite devoid of grain. Now a sculptor in tenth-century Byzantium might prefer one or the
other type of ivory, but this does not mean that he could always find it. The distinction in
terms of materials should probably bow before similarities in the way that they were
worked. All four haloes and the external contours of both figures are heavily circum-
scribed, so much so that the Berlin plaque has broken (and been repaired) along lines that
radiate from these incisions. The thickness of the upper lip in each case is emphasized by
the amount of material removed between it and the nose above. The Virgin's chin on both

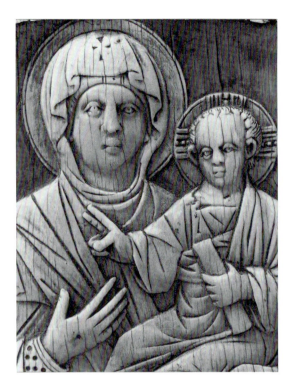

*209. Berlin, Staatliche Museen.
Detail of fig. 199*

pieces is modeled asymmetrically, as if to denote that she turns her head to her left. Folds in the drapery—a favorite touchstone of stylistic analysis—differ markedly from one plaque to another, but both these and fleshy areas are rendered in Kerbschnitt; undercutting is entirely missing. In sum then, there is a distinct possibility that the sculptor who eschewed this technique in both plaques was one and the same. In this instance, no single argument, or type of argument, can yield certainty—a finding fraught with cautionary significance as we turn from the identity of individual craftsmen to the conceptually and quantitatively much more complex business of classifying their body of production.

V

PROBLEMS OF CLASSIFICATION AND CHRONOLOGY

1. "GROUPS" AND INDIVIDUALS

Before suggesting diagnostic methods by which the work of individual sculptors may be identified (Chapter IV.3), I deliberated at some length upon two ivories (pl. VII and fig. 105) that display similar visual effects but achieve these by very different means.[1] This was no random comparison but one that also serves to illustrate the central concern of the present section: the apparent similarity of objects that has led to their classification in the same "group" in the standard corpus of Byzantine ivories.[2] As distinct from more recent attempts to modify the chronology of particular pieces or further to refine this taxonomy by creating sub-groups, both of which efforts are considered below (Chapter V.2), the analytical system erected well over half a century ago remains widely observed and deservedly respected. In their second volume (1934), Goldschmidt and Weitzmann detected relations that had not been recognized among the then-known ivories and differentiated between them in terms that continue to define the ways in which these objects are regarded.[3] It is these terms and these implications of the established categories that I propose to examine.

More than thirty years have passed since an art historian pointed out for his colleagues some of the effects on their discipline of acts of classification normally undertaken in all fields of scholarship.

> We can group the universe of things only by simplifying it with ideas of identity by classes, types and categories, and by rearranging the infinite continuation of non-identical events into a finite system of similitudes. It is in the nature of being that no event ever repeats, but it is in the nature of thought that we understand events only by the identities we imagine among them.[4]

And later:

> Whenever we group things by their style or class, we reduce redundancy, but it is at the cost of expression.[5]

The classification of Byzantine artifacts is, as Kubler observed in another context, "a subject still undisturbed by deep thought," yet of the need for classification there can be no doubt. The problem lies not in taxonomy as such but in the way objects fabricated as differently as the ivory with three scenes from the life of Christ now on a book cover in Munich (pl. VII) and that with the Nativity now in the Museo Sacro (fig. 105) are— through the reductionism inherent in a classification based upon their literally superficial, head-on appearance—lumped together. We shall have occasion to return to their "group," to look at it with different eyes (or at least at different angles) when discussing the value of "the sculptural" as a taxonomic criterion.[6] For now it is necessary only to point to one distinction between classification in the area of natural science and that in our field, before passing on to a set of reflections on the names and nature of the groups that Goldschmidt and Weitzmann used to differentiate among Byzantine ivories in their totality.

There are, it seems, some 230 species of potato. While every one is related to the others more nearly than to any other vegetable—in the way that our objects resemble each other more closely than they do any painted icon or manuscript illustration—they are sufficiently different for their diversity, based on accepted morphological standards, to be recognized. It may justly be countered that the huge variety[7] among tubers is the result of thousands of years of natural selection and later, purposeful interbreeding, whereas most of the ivories were man-made products of (I shall suggest) less than two centuries. The fact remains that criteria sufficient to a proper distinction between one "group" of ivories and another have not been developed, and that the prevailing classification in terms of five "groups" includes objects which (unsurprisingly, and on the admission of the authors of the system) display qualities common to two or more "groups."[8] A classic example is the Descent from the Cross in Washington (fig. 109). The author of the Dumbarton Oaks ivory catalogue remarked in it a mixture of iconographical elements. This he explained as "the artist's endeavor to combine that dramatic action of the 'painterly' group with the compositional principles of the Romanos group, which aim at a hieratic and iconic quality."[9] He went on to observe that the plaque, correspondingly, shows a mixture of styles.[10] Given that the ivory adequately fits no "group" in terms either of its content or of the way in which it was carved, it seems reasonable to suggest that the fault lies not in the ivory or its maker but in the system of classification that is employed.

Perhaps sensing this, at the end of his entry on the Descent, Weitzmann reverted to a consideration of its sculptor who, he hypothesized, was probably not a member of this "imperial court workshop" (that is, the workshop of the "Romanos group").[11] Even if the notion of workshops is itself highly problematical,[12] this willingness to treat an artifact as the product of a particular person represents an advance over the position taken in 1934 when differences in facture were held to be not the "accidental" expressions of individuals but of "a whole school or groups of workshops or a particular time frame or a local limitation."[13] Since the publication of the corpus others have felt the corsetry of the

"group" system to be too constricting. As early as 1962, Beckwith opined that the style of carving in both the Romanos and Nikephoros groups is so various "that it would seem preferable to regard many of the carvings at the work not so much of 'groups' but of different artists established at the Palace."[14] And in 1985 Caillet was ready to explain stylistic differences between the ivories of the Forty Martyrs in St. Petersburg (figs. 28, 29) and Berlin, and the Veroli casket (figs. 61, 123), assigned by Weitzmann to the same "group," as expressions of the different temperament of approximately contemporary artists.[15]

I have spoken of, and shall return presently to, the idea of the individual sculptor as the largest organizational entity knowable in the history of Byzantine ivory carving.[16] But the patient reader—and it is hard to imagine one patient enough to reach this point without some prior interest in the five "groups" under discussion—is entitled to some conclusion about the utility of the classification system as a whole. Specialists in the field have for so long used the labels attached to these sets that they have ceased to regard them critically. An innocent newcomer to the corpus might, on the other hand, point to the fact that the names applied to their categories differ radically in kind. That of the "Painterly" (*malerische*) group derives from the nature of the sources on which its members are said to have depended as models; the labels of the "Romanos" and "Nikephoros" groups stem from major pieces (pls. I, II, IV) in the categories that bear these names; that of the Triptych group from the compositional nature, and hence the supposed functional role, of the pieces that make up the group; and that of the Frame group (*Rahmengruppe*) from the physical form that its representatives exhibit. As explained in the Introduction, with the exception of the plaque with six scenes from the life of Christ (figs. 31, 165), I exclude this last "group" from discussion since I do not consider the origin of its members to be certain enough to call them Byzantine in any meaningful sense of the word. But even without these, it will be clear that, at least at the level of terminology, no single conceptual basis is offered for the stylistic differentiations argued in some detail in the corpus. This in itself is not a fatal flaw; indeed, as in many fields where traditional labels have proved to be inaccurate, their convenience value probably outweighs their capacity to mislead. We have survived similar terminological pluralism in speaking of Renaissance, Mannerist and Baroque styles, where the first relates to a self-conscious intellectual attitude, the second to a way of handling form and hence a habit of mind, and the third (according to some) to the Portuguese word for an imperfect pearl. Yet the problem is more acute in that the objects referred to in the corpus by these newer labels are regarded by Weitzmann (and, as will be seen, by the present author) as more or less contemporaneous. Even if this were not so, even if the "Romanos group" were to include ivories carved as far apart as ca. 945 and ca. 1070, as has been proposed,[17] the notion of "group" would still be strained to the breaking point, though in this case by chronological dilation rather than conceptual unevenness.

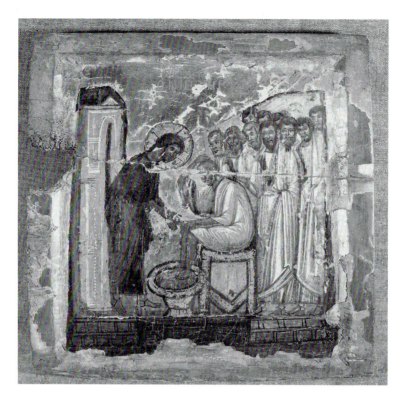

210. Sinai, Monastery of St. Catherine. Icon, The Washing of the Feet (25.6 × 25.9 cm)

What limits the utility of the "group" theory is damaging in practice to the definition of its constituents: too much that is too disparate is admitted. At the root of this problem in the "Painterly group" is the premise that these, unlike other ivories, derive from schemes laid out in miniatures and icons.[18] We have seen that some sort of sketch was necessarily drawn by the craftsman on the surface of any panel before he blocked out the figures and other main elements.[19] This two-dimensional rendering would minimize the difference between "Painterly" ivories and those said to exhibit other characteristics, whether or not the representatives of this first "group" were simulacra of painted models. Like many other hypotheses, that of pre-existent, two-dimensional exemplars cannot be disproved, but it can be tested since it is an inference made from the appearance of artifacts that are said to be the result of such borrowings. One of the pieces most frequently cited as a derivative of this sort[20] is the Washing of the Feet in Berlin (fig. 81). Models proposed include miniatures like that in a lectionary in St. Petersburg (Public Library, cod. 21, fol. 6v)[21] and a panel at Mount Sinai (fig. 210), usually assigned to the first half of the tenth century.[22] Yet it is remarkable that none of those aspects of the scene that exercised the sculptor are observed in the painted versions. Where he took pains to suggest that the

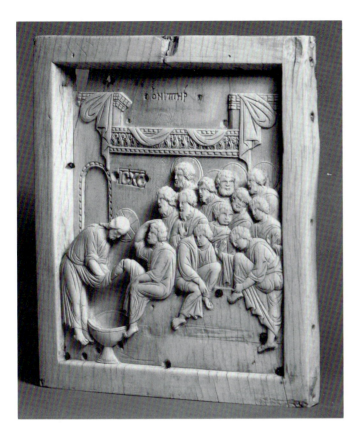

211. Berlin, Staatliche Museen.
Oblique view of fig. 81

event occurs indoors—the room where the Last Supper took place—any difference be-
tween interior and exterior is elided in the icon and the book illustration. Where the
sculptor profoundly undercut Peter's right leg, thus giving focus and meaning to the
narrative by setting its whiteness against deep pools of shadow, no such contrast is present
in the examples offered for comparison. Where the carver arranged the apostles in recessed
strata, piling them high in vertical perspective, the painters strung out most of them in a
horizontal line. Far from aping the lack of depth in the two-dimensional renderings, the
carver took care to suggest that the Footwashing happened in an intelligible, if inconsis-
tent,[23] space. There is no more reason to suppose that this ivory was copied directly from a
pictorial model than, for example, the half-length ivories of the Hodegetria (figs. 15,
195–205, 208)—a subject known in dozens of painted versions—far removed in the
corpus from the "Painterly group."

It is true that one common characteristic of this "group" is represented by the Berlin
plaque. As an oblique photograph (fig. 211) makes clear, none of the figures project
beyond the plane of the frame, but this is true of ivories (e.g., figs. 131, 176) associated
with quite other "groups." Equally telling is the fact that this condition is not met by

212. *Munich, Staatsbibliothek*, Clm. 4453.
Oblique view of fig. 155

other supposed members of the "Painterly group." In the Copenhagen Crucifixion (fig. 191) the figures appear to press against a plane, the surface that the craftsman first attacked as he brought them into being. It is against and behind a similar plane that the actors pullulate in the teeming narrative of the Munich plaque (pl. VII). But this surface is far less in evidence in the Dormition ivory reused on another book cover in the same library (fig. 155). Even in a head-on view, only Paul and the footstool beside the Virgin's bier press against it. Both stand on a stage defined by an architecture whose pierced canopy and columns imply the space in which the epiphany unfolds. This is not to deny the generic resemblance of the Dormition to the Footwashing. In both cases the largest and most active figure stands at the lower left of a scene otherwise given over to heaped configurations of old men. But the space that they inhabit is of a different order—shallow and constrained in the Berlin plaque, deep and darkling in the Munich ivory. An oblique view suggests how the cloth over Paul's right leg surpasses the boundaries of the columns, as well as the position of the angels hovering much nearer to the spectator than the majority of the apostles (fig. 212). Suspended above the bed, they emphasize the concavity of the composition. This is not a screen but a capacious pool, somewhat deeper than a hemisphere, toward the center of which the figures seem to incline.

This illusion of motion, and by extension of actuality, is powerfully aided by the deep undercutting which in itself implies how much space the protagonists in the drama displace. In the corpus this technique was aptly characterized as *Rundplastik*,[24] an effect which is in no way reduced by the incised webs that describe folds in the clothing of the figures and the Virgin's bier. Such incisions occur no less often on ivories assigned to the "Painterly group" that display much less undercutting (e.g. Figs. 105, 127). This diversity not only supports the critique that tags like "sculptural" and "plastic"—precisely because the qualities they denote vary according to the context—are of limited usefulness as analytical terms,[25] but also shows that birds of very different feathers are coaxed into the net of the "Painterly group."

The sense that by no means all the appointed representatives of this "group" obey the rules of membership—that the falcons do not hear the falconer—is borne out by several ivories whose carving technique we have briefly considered earlier. The St. Eustratios in the Wernher Collection (fig. 88) lacks any sign of the deep undercutting and movement that occur both in narrative scenes and in other portraits of holy men in the "group." Indeed he is relieved from eternal torpor only by his *coiffure chevronnée* and the elaborate border of his tunic.[26] Similar in this respect are St. Smaragdos and one who has lost his name (possibly Meliton) on a broken plaque at Bryn Athyn.[27] All three saints wear garments treated as flat surfaces for incision, but this feature alone is insufficient to admit them to the "Painterly group." These figures are better explained as expressions of an individual craftsman's attitude toward the human figure than by coercion into the same group as the knobbly, painfully jointed militiamen in Venice (fig. 44).

We are approaching the recognition that the "groups," for the very reason that their formulation involves those acts of simplification and that softening of rigorous criteria discussed at the start of this chapter, can hardly accommodate the diversity of styles, content, and techniques displayed by their constituents. Obviously no single trait, however dominant, is sufficient to require the admission of an ivory into a particular category. The British Museum Nativity (fig. 213), for instance, clearly exhibits one of the most characteristic aspects associated with the "Painterly group"—the layers of relief which suggest that the Virgin rests on a bed, superimposed on the child's crib, against a rocky backdrop that itself overlies the angels. This collage style is evident in the Ezekiel in the same museum (fig. 127), and other pieces assigned to the same group. Sometimes, as in the Vatican Nativity (fig. 105), it is the most striking feature of a plaque; at others, as on the lid of the box in Stuttgart (fig. 93), this organizational principle is applied more subtly—in this case, at least in the lower register, modulated by the greater degree of undercutting in the figures and the variety of their attitudes. Some members of this "group" (pl. V, fig. 44) largely or entirely lack such stratification. Yet it occurs no less in ivories placed in quite other categories: in the Walters Nativity (fig. 42), given to the "Nikephoros group," it lends some slight semblance of depth to a receding series of human

215. Antwerp, Museum Mayer van den Bergh, a. Triptych fragment (12.2 × 4.2 cm), b. reverse

The two figures clearly represent different saints but they have the same raised nimbus, surrounded by a double line, even while the companions of the Cluny bishop share the same haircut as the full-length martyr in the Belgian museum. The irregular book that he holds with his draped left arm, the spread fingers of his other hand, and the uneven lines of the borders between all the saints in this group, add to the sense of the esthetic symmetry of these triptych wings. The fragments in Cluny have been put in the "Nikephoros group." On these grounds, the same designation could be applied to the Antwerp wing, and to the Hodegetria triptych in Baltimore (fig. 91) that shares each of these characteristics and was quite possibly carved by the same individual. The Cluny and Antwerp wings, nonetheless, exhibit a physical characteristic shared by only the right wing of the Walters triptych—they are carved from sections of what appears to be the same panel of striated, cloudy ivory. The virtual identity of the crosses on the back of the Baltimore (fig. 92) and Antwerp wings (fig. 215b) tends to confirm the impression that they are the work of one master.[33] But even without this hypothesis, the wings in Antwerp and Paris constitute what we may call a minimal cluster—two or more pieces which different sorts of evidence suggest are by the same hand, to which other works can be added if and when they can be shown to fit the same criteria.

As I observed above, the business of recognizing a master is facilitated when the content and/or format of objects argues initially for some degree of kinship. This being so,

the concept of a "group," such as that formed around the plaque in Cortona, cannot stand if it is also to contain the so-called "scepter tip" in Berlin (fig. 158). Quite apart from the demonstrable gap of at least three quarters of a century that separates them,[30] these two putative members of the "Nikephoros group" are fashioned in utterly different ways. The object in Berlin shows no undercutting at all save for Peter's staff and the emperor's scepter, both now broken off. On the Cortona reliquary, by contrast, the Virgin's mantle, the angels' wings and Christ's sling are all quite deeply undercut. It is for this reason that they "look" different. But no less decisive than differences in the way things appear are differences in the way they were made. Supposedly perceptible variations in manner need, in other words, coefficients by which they can be checked; acts of both association and dissociation benefit from such contrasts.

It is not often that *aperçus* of stylistic likeness can be reinforced by observations of a purely material kind. This holds true for a Byzantine triptych, now dismembered and placed on either side of a Latin version of the Virgin and child on the back cover of a manuscript in the Cluny Museum (fig. 214).[31] The saints who flank the central figures were almost certainly created by the same hand as made a little known and even more fragmentary vestige of a triptych in Antwerp (fig. 215a).[32] The bishop at upper right of the wing in Paris is clad differently from his counterpart in the Antwerp fragment, but he displays the same balding pate and prominent ears set parallel to the plane of the ground.

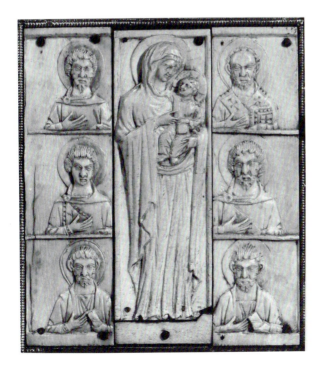

214. Paris, Musée Cluny. Bookcover with Latin Virgin and Child and fragments of a Byzantine triptych (10. 5 × 3. 1 cm)

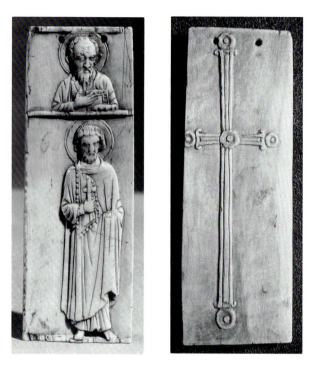

215. Antwerp, Museum Mayer van den Bergh, a. Triptych fragment (12.2 × 4.2 cm), b. reverse

The two figures clearly represent different saints but they have the same raised nimbus, surrounded by a double line, even while the companions of the Cluny bishop share the same haircut as the full-length martyr in the Belgian museum. The irregular book that he holds with his draped left arm, the spread fingers of his other hand, and the uneven lines of the borders between all the saints in this group, add to the sense of the esthetic symmetry of these triptych wings. The fragments in Cluny have been put in the "Nikephoros group." On these grounds, the same designation could be applied to the Antwerp wing, and to the Hodegetria triptych in Baltimore (fig. 91) that shares each of these characteristics and was quite possibly carved by the same individual. The Cluny and Antwerp wings, nonetheless, exhibit a physical characteristic shared by only the right wing of the Walters triptych—they are carved from sections of what appears to be the same panel of striated, cloudy ivory. The virtual identity of the crosses on the back of the Baltimore (fig. 92) and Antwerp wings (fig. 215b) tends to confirm the impression that they are the work of one master.[33] But even without this hypothesis, the wings in Antwerp and Paris constitute what we may call a minimal cluster—two or more pieces which different sorts of evidence suggest are by the same hand, to which other works can be added if and when they can be shown to fit the same criteria.

As I observed above, the business of recognizing a master is facilitated when the content and/or format of objects argues initially for some degree of kinship. This being so,

This illusion of motion, and by extension of actuality, is powerfully aided by the deep undercutting which in itself implies how much space the protagonists in the drama displace. In the corpus this technique was aptly characterized as *Rundplastik*,[24] an effect which is in no way reduced by the incised webs that describe folds in the clothing of the figures and the Virgin's bier. Such incisions occur no less often on ivories assigned to the "Painterly group" that display much less undercutting (e.g. Figs. 105, 127). This diversity not only supports the critique that tags like "sculptural" and "plastic"—precisely because the qualities they denote vary according to the context—are of limited usefulness as analytical terms,[25] but also shows that birds of very different feathers are coaxed into the net of the "Painterly group."

The sense that by no means all the appointed representatives of this "group" obey the rules of membership—that the falcons do not hear the falconer—is borne out by several ivories whose carving technique we have briefly considered earlier. The St. Eustratios in the Wernher Collection (fig. 88) lacks any sign of the deep undercutting and movement that occur both in narrative scenes and in other portraits of holy men in the "group." Indeed he is relieved from eternal torpor only by his *coiffure chevronnée* and the elaborate border of his tunic.[26] Similar in this respect are St. Smaragdos and one who has lost his name (possibly Meliton) on a broken plaque at Bryn Athyn.[27] All three saints wear garments treated as flat surfaces for incision, but this feature alone is insufficient to admit them to the "Painterly group." These figures are better explained as expressions of an individual craftsman's attitude toward the human figure than by coercion into the same group as the knobbly, painfully jointed militiamen in Venice (fig. 44).

We are approaching the recognition that the "groups," for the very reason that their formulation involves those acts of simplification and that softening of rigorous criteria discussed at the start of this chapter, can hardly accommodate the diversity of styles, content, and techniques displayed by their constituents. Obviously no single trait, however dominant, is sufficient to require the admission of an ivory into a particular category. The British Museum Nativity (fig. 213), for instance, clearly exhibits one of the most characteristic aspects associated with the "Painterly group"—the layers of relief which suggest that the Virgin rests on a bed, superimposed on the child's crib, against a rocky backdrop that itself overlies the angels. This collage style is evident in the Ezekiel in the same museum (fig. 127), and other pieces assigned to the same group. Sometimes, as in the Vatican Nativity (fig. 105), it is the most striking feature of a plaque; at others, as on the lid of the box in Stuttgart (fig. 93), this organizational principle is applied more subtly—in this case, at least in the lower register, modulated by the greater degree of undercutting in the figures and the variety of their attitudes. Some members of this "group" (pl. V, fig. 44) largely or entirely lack such stratification. Yet it occurs no less in ivories placed in quite other categories: in the Walters Nativity (fig. 42), given to the "Nikephoros group," it lends some slight semblance of depth to a receding series of human

and topographical components entirely lacking in undercutting; and in the Dumbarton Oaks Gabriel, later connected with the "Romanos group,"[28] superimposition is essential to the distinction between the various items of the archangel's regalia and in turn, between these and his body, his wings, and the ground.

The need to "flesh out" a figure was incumbent upon any competent craftsman faced with the problem of suggesting its bodily presence in a space in actuality rarely deeper than six millimeters. The depth of the step[29] represented the absolute confines within which he had to work and it is not surprising to find a variety of means undertaken to surmount this limitation. It could be effectively disguised by placing the principal figure of a plaque like the London Nativity (fig. 213) on a central axis, so that it seems to lie at the apex of a triangle the sides of which appear to recede toward the ground as they diverge. The sculptor of the Cortona cross-reliquary (pl. I, figs. 37, 38) achieved this effect by cutting the elbows and feet of his saints so that they project beyond the *quadratura*. Conversely, the master who set the Baptist amid four apostles on a plaque in the Victoria and Albert Museum (fig. 194) restricted the depth of its frame, realizing the figures fully within it but never allowing them to exceed their casements.

These several techniques are clues to the work of independent hands. As such, they testify primarily not to the differences between "groups" but to the variety of ways in which ivory could be carved by distinct individuals. In the face of such palpable evidence,

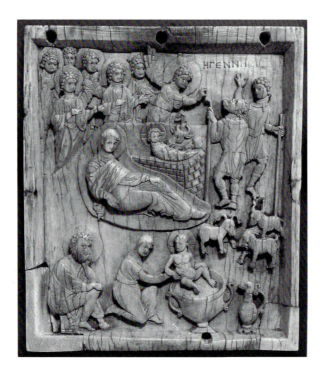

213. London, British Museum.
Nativity (10.8 × 10.1 cm)

I shall close this section by examining the resemblance between two ivories with *different* subject matter and assigned to very different groups in the corpus: the Moscow plaque with the coronation of Constantine (fig. 76) placed in the "Romanos group," and the triptych at Tskhinvali (fig. 148) of the "Triptych group." It is not possible to establish that they are by the same hand because of the way the object in Georgia is preserved.[34] It is sheathed in gilded metal plaques and this assemblage, in turn, housed in a *châsse*, conditions which make it impossible to examine the ground of the carved surfaces and their reverses: in other words the desirable technical confirmation of the stylistic evidence is largely unavailable. Yet some details in the treatment of the pieces suggest analogies that go far beyond the norm in such relationships. Most compelling of these is the series of imbricated arcs that descends Christ's left leg in the central panel of the Tskhinvali triptych (fig. 216) and his right in the Moscow plaque (fig. 217). At mid-calf on both figures the hem of the mantle draped in this way rises through a series of undercut folds that are repeated at the hem of his tunic. These commonalities in the treatment of garments are echoed in the handling of anatomy. While the Lord is turned in different directions he has a similarly full head of wavy hair (fig. 218), which, over the forehead, flanks a lock made of three longer strands—the only instances in ivory that I know of this

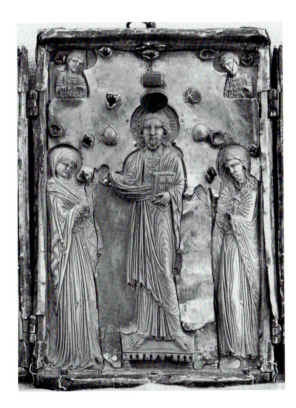

216. *Tskhinvali, Museum of Southern Ossetia.*
Detail of fig. 148

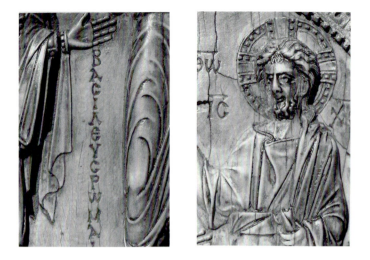

217. Moscow, Pushkin Museum. Detail of fig. 76
218. Moscow, Pushkin Museum. Detail of fig. 76

phenomenon. Less unusual but still worth observing are the nimbi of Christ, both with a splayed cross defined, as is the perimeter, by pellets. His feet, both in Moscow and Tskhinvali, are characterized by articulated toes and a big toe that is separated from the others. Those who prefer material to formal resemblances will be more impressed by the craftsman's selection of a panel with a pronounced grain, visible between the legs of the two figures on the Constantine plaque (fig. 217) and, where the metal *oklad* has broken, between Christ and his mother in the triptych. This cunning exploitation of a natural phenomenon occurs likewise on a Deesis in the Metropolitan Museum,[35] where Mary once again leans against the frame of the plaque and where her right hand is similarly lost.[36]

If the resemblance between the Christ in Tskhinvali and that in Moscow is granted, then it is a phenomenon that deserves scrutiny, although it could be accounted for in several ways. It could be argued that this figure on the Constantine plaque was directly copied by the Tskhinvali carver.[37] This would imply that the latter had direct access to his model after it was in use—an improbable though not inconceivable situation, and an argument that is weakened by the lack of counterparts in Moscow for the figures that flank Christ in the triptych. To explain this last fact it might be supposed that the craftsman used an old sketch as a model for his Christ and combined it with types of the Virgin and the Baptist that he already possessed. Yet, as we have seen, it is unlikely that ivory sculptors' preliminary sketches included the sort of detail that is found on the "free" leg of both figures of the Saviour.[38] Such aspects tell us more about the carver's individual style than about his models or his memory.

All in all, the most economical, though not necessarily the correct, explanation is that the sculptor of the Constantine plaque also carved the Tskhinvali triptych. If this is so, it suggests that those elements on both ivories that at first sight do not appear to "belong" to the Constantine master were also part of his repertoire. His artistic range is thereby expanded to include what we find on the Tskhinvali ivory and also perhaps the Deesis in New York. (It would be absurd to suppose that so skilled a craftsman was capable *only* of the effects visible on the plaque in Moscow). If the carver of the two pieces were one and the same person, certain conclusions follow. First, it allows us to observe a relationship formerly obscured by the removal of the ivories to different "groups." Secondly, it suggests that a master had more strings to his bow than any one object, considered alone, would lead us to believe. And lastly, it argues for the closeness in time of works that, to many eyes, look very different.

At least such an account has the merit of conceiving of a body of work in human terms rather than as abstract stylistic tendencies existing independently of the hands that realized them. A master executing works which, within the norms of the period, depart considerably from each other, and no less from the narrow range that the modern connoisseur allows him, makes more sense as a model of production than a "workshop," a hypothetical system in which the "input" of many individuals is pooled.[39] (Certainly there is no need to see different hands collaborating on the triptych, an object no larger than 32 × 24 cm). Theories of "workshops" and "groups"—pools that gradually dry up as artists wander off to join other teams, taking with them a supposedly influential manner and postulated model books—explain the diffusion of styles and technical expertise no better than one of competing masters who, over time, developed their skills and successively different ways of working. Diverse issues from the same hand may at the moment be dark to us. But if we assume, as we must, that techniques (and styles) were passed on to an assistant, or imitated by a rival, then the relationship between different pieces takes on a chronological cast. This is an aspect of the problem of transmission and diffusion, part, in short, of the history of Byzantine ivory carving.

2. TOWARD A HISTORY: DATABLE WORKS AND MINIMAL CLUSTERS

In many well-ploughed fields of ancient and medieval art history, works that lack names, dates or datable content, or external documentation, are approached comparatively. This is to say they are studied and categorized in terms of their relationship to objects that are better known, be this by virtue of secure attribution or well-founded knowledge of their (preferably early) provenance. We have seen that references to ivory carving in Byzantine

literature are at best scant;[40] the records that we have cannot be connected with any piece that is preserved today. In the face of this difficulty, scholars weigh surviving works against the few datable pieces—a method fraught with obvious risks but one that is used (and I shall use it) precisely because no better way exists. Traditionally, a number of supposedly critical touchstones—"plasticity," figural proportion, "drapery" and so on—are selected with an eye to identifying associations and, on the larger scale just examined, "groups." I have tried to set out the often unsatisfactory nature of this procedure, but, before suggesting an alternative, want to examine what happens when we apply to Byzantine ivories criteria that, at least in the study of classical art, have proved highly successful. Hair styles, for instance, have often provided the means to date, localize, and thus better understand the development of Roman sculpture.

If almost at random we choose an ivory object—the Apostles casket in the Metropolitan Museum (fig. 68)—that offers evidence sufficient for such tests, the results are illuminating. The box, made of solid ivory and assigned in the corpus to the eleventh or twelfth century,[41] shows Christ, the angels and saints about him on the lid and the apostles on its four sides with a range of hair styles similar to that which we have already noted on the Berlin Entry into Jerusalem (fig. 138).[42] Christ's hair, for example, on the box lid and in the Entry, is brushed sideways from a central part to cover thick tresses over his ears on the right side of the box (fig. 219). Philip's is cut back from his forehead in a chevron pattern, while Thomas's hair is rendered as upswept, flamelike locks. The same styles occur on the (unnamed) apostles of the Washington Incredulity (fig. 57) and the Houston Dormition (fig. 234),[43] all, like the Berlin Entry, usually placed in the tenth century.[44] The faces of the older apostles in each of these ivories are characterized by quizzically raised eyebrows but only the box in New York (fig. 68) goes on to add the "scarification" that makes them look as if they are ready for battle. This scar tissue is found supremely on the Venice Theodore and George (fig. 44) whose "permanent waves" look, however, nothing like the hair on any of the other ivories we have just considered. In other words, two stylistic criteria—coiffure and "scarring"—produce different results when applied to the same set of ivories. Are the ivories to be dated differently or are they all of the same period? If their chronology varies, what value should be attached to hairstyle (or "scarification") as a dating device? If they are contemporaneous, on what grounds should one criterion be preferred and the other dismissed?

As we shall see there is a way out of these dilemmas,[45] but it must wait until we have traced patterns of evolution that are implicit in the identification of minimal clusters. For the moment, we have no way of knowing the relations between objects that have many but not all features in common. The evidence of style posits some sort of nexus but does not define it. Does the absence of even a relative chronology for such pieces matter? For at least two reasons, it does. First, because chronology affects the way we evaluate them. At the end of the last century, F. Hermanin, like many art historians of his day, believed that the

219. *New York, Metropolitan Museum. Box
with Philip and Thomas. See also fig. 68*

Romanos ivory (pl. IV) was to be dated in the reign of the fourth emperor of that name (1068–1071). Being therefore more than a century later than the great ivories of the time of Constantine VII, he could describe it as "questa miserabile opera, nella quale si rivedono, per così dire, mummificate le belle figure del dittico [*sic*] Harbaville" (figs. 152, 170).[46] Secondly, in more recent criticism, much work has been directed seemingly towards the undoing of history. Deconstructionists, for instance, argue that an artifact does not exist so much for its own time as for that in which we regard it. I would (minimally) modify this view to argue that a work cannot be said to have existed for its own time until we know what time that was. Since it is we, not the artifact's maker or users, who want to know that time, it is we who must try to make sense of apparently conflicting evidence. The only way to do this is (to use a phrase of Jacques LeGoff's) to "do history."

The earliest references to ivory in the Byzantine world after the so-called Dark Ages of the seventh and eighth centuries are all in Latin chronicles. In 803, Fortunatus, Patriarch of Grado, received "de Grecis" two ivory doors which he is said to have presented to Charlemagne.[47] Thereafter the Carolingian sources are silent until 828, in which year, according to Gérard I, the mid-eleventh-century bishop of Cambrai, his predecessor Halitcharius had been honorably received by the emperor Michael II in Constantinople and returned with a large number of relics and ivory plaques ("tabulae eburneae"). These were made into book covers which, in Gérard's day, could still be seen in a church of the Virgin at Aachen.[48] These two pieces of evidence cannot be taken as unqualified proof of an active ivory industry in early ninth-century Byzantium. The archbishop's doors "from the Greeks" may be as fanciful an attribution as the gospelbook with a binding "of Parian ivory and gold" mentioned in a list of donations to the abbey of St.-Sauveur-de-Redon about half a century later:[49] Paros, the island famous for its marble quarries, had neither elephants nor, as far as we know, ivory workers. Generally, sources for the material given in both antique and medieval documents are notoriously untrustworthy.[50] Two other, more

specific points must be made with regard to Halitcharius's plaques. His reception at the emperor's court occurred during the second phase of Iconoclasm; it is, to say the least, unlikely that he would have been given ivories bearing Christian imagery. Again, they are said to have been applied to bookcovers once he was home.[51] More than likely, the figural carving of the plaques took place as part and parcel of this operation in the West.

The working of ivory, in short, is a question to be treated separately from that of its sources of supply. While the first could not occur without the second, testimony to its availability is not per se evidence of its fashioning. As we have seen, both African and Indian ivory seems to have been available to the Arabs in the ninth century.[52] Artifacts to be considered immediately below suggest that some of it reached Constantinople at that time. But, given the volume of accounts of commerce in this commodity in Arab travelers of the tenth century, it is unlikely that quantities adequate to an earlier, large-scale ivory industry in the capital would have gone unreported.[53] This, admittedly, has all the weakness of an argument from silence. But, when supported by similar evidence from Byzantium itself, the silence can be deafening. A long and long-ignored list of craft workers in Constantinople, said by Theodore of Stoudios in a letter of 802 to the empress Eirene to have benefited from her restoration of icon veneration, includes architects, bronze casters, goldsmiths, woodworkers, weavers, and dyers.[54] There is no mention of ivory carvers.

A less partisan observer than Theodore might attribute these signs of improvement to the recovery of the Byzantine economy as much as to the hiatus in Iconoclasm. Between 780 and 850 state revenues appear to have doubled.[55] If the arrival in the capital of sufficient supply of tusks was a precondition of the development of the craft of ivory, some sort of social prosperity would have been necessary for the development of a market for its products. In this connection it is interesting to note that the only pieces in our material that can be confidently assigned to the ninth century both involve, in one way or another, the person of the emperor. The first is the object in Berlin (fig. 158), long supposed to be a scepter tip, inscribed with the name of an emperor Leo. A recent analysis of the content of its inscriptions has shown that a connection with the coronation of Leo V in 813 is unwarranted.[56] It must therefore pertain to Leo VI (886–912). Its words and most of its images still require some connection with a coronation and any understanding of the object's purpose must take this into consideration. Clearly, both sides are made to be legible yet it was no less intended to be seen, on occasion, from above. This accounts for the fine work on its apex, adorned with a double row of guilloches set between sheaves that are now partly broken off (fig. 158b). It should be noted that the piece is slightly taller (10.2 cm) than it is wide (10.0 cm), while its thickness (2.1 cm) makes it far more massive than any other Byzantine ivory of its size; its weight is lessened only minimally by the dowel hole driven 3.2 cm into its base. These indications point to an object attached to something else and intended to be handled. The thumb and fingers of one hand fit

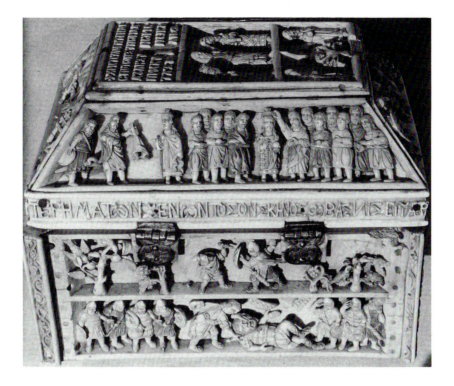

220. *Rome, Palazzo Venezia. Box with scenes of coronation and the life of David (10.3 × 16.1 × 8.4 cm). See also fig. 125*

comfortably into the conchoid niches above the holy figures. It was perhaps the grip on the lid of a casket, one that may have contained the emperor's crown. The shape of such a casket is suggested by our second ninth-century object, the box in the Palazzo Venezia in Rome (figs. 125, 220), itself embellished with a coronation by Christ and scenes from the life of David.[57]

Whatever the function of the Leo ivory, it is carved in fashion quite different from a diptych in Warsaw that has been associated with it[58] and to which it bears an obvious but superficial resemblance. Where the contours of the figures in Berlin are rounded back to the ground without undercutting, those of the diptych are detached by means of both Kerbschnitt and undercutting. The resulting chiaroscuro is exaggerated in a photograph of one leaf (fig. 73) but even the other leaf, less theatrically lit (fig. 221), shows deep shadows behind the Virgin's bench, John's forearm in the Baptism, and Christ's in the Raising of Lazarus and the Anastasis.[59] The histrionic lighting of the right leaf is, nonetheless, useful in that it shows the stagelike spaces in which the scenes are set, much as on the box in the Palazzo Venezia. This casket, to which N. Oikonomides and I assigned a date of 898 or 900,[60] cannot, however, be attributed to the same hand as made the Warsaw diptych. The latter exhibits techniques, notably the struts on which Christ's head is raised in the Ascension and the sun and moon in the vignette below (fig. 73), not found before ivories of the tenth century (fig. 78) and later (fig. 31).

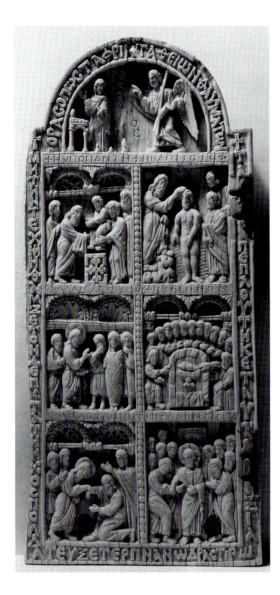

221. Warsaw, National Museum. Diptych, left leaf (22.2 × 10.0 cm). Annunciation and scenes from the life of Christ

We possess, then, only two pieces that securely can be dated in the ninth century, although an attempt has recently been made to insert at least sixteen others into this period.[61] Since I have responded elsewhere[62] to this effort to recognize a development starting "as early as the 860's" and continuing through "the last quarter of the ninth century," I will limit myself to two observations. First, the attempt is based upon a comparison with the "drapery style" of the Paris Gregory manuscript (Paris, B.N. gr. 510) of 880–883, that is, some twenty years later than the supposedly earliest members of this hypothetical group. Secondly, and fundamentally, this reasoning is exposed as circular by the claim that the techniques used in the Palazzo Venezia casket "were transferred from the practice of carving plaques for boxes to using ivory for icons."[63] This could be so only if the

plaques in question had been shown to be of the ninth century, which is not the case. What starts as a chronological hypothesis becomes the predicate of an argument regarding the relationship of the box to the plaques. The fault lies not only in logic but also in observation. The walls of the Rome casket are of solid ivory, most of which was excavated by the sculptor. They likewise display far more radical undercutting than the plaques. As a consequence, the dance of light and shade set in play by the box's figures is much more extensive than on the ivory icons where considerably less material was removed (compare figs. 81 and 125).[64] Even if the proposed analogies between the Palazzo Venezia box and the Paris Gregory were to be accepted, the argument rests upon the belief that at any one time there was only one style of ivory carving—something that we shall shortly see to be untrue[65]—and one style of painting. The notion is vitiated in this particular instance by the lack of any resemblance between the miniatures in the manuscript made for Basil I and the Leo ivory, made for his son probably less than a decade later.

There is, then, no relationship between the one surviving box of the late ninth century and the long series of plaques with New Testament imagery that, in the corpus, constituted the majority of the "Painterly group." In this sense (and in this only) there is some truth to the dictum that "there was no tradition of ivory carving in the capital on which the artists [of the "Painterly group"] could or wanted to build."[66] On the other hand, there do exist palpable connections between *some* of these ivories and boxes like the Veroli casket (figs. 61, 128). This point must wait, however, until we have examined the evidence for the dating of these objects. For now, with no progeny identifiable for either the Leo ivory or the casket in Rome, it is necessary to observe the ensuing gap in the series of datable ivories: not one piece can be ascertainably ascribed to the first four decades of the tenth century. This does not mean that no ivory was carved in the two generations after the Palazzo Venezia box; it means that we cannot prove the manufacture of any such object in this period. The hiatus can in part be filled by extrapolation backwards from works datable in the 940s: their quality in no way requires that they were the first ivories carved by the craftsmen responsible for them. But, in a section devoted to chronology, it is preferable to treat first the objects that can be dated. Indeed, these provide the lineaments of the argument whereby the priority of others may be supported.

The earliest firmly datable plaque is the well-known likeness in Moscow of an emperor Constantine crowned by Christ (fig. 76). As has often been pointed out, the epithet *autokrator* in the inscription points directly to Constantine VII, who ruled independently of the sons of his predecessor from 27 January 945.[67] As in the case of the Leo ivory, the coronation by Christ suggests that the ivory was made either for the earthly equivalent of this event or soon thereafter. I have already indicted the problems that surround attempts to discover closely related works:[68] not even a minimal cluster of ivories carved by the same hand can be identified. But proximity in terms of time rather than of craftsmanship is assured by the thematically similar image of Romanos II, co-emperor with his father

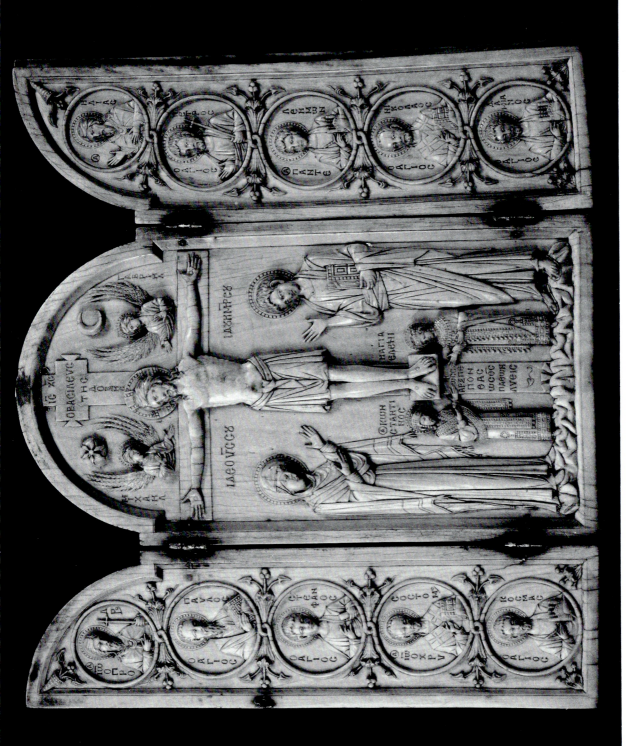

222. *Paris, Cabinet des Médailles. Crucifixion triptych (overall 25.2 × 28.5 cm). See also fig. 146*

Constantine VII from Easter 945, and his wife Eudokia who died in 949 (pl. IV). This is not the place to rehearse the reasons why this image must represent the second rather than the fourth emperor of this name.[69] Suffice it to point out that considerations of titulature, iconography, letter forms, and the youthful appearance of the junior emperor and his spouse all lead to the same conclusion.[70]

It is both convenient and instructive to compare the Romanos ivory to the triptych in the same collection (fig. 222).[71] So numerous are the technical and stylistic resemblances between the two pieces that the chance they are carved by different artists is mathematically remote. In first place one notices the extraordinary degree of transparency achieved in both the imperial plaque and the central member of the triptych. This is due not to the cutting of thin panels, indeed at 1.2 cm thick—twice that of the Crucifixion plaque—the Romanos is unusually thick. Instead, as I have pointed out, the depth of the step is a conscious decision taken early by the sculptor and one that necessitates a great deal of careful labor.[72] Almost the entire upper half of the Romanos ivory is pellucid; around Christ's nimbus, where the ground has been repaired, it is eggshell thin. In light of this bravura, it is hardly surprising that the deeply scored outline around Christ's right hip on the triptych (fig. 146) is filled with the traces of a white substance (used for much later casting or cleaning?). The depth of this contour is matched by that which runs down Christ's right shoulder on the Romanos plaque, as an oblique view (fig. 115) makes clear. On both ivories all the nimbi are disks raised in low relief, while the cross arms in Christ's haloes contain the additional ridge which, in the corpus, was considered one of the hallmarks of the "Romanos group." Yet more than generic similarities of this sort connect the two objects. In both, the garments are "built up" from the ground in multiple planes of shallow relief, a technique in striking contrast to the profound undercutting used especially around the necks and *pendilia* of the imperial couple and the Lord on the Romanos, and around the Virgin's neck and her son's loincloth on the triptych. On the plaque Christ's hands are as deeply undercut as the angels about his head in the Paris Crucifixion. The same methods of skillful carving, in short, are in evidence on both pieces. But the connection between them is not limited to matters of technique. They are two of the only three ivories to employ the detached ivy leaf ornament, on the *tablion* of Eudokia's regalia and at the end of the inscription on the foot of the cross.[73] This feature, because of its very rarity, is more telling than identity of letter forms, though it should be noted that both sets of inscriptions display the mid-tenth-century small-looped *rho* and a *kappa* with its upright stroke separated by a space from the rest of the letter.[74]

Most of these same features characterize the leaves of the diptych now divided between Hanover (fig. 223) and Dresden (fig. 110). I have already remarked on the translucent grounds of this pair.[75] Their kinship to the triptych in the Cabinet des Médailles is affirmed by details of both style and iconography found nowhere else. The Hanover plaque twice repeats the motif of the headboard of the cross conceived as a *tabula ansata* in the

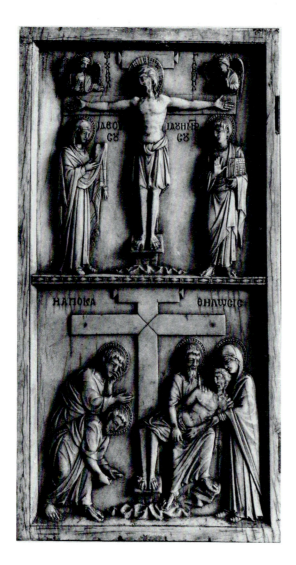

223. Hanover, Kestner Museum. Crucifixion
and Deposition (22.9 × 11.9 cm)

Paris Crucifixion, and each representation of Christ's body gives him a navel rendered as a half moon on its back. At the same time, the shallow planes of the Virgin's mantle—in Hanover, draped over her left hand—are decorated with double lines and tassels. These recur only on the Utrecht (fig. 119) and Liège (fig. 243) Hodegetrias whose carefully observed tear ducts are one of the marks of this master, along with the exceptionally long hair that he gives to the head of the crucified and deposed Christ. Wherever he depicts the cross he plants it in a would-be rocky terrain which, to the modern eye, looks more like toothpaste. The Dresden leaf shows us other interests of his, notably his liking for the grain of his material. This he exposes to great effect on the torso of Hades (fig. 147), as on Christ's body in the Paris triptych (fig. 146).

These works, then, constitute a cluster made by one of Byzantium's finest craftsman whose *floruit* encompassed the years 945 to 949. We have no way of tracing, or even of

identifying, the beginning and end of his career but it is entirely possible that other pieces should be attributed to his hand. The resemblance between the head of the emperor on the Romanos ivory and those of the crowned riders on the lid of the Troyes casket was observed long ago,[76] a link strengthened by the fact that the fluttering mantles of these horsemen display gratuitous if elegant *Zangenfalten*. But so much of the rest of their figures is relatively wooden, and the so-called Sassanian and Chinese motifs on the sides of the box in Troyes so alien to what we know of his oeuvre, that I hesitate to ascribe them to the same hand. I have similar reservations about attributing to the Romanos master the Christ in a Swiss collection (fig. 46). The feet are treated in a manner almost identical to that on the imperial plaque (compare Fig. 103 and pl. IV), but the resemblance between Christ's head on the two plaques is more compelling. An oblique detail of the "Swiss" Christ (fig. 224) shows the same, almost concave profile as is evident in a similar view of the Romanos (fig. 115), while on both ivories the maximum undercutting is to be found between his neck and his collar. But below, and particularly in the already remarked zone between his waist and his ankles, the enthroned figure is disproportionate enough to invalidate any comparison with the standing Christ of the Paris plaque. The atrophied lower body here has a close counterpart in the seated Abgar on an icon at Mount Sinai that Weitzmann put in the mid-tenth century and convincingly identified as a likeness of Constantine VII.[77] I have no doubt that the Hirsch Christ is a creation of the same time but it wanders too far from the hand of the Romanos master to allow a sure ascription. Being the attempt to restrict a body of work to an individual rather than to the broader concept of a "period style," attribution is a more fastidious exercise than chronology.

Insofar as dating is concerned, nonetheless, there are means other than technical and stylistic analysis that provide useful pointers. Given the normative nature of much Byzantine artistic performance,[78] not to speak of frequent deliberate archaisms, iconography is a

224. Switzerland, private collection.
Detail of fig. 46

notoriously risky chronological device. Yet for the representation of regalia, dated or datable controls are available in the form of coins and seals. For example, the *loros*, the gem-studded, scarf-like garment worn by Constantine Porphyrogennetos on the Moscow ivory (fig. 76), is of a type not worn by the emperor after this reign.[79] The modified loros, a similarly bejeweled but more simply cut cloth hanging on the torso and again draped over the left arm, is worn by the youthful Romanos II (pl. IV). In other words, for a while the two types of regalia co-existed in works of art. With a few notable exceptions,[80] however, the simpler loros replaced the more elaborate form that is represented on the diptych leaf with an unnamed emperor in Washington, D.C. (fig. 24), on a triptych wing showing a figure usually said to represent Constantine the Great in the same collection,[81] and the emperors identified as Constantine on the triptychs in the Cabinet des Médailles (fig. 222) and Berlin (fig. 124). Each of these ivories should therefore date no later than 959, the year of Constantine VII's death, and possibly as early as the first years on his sole reign.[82] A seal dated to the year 945 by C. Morrisson and G. Zacos,[83] like the Moscow plaque (fig. 76), shows the Porphyrogennetos wearing the "old-fashioned" loros (fig. 225).

The usefulness of such dated evidence may extend beyond the study of imperial imagery. The same seal presents Christ with a cross but no nimbus behind his head, and his right hand held to the right of his body, as opposed to its situation in front of his chest on the Bamberg diptych (fig. 136) and the Leo ivory in Berlin (fig. 158). It is highly doubtful that the meaning of the gesture changed with position. But these iconographical variants, matched precisely on the series of Christ images (fig. 116–118) which I have earlier attributed to one master,[84] could well mean that these too were created about the middle of the tenth century.

An emperor Constantine is named in the inscription on four of the finest ivories that we have—the triptych in the Palazzo Venezia (fig. 176) and three plaques (figs. 48, 139, 226) closely related to each other, the technical subtleties of which have already been considered.[85] This quartet is linked by the rounded folds of clothing—in contrast, say, to the hard-edged arrises of the Prodromos in Liverpool (fig. 13). But they are also bound by

225. Washington, D.C., Dumbarton Oaks. Seal of Constantine VII

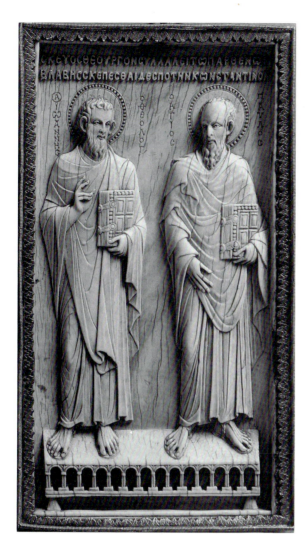

226. Dresden, Grünes Gewölbe. John the Evangelist and Paul (24.6 × 12.6 cm)

their texts, all comparatively lengthy, which invoke divine protection for the emperor in times of peace and war. The latter, especially, is a sentiment elaborated in the time of the Porphyrogennetos.[86] The legend on the left wing of the Rome triptych which declares that with the aid of the four martyrs represented the emperor puts his enemies to flight, also attributes their carving to him—echoing perhaps Constantine VII's well-attested interest in craftsmanship[87] and a concern not attributed to other emperors of this name in Byzantine sources. While the carriage of Paul and John the Evangelist on the Venice (fig. 48) plaque differs from that in Dresden (fig. 226), the disposition and content of the inscriptions announcing the apostles' compact to protect Constantine from harm is identical. On the ivory in Vienna, the "bodily brothers" (Peter and Andrew) are said to absolve his sins. Oikonomides has related the inscription on the central part of the Rome triptych, which mentions the emperor's illness, to the last years of his reign.[88] Whether or not such

a restricted span applies equally to the plaques with pairs of apostles, all four ivories obliquely depict the thought-world spun about Constantine VII, a world in which he is assured of the preservation by Providence that is implicitly necessary to his subjects' wellbeing.[89]

Not only the content of inscriptions but their form and deployment may have important consequences for, at least, a relative chronology. The reader attentive to niceties of epigraphy will have noticed that neither the expansive legends incised on each part of the Palazzo Venezia triptych, nor those raised in relief on the plaques in Dresden, Vienna, and Venice, have any accents, breathings or ligatures. This resistance to the sort of abbreviation and diacritical ornamentation that were well-established in book hands by the beginning of the tenth century suggests the different rates at which writing in the two media developed—the speed demanded of the calligrapher having an end quite distinct from the time-consuming labor of the carver of inscriptions. The absence of such economies, evident on all the ivories that we have assigned to the period between the late ninth- and mid-tenth century, cannot be unrelated to the fact that on these, ample spaces for inscription were laid out in their initial design stage.[90] This provision allowed fulsome dedications as on the bands on the Rome casket (fig. 125), ideological sentiments as on its lid (fig. 220) or the Apostles (figs. 48, 139, 226) that we have just examined, and theological commentary as on the triptych in the Cabinet des Médailles (fig. 222). If together the absence of diacritical marks and the evidence of pre-planned inscriptions is characteristic of datable works, then such a rule should be observed on other, not exactly datable, pieces that display the same features. In this category should fall inter alia the Stuttgart box (fig. 93) and the Florence Ascension plaque.[91] A corollary proposition is that works that lack this forethought should tend to date in or after the decline of "the antique tradition of epigraphic script."[92]

I am not arguing for a decisive watershed, a moment when inscriptions, before disappearing entirely, became messy and, at the same time, more elaborate. But there is a clear difference between the stately, well-spaced lettering on a plaque like the Romanos ivory (pl. IV) and the botched arrangement of a text as on the Ezekiel plaque in London (fig. 127). Of course, ivories without inscriptions may have been produced before the death of the Porphyrogennetos, just as others, like the Liverpool John the Baptist (fig. 13), appear to send conflicting signals—an area reserved for inscription that is then filled with letters wreathed with breathings and accents, at least some of them being later additions. Such a work points to both the past and the future.

But that the future saw a gradual replacement of verbal by nonverbal data, and the triumph of ligatures and contractions over fully expanded words and names, seems to my mind incontestable. Where the carver of the Palazzo Venezia triptych (fig. 125) laid out swaths of text, placed between and commenting on the surrounding figures, his successors inserted rows of busts on the triptych in the Museo Sacro (fig. 169) and on the wings of

227. Paris, Louvre. Detail of fig. 152

that in the Louvre.[93] Similarly, where mid-century craftsmen had been content with chaste floreate crosses on the back of the central panel of such assemblages,[94] the sculptor of the Vatican triptych filled this space with a riot of botanical and ornithological wonders.[95] This process culminates in the Harbaville triptych where the cross stands between vine-girt cypresses, cut with some sort of needle-file and a delicacy unseen since the top of the Leo ivory (fig. 158b), and above a landscape teeming with the flora and fauna of paradise (fig. 227).

It is true that we cannot date either of these works with precision, although the serrated, "cookie cutter" edges of the roundels and the median strips of the Vatican triptych are found on the Cortona reliquary of 963–969 (pl. I).[96] But so banal an ornament—it occurs frequently on the Leo ivory (fig. 158a)—will not support a chronological load. The piece in the Vatican seems earlier than the Harbaville triptych if only by virtue of the lack of the ligatures and contractions that are rife on the Louvre ivory (fig. 170). Yet this triptych in turn, while presenting a somewhat different repertoire of saints,[97] preserves the central position given to Peter in the Palazzo Venezia and Vatican triptychs. Peter's significance for the early Macedonian era is now well understood, as is the decline in his importance in Byzantium in the wake of the schism of 1054.[98] This datum alone argues against the creation of the Harbaville triptych in the second half of the eleventh century.[99]

If the triptych in and of itself does not reveal its date, it does yield a sculptor working in ways that are eminently distinguishable from others we have considered to this point. Although the ornament that he employs, notably the double lines and tassels on the Virgin's maphorion (fig. 170), resembles that of the Utrecht Hodegetria (fig. 99), and the bead-and-reel astragals on the apostles' footstools echo those on the median strips of the Dresden and Hanover diptych (fig. 110, 223), a number of the Harbaville master's techniques differentiate him from the makers of the Rome and Vatican triptychs. He rarely undercuts, even in such areas as the sling of Christ's mantle, and thus separates himself from the way in which the Romanos plaque (pl. IV) and the Crucifixion in the Cabinet des Médailles (fig. 222) were carved. Compared with the gentle folds of the Utrecht Virgin's tunic and mantle, the pleats on many of his garments seem heavily ironed. Their sharp

228. Hamburg, Museum für Kunst und Gewerbe.
Virgin Hodegetria, detail of drapery

arrises recur on the standing Hodegetrias in Liège (fig. 243), New York (fig. 244) and Hamburg (fig. 228)[100] at the edges of pans that are as often as not worked with a scorper. Under magnification these folds look like bisected reeds or, as I suggested earlier, fluted columns.

Similarly incomprehensible, in normal, head-on photographs is the treatment of the weapons held by the military saints in the upper registers of the Harbaville's inner wings (fig. 170). Eschewing undercutting and even Kerbschnitt, the craftsman carved the lances as flat laths with one narrow side turned toward the spectator. The virtues of the technique whereby the other narrow edge was securely and continuously attached to the ground were evidently widely appreciated, for it is found on plaques carved by other hands. On the left wing of the Forty Martyrs in the Hermitage (fig. 28) the one fully preserved lance is cut in this way, as is the cross held by Constantine and Helen on the Berlin Crucifixion triptych (fig. 159). While the technique proved no defense against the rude shocks that some plaques suffered,[101] the survival of parts rendered in this fashion where undercut details on the same ivory have been lost (fig. 124) is testimony to its effectiveness. Often used for rods or staves, it could be applied equally to substantial things like spears and furniture on a casket plaque in Dresden (fig. 229)[102] and immaterial forms like the rays of the Nativity star on the Quedlinburg plaque (pl. VIII).

The narrative impulse that called for such scenes is signally absent from the Cortona cross-reliquary (pl. I) and the ivories that are traditionally associated with it. In the main, the "Nikephoros group" consists of devotional icons—full- or half-length images of the Virgin and child, of her Dormition, of Christ steadily returning the beholder's gaze or crucified. Yet this functionally cognate subject matter does not entail uniformity of technique or even of style. Much has been made of the large noses, thick lips, prominent ears, and schematically incised hair of the heads in this "group" (figs. 43, 214) but, with equal justice, one could point to lobes of hair falling over the forehead (figs. 37, 38, 91) or the already noted continuous line at the base of the fingers on exposed palms.[103] In fact, some of these features are present in some of the cohort and some conspicuous by their

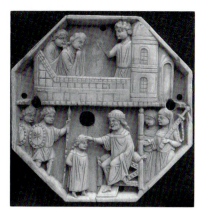

229. Dresden, Grünes Gewölbe, casket plaque (8.7 × 8.3 cm).
Two scenes from the youth of Joseph

absence. As before, it makes more sense to search for minimal clusters that display a
maximum amount of coherence—technical as well as stylistic—than to impose on all
supposed representatives rules that are strained if not broken by the very number of
exceptions.

As has been pointed out, the "group" derives its name from an emperor called
Nikephoros who, according to the inscription on the reverse of the plaque (pl. II) that is
said to contain (a fragment of) the Cross, "puts to flight the tribes of barbarians because he
possesses it." The problem lies not in the identification of the emperor—he is indubitably
Nikephoros II Phokas (963–969)[104]—but in the salient differences between this huge
ivory and the others that have been associated with it. For example, the master who carved
the Christ on a now empty bookcover formerly in Zuglio (fig. 230)[105] was almost certainly

230. Udine, Museo Diocesano. Bookcover, detail (15.4 × 11.6 cm)

231. Lyon, Musée des Beaux-Arts. Christ plaque (12.2 × 11.5 cm). Detail

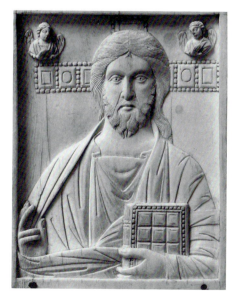

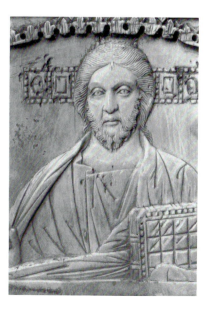

213

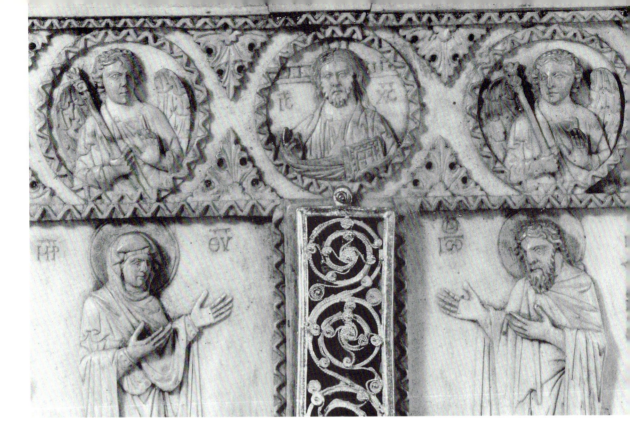

232. Cortona, S. Francesco. Detail of pl. 1

also responsible for a plaque in Lyon (fig. 231):[106] not only are the forms of the beard and the cowlick over the forehead the same but also the strong incision that defines the shape of the head. None of these features characterize the Cortona Christ (fig. 232), whose beard ends in curly clumps and whose head appears to grow out of the surrounding ground instead of being separated from it by a deep contour. Again, the deeply undercut wings of the angels on either side of Christ offer a marked contrast to the one authentic angel[107] preserved on the Munich Hodegetria with a donor (figs. 188, 189) ascribed to the same "group." The firm cuplike volume of the Cortona angel's hands, matched by those of Stephen on the same plaque (fig. 37) finds few echoes in supposedly related ivories; hands, generally, are either flat (fig. 33) or flaccid (fig. 36).

Such variety could be accounted for in two ways. Either we are confronted with craftsmen working at the same time but in a variety of manners, or these differences are symptomatic of different periods. I have said enough above to indicate my preference, in principle, for an explanation of the first sort. But in truth we have no idea of the active life span of the Cortona master or of those who shared some, but clearly not all, of his ways of working. This difficulty would be eased if we had inscriptions on other ivories linked to his great reliquary. We could then compare them to his letter forms—the crablike omega (found also on the Romanos ivory), his triple ligatures (the monogram formed by the first

214

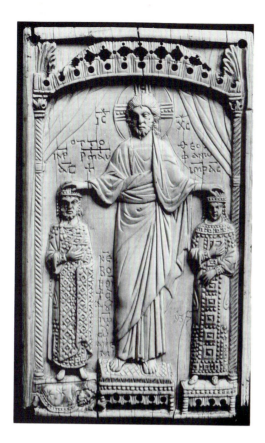

233. *Paris, Musée Cluny. Otto II and Theophano crowned by Christ with a donor (18.5 × 10.6 cm)*

three letters of the epithet Prodromos), the serifs with which he decorated his abbreviations. Unfortunately, if there is a single hallmark of the "Nikephoros group" it is its almost universal lack of epigraphy. One of the two exceptions to this rule is the plaque in the Cluny Museum depicting Otto II and Theophano crowned by Christ (fig. 233),[108] an image based on the type used in the Romanos ivory (pl. IV). Inscribed perhaps by a Greek attempting to write Latin for a Western patron,[109] it obviously belongs to a time when the text, here consisting of crowded and clumsy letter forms, was no longer a pre-planned part of the carver's design. Charitably, it might be related to the half-length Hodegetria in St. Petersburg (fig. 198), whose pupilless eyes it shares, but the case for connection with this piece is weakened by its cavalier attitude toward detail. Unlike the fragment in the Hermitage and the reliquary, the Otto ivory is devoid of fingernails; on the other hand, its maker believed that the incarnate Christ's navel would show through his mantle.[110] The main virtue of the piece might be said to be chronological: if it is an authentic creation of the tenth century, its titulature requires a date between Otto's assumption of the title *Imperator Romanorum* in Spring 982[111] and his death in Rome in December of the following year.

The holes in the upper corners of the Cluny ivory and its broken lower corners suggest that at some time it was fastened to a bookcover. The evidence for the employment of ivory

215

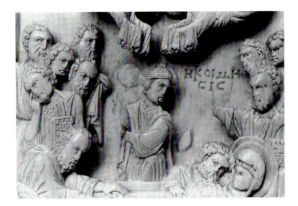

234. Houston, Museum of Fine Arts.
Dormition of the Virgin (10.6 × 8.2 cm),
detail

in this way in Byzantium is scarce,[112] even if opinions that it was so used are abundant. What is indubitable is that plaques brought (by fair means or foul) to the West were turned to this purpose. Indeed, so established did this custom become that ivories imported from the East and used originally for different purposes were inserted into bookcovers as late as the fifteenth century (pl. III). This particular case obviously removes any hope of extracting from the book a terminus ante quem for the plaque in question. But in a fair number of instances, chronological information can and has been derived from this sort of evidence. I do not intend to review every example posited in the corpus or later contested. The arguments pro and con are set out in extenso for those who wish to pursue them.[113] Yet the fact remains that Byzantine ivories of both high and mediocre quality were used as the basis for the covers of Ottonian manuscripts and portable altars (e.g., fig. 18) created expressly to incorporate them. Plaques that have been discussed above, and whose datable application to Western artifacts has not been questioned by critics, include the Leipzig Hodegetria (fig. 204), still on the cover of a Reichenau lectionary of the end of the tenth century, and the tall plaques (fig. 133–136) for which appropriately shaped bindings were made to cover prayer books of Henry II and Kunigunde, who ruled the Western empire from 1002 to 1012.

Of special interest is the famous Gospelbook in Munich, made at Reichenau for Otto III (983–1002). Its original front cover contains the well-known Dormition plaque (fig. 155) which must therefore antedate the making of the book. The inscription identifying the scene contains one letter—a *mu* written much like an upside-down *pi*—that is found on only three other ivories, all of which we have examined and associated on technical and stylistic grounds.[114] These are the Apostles box in the Metropolitan Museum (fig. 68), the Washington Incredulity (fig. 57), and the Dormition in Houston (fig. 234) where it is perhaps most in evidence. While the floruit of such forms in book hands cannot be precisely determined, it is worth noting that this sort of *mu* is found in a manuscript finished in August 984.[115] If my observations concerning the way these four ivories were

worked allows us to see them as constituting a minimal cluster of objects carved by one hand, the form of the letter enables us, roughly of course, to date it. Despite the eleventh- or twelfth-century date given to the New York box in the corpus,[116] like the other three it was more likely made towards the end of the tenth century or at the very beginning of the eleventh.

Those who discount epigraphic argument might still wish to correlate it with the chronological implications of the Munich bookcover's origin. The Dormition (fig. 155) must have been carved before the death of Otto III in 1002. More generally, a time span of the last quarter of the tenth or the first quarter of the eleventh century is indicated by the provenances of at least twenty of the twenty-nine bookcovers and portable altars (fig. 18) into which our plaques were inserted.[117] As the already cited passage of Gerard of Cambrai[118] suggests, imported ivories were quite swiftly attached to sumptuous objects of Western manufacture. I know of no evidence, Latin or Greek, to suggest that they were kept in storage before at least their first such application. In sum then, the testimony of the technique, epigraphy, and history of these pieces argues for their creation shortly before they were exported, a series of events which, where datable, is for the most part concentrated in the period before the middle of the eleventh century.

Reasoning of this sort, even if it can be falsified in one or two instances, is still stronger than the comparisons usually made with works in other media. Nonetheless, stylistic parallels have their place as a body of argumentation of lesser force. In good Morellian fashion, it is the parts of an image of minor consequence to its meaning that are worth examining. The labile capitals, for example, on a number of ivories (e.g., figs. 59, 86, 203) are clearly distinct from their more sturdy counterparts on the Oxford Hodegetria (fig. 108) or the Washington Deposition (fig. 109). This does not mean that they were due to the same craftsman or that they are necessarily later than more stable representations of this architectural member. Yet it is remarkable that they are matched by those in the Psalter of Basil II, a manuscript datable after 976 and possibly of *ca.* 1005.[119] And the pointed, bowing cypress trees on the Chairete scene of the Milan diptych (fig.2), once described as "of late type" by critics who objected to a tenth-century date for the object,[120] occur with the same shape and again in pairs in the Menologion made for the same emperor.[121] Thus the continuation of ivory carving into the eleventh century cannot be ruled out, even if we have not one piece that is firmly datable to that period.

For this reason there is no technical innovation that can be identified as a sign of eleventh-century (or, indeed, later)[122] workmanship. Works that have been given to the eleventh or twelfth century are usually so assigned because they do not seem to fit supposed stylistic norms,[123] or because, like the "Swiss" Christ (fig. 46),[124] they are associated with plaques that have been wrongly dated. It is improbable that the two ivories which now present Christ on a backless throne (fig. 4)[125] followed the lead of thrones without a dossal that suddenly make their appearance on coins of Michael IV (1034–1041)[126] for both are

excised fragments: the plaques in their complete state most likely showed the back of the throne in low relief, as on an example in Paris.[127] Numismatic parallels, even if they prove inapplicable, have the advantage of being datable. Where this is not the case, comparison with undated artifacts is an obvious invitation to error. The tenth-century date given to the Vatican Ascension ivory in the corpus was criticized on the grounds of the "fairly circumscribed date in the last [*sic*] half of the thirteenth century" of a similar miniature in a gospelbook in St. Petersburg—a manuscript that we now suppose to be of *ca.* 1180.[128] A late-eleventh or early-twelfth-century date is possible for the plaque in Berlin with a Virgin and child enthroned below angels.[129] As Annemarie Weyl Carr has pointed out to me, the motif of Jesus tugging at Mary's veil is a prime nuance of the Virgin Kykkotissa, an iconic type cultivated by Alexios I Komnenos (1081–1118).

It will be apparent that in order to find ivories of this period we are straining at a gnat. Pieces are habitually assigned to the twelfth century without even enough reasoning to qualify as sophistry. Where there exists archaeological evidence, as for example, for the bone triptych found in a twelfth-century stratum at Volkovysk in Belarus,[130] the datable context provides only a *terminus ante* for the object's fabrication. Naturally, as a raw material becomes scarce, both experience of and skill in its working will decline; in short, the craft will wither. With this in mind it is noteworthy that of the thirty-nine fragments found in the excavations at Saraçhane,[131] only three came from deposits of the twelfth or later centuries.[132] I have elsewhere pointed to the striking absence of ivory images of Komnenian emperors (1081–1185), a dynasty well-known for the propagation of their likenesses in other precious materials.[133] This lacuna is theoretically explicable in two ways: either dentine was no longer available, or it had ceased to be a prestigious substance even while it continued to be carved for persons well below imperial rank. The second alternative is unconvincing in light of the earlier history of the material. Surviving artifacts datable in the ninth century are associated only with the emperor. In the tenth and eleventh century, ivory plaques were available to an élite, although only the diminished quality of some pieces and the relative incompetence of some carvers suggests that they may have been accessible to a broader circle. The implication for the twelfth century seems inescapable: the absence of Komnenian portraits in ivory is better explained by the virtual disappearance of the material than in terms of a demand confined to the lower strata of society.

Concurrent with the evident reduction in Constantinople's access to elephant ivory is its incremental substitution in western Europe for the walrus ivory that had been the staple of early medieval craftsmen. When the Arabs had dominated the sea-lanes of the Mediterranean, elephant ivory had arrived in all regions—Spain, southern Italy, Byzantium—touched by this commerce. But from the twelfth century, and reaching the level of an industry in the thirteenth, dentine was worked primarily in England, France, Germany, and possibly Venice. It is difficult to resist the conclusion that this diversion is

connected with the new supremacy of Italian merchants in the eastern Mediterranean.[134] The amply studied documents of this trade, demonstrating Venetian, Pisan, and Genoese activity in Damietta, Alexandria, and Syria, as well as Constantinople,[135] give no hint of ivory moving in either direction between Byzantium and Italy. Such silence is not in itself proof of Constantinople's deprivation for, as we have seen, the commodity was similarly unmentioned at a time when it was available (if always treasured) in the Byzantine capital.[136] But in the heyday of western European carving, so dominant were Venetian vessels in the ports of Fatimid Egypt—the main entrepôts for the African ivory on which Christian craftsmen depended[137]—that ships from the northern Adriatic must have been the means whereby the material reached the Latin world. We know from the wealth of surviving contracts that Venetian convoys docked in Greece and Constantinople en route to and from Damietta and Alexandria.[138] These agreements are usually more concerned with the size of a merchant's investment and the landfalls that a ship was to make than with the commodities it carried. Yet the abundance of ivory carved in western Europe in the twelfth and thirteenth centuries provides the evidence that these documents lack. For Byzantium in this period the archives and archaeology alike offer only negative testimony.

That the Greek world was not the destination of African ivory carried in Italian bottoms allows the suggestion, made more than sixty years ago and since refined,[139] that some of it was carved in Venice in an era when its working in Constantinople had all but ceased. In other materials, artisans of the Most Serene Republic were adept mimics of contemporary Byzantine works.[140] Whether or not they were also responsible for the dozens of "Italo-Byzantine" plaques, diptychs, and boxes that we have, the techniques, manners, and content of these artifacts were largely those of tenth- and eleventh-century Constantinopolitan craftsmen.

3. THE IMPLICATIONS OF CONTEMPORANEITY

The diachronic route that we have just traced from the end of Iconoclasm to the virtual demise of the ivory industry a century or so before the Latin conquest of Constantinople, has not yielded straightforward, linear sequences of technical, iconographic, or stylistic development. If this body of production were to be treated graphically, it could be based on two axes—the substantive objects as we have them and the much more shadowy presence of the people who commissioned or bought and used these objects. Moving diagonally through these axes is time, represented both by the duration of constants and the occurrence of variants, or, put another way, by the norms of ivory carving and departures therefrom. These I have attempted to recognize in terms of the individuals directly responsible for their expression—the nameless sculptors who have left us nothing but the objects they carved. Art historians traditionally treat the appearance of themes,

variations, and innovations as manifestations of a temporal succession. But, lacking the "fixed points" whose dearth in the case of Byzantine ivory is all too evident, scholars often fall back on dating by analogy with other sorts of artistic production. The foundation for such a step is the unspoken premise that there exist "period styles" that transcend the differences between different media, differences which, of course, were most obvious to those who made the artifacts and least apparent to those who depend on photographs of them. But the problem is not simply the lack of direct familiarity with the objects in question. The very postulate of a period style ignores the significance of other variables: on one side, the maker's level of competence, his experience of works in his own and other media; on the other, the nature and purpose of the commission that he received, the end that the client had in mind, and his or her rank, wealth, and willingness to invest in an expensive material. I shall return to these last matters, to the extent that they can be assayed, in the final chapter of this book. For now, and for one last time, it is necessary to consider the implications of the chronology that has emerged, the temporal context in which the making, buying, and first uses of our objects took place.

Rather than a sequence of techniques, styles, and content, Chapter V.2 suggested the coexistence of pieces carved in a variety of ways. To limit ourselves for the moment to works datable on grounds that have already been pointed out, this diversity is already evident in the two ivories made for Leo VI between 886 and the end of the century, the casket grip (if it is that) in Berlin (fig. 158) and the box in the Palazzo Venezia (fig. 220). Both objects involve a prodigious amount of ivory and a readiness to sacrifice much of it in order to suggest the space displaced by the figures and their settings. Yet the techniques employed—profound undercutting on the Rome box as against the rounded or flat surfaces of the object in Berlin, and the use of much finer tools on the latter—point to the all but simultaneous employment of quite distinct methods of carving.

After an interval (not necessarily in the industry itself but in its datable representatives) of some forty years, the sole reign of Constantine VII (945–959) offers the richest evidence for, and greatest variety in, ivory carving of any determinate period in Byzantine history. The value of the "great man theory" in history is limited and I ascribe this abundance neither to the emperor's personal intervention nor to his famous interest in the arts.[141] The very different techniques used in the image of his coronation in Moscow (fig. 76), that of his junior emperor, Romanos, and his spouse in Paris (pl.IV), the triptych in Rome (fig. 176) and the plaques in Venice, Vienna, and Dresden (figs. 48, 139, 226) which make almost certain allusions to this same Constantine, do not necessarily all belong to the period after his accession to independent rule. If the contrast between these lavishly inscribed works and the sparseness of texts on ivories that I have assigned to the period after 959 is accepted as a valid chronological indicator, then the Stuttgart Ascension casket (fig. 93) and the plaque in Florence[142] with the same subject could be coeval with or antedate Constantine's reign. These objects, like those that can be positively

connected with the Porphyrogennetos, lack ligatures and diacritical signs. So, too, do the triptych in the Cabinet des Médailles (fig. 232) and the Forty Martyrs in Berlin and Leningrad (fig. 28) which, for this reason, should also belong to the period before *ca.* 959. Other ivories, without any inscription save for *nomina sacra* (fig. 46) or devoid even of these, which, on technical grounds, suggest the sole reign of Constantine, include the diptych divided between Dresden and Hanover (figs. 110, 222) and the leaves now at Dumbarton Oaks (fig. 24) and in Gotha (fig. 25).

The late forties and fifties of the tenth century were a time of intense activity, then, even if we discount those ivories that have proven to be similar while remaining intrinsically undatable. Since it is inherently improbable that all of the masters of this period died when the Porphyrogennetos did, or that they or their successors found no employment during the short reign of Romanos II (959–963), the period merges seamlessly with that of Nikephoros II from which it is separated only by the semantic force of the label (the "Nikephoros group") used to define works that in ways we have explored, resemble in one or more ways the Cortona cross-reliquary (pl. I). These last pieces seem to have been carved by hands other than those that made the Harbaville triptych (fig. 152) and the Liverpool Prodromos (fig. 13). The first of these, I have suggested, may be distinguished from the triptych in the Palazzo Venezia by the ligatures it employs,[143] while the second, although in carving technique it rehearses works of the 940s and 950s, should be later by reason of the wealth of breathings and accents on the Baptist's scroll. I see no reason, however, to place them beyond the third quarter of the century, a date which would make them contemporaneous with the Walters triptych (fig. 91) and the Christs in Udine and Lyon (figs. 230, 231). Exactitude on these points is impossible, as it is in the case of the Vatican triptych (fig. 169). The figures in the latter are much more etiolated than those on the Cortona plaque, but they share (with a few other pieces)[144] zigzag frames, as noted above, and, more importantly, a taste for elaboration which, on the back of the cross-reliquary (pl. II), is no less remarkable for being applied to words rather than images.

In essence I am urging the case that whether we are concerned with technique or with the quality of carving, it is not necessary to translate differences in workmanship into chronological distinctions. The physical evidence suggests that many more craftsmen were at work in our medium in the second and third quarters of the tenth century than in the time of Leo VI. This, in turn, argues for a demand for ivory that could be satisfied by supplies of this "colonial" commodity and, reciprocally, a passion for it which, possibly in the wake of imperial example, extended beyond the palace *sancta* where ivory appears in the late ninth century. Simplistic as the formulation may sound, if more people wanted more ivories then more carvers would have found employment. As long as tusks continued to arrive in Constantinople, it should be surprising neither that the number of hands involved in their working should multiply nor that a wider range of styles and skills should be in evidence.

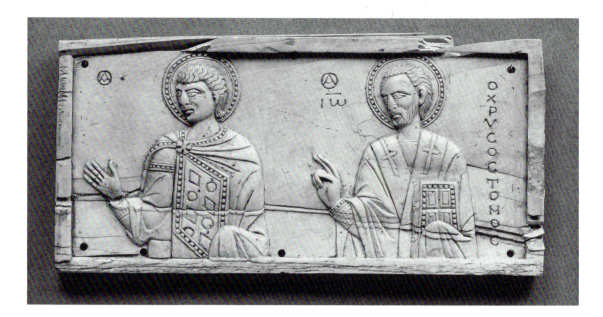

235. Baltimore, Walters Art Gallery. Box plaque with an unidentified saint and John Chrysostom (16.4 × 7.8 cm)

When a craftsman can be shown to be responsible for one of the minimal clusters that I have described above, the contemporaneity of his products is a given. But, in the face of palpable likenesses among other works, their susceptibility to dating is not their only quality of importance. If a greater number of plaques and boxes were being carved, the greater the chance that some will not present those features that enable us to fix the moment of their origin, even while we may recognize the hand that carved them. A cluster may be identifiable and informative, even when its chronology cannot be precisely known. For example, a box plaque with John Chrysostom and an unidentified saint in the Walters Art Gallery (fig. 235)[145] treats the bishop's physiognomy and vestments in a manner much closer to his image on the Moscow Hodegetria triptych (fig. 236) than is required by the norms of Byzantine portraiture. His abbreviated Christian name and his epithet are inscribed in an all but identical manner. His book, the way that he holds it, and the pelleted nimbus traversed at its upper edge by the frame, all suggest that the same sculptor carved both ivories. Both Chrysostom and his youthful companion have the same long, ovate eyes as the saints in the Berlin Crucifixion triptych (fig. 124) where, moreover, the abbreviations for *hagios* [146] take the same form as on the Walters plaque.

The haphazard distribution of the inscriptions on the two triptychs suggests that they should date after the middle of the tenth century, but it is the analogies with the box plaque that are of greater moment. The close relations of casket decoration to that of the main body of Byzantine ivory production, even while they were pointed out repeatedly by

236. *Moscow, Pushkin Museum. Triptych wing, detail of fig. 77*

the authors of the corpus,[147] have generally been ignored—the result, perhaps, of the distinction between boxes and plaques, each given their own volume in the standard reference work. Yet there can be no doubt that the figural revetment on at least the majority of the caskets was produced by men who otherwise carved icons, diptychs, and triptychs in ivory. It is necessary to separate the figured plaques from the rosette strips and other ornament on the boxes. The difference is not only in the materials—most of the plaques and all the framing decoration on most caskets are of bone—but in the means of production. Prefabricated rosette strips were cut to size for use on the boxes' wooden matrices (figs. 74, 75) as heedlessly as the plaques, painstakingly carved by our craftsmen, were fastened with an excessive number of pegs and little thought for the damage they did to the sculptors' designs (fig. 75).[148] The manufacture of these boxes, which involved the juxtaposition of work by different hands,[149] is the only evidence we have to justify the use of the term "workshop."

There is an obvious economic parallelism between the cost of materials used in the boxes and the speed with which they were put together. Cheap bone was understandably combined with rapid assembly. Yet, as we have seen, by no means was the domestic material used only for profane figures and scenes.[150] A perhaps representative example at Dumbarton Oaks (fig. 237)—part of the lid of a "rosette casket" with apostles and saints—has a Christ carved of ivory while the interceding Virgin beside him is of bone.[151] No appreciable difference is evident in the finesse with which these figures are carved: both

223

seventeenth-century Holland, nor were those who ordered ivories connoisseurs of the sort that we know in Leiden and Amsterdam. Others who found their ivories in the marketplace bought, we may presume, carvings of lower quality (e.g., figs. 15, 43, 86, 141, 144). It is tempting to place these in that uncertain period when the Byzantine ivory industry was slouching toward extinction. Yet there exists no reason to suppose that they were not works contemporaneous with the masterpieces that we have considered. The notion that the quality of carving declined over time can reasonably be based only on the presumption of declining skills among craftsmen, a proposition which in turn suggests that they had less material to work. Were this the case one would expect ivory to have again become an imperial prerogative, the status that it seems largely to have enjoyed in the half century after Iconoclasm. Such a notion is, in any case, incompatible with the belief—responding to some unwritten art historical Gresham's Law—that in the eleventh century ivory carving became debased because the material was available in quantities sufficient to make it cheap enough for widespread consumption. The truth, instead, would seem to be that carving, good and poor alike, declined and all but disappeared when supplies were insufficient to allow regular exercise of the craft. Such a view has at least the merit of paralleling the situation at the end of the ninth century and the first half of the tenth, when skills in working appear to have developed in proportion to the amount of ivory available.

The sub-groups of similar ivories that have recently been distinguished within the "Painterly group"[155] do indeed represent differences. But this is insufficient reason to see them as the expressions of successive phases in the history of Byzantine carving. Lacking independent chronological evidence, and even adequate comparanda in other media, these clusters could more simply be interpreted as the work of different, contemporaneous hands, or as the variety that one might expect of different artistic temperaments active at the same time.[156] Unfortunately we know nothing of such temperaments and their varieties. The tasks of understanding how their products functioned, and how they served the needs of their clientele—problems to which we now turn—are sufficiently daunting in their own right.

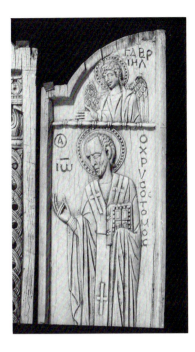

236. Moscow, Pushkin Museum. Triptych wing, detail of fig. 77

the authors of the corpus,[147] have generally been ignored—the result, perhaps, of the distinction between boxes and plaques, each given their own volume in the standard reference work. Yet there can be no doubt that the figural revetment on at least the majority of the caskets was produced by men who otherwise carved icons, diptychs, and triptychs in ivory. It is necessary to separate the figured plaques from the rosette strips and other ornament on the boxes. The difference is not only in the materials—most of the plaques and all the framing decoration on most caskets are of bone—but in the means of production. Prefabricated rosette strips were cut to size for use on the boxes' wooden matrices (figs. 74, 75) as heedlessly as the plaques, painstakingly carved by our craftsmen, were fastened with an excessive number of pegs and little thought for the damage they did to the sculptors' designs (fig. 75).[148] The manufacture of these boxes, which involved the juxtaposition of work by different hands,[149] is the only evidence we have to justify the use of the term "workshop."

There is an obvious economic parallelism between the cost of materials used in the boxes and the speed with which they were put together. Cheap bone was understandably combined with rapid assembly. Yet, as we have seen, by no means was the domestic material used only for profane figures and scenes.[150] A perhaps representative example at Dumbarton Oaks (fig. 237)—part of the lid of a "rosette casket" with apostles and saints—has a Christ carved of ivory while the interceding Virgin beside him is of bone.[151] No appreciable difference is evident in the finesse with which these figures are carved: both

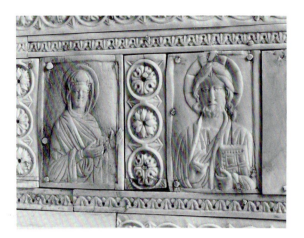

237. *Washington, Dumbarton Oaks. Casket lid, detail (41.0 × 17.5 cm)*

heads rise in relief from carefully hollowed, cushionlike haloes. Another detail—the extension of Mary's left hand into the frame—connects the plaque not only with later boxes, such as the Lyon Genesis (fig. 53) where Adam's feet surpass their allotted boundary but also with ivories like the London Ezekiel (fig. 127) where limbs and garments intrude upon the beveled walls on either side of the scene. If artifices of this sort are no more than forms of expertise shared and transmitted by craftsmen in the second half of the tenth century, there exist cases where so many technical skills are deployed in common that a master like the author of the Veroli casket can be shown to have carved a triptych as cunning as the Louvre Nativity.[152]

Only where such manifold technical affinities exist are we entitled to suppose a cluster of works by one hand, and therefore the contemporaneity of the ivories in question. Mere components, be they of iconography or ornament, are insufficient to support such a claim. For example the contrapposto position of the Virgin in the Quedlinburg Nativity (fig. 104), which recurs, as the authors of the corpus pointed out, only in a "group" of ivories that they assigned to the eleventh century,[153] and of whose Byzantine origin I am not convinced, may argue for some sort of filiation, but assuredly no more than this. So, too, the acroteria that decorate objects as different as the Leo ivory in Berlin (fig. 158b), the Entry into Jerusalem in the same museum (figs. 39, 40), the Walters triptych (fig. 91), and a host of others tell us only that carvers learned from each other, exchanging motifs as readily as they did the technology of hinges.[154]

This is not to deny the possible impact of "models," of schemes and savoir faire of the tenth century being reused in the eleventh. The power of a model to influence later generations, particularly in a society that revered what was old and therefore established, is undeniable. Rembrandt's drawings, copied directly from Titian, show how he was "taught" by the Italian to use much finer pen strokes. But Constantinople was not

VI

THE PLACE OF IVORY IN BYZANTINE SOCIETY

1. USES AND USERS

I began this book by observing that men and women in the modern world do not "know" ivory, and, by way of commentary, spoke of its rarity in an age concerned with preserving elephants and the high prices that artefacts carved from their tusks bring at the hands of dealers and auctioneers; I mentioned the conditions imposed upon their preservation by museums, and the ubiquity of photographs as surrogates for the objects themselves. I have repeatedly remarked on the extent to which photographs limit the ability of scholars to answer the sort of question that they ask of a piece of ivory: where was it made? What would you compare it with? And (above all) when would you date it? Only when students "grow up" do they learn to raise such problems. Before this stage, faced with such an object, they want to know what it was used for. Even if the gulf between these sorts of responses represents, in its own right, the fact that we do not "know" ivory, the students' question is no less important, and no less deserving of an answer, than those of savants. Failing to raise this issue, the scholar implies that his or her questions are "answerable" in a way that questions about function are not, and that matters of use are somehow irrelevant to the context in which the ivories were made.

In the sense that luxurious medieval artifacts were often made for no single, utilitarian purpose—so I have argued for the ivory- and bone-clad boxes (figs. 17, 50, 61, 65, 74, 128)[1]—scholarly reserve is apt. But more than the lack of narrowly interpreted function complicates the question. To the extent that a unique, use-driven answer is inappropriate, there arises the question of latent function, of an object's uses beyond its immediate utility. It is not only in Byzantium, with its infamous lack of concern with practical things, that it is difficult to discover and to rank intentions and effects that are "undeclared or secondary," or even to be sure that the distinction between manifest and latent functions is useful as a heuristic tool in the history of art.[2] As far as Byzantine ivories are concerned, *all* functions are undeclared save by the objects themselves and of none is this truer than of

the plaques, the largest surviving class and the one with which we have been primarily concerned.

To this point, likewise, we have been preoccupied with what is visible, palpable and, as we used to say, empirically verifiable—qualities surely less important to the Byzantines than the way they *used* the objects under discussion, even while this obviously involved gazing at and, I have argued, touching them. It follows that any account of these ivories would be incomplete without some consideration of their uses. Yet the fact remains that we cannot *see* function. In the absence of texts, this must be inferred from their form, the shapes, sizes, and content imposed on panels of dentine—in short, their style in the broadest sense of the term. The structure of Byzantine style, like that of any culture, is potentially observable not only in the objects themselves but in the processes of their production and use.[3] The first I have discussed at length; the latter remains to be treated. Difficult as it is to know the *objet vécu*, we must try to describe both the purposes and nature of its consumers. It would be as much an error to separate the operational from the conceptual process in the matter of these objects' uses as it would to separate these uses from their manufacture. The functions of ivory and those who defined these functions are as much parts of the picture of this material in Byzantine society as the conditions and stages of its production (Chapters II, III).

It is now customary and, I believe, correct to describe the great majority of surviving plaques as "icons."[4] As used, the word implies more than the generic Greek word for an image; it means an object of contemplation and veneration. An ivory icon was the equivalent, carved in a more expensive material, of the much better known, painted wooden panels. We have icons in enamel, intarsia, mosaic, and both precious and base metals; I see no way, and no reason, to distinguish them functionally. There are, however, characteristic features of the ivory icon that makes the term peculiarly apt. In contrast to lumber, which could be hewn in bigger sections, or metal, which could be planished in larger sheets, the natural limits on the size of an ivory plaque—as we have seen, rarely exceeding 25 × 15 cm—made it an ideal vehicle for individual cult, for an object of private devotion as against the group experience that mosaics and wall paintings offered congregations in ecclesiastical or secular settings. Seen from a few meters away, the legibility of its carving and/or inscription disappears (fig. 1); from a greater distance, it becomes a mere blur on the wall. As a work of "minor" art, in the sense of its scale, a plaque, then, was perfectly suited to the privacy that, at least among those who could afford ivory, progressively supplanted collective liturgical celebrations.[5]

Before we are in a position to define the place of ivory icons in this situation, however, their very nature still offers problems that remain to be solved. How were they exposed? Were they somehow mounted and hung? There is no need to insist that they were enclosed in frames, for virtually every icon that we have examined has its own frame.[6] Clearly an ivory plaque was not "exposed as little as possible . . . especially in places where it could

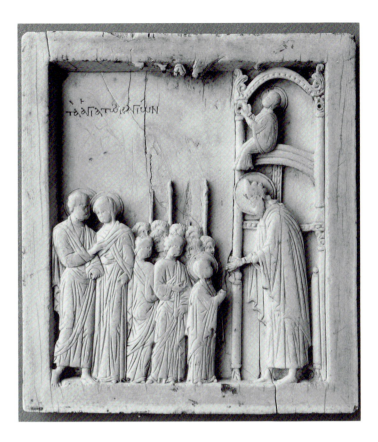

238. Berlin, Staatliche Museen.
Presentation of the Virgin in the Temple
(15.0 × 13.1 cm)

be chipped easily," as has been claimed of steatite.[7] Against this, we have the evidence of both wear and loss of material resulting from a great variety of shocks (e.g., figs. 76, 108, 185, 188, 221, 234) not all of which can have occurred only after the plaque in question entered a museum. In fact, some of the worst damage has been suffered by icons the frames of which remain virtually intact (fig. 238). Rather, as we have seen, the stability of an ivory's parts was primarily a function of the technique in which they were carved.[8] Regarding the means by which an icon was fastened to another surface, there remains considerable doubt as to whether such a setting was considered necessary. Whereas the dowel holes drilled in a frame (e.g., figs. 141, 204) were one standard method of attaching a cornice and base that would accommodate the wings of a triptych (figs. 15, 152, 170), those driven through other parts of a plaque (e.g., figs. 18, 81, 109, 127, 144) are too irregular to suggest any consistent practice in this respect. Indeed, only one set of such punctures, discussed immediately below, can be shown to belong to an icon's primary role. In contrast to the excessive number originally driven into the bone plaques on boxes, their superfluity on such objects as the Halberstadt diptych (fig. 239)[9] shows that these holes generally are the expression of secondary, if not of many subsequent, uses.

Even if we suppose that the suspension hole on the central member of a triptych like that in Utrecht (fig. 99) was original—something that I doubt greatly—any belief that in

239. Halberstadt, Cathedral Treasury. Diptych (left leaf 25.8 × 11.3; right leaf 26.0 × 11.0 cm)

Byzantium triptychs were normally exhibited in this fashion is belied by the fact that the majority show no such signs and by the elaborately carved reverses of some of the finest compositions of this sort (fig. 152).[10] Affixing such triptychs to a wall would render invisible areas on which the craftsman had lavished many hours of work. Presuming some correlation between labor of this sort and the way in which icons were displayed, the only reasons to suppose that some were mounted in a setting would be their uniformity of size and a relationship of content sufficient to suggest that they were designed to be displayed together. This holds true for the Doubting Thomas in Washington (fig. 57), the Houston Dormition (fig. 234)—plaques that I have suggested were products of the same hand—and the Berlin Raising of Lazarus.[11] Their kinship is fortified by the distribution of the holes drilled near the inside corners of their frames. Yet even if we assume that these ivories represent one of the earliest examples of a collective "Great Feast" cycle, the case or

framework in which they were assembled did not require attachment to a wall. They could have been displayed on panels hinged as diptychs or triptychs, resting on a ledge or table, in any situation that would allow them to be viewed from the variety of positions necessary to their maximum effect. [12]

To keep plaques simply propped up on a ledge, or at the very least movable, would have facilitated their use in liturgical processions and permitted the full exploitation of the translucent effect that sculptors worked hard to achieve (pl. V). Without the possibility of illuminating some ivories from behind it is hard to imagine why, at the risk of breaking their plaques' almost eggshell-thin grounds and damaging their already carved frames, [13] craftsmen would have bothered to remove so much material from around the figures they had blocked out. The monastic *typika* that make so much of the lighting of icons date from the eleventh and twelfth centuries [14] and thus cannot be used to sustain this idea. Later, too, than the date of most of our ivories is the evidence for the presence of icons on the epistyle above the templon screens of Byzantine churches. [15] Although ivory may have been used to decorate such members before the end of the ninth century, [16] even later Cappadocian churches, sometimes closely connected with developments in the capital, display no images in this area. [17] Caution is therefore in order with respect to hypotheses that ivories like those in Bamberg (figs. 133–136) were made to adorn "iconostasis beams." [18]

One of the arguments used to advance the notion that the Bamberg ivories and similar works were meant to be seen "high up on a beam . . . from a considerable distance" is the "more summary" [19] form of their carving. This is an apt description of the Bamberg Christ who, as we have seen, narrowly escaped being endowed with six fingers (fig. 136); and of the same craftsman's Paul, around whose feet the carver left plentiful traces of the way in which he excavated his material (fig. 134). It is no less true of the shallow folds in the garments of both apostles, Christ, and the Virgin. But on the supposedly related plaque in St. Petersburg (fig. 240) the bony structure of Symeon's forehead and the complicated strands of his beard are treated in almost inordinate detail; likewise the tassels on the Hermitage Virgin's mantle are more numerous and more elaborate than those in Bamberg (fig. 135). The point now is neither the authorship of these plaques nor the likelihood of their being designed for a common end. Instead, it is to recognize once again variations in the quality of workmanship even in objects which in other respects exhibit considerable similarities.

As we have seen, such diversity has been interpreted in terms of both "workshop" practice [20] and chronology. [21] The first and more widely accepted of these explanations has at least the merit of trying to fit variation into the historical circumstances of production, rather than treat it as an independent development within an autonomous realm called "style." For Weitzmann, the perceptible range of quality in carving was due no less to the difference in clienteles to which his "workshops" catered than to the caliber of the crafts-

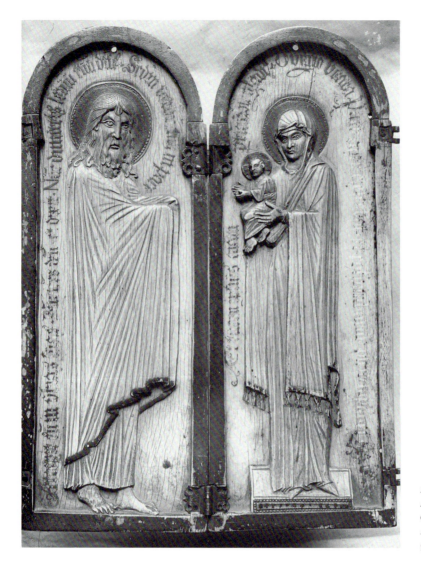

240. *St. Petersburg, Hermitage
Museum. Presentation of the
Christ child to Symeon (left leaf
27.8 × 9.9; right leaf 27.5 ×
9.9 cm)*

men who made up such a shop. The "Romanos group," for example, worked for the court,
whereas the "Triptych group," a "mass-production workshop,"[22] served a "larger," if
unspecified, public of the same period. The sources of patronage for the "Painterly" and
"Nikephoros groups" were left undesignated though, if the technical resemblances be-
tween the first of these and the boxes with mythological scenes is accepted, it might be
supposed that the "Painterly" ivories and the rosette caskets appealed to those interested as
much in "classical" forms as in "classical" content.[23]

No objection can be raised to the belief that the needs, interests, and tastes of those
who bought and used our ivories were vectors that powerfully affected their creation. But,
as in the case of the concept of "workshop," so broad and so sweeping is the identification
between its supposed output and a distinct clientele that the differences between its

products—addressed, it is implied, to a single, undifferentiated audience—become elided. Of course the level of carving varied. No discriminating beholder, Byzantine or modern, would equate the quality of the Dormition in Munich (fig. 155) with that of the same scene in Trier (fig. 18), where the Virgin's arms are as stiff as clothespins, and the apostle at the foot of the bed has clawlike feet and fingers that look as if they were shaped in a pencil sharpener. But sensitivity to such differences is a far cry from the ability to connect them with particular classes of patron, especially since, as I have observed, the population of those rich enough to possess ivory in tenth-century Byzantium cannot have been very large.[24] It may be that a fair number of the ivories that Weitzmann put in the "Triptych group" (e.g., pls. III, VI, figs. 15, 86, 185) were *prêt-à-porter* items, the sort of image available in the market place of which we catch a glimpse in the story of an icon stolen and sold in an eleventh-century *Life* of Symeon the Theologian.[25] But workaday specimens like the Walters Nativity (fig. 42) occur outside this group and the fact that they might not appear *salonfähig* to us is no more reason to identify their owner as some urban bumpkin than it is to attribute them to a provincial workshop. Ivories, whatever their quality, are best examined individually if we wish to distribute them on a social basis.

So heavy an undertaking can be lightened if we prescind those plaques which, in their confessed content, declare some connection with the emperor (pl. IV, figs. 48, 76, 125, 139, 158, 176, 226), even if we cannot be sure whether they were presented to or by some member of the imperial family. Yet among these eight objects, so great is the range of techniques and quality that to assign their creation to a "Palace workshop" is to deny any sense to such a unitary concept. In this connection, two points need to be made. First, apart from the lack of any evidence, archaeological or literary, for such an enterprise— something which no rational student of Byzantium would, in any case, expect—, there is no reason to suppose an atelier of ivory carvers *within* the palace even during the reign of Constantine VII.[26] Imperial factories (*ergasteria basilika*), even those producing such strategic artifacts as weapons, coins, silk, and jewelry were under the control of government officials but, as the *Book of the Eparch* suggests of some, situated at designated sites elsewhere in the city.[27] The best, if still inexact, parallel to the hypothetical imperial Byzantine workshop is the presumed ivory factory in the palace of the Ming and Qing emperors—a presumption that has been devastated in recent scholarship.[28] The analogy is imperfect because Chinese craftsmen carved dice, chess pieces, ebony, and fan handles in addition to ivory combs, a spectrum of objects without Constantinopolitan equivalent. But the demonstration that "the [Ming and Qing] palace was served by some of the best people but not by *all* the best people" implies the means whereby we can approach Byzantine ivories of high quality that offer no direct evidence of imperial associations; and the argument that, in Ming practice, "craftsmen were occasionally required to fill corvée obligations by producing for the court"[29] suggests one way in which "imperial" styles and subject matter could attain wider diffusion.

241. *Gotha, Schlossmuseum. Reverse of fig. 25*

This latter piece of reasoning leads directly to our second point—the appearance on ivories without demonstrable imperial connections of the techniques, motifs, and ornament found on pieces that can be associated directly with the emperor. Carvers at work in *ergasteria* in the city would be accessible not only to court dignitaries and their dependents but to all who wanted, and were willing to pay for, dentine. The finest examples sharing such a common origin would be the triptych in the Cabinet des Médailles (fig. 222) and the diptych now divided between Dresden (fig. 110) and Hanover (fig. 223), both works that I have assigned to the hand that carved the Romanos ivory (pl. IV).[30] The same sort of attention to detail that led to this attribution can take us a step further in our search for the uses of our ivories. The bars of the crosses on the reverse of the Dresden (fig. 111) and Hanover leaves display a peculiar tripartite formation consisting of a central zone seemingly depressed between contiguous, more prominent flanges. These are quite different from, say, the crosses on the backs of the Palazzo Venezia triptych, the Liverpool triptych, and a pair of leaves in Bonn.[31] The cross arms of the Dresden and Hanover diptych leaves terminate in small, pelleted disks between which are suspended eight-petaled florettes.

Each of these features recurs on the outside of the Halberstadt diptych (fig. 239) on which, moreover, the letter forms of the now partially destroyed inscriptions [IC XC] NIKA are all but identical to those on the Dresden-Hanover plaques. It is no longer possible to inspect the insides of the leaves in Halberstadt,[32] now attached to a composition board, although Weitzmann reported them to be smooth and "probably prepared for liturgical use."[33] The slightly larger and similarly shaped leaves of the Dumbarton Oaks-Gotha diptych (figs. 24, 25) have on their interiors framed recesses with notches at the springing of their arched tops (fig. 241), a scheme that comports perfectly with the overall design of the plaques and is thus surely no later addition.[34] The recessed surfaces of both leaves are one millimeter deep, a precise cut (whatever the system of measurement) that would not have been provided without reason. The function of these, I have suggested elsewhere,[35] was to hold a sheet of parchment, possibly the codicils of appointment, which, together with ivory plaques, were presented at court according to the *Kletorologion* of Philotheos.[36] The text refers to various plaques of this sort without further elaborating on them; it does specify, however, that they are placed by the emperor in the hands of men and women raised to the dignity of the patriciate.[37]

Unlike the Halberstadt plaques, the Washington leaf bears an emperor's portrait (fig. 24), an image that tends to confirm our sense of the context in which the diptych was used. Small and similar portrait-bearing silver crosses may have been distributed on feast days.[38] The role of such precious materials in the gift-culture of the imperial court would thus appear fairly certain. Carved with the images of Christ, nimbed emperors, and saints, such distributions parallel the offerings of relics, to notables at home and abroad, as instruments of imperial policy.[39] It is even possible that the ivory plaques with scenes of the emperor crowned by Christ (pl. IV, fig. 76) were intended for distribution at imperial coronations.[40] But to limit our ivories to the ceremonial life of the court is to deny the evidence of the ways they were fabricated and the visual messages that they purvey. The same arrangement of elements and inscriptions as appears on the Halberstadt plaques is found on the outer sides of the wings of the Borradaile triptych in London (fig. 242).[41] The identity of the figures enclosed in their zigzag medallions varies, and was possibly determined by the dedication of the institution to which these icons were presented, but the commonality of the theme—that the victory of Christ mediated through the particular saints represented would ensure the donor's salvation—is expressed in their uniform composition. Whether they all issued from the same master is here less important than the demonstration that in making objects for diverse uses within a single culture, ivory carvers drew on a shared body of designs and types.

That ivories were offered to religious institutions is clear from the inscription on the back of the Cortona plaque (pl. II), where a monastery of uncertain name is declared the recipient of the reliquary that the *skeuophylax* Stephen had commissioned. We cannot be sure that the official cited in the legend on the Warsaw diptych was a monk since the title

242. *London, British Museum. Borradaile*
triptych, closed (27.4 × 16.3 cm)

epistates occurs also in purely secular contexts.[42] But, fragmentary as it is, the inscription makes clear the purpose of the donor's gift, his choice of iconography, and his attitude towards the hand that carved the object:

Left leaf:	You see how the terrors of divine miracles
(Fig. 73)	Have enriched these small tablets.
	Marvel not at the artistry, but at the administrator
	Who wrought many delights with an active mind.

Right leaf:	Yeah, may I reap naught of delight from the artist
(Fig. 221)	Save from those things which Christ, God by nature,
	Willingly in the flesh [], and also sure salvation.

Whether or not the Warsaw diptych was made for a monastery,[43] it is remarkable that the number of monastic saints depicted on the ivories generally is much smaller than that of military and ecclesiastical holy men. When to this datum is added the observation that relatively few women are represented,[44] to the extent that we may assume a connection between an object's patron and/or its destination, on the one hand, and its imagery,

236

on the other, the clientele for the majority of at least the more elaborate of our plaques proves to consist of laymen or members of the regular clergy. These large groups of patrons may again be reduced by the cost of ivory, which would exclude those whom the Byzantines called the "small" or "poor" people.[45] Of course there is no less reason to assume that civilian bureaucrats could sometimes pray to military figures (e.g., figs. 28, 44, 126) than to suppose that women also venerated male saints.[46] But such behavior only strengthens the belief that paradigmatic representation in Middle Byzantine society was determined by the choices of a male élite.

I shall postpone a more precise description of this class until we have had a chance to examine their education and culture (Chapter VI.2)—criteria by which that class largely defined itself. For the moment I prefer to pursue that which the artifacts themselves suggest, above all the contexts in which ivory icons were used. Their size, often fine craftsmanship, and wealth of detail all suggest that they were designed to function in private rather than public spaces, in chapels rather than greater ecclesiastical settings. A large-scale example of these might be Nea Ekklesia, built by Basil I in the Great Palace in 880. The literary record offers an ample account of its sumptuous decoration[47] and, though no ivory plaques are mentioned, we know for example that Leo VI lit candles at an icon of its founder, his father, in an adjoining oratory.[48] Leo's *Novellae* testify to a proliferation of private chapels,[49] tended by household clergy for patrons often closely associated with the emperor. Typical of these would be the very ornate, tiny oratory built near the church of the Holy Apostles by Theophilos Belonas, *patrikios* and later eparch of the city, in cooperation with Constantine VII.[50] Surviving monastic examples include the roof-line chapels in the church of the Virgin founded by Constantine Lips in 907. The shallow niches in these tiny spaces (each less than 3 m sq.) could well have accommodated ivory plaques. Be that as it may, fragments of figured intarsia from the site show that, at least in the capital, monasteries shared in the artistic benefactions of well-connected patrons.[51] Men of the learning to function in the role that I have called the "designer" (Chapter IV.1) characteristically devoted themselves to the rebuilding and refurnishing of monasteries.[52] In such cases it is conceivable that the client and designer were one and the same person.

Of the one hundred patriarchs of Constantinople between the fourth century and the Fourth Crusade, at least thirty were either former *hegoumenoi* (abbots) or held lesser monastic office before their elevation to supreme position in the church.[53] Given the authority and wealth that accompanied this status, it is legitimate to inquire whether any ivory can be associated with a patriarch. The most obvious candidates for such ownership would be the full-length, standing images of the Hodegetria, for this was the type most favored on patriarchal seals between the end of Iconoclasm and the mid-eleventh century.[54] With the exception of the freestanding figurine in the Victoria and Albert Museum (fig. 60), all are either plaques (figs. 99, 243), or cut from plaques (fig. 112), larger than most Byzantine ivories, painstakingly worked,[55] and of the highest quality. The some-

243. *Liège, Trésor de la Cathédrale St. Paul. Virgin Hodegetria (18.4 × 10.1 cm)*

what neglected Liège Virgin (fig. 243) is epigraphically close to the Romanos ivory (pl. IV)[56] and similarly datable to around the middle of the tenth century. It is clearly different from the version in New York (fig. 244)[57]—in the height at which the child is carried, in his unsmiling face (as against the large-eared, puckish imp of the Metropolitan) and in the way the Virgin's tunic is draped—but not necessarily later. Whether or not they date from the time of Theophylaktos, who was patriarch throughout most of Constantine VII's sole reign, nothing in their facture entitles us to connect them with the patriarchate. They are more beautiful, but no less anonymous, than the long series of half-length Hodegetrias that we examined earlier (Chapter IV.4).

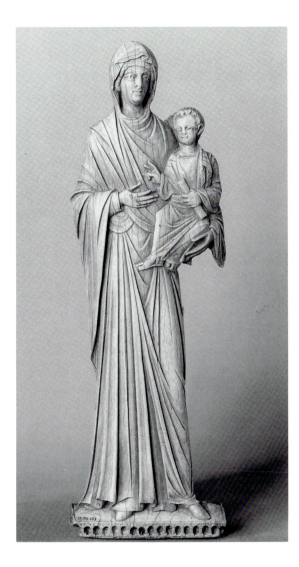

244. *New York, Metropolitan Museum. Virgin Hodegetria (23.0 × 7.2 cm)*

2. THE CULTURE OF THE CLIENTELE

If the Patriarch Theophylaktos (933–956) cannot be shown to have sponsored any of the icons of the Virgin that we have just discussed, he represents nonetheless the class of patron with which we have been much concerned. The son of an emperor (Romanos I Lekapenos), who intended him to become patriarch, he was the younger brother of two co-emperors, deposed in 945 by Constantine VII, and half-brother of Basil the Nothos, the famous *parakoimomenos*, one of the century's best-known patrons of art and the man who commissioned the famous cross-reliquary now at Limburg-an-der-Lahn and books that record his name.[58]

It is through their books that this *nomenklatura* is accessible, not so much the books that its members promulgated—like the famous illuminated bible (Vat. Reg. gr. 1) for

the pictures of which Leo, *patrikios, praipositos* and *sakellarios*, seems to have composed the epigrams and a manuscript that he gave to a monastery founded by his brother Constantine—as the books that they used and the use made of them in their education. Rhetoric and composition of the tenth century were based on the principle of imitation of , and perfect conformity with, models whose virtue was proved by their millennial service.[59] Nearly half of the authors listed in the *Excerpta* of Constantine Porphyrogennetos are writers of the fifth to the seventh century and are there treated as synchronous with both earlier and later authors. The resulting "anti-histoire," as Lemerle called it,[60] "the near-impossibility of dating unattributed texts which make no clear allusions to their period,"[61] rehearse the difficulties we have had in dating the plaques. Their uniformity of content, their shared styles, the commonalities of technique that we have tried to pierce by minute scrutiny, are aspects not only of literature or ivory carving but a general phenomenon, an attitude toward creation shared by the members of this culture. This attitude traverses the barriers between genres by means of a language to which was attributed the virtue of maintaining and renewing in itself "all the qualities that were attributed to a golden age."[62] When we look at an image of Christ washing the apostles' feet (fig. 81), none of them clad as they would have been either in their own day or that of the craftsman, or Joshua's troops armed and garbed as were neither Byzantine nor Hebrew fighting men, there is recognition but no shock. We take it as normal, as did the class with which we are concerned. They, like us, had seen such figures a hundred times before, in wall paintings and books, on silver plates and in enamel, perfectly aligned along the Middle Byzantine horizon of expectation.

Ivory, then, was exclusive by virtue of its cost, doubly so by virtue of the visual lexicon that its carvers employed—a vocabulary which, as we have seen, they could handle adeptly but which was far from their everyday tongue. Insofar as this language was shaped by the hands of craftsmen, it could not be as exclusive as that written and spoken by initiated intellectuals and those for whom they worked. But these same craftsmen were also employees; exponents, not creators, of the culture of a restricted "set," a self-conscious élite consisting of lay people and ecclesiastics, of dignitaries of the state, high functionaries of the Church, the imperial chancery, and the central administration. Often of noble birth and intermarried among themselves, this group was educated by professional teachers who defined the tastes of the class that they served.[63]

The most obvious expressions of such taste are the boxes revetted with "mythological" plaques, occasionally of ivory but, as we have seen, more often of bone. As in the case of the bowl in the treasury of S. Marco in Venice (fig. 175), the qualification regarding their subject matter is necessary: the figures depicted are not actors in continuous ancient narratives, respectfully reproduced a millennium and more after their invention, but the shards of such stories. They are assembled in a sort of bricolage that joined fragments of myth, and meaningful not as wholes but as mélanges with the "flavor" of antiquity. A box

245. *Paris, Louvre. Box plaque*
(4.4 × 9.2 cm)

plaque in the Louvre (fig. 245)[64] loses none of this sense by virtue of being a fragment. Here are juxtaposed a lyre, once perhaps played by Herakles,[65] a syrinx-blowing centaur, a putto perched on an altar, Meleager with this spear and mantle, and another centaur holding yet another putto. The diversity and disparity of these figures, the fact that they are *disiecta membra* rather than parts of a coherent and consequent story[66] is shown by their "quotation" in other contexts. The child with his bottom sticking out of a basket recurs on the back of the Veroli casket (fig. 61), Herakles watching the Rape of Europa on its lid (fig. 128), and Meleager on a plaque in Dresden (fig. 120). The element of parody, or at least of fun poked at antiquity is strong: the slayer of the Calydonian boar is framed by cheeky, naked erotes (fig. 245); Herakles' musicianship is mocked by another;[67] Europa's rape is rehearsed on the back of the Veroli, seemingly with a boy in the part of the tragic heroine.[68]

All in all, the tone is one of mockery, of caricature of that excessive imitation of antiquity that the Patriarch Photios called "hyperatticism."[69] Since performances of this solemn sort characterize literature both sacred and profane, to identify icons with the clergy and our parodic (and sometimes bawdy) boxes with the laity is too easy an equation. "Things of the stage . . . games, hunting and dancing scenes, various kinds of dogs, rampant and flying animals, herds of horses"[70] and so on were to be found, much to the horror of Symeon the Theologian's biographer, in eleventh-century churches. To deny caskets with figures of pagan mythology, animal battles (fig. 75), warriors (figs. 17, 67), or hunters (fig. 172) to ecclesiastics would have as little foundation as to suppose that bureaucrats and generals did not own icons. Neither ecclesiastics nor men and women of the secular world were peculiarly equipped to be the owners of boxes with scenes from the Old Testament (figs. 53, 79, 82, 132) and if indeed such iconography concealed allusions to contemporary matters of church and state,[71] all the more reason why they would interest both such parties. Any attempt to apportion the caskets to specific groups of clients on the grounds of their apparent iconography fails in the face of creations like the

Xanten box (fig. 246)[72] where plaques said to derive from Joshua imagery (cf. fig. 50) are mixed with details of the labors of Herakles.

The very variety of such scenes across the gamut of boxes that we possess demonstrates that their makers were no slavish imitators of antique models. For example, the nude and beardless figure of Herakles, shown in the second plaque from the right on the front of the Xanten box, is often described as depending on Lysippus's hero resting after cleaning the Augean stables, a statue still visible in the Hippodrome of Constantinople in Middle Byzantine times. But in 1984 there was discovered in an excavation in the Chiemsee, east of Munich, fragments of a casket with a quite different version (fig. 247). Instead of cupping his chin in the manner of Rodin's *Thinker*, the pensive and now bearded Herakles, still seated on his lionskin-draped basket, clasps his hands around a raised knee.[73] The plaque from the Chiemsee is no mindless variant on an established type but one that would have satisfied its beholder as a valid reading of the scene. One could cite a dozen other intelligent signs that their users would have appreciated, not least the boxes, originally equipped with a lock and thus appropriate for money, decorated with the story of Adam and Eve in a sequence that ends with the expelled pair working metal at a forge and anvil, with Ploutos, the god of wealth, between them.[74]

The "mythological" and "biblical" caskets could at the same time, then, evoke a lost world and be meaningful to that in which they were used. If there is no reason to suppose that those who bought them had a prior say in their decoration, *to be bought* they would still have had to appeal to a public devoted to the antiquity that lived on in their books. Whether such books transmitted Greco-Roman images as well as they preserved texts is a question beyond our present concern. What the student of ivory can observe is the extent to which box plaques and icons alike perpetuated the art of late antiquity. Recent on-slaughts on the inappropriately named "Macedonian Renaissance,"[75] justified as the criticism is at the theoretical level, have tended to divert attention from the evidence for

246. Xanten, Cathedral treasury. Box (12.0 × 41.9 × 17.0 cm). Front

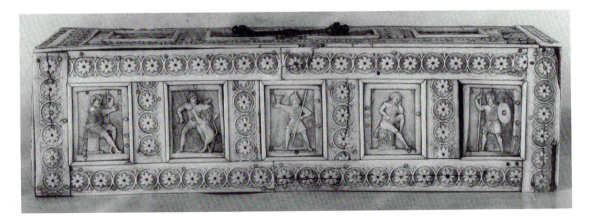

247. Munich, Prähistorische Staatssammlung. Box plaque

the recovery of forms that had not been widely used since the Justinianic era. The sheer weight of this testimony in the luxurious medium of ivory requires that it be examined briefly here. But it must first be emphasized that, even in toto, it does not add up to a "Renaissance": widespread among sculptors of very different levels of competence, the revival of antique, or rather late antique, motifs, epigraphy, and object types brought with it no change in the craftsman's status, no heroic sense of surpassing the ancients, no recovery of a "golden age." In contrast to the Quattrocento, the artisans of tenth-century Byzantium remained unsung. On the rare occasions when their activity was acknowledged, their achievement was denigrated;[76] when their execution was superb, as in some instances we have examined, it remained anonymous. Better proof could not be found that the so-called encyclopaedic culture of the age was determined by the taste of the ruling class to which this chapter is devoted.

In the last half century of research on ivory carving one of the most celebrated demonstrations was that the figured friezes of the Veroli casket (figs. 61, 128) depend ultimately upon the *Dionysiaka* of the fifth(?)-century Egyptian poet, Nonnos of Panopolis.[77] Important as the discovery is, two points yet need to be made. First, to identify the literary source of a major work of Byzantine art is not the same as to identify the nature of the impulse that led to that source's exploitation and, second, to view this achievement independently of other aspects of "recovery" is to deprive it of much of its force. Not only the figural scenes on the Veroli casket but its bands of rosette ornament derive from late antique Egyptian art. They are found, together with scenes of putti hunting wild animals with dogs (cf. fig. 172), on the panels of wooden chests like a recently published example in Princeton.[78] Even the truncated pyramid that is the overall shape of many "rosette caskets" (e.g., fig. 17) has long been recognized as that of wooden boxes revetted with bone plaques and made in fourth- or fifth-century Egypt.[79]

I do not wish to suggest that ivory carvers of the tenth and eleventh centuries depended only or directly on the work of much older practitioners of their craft. Into the

catchment basis that was the art of the Macedonian élite flowed so many antique streams that it would be pointless to try to identify the earliest or most powerful. The variety, not the priority, of "sources" is the issue here, a range that extends at least from the repetition on the back of the Harbaville triptych (fig. 152) of the flowering crosses of early Christian silver book covers and ivories[80] to the bare-bottomed putto diving into a basket (figs. 61, 245) found, for instance, in a similarly comic setting among the floor mosaics of Madaba.[81] Supreme representative of the great triptychs of its time as the Harbaville now seems, it is still a treasure house of late antique themes. The lions and hares in the undergrowth of its triumphal cross (fig. 227) echo the creatures that inhabit the vine scrolls of Maximian's cathedra[82] and the transept pavement of the Dumetios basilica at Nikopolis.[83]

It would be tedious to list all the examples of ornament whose late antique ancestry is beyond question. Suffice it to mention the spiral columns, with elaborate bases and capitals often aslant, that frame figures and groups as on the Hildesheim Crucifixion (fig. 33); they adorn the Evangelist panels on the cathedra as well as countless late antique boxes in a variety of materials.[84] And the leafy acroteria, rising from fanciful architectures not only on numerous ivories (e.g. figs. 39, 91, 158b) but in the Leo Bible[85] and other books produced for the same clientele, sprout in exactly the same way on the sixth-century Archangel plaque in the British Museum.[86]

Ornament, being peripheral and often nonrepresentational, in the traditional sense of the term, is frequently held to lack the signifying power of figures and scenes. Yet one does not have to be an anthropologist to understand that masks and disembodied heads, be they human or animal, can denote a territory as holy, guard it from harm, honor or somehow epitomize the force that lies within it. The busts of angels above the Crucifixion (figs. 9, 124, 191, 222, etc.), even while not required by scripture, are far from ornamental, but what is to be made of the anthropomorphic capitals on the propylaea of manuscript canon tables and a variety of ivories? They are surely no more "neutral" than the curly-headed herms below the emperors and deferring barbarians on the base of the Theodosian obelisk,[87] marking off a reserved and sacred precinct within the public domain of the Constantinopolitan hippodrome. And if such "headers" are not without meaning, can any less be said of the elaborate footstools on which the holy are exalted, especially those of the "Biedermeier" variety (fig. 127)[88] anticipated in portraits of the great authors of antiquity?[89]

One argument against the notion that such forms were loans unthinkingly drawn on the credit of the past by illiterate craftsmen is the renewed interest in much older literature. If on the caskets this is exemplified by Veroli, on the icons it is expressed by the New York Crucifixion (pl. V) where the belly of Hades, split by the Cross, depends upon a *kontakion* of the mid-sixth-century Romanos the Melode.[90] It is a priori unlikely that men who worked with their hands all day had access to such texts. On the other hand, their

244

recovery falls naturally into the context of the search for ancient *testimonia* alluded to by Constantine VII.[91] The men involved in this search, or their beneficiaries, found new inspiration in ancient sources of this sort. Yet again, as in the case of the Egyptian boxes, their exploitation was not limited to one aspect of the material upon which they stumbled. Along with the infusion of ideas for new creations in the visual arts, they appropriated the very forms in which they were expressed. Many of the letter forms that we have observed, notably the alpha with the chevron-shaped cross bar (as on fig. 124),[92] are appropriated from late antique inscriptions.

Late antiquity, as Peter Brown once put it, is later than you think: we cannot give a "cut-off date" for the age of the resources on which the culture of Macedonian Constantinople drew. The academic dichotomy between "continuity" and "revival" may well obscure the ways in which the past was used in Byzantium. Indeed the distinction seems over-nice in the face of a civilization that essentially proclaimed the authority of what was old and the undesirability of novelty.[93] Works of the late seventh century were certainly venerable enough to be imitated in the tenth, as the cross without a nimbus behind the head of Christ on icons (figs. 116–118), seals (fig. 225), and money of Constantine Porphyrogennetos suggests; this device was borrowed from the coins of Justinian II's first reign.[94] *Grosso modo*, the ivories present little that was unknown to the pre-Iconoclastic period, and even rarities in Middle Byzantine art, like the *two* boys who throw a tunic in the way of Christ's ass (figs. 39, 40) can be traced to artifacts of the fifth and sixth centuries.[95] Innovations such as St. Michael handing a hoe to Adam cast out of paradise, found in the Paris Gregory,[96] rather than simply gesturing toward him (fig. 82), are avoided; although the modification of the Chairete whereby Christ regards the spectator (fig. 2) rather than the women (figs. 31, 110) does occur.

Variants of this sort point to the breadth of the repertoire available not in the "model books" of carvers' ateliers but in the collections of those who patronized them. Rather than the single-minded and slavish borrowing from painted prototypes that we—possessing many more tenth-century books than objects—reconstruct as their *modus operandi*, as a whole the community of craftsmen had access to a range of iconographic types, the size of which we can only guess. The fact that the Joshua Roll was not the source for the defeat of the men of Ai depicted on the New York plaques (fig. 50)[97] indicates something of this wealth: the sculptor not only multiplied the number of the defeated between the groups of Israelites but made more of their hapless leader to the far right of the plaque than the painter of the rotulus. The pathetic gesture of the captain's hand placed on the ground even as he is beheaded (and his figure truncated, in the manner of a Japanese print, by the carver) suggests the use of another version of a picture-sequence that had been around since the seventh century.[98]

The relative role of the patron's taste, as against that of objects he or she possessed, cannot be assessed and is, in any case, a fairly pointless distinction. It is more important to

recognize in the body of ivories that we have expressions of a shared culture, contributions to which flowed from client and craftsman alike. One may differentiate the phases of conception, where the ideas of designers dominated, from those of execution, where the talent and experience of craftsmen took the upper hand. Just as the latter were not cognoscenti of ancient literature, so most clients were probably not expert in materials: if many museum curators cannot tell bone from ivory, should we expect more of tenth-century intellectuals?[99] Nonetheless, it would be rash to deny them any response to the material beauty of dentine,[100] the grain patterns of which (e.g., fig. 29) can rival those of the marbles celebrated by Justinianic authors.[101]

Ivory icons and bone boxes were personal possessions which, to judge from slightly later comments on objects in other media, were treasured by their owners. In 1077, the historian Michael Attaleiates describes in detail his silver *dithyros* (triptych) which, in the nature and distribution of its iconography,[102] closely resembled specimens of the genre that we have examined (figs. 169, 170, 176). Eighteen years earlier Eustathios Boilas, *protospatharios* and *hypatos*, lists a Crucifixion triptych (cf. pl. VI, figs. 77, 124, 222) among the goods that he distributed to his family and his private monastery[103] with as much devotion as he lavished on his books. In the absence of sufficiently detailed accounts of private monasteries and chapels,[104] we cannot tell how icons of this sort fitted into their schemes of decoration; lacking an equivalent for the Ciceronian evidence that enables us to see how a Roman aristocrat's house functioned as the "strategic center of his political influence both as a patron and colleague,"[105] we do not know the extent to which a Byzantine's personal property functioned in the way that the bronze and marble sculptures, in the landscape and domestic settings (including "chapels") of Campanian villas, serve as evidence of their proprietors' political and philosophical concerns.[106] But wherever they were housed, a Byzantine's ivories were no less objects of display than of veneration. They speak not only of their owner's Orthodoxy but of the culture of which that faith was a part.

3. CONCLUSIONS

The reader who has reached this point progressively, rather than initially, will have noticed certain themes and observations that have recurred frequently, even while they have arisen in the course of various approaches to the place of ivory in the Byzantine world. These have included the exotic origin of the material and hence its presumably high cost and imputed value; the complexity of the process involved in its cutting and carving; the anonymity of these processes—total in the case of those who executed them and largely so for those who enjoyed the results; the limited range and generally "conservative" nature of both the uses

to which dentine was put and the imagery imposed on it; the grounds for supposing that almost all examples belong to a span of time no longer than (at most) two centuries (*ca.* 880–*ca.* 1080); and, above all, the role that individuals played in the commissioning, fabrication, and employment of carved ivory, notwithstanding the links that connected one craftsman with another in terms of their techniques and markets, and their clients in terms of their education, social class, and tastes. To these points I now return not so much in the belief that I can reinforce my conclusions by repeating the reasoning behind them, as in the hope of detecting organic relations among those that are recognizable as parts of the Byzantine *système du monde* that we know from other sources.

Early efforts to see our objects as exponents of social and political conditions led to readings that were either misguided[107] or simply wrong.[108] More recent attempts have recognized the oblique ways in which iconography could be used to allude to current circumstances,[109] but still lacking is any comprehensive view that treats ivory—as a commodity, as a favored means of expression, and as an ideological instrument—as a constitutive and characteristic part of Byzantine culture between the late ninth and late eleventh century. The task, in other words, is to recognize the broader implications of the commerce, craft, and applications of a substance that has generally been regarded as an inert medium for the making of "works of art." This dissociation from the world in which it was used is in part due to the fact that, unlike other materials, ivory does not readily suggest the way it is shaped. As we have seen, the variety of techniques in which it was carved and its final polishing obscure rather than reveal the labor of human hands. In this way charges of the gross materiality of images, leveled two hundred years earlier by the Iconoclasts,[110] might have seemed less pressing.

But no less responsible for the modern separation of ivory from historical reality is the fact we have no idea how much it cost in its natural state or as a finished product. Herein lies the root of our inability to define precisely the social standing of those who bought it. Slightly clearer is the status of those who worked it. Whether or not clients supplied with raw material those whom they employed—a provision suggested of other media in the *Book of the Eparch*[111]—its carving, which is to say the cost of labor, added little to the initial price of ivory. Although the only numbers that we have are for wages of the eighth century, and are difficult to translate into purchasing power, it is worth noting that a worker in an *ergasterion* earned six and a half nomismata a year—less than a builder or a smith, but more than a scribe who got only six. By contrast, in Leo VI's reign, the *strategoi* (military commanders) received in gold the equivalent between 30 and 240 nomismata per month.[112] Even if a fine sculptor, as the makers of some of our ivories obviously were, earned twice as much as an artisan, the income from his labor would be as small as the value that we have seen was put on his contribution.[113] In thirteenth-century Islam, a load of worked ivory cost only 20 percent more than a shipment of dentine in its raw state,[114] and there is little reason to suppose a greater differential in tenth-century Constantinople.

Value, then, lay in the material, not in the price of labor and probably not even in the relative competence of the craftsman. If the latter was a variable independent of the material, so, most likely, the carver's skill was independent of the amount that he gained for his product. Excellence was a quality of the mind that designed the artifact—this is a main point of the inscription on the Warsaw diptych (fig. 221). [115] Yet above all, it inhered in the material itself, in the social and symbolic significance that it possessed. In a situation familiar to anthropologists, a prestigious artifact might be not merely an expression of its owner's status but the occasion, if not the cause, of that status. [116] That we are dealing with *ascribed* value is evident from the majority of the boxes (figs. 17, 64, 74, 246) on which bone plaques simulate the appearance of dentine. But it is even clearer from the form that most ivory took in the Middle Byzantine world—plaques, rarely more than a centimeter thick, offering the maximum surface area in relation to their weight. In this respect, our lustrous material resembles the way in which gold, silver, and precious stones were (and are) used. Like them, it is not "liquid"; it cannot be melted down, and only rarely is it satisfactorily recut.

Thus beyond its value in the market place, ivory was a *sign* of wealth. Bearing Christian iconography, it was also a sign of grace and in a society that prized both wealth and grace, it was displayed. The exhibition of ivory was not simply ostentation but a means of declaring its owner's state of wealth and grace. In turn, exhibition would encourage emulation. In the language of the economist display had a multiplier effect, increasing the demand for ivory and ipso facto enhancing its virtue. Especially telling is the very small number of icons that we have in bone (fig. 70). [117] Although some may have been lost due to the material's more rapid rate of decomposition, the numerical disparity between surviving specimens in bone and ivory points to a cultural decision: [118] good enough for the motley and sometimes comic decoration of boxes serving a variety of ends, bone was inappropriate for images that received veneration. That ivory was reserved for this domain is also suggested by its infrequent incidence among objects of daily use preserved in the archaeological record. [119] The medium of ivory was—to use a now-hoary cliché—part of its message. Put more directly, and with greater relevance to our immediate concern, we can say that the Byzantine belief system found expression not only in iconography but in the materials and techniques selected for its representation. [120]

While all such choices may be said to be expressions at the behavioral level of cultural patterns, the choice of ivory was reinforced in Byzantium by properties that, taken together, distinguished it from other materials. Expensive enough to exclude many from possessing it, its employment was sanctioned by widespread use in Christian antiquity. Durable enough to withstand even fire (fig. 41), it could be shaped by craftsmen endowed, as we have seen, with a marked range of talents. Rare enough to be alluring, it was sufficiently akin to steatite, bone, and wood to be carved by men who worked in these materials. Not least important was the relation between its naturally restricted size (both

as a tusk and in section) and artisanal organization in the capital. One pair of hands was sufficient to move a load of raw dentine, to cut, carve, and finish the plaques that it yielded. Commissions from the palace, as from the élite more or less associated with it, could be executed in the same small shop; aided by a family member or assistant, a craftsman could produce works "on spec," for sale in the market place. The different levels of skill and the formal variety that we have noted imply the sizable (if unquantifiable) number of hands at work in the same period. But nothing in the body of their output, as we have it, indicates technological evolution over time, nor apparently did the social conditions of its employment offer incentives for developments of this sort. Carving of both low and high quality occurs throughout: the very fine tool—perhaps a needle file or burin—used on the back of the Harbaville triptych (fig. 152) stands out by virtue of the delicacy with which it was used; but a similar tool, applied with no less cunning, is evident on the apex of the Leo ivory (fig. 158b).[121]

Hardest for us to gauge is the nature and extent of esthetic appreciation among those who made use of the carved material. Near the beginning of this book I tried to suggest the qualities in an ivory to which a Byzantine might respond, but, in the absence of contemporary commentary,[122] it proved scarcely possible to distinguish its impact on us from what might have been its medieval effect.[123] If candles were set not only in front of the translucent triptychs but also behind them, it is difficult to believe that their beholders failed to react to their dramatically changed appearance. The heavy shadows cast on the opaque ground by Christ's arms and body and by the Virgin's raised hand disappear when the Metropolitan Crucifixion (pl. V) is illuminated in this way. Chiaroscuro is replaced by planes of different hue—almost green for the flesh and garments, a lambent gold for the bars of the cross and the protagonists' haloes, all set in a sea of variegated amber. Liquid and flowing, the ground acts as a foil to the quicksilver highlights that animate Jesus' arms, John's hair, Mary's back, and Hades' shoulder and knee. The canopy above them becomes a three-dimensional dome embracing figures caught in momentary fixity. In a second Christ or John will change his position, Mary will raise her head. The soldiers will make other gestures and even Hades, dispassionately transfixed by the Cross, might try to rise or cry out.

The reading of movement and potentiality into images that seem to us static is no modern (or modish) attempt to compensate for their absence. In the mid-eleventh century just this response was repeatedly urged by Psellos with specific reference to icons of the Crucifixion. He concluded a tract on this topic by observing that its beauty lay not in its colors but in the movement that enlivened the ensemble;[124] and in a letter he invited his correspondent to reach out to the head of the crucified and the blood from the wound in his side.[125] Empathetic attitudes of this sort are borne out when we segment the subject matter of our plaques. Of the ninety-four "Feast" scenes in the corpus of ivories, forty-five are Crucifixions and nineteen images of the Virgin's Dormition. It is possible that this

statistical preponderance is due to their doctrinal import—the physical deaths of Jesus and Mary implying the resurrection of the spirit—and its significance in a domestic context, what has been read as "the art of dying well."[126] But these scenes are also the culminations of the lives of Christ and his mother in larger programs of decoration, in the cycles that normally surrounded a worshiper in church. Thus composite images (pl. VIII, figs. 2, 20),[127] and even more those of the final events in the earthly histories of the Savior and the Virgin could, in the setting of a chapel, function synecdochically, the climactic part standing for the narrative whole.

Repeatedly above I have argued for the private and even personal use of ivories. However, as on the lead seals—the richest single archive that we have of iconographic choices[128]—the part that our objects played in personal devotions did not lead to a disproportionate number of images of the saints. Indeed, the quantity of ivories showing individual (fig. 88) or collective representation of holy men (figs. 28, 44, 169, 170, 176, 194) does not exceed that of the Dormition and is markedly inferior to that of the Hodegetria. She, in turn, appears more than half again as often as Christ, either alone or enthroned with angels (thirty-two as against twenty examples); among her images, dominant, as we have seen, is the half-length figure who invites proximate and direct contemplation.[129]

What do these ratios imply? Beyond a preference for the Virgin, and for "simple" as against complex imagery, they suggest the prevalence of convention, a conservatism that is apparently more marked than in any other medium of Byzantine art. Our last task is to account for these norms, expressing as they must the wishes of the clientele and the compliance of the craftsmen responsible for their execution. This much said, three qualifications to this proposition need to be made. First, terms like conservatism and convention are (at best) descriptive labels, not analytical tools. They paraphrase but do not explain the frequency with which certain subjects recur or the minimal number of significant variations in the content of our plaques. They neither unfold the tightly wound, largely standardized mass of iconography, nor make clear the reasons for its distribution and continuity. Secondly, the impression of imitation, of both the present and the past, implied by such labels masks the deliberate reversion to late antique and early Christian motifs observed in the previous section of this chapter: in sum these are tantamount to what, in a literary context, has been called "the revolutionary act of reviving forms and conventions that had been so long out of use."[130] Lastly, to lay too much weight on the "conservatism" of the carvers and owners of ivory is tacitly to ignore the extent to which works in other materials display this quality. The body of ivory icons is remarkably cohesive. Not only does one part of a triptych have predictive value for the content or, say, the lost wing of another, but we can also be fairly sure that the missing member was laid out according to the rules of symmetry evident in the ivories that we have. Angels, Church fathers, military saints balance each other. If on one occasion they flank the Hodegetria

and on another the Crucifixion, the ease with which these are substituted itself testifies that we are dealing with a cognitive system that transcends the medium of ivory. It is true that the boxes are decorated with imagery that is very rare elsewhere in Byzantine art, but even then the sum of these appliqués is internally consistent,[131] repeating and varying themes and attitudes towards those themes that are Byzantine, not pious obsequies to pagan antiquity.

A Crucifixion in ivory looks as it does because this is the way it was *supposed* to look—in the expectations of its purchaser, in the experience of its maker, and in the visual accounts of the same scene offered in enamel, bronze, and painting. Against the reading which sees here homeostasis, "timelessness," and an absence of "fashion" it must be pointed out that fashion is very much part of the totality with which we are engaged. The decision to use ivory is an expression not only of the material's availability but of a cultural style that may have originated at the imperial court and was thence diffused. If, for economic reasons, the lower strata of the laity and clergy could not subscribe to this behavior, and if , in the end, the fashion vanished because the material itself disappeared, the huge body of consumption that lay within these boundaries exhibits a technological and ideological style that is no less evident than the much more often remarked features of hair- and figure-style, "plasticity," "drapery," and so on. Such aspects of form are also manifestations of the Byzantine view of the world, but they are less eloquent than the expressions that I have tried to define. Together, these characteristics constitute a set of images constructed to present an orthodoxy of Christian beliefs concerning the supernatural as if these were natural phenomena.

It is easy to detect the political nature of those ivories in which the emperors are touched by the divine (pl. IV, figs. 76, 220), brought into proximity with it (figs. 24, 25) or associated with it by their texts (figs. 48, 139, 158, 176, 226): the splendor of the garments and/or the explicit nature of the inscriptions leave no doubt on this point. This understanding can be extended to officials of the state or Church likewise brought into conjunction with Christ, his mother, his Cross, or his saints by the words, functions, or images imposed on the plaques (pl. II, figs. 188, 233). These patrons accepted the rules of a code the observance of which, in turn, helped to exalt those who accepted and observed them. It is harder to see the relation of this code to the caskets decorated with scenes of classical and Old Testament "mythology" if we worry more about the literacy of those who crafted them than the culture of whose who bought them: seen in this way, the boxes emerge as political statements as lucid as the tenth-century restoration of ancient ceremonies and the perpetuation of titles long since passed into disuse.[132]

It is scarcely easier to recognize in "ordinary" icons, in plaques that we cannot connect with particular individuals, codified statements of that logical relationship between earth and heaven declared in Constantine VII's preface to the *Book of Ceremonies*.[133] This "program," as much as the carvers' skills and the clients' interests, determined the essence of

our ivories. On the other hand, their existence—that which this book set out to explicate—depended upon the mutual impact of a culture's readiness to endow material splendor with ideological associations and its craftsmen's participation in these beliefs, even while they produced the materially splendid works that we have examined.[134]

Abbreviations

Aach Kb = *Aachener Kunstblätter*

AASS = *Acta Sanctorum*, 71 vols. (Paris 1863–1940)

AJA = *American Journal of Archaeology*

ArtB = *Art Bulletin*

BAR = *British Archaeological Reports*

BMGS = *Byzantine and Modern Greek Studies*

BSC = *Annual Byzantine Studies Conference, abstracts of papers*

ByzF = *Byzantinische Forschungen*

BZ = *Byzantinische Zeitschrift*

CahArch = *Cahiers archéologiques*

CEB = *Actes [Atti, Berichte, etc.] du [#] Congrès international des études byzantines*

CFHB = *Corpus fontium historiae Byzantinae*

De cer. = *De ceremoniis aulae byzantinae*, 3 vols., ed. J. J. Reiske, Bonn 1829–1830

DOC = A. R. Bellinger, P. Grierson, *Catalogue of the Coins in the Dumbarton Oaks and Whittemore Collections,* Washington, D.C. (in progress)

DOP = *Dumbarton Oaks Papers*

ΔXAE = *Δελτίον τῆς Χριστιανικῆς Ἀρχαιολογικῆς Ἑταιρείας*

FelRav = *Felix Ravenna*

GBA = *Gazette des beaux-arts*

G-W I = A. Goldschmidt and K. Weitzmann, *Die byzantinischen Elfenbeinskulpturen des X.-XIII. Jahrhunderts. I. Kästen.* Berlin, 1930, reprinted Berlin 1979

G-W II = A. Goldschmidt and K. Weitzmann, *Die byzantinischen Elfenbeinskulpturen des X.-XIII. Jahrhunderts. II, Reliefs.* Berlin 1934, reprinted Berlin 1979

JbAChr = *Jahrbuch für Antike und Christentum*

JDAI = *Jahrbuch des Deutschen Archäologischen Instituts*

JESHO = *Journal of the Economic and Social History of the Orient*

JHS = *Journal of Hellenic Studies*

JRA = *Journal of Roman Archaeology*

JWAG = *Journal of the Walters Art Gallery*

JWarb = *Journal of the Warburg and Courtauld Institutes*

Mansi = *Sacrorum Conciliorum nova et amplissima collectio,* 53 vols. in 58 parts, Paris-Leipzig 1901–1927

MEFRA = *Mélanges de l'Ecole française de Rome, Antiquité*

MGH = *Monumenta Germaniae historica*

MM = F. Miklosich and J. Müller, *Acta et diplomata graeca medii aevi sacra et profana*, 6 vols., Vienna 1860–1890

MünchJb = *Münchner Jahrbuch der bildenden Kunst*

OCA = *Orientalia christiana analecta*

OCP = *Orientalia christiana periodica*

ODB = *The Oxford Dictionary of Byzantium*, ed. A. Kazhdan, A.-M. Talbot, A. Cutler, T. E. Gregory and N. P. Ševčenko, 3 vols., New York 1991

PG = J. P. Migne, ed. *Patrologiae cursus completus. Series graeca*, 161 vols. in 166 parts, Paris 1857–1866

PL = J. P. Migne, ed., *Patrologiae cursus completus. Series latina*, 221 vols. in 222 parts, Paris 1844–1880

RACr = *Rivista di archeologia cristiana*

REB = *Revue des études byzantines*

SbWien = *Sitzungsberichte der Österreichischen Akademie der Wissenschaften, philosophisch-historische Klasse*

SC = *Sources chrétiennes*

SettStu = *Settimane di studio del Centro italiano di studi sull'alto medioevo*

Skyl = Skylitzes, *Synopsis historiarum*, ed. I. Thurn, Berlin-New York 1973

Synax.CP = *Synaxarium ecclesiae Constantinopolitanae: Propylaeum ad Acta sanctorum Novembris*, ed. H. Delehaye (Brussels 1902)

Theoph = Theophanes, *Chronographia*, ed. C. de Boor (Leipzig 1883–1885, reprint Hildesheim 1963)

TheophCont = Theophanes Continuatus, ed. I. Bekker, Bonn 1838

TM = *Travaux et Mémoires*

VV = *Vizantijskij Vremennik*

253

Frequently Cited Works

Arnulf 1990 = A. Arnulf, "Eine Perle für das Haupt Leons VI. Epigraphische und ikonographische Untersuchungen zum sogennanten Szepter Leons VI.," *Jahrbuch der Berliner Museen* 32, 70–84

Asano 1988 = K. Asano, "Santen no zoge toripitikku no purigurama," *Bijutsushi* 37, 97–108

Bank 1978 = A. Bank, *Prikladnoe isskustvo Vizantii IX–XII vv.*, Moscow

Bank 1981 = A. Bank, "Les principales tendances dans l'évolution des arts mineurs byzantins aux XIIᵉ-XIIIᵉ siècles," *Actes du XV CEB*, IIa, Athens 1981, 43–50

Bank—Popova 1977 = A. Bank and O. S. Popova, *Iskusstvo Vizantii v sobranijach SSSR*, vol. II, Moscow

Baxandall 1980 = M. Baxandall, *The Limewood Sculptors of Renaissance Germany*, New Haven

Beaton 1989 = R. Beaton, *The Medieval Greek Romance*, Cambridge

Beckwith 1962 = J. Beckwith, "'Mother of God showing the way.' A Byzantine ivory statuette of the Theotkos Hodegetria," *The Connoisseur* 150, 2–7

Bouras 1989–90 = Ch. Bouras, "The Olympiotissa Wood-carved Doors, Reconsidered" ΔΧΑΕ, ser. 4, vol. 15, 27–32

Buschhausen 1971 = H. Buschhausen, *Die spätrömischen Metallscrinia und frühchristlichen Reliquiare. I. Katalog*, Vienna

Caillet 1985 = J.-P. Caillet, *L'Antiquité classique, le haut moyen age et Byzance au Musée de Cluny*, Paris

Conkey 1982 = M. W. Conkey, "Boundedness in Art and Society" in *Symbolic and Structural Archaeology*, ed. I. Hodder, Cambridge 1982, 115–28

Connor 1991 = C. L. Connor, "New Perspectives on Byzantine Ivories," *Gesta* 30, 100–11

Corrigan 1978 = K. Corrigan, "The Ivory Scepter of Leo VI: a Statement of Post-Iconoclastic Imperial Ideology," *ArtB* 60, 407–16

Ćurčić—St. Clair 1986 = *Byzantium at Princeton. Byzantine Art and Archaeology at Princeton University*, exhib. cat., ed. S. Ćurčic and A. St. Clair, Princeton, N.J.

Cutler 1984a = A. Cutler, "The Making of the Justinian Diptychs," *Byzantion* 54, 75–115

Cutler 1984b = A. Cutler, "'Roma' and 'Constantinopolis' in Vienna," in *Byzanz und der Westen. Studien zur Kunst des europäischen Mittelalters* (= SbWien 432), Vienna

Cutler 1984c = A. Cutler, *The Aristocratic Psalters in Byzantium* (Bibliothèque des Cahiers archéologiques, XIII), Paris

Cutler 1984–85 = A. Cutler, "On Byzantine Boxes," *JWAG* 42–43, 32–47

Cutler 1985 = A. Cutler, *The Craft of Ivory. Sources, Techniques, and Uses in the Mediterranean World: A.D. 200–1400* (= *Byzantine Collection Publications*, 8), Washington, D.C.

Cutler 1987 = A. Cutler, "Prolegomena to the Craft of Ivory Carving in Late Antiquity and the Early Middle Ages, in *Artistes, artisans et production artistique*, ed. X. Barral i Altet, II, Paris, 431–75

Cutler 1988 = A. Cutler, "Un Triptyque byzantin en ivoire. La Nativité du Louvre: étude comparée," *Revue du Louvre* 38, 21–28

Cutler 1991 = A. Cutler, "Inscriptions and Iconography on Some Middle Byzantine Ivories. I, The Monuments and their Dating," *Scritture, libri e testi nelle aree provinciali di Bisanzio. Atti del Seminario di Erice* (18–25 settembre 1988), ed. G. Cavallo, G. de Gregorio and M. Maniaci, Spoleto, 645–59

Cutler 1992a = A. Cutler, "ΠΑΣ ΟΙΚΟΣ ΙΣΡΑΗΛ. Ezekiel and the Politics of

Resurrection in Tenth-Century Byzantium," *DOP* 46, 47–58

Cutler 1992b = A. Cutler, "Sacred and Profane: the locus of the political in Middle Byzantine Art," *Milion* 3 (in press)

Cutler 1994a = A. Cutler, "Theory and *Theoria*: the Ivories of the Forty Martyrs as Models of Historical Understanding," in *The Forty Martyrs of Sebasteia*, ed. M. Mullett (in press)

Cutler 1994b = A. Cutler, "The Date and Significance of the Romanos Ivory," in *Byzantine East, Latin West: Art Historical Studies in Honor of Kurt Weitzmann*, ed. D. Mouriki, S. Ćurčić, G. Galavaris, H. Kessler and G. Vikan, Princeton, N.J. (in press)

Cutler—Oikonomides 1988 = A. Cutler and N. Oikonomides, "An Imperial Byzantine Casket and its Fate at a Humanist's Hands," *ArtB* 70, 77–87

Davidson 1952 = G. R. Davidson. *Corinth*. XII, *The Minor Objects,* Princeton, N.J.

Delbrueck 1929 = R. Delbrueck, *Die Consulardiptychen und verwandte Denkmäler*, Berlin-Leipzig

Dmitrievskij 1895–1917 = A.A. Dmitrievskij, *Opisanie liturgičeskich rukopisej*, 3 vols., Kiev

Dobschütz 1899 = E. von Dobschütz, *Christusbilder. Untersuchungen zur christlichen Legende*, Leipzig

Dufrenne 1966 = S. Dufrenne, *L'illustration des psautiers grecs du Moyen Age*, Paris

Dufrenne—Canart 1988 = *Die Bibel des Patricius Leo. Codex Reginensis Graecus IB*, facsimile with introductory volume by S. Dufrenne and P. Canart, Zürich

Durand 1992 = *Byzance. L'art byzantin dans les collections publiques françaises*, ed. J. Durand, Paris

Ebitz 1986 = D. M. Ebitz, "Fatimid Style and Byzantine Model in a Venetian Ivory Carving Workshop," in *The Meeting of Two Worlds. Cultural Exchange between East and West during the Period of the Crusades*, ed. V. P. Goss and C. V. Bornstein, Kalamazoo, Mich., 309–29

Engemann 1987 = J. Engeman, "Elfenbeinfunde aus Abu Mena/Ägypten," *JbAChr* 30, 172–86

Eparchikon biblion = *Das Eparchenbuch Leons des Weisen*, ed. J. Koder (*CFHB*, 32), Vienna 1991

Frazer 1974 = M. E. Frazer, "Hades Stabbed by the Cross of Christ," *Metropolitan Museum Journal* 9, 153–61

Frolow 1961 = A. Frolow, *La Relique de la Vraie Croix*, Paris

Gaborit-Chopin 1988 = D. Gaborit-Chopin, *Avori medievali* (= Lo specchio del Bargello, 44), Florence

Giusti 1981 = P. Giusti in P. Giusti and P. L. de Castris, *Medioevo e produzione artistica di serie: smalti di Limoges e avori gotici in Campania*, Milan, 35–54

Graeven 1900 = H. Graeven, *Frühchristliche und mittelalterliche Elfenbeinwerke in photographische Nachbildungen. Nr. 1–80. Aus Sammlungen in Italien*, Rome

Guillou 1979 = A. Guillou, "Deux ivoires constantinopolitains datés du IXe et Xe siècle" in *Byzance et les slaves. Études de civilisation. Mélanges Ivan Dujčev*, ed. S. Dufrenne, Paris, 207–11

Harrison 1986 = R.M. Harrison, *Excavations at Saraçhane in Istanbul*, I, Princeton, N.J.

Harvey 1989 = A. Harvey, *Economic Expansion in the Byzantine Empire 900–1200*, Cambridge

Hodder 1987 = I. Hodder, "The Contextual Analysis of Symbolic Meanings," in *The Archaeology of Contextual Meanings*, ed. I. Hodder, Cambridge, 1–10

Jacobs van Merlen, L. 1948 = L. Jacobs van Merlen, "Les Ivoires pré-gothiques du Musée Mayer van den Bergh à Anvers," *Bulletin de la Société Royale d'Archéologie de Bruxelles*, August 1948, 7–17

Kalavrezou 1977 = I. Kalavrezou-Maxeiner, "Eudokia Makrembolitissa and the Romanos Ivory," *DOP* 31, 307–25

Kalavrezou 1985 = I. Kalavrezou-Maxeiner, *Byzantine Icons in Steatite* (= *Byzantina Vindobonensia*, 15), Vienna

Kalavrezou 1989 = I. Kalavrezou, "A New Type of Icon: Ivories and Steatites," in *Constantine VII and his Age. 2nd International Byzantine Conference, Delphi, 22–26 July 1987*. Athens, 377–96

Kantorowicz 1942 = E. Kantorowicz, "Ivories and Litanies," *JWarb* 5, 56–81

Kazhdan—Constable 1982 = A. Kazhdan and G. Constable, *People and Power in Byzantium. An Introdution to Modern Byzantine Studies*, Washington D.C.

Keck 1930 = A. S. Keck, "A Group of Italo-Byzantine Ivories," *ArtB* 12, 147–62

Keck—Morey 1935 = A. S. Keck and C. R. Morey, review of G-W II in *ArtB* 17, 397–406

Khuskivadze 1986 = L. S. Khuskivadze, "Le Triptyque en ivoire de Cxinvali," *Revue des études géorgiennes et caucasiennes* 2, 173–195

Laiou 1982 = A. E. Laiou, "Venice as a Centre of Trade and of Artistic Production in the Thirteenth Century," in *Il Medio Oriente e l'Occidente nell'arte del XII secolo*, ed. H. Belting, Bologna, 11–26

Lange 1964 = R. Lange, *Die byzantinische Reliefikone*, Reckinghausen

Lechtman 1977 = H. Lechtman, "Style in Technology-Some Early Thoughts," in *Material Culture. Styles, Organization, and Dynamics of Technology* (1975 Proceedings of the American Ethnological Society), St. Paul, Minn., 3–20

Lemerle 1971 = P. Lemerle, *Le premier humanisme byzantin. Notes et remarques sur enseignement et culture à Byzance des origines au Xe siècle*, Paris

Lemerle 1977 = P. Lemerle, *Cinq études sur le XIe siècle byzantin*, Paris

Lowden 1988 = J. Lowden, *Illuminated Prophet Books. A Study of Byzantine Manuscripts of the Major and Minor Prophets*, University Park, Pa.

Lowden 1992 = J. Lowden, *The Octateuchs. A Study in Byzantine Manuscript Iluustration*, University Park, Pa.

Madigan 1987 = S. P. Madigan, "The Decoration of Arundel 547: Some Observations about 'Metropolitan' and 'Provincial' Book Illumination in Tenth-Century Byzantine Art," *Byzantion* 57, 336–59

de'Maffei 1974 = F. de'Maffei, *Icona, pittore e arte al Concilio Niceno II*, Rome

Maguire 1981 = H. Maguire, *Art and Eloquence in Byzantium*, Princeton, N.J.

Maguire—Duncan-Flowers 1989 = E. D. Maguire, H. P. Maguire and M. J. Duncan-Flowers, *Art and Holy Powers in the Early Christian House*, Urbana, Ill.

Mango 1972 = C. Mango, *The Art of the Byzantine Empire, 312–1453. Sources and Documents*, Englewood Cliffs, N.J.

Mango—Hawkins 1972 = C. Mango and E.J.W. Hawkins, "The Mosaics of St. Sophia at Istanbul. The Church Fathers in the North Tympanum," *DOP* 26, 2–41

Martini—Rizzardi 1990 = L. Martini and C. Rizzardi, *Avori bizantini e medievali nel Museo Nazionale di Ravenna*, Ravenna

Mateos 1962 = *Le typicon de la Grande Église. Ms. Sainte-Croix nº. 40, Xe siècle, I, Le Cycle des douze mois* (= OCA, 165), Rome

Mateos 1963 = *Le Typicon de la Grande Église. Ms. Sainte-Croix nº. 40, Xe siècle, II, Le Cycle des fêtes mobiles* (= OCA, 166), Rome

Mathews 1982 = T.F. Mathews, "'Private' Liturgy in Byzantine Architecture: towards a Re-appraisal," *CahArch* 30, 125–38

Mazzucchi 1978 = C. M. Mazzucchi, "Dagli anni di Basilio Parakimomenos. (Cod. *Ambr.* B119 Sup.)," *Aevum* 52, 267–316

Il Menologio = *Il Menologio di Basilio II (Cod. Vaticano greco 1613)*, Turin 1907

Mišakova 1975 = I. A. Mišakova, "K voprosy o stile srednevizantijskih rel'efov iz slonovoi kosti," in *Kultura i iskusstva Vizantii. Tezicy dokladov naučnoj konferencii*, Leningrad, 33–34

Mišakova 1978 = I. A. Mišakova, "'Rel'ef koronovanie Konstantina' v GMII i vizantijskaja reznaja kost' 'Gruppy Imperatora Romana'" in *Iskusstvo Zapadnoj Evropy i Vizantii*, Moscow, 224–36

Nikolajević 1991 = I. Nikoajević, *Gli avori e le steatiti medievali dei Musei Civici di Bologna*, Bologna

Oikonomides 1972a = N. Oikonomides, *Les Listes de préséance byzantines des IXe et Xe siècles*, Paris

Oikonomides 1972b = N. Oikonomides, "Quelques boutiques de Constantinople au Xe s.: prix, loyers, impositions (Cod. *Patmiacus* 171)," *DOP* 26, 345–56

Oikonomides 1986 = N. Oikonomides, *A Collection of Dated Byzantine Lead Seals*, Washington, D.C.

Oikonomides 1994 = N. Oikonomides, "The Concept of 'Holy War' and Two Tenth-Century Byzantine Ivories" in *Studies in Honor of George T. Dennis*, ed. T. S. Miller (forthcoming)

Omont 1929 = H. Omont, *Miniatures des plus anciens manuscrits grecs de la Bibliothèque nationale du VIe au XIVe siècle*, 2nd ed., Paris

Pegolotti = F. B. Pegolotti, *La pratica della mercatura*, ed. A. Evans, Cambridge, Mass., 1936

Petersen 1990 = *The Getty Art History Information Program Art and Architecture Thesaurus*, ed. T. Petersen, 3 vols., New York—Oxford

Polacco—Traversari 1988 = R. Polacco and G. Traversari, *Sculture romane e avori tardo-antichi e medievali del Museo Archeologico di Venezia*, Rome

Poplin 1976 = F. Poplin, "Analyse de matière de quelques ivoires d'art" in *Méthodologie appliquée à l'industrie de l'os préhistorique* (= Colloques internationaux du C.N.R.S., no. 568), Paris, 84–87

Psellos = Psellos, *Chronographia*, ed. and trans. E. Renauld, I, Paris 1926; II, Paris 1928

Randall 1974 = R. H. Randall, Jr. "A Monumental Ivory," in *Gatherings in Honor of*

Dorothy E. Miner, ed. V. E. Mc Cracken, L.M.C. Randall, and R. H. Randall, Jr., Baltimore, Md.

Randall 1985 = R. H. Randall, *Masterpieces of Ivory from the Walters Art Gallery*, New York

Ratkowska 1965 = P. Ratkowska, "An East Christian Diptych with the Heortological Cycle," *Biuletynie Muzeum Narodwego w Warszawie* 6, 92–115

Schrader 1972–1973 = J. L. Schrader, "An Ivory Koimesis Plaque of the Macedonian Renaissance," *Bulletin of the Houston Museum of Fine Arts* 1, 72–88

Severin 1987 = H.-G. Severin, "Zu drei restaurierten Kunstwerken der Frühchristlich-Byzantinischen Sammlung," *Jahrbuch Preussischer Kulturbesitz* 24, 125–35

Shelton 1982 = K. J. Shelton, "The Diptych of the Young Office Holder," *JbAChr* 25, 132–71

Spatharakis 1981 = I. Spatharakis, *Corpus of Dated Illuminated Manuscripts to the Year 1453*, 2 vols., Leiden

Splendeur de Byzance = *Splendeur de Byzance* (exhibition catalogue: Musées royaux d'Art et d'Histoire), ed. J. Lafontaine-Dosogne, Brussels 1982

Splendori di Bisanzio = *Splendori di Bisanzio. Testimonianze e riflessi d'arte e cultura bizantina nelle chiese d'Italia* (exhibition catalogue: Museo Nazionale, Ravenna), ed. G. Morello, Milan 1990

St. Clair—McLachlan 1989 = *The Carver's Art. Medieval Sculpture in Ivory, Bone, and Horn*, ed. A. St. Clair and E. P. McLachlan, New Brunswick, N.J.

Stethatos, *Vie* = "Vie de Syméon le nouveau théologien," ed. I. Hausherr and G. Horn, *OCA* 12 (Rome, 1928), 2–228

Treadgold 1988 = W. Treadgold, *The Byzantine Revival, 780–942*, Stanford, Ca.

Vikan 1989 = G. Vikan, "Ruminations on Edible Icons: Originals and Copies in the Art of Byzantium," *Studies in the History of Art* 20, 47–59

Volbach 1976 = W.F. Volbach, *Elfenbeinarbeiten der Spätantike und des frühen Mittelalters*, 3rd ed., Mainz

Weitzmann 1935 = K. Weitzmann, *Die byzantinishe Buchmalerei des 9. und 10. Jahrhunderts*, Berlin

Weitzmann 1948 = K. Weitzmann, *The Joshua Roll. A Work of the Macedonian Renaissance,* Princeton, N.J.

Weitzmann 1967 = K. Weitzmann, "Die

byzantinische Elfenbeine eines Bamberger Graduale und ihre ursprüngliche Verwendung," in *Festschrift für K. H. Usener*, Marburg, reprinted in Weitzmann 1980, study VII

Weitzmann 1971a = K. Weitzmann, "Ivory Sculpture of the Macedonian Renaissance," in *Kolloquium über spätantike und frühmittelalterliche Skulpur* 2 (Mainz), 1–12

Weitzmann 1971b = K. Weitzmann, "Diptih slonovoj kosti iz Ermitaža, otnosjaščijsja k krugu imperatora Romana," *VV* 32, 142–156; translated as "An Ivory Diptych of the Romanos Group in the Hermitage," in Weitzmann 1980, study VIII

Weitzmann 1972 = K. Weitzmann, *Catalogue of the Byzantine and Early Medieval Antiquities in the Dumbarton Oaks Collection. III. Ivories and Steatites*, Washington, D.C.

Weitzmann 1974 = K. Weitzmann, "An Illustrated Greek New Testament of the Tenth Century in the Walters Art Gallery," in *Gatherings in Honor of Dorothy E. Miner*, ed. V. E. McCracken, L.M.C. Randall, and R. H. Randall, Jr., Baltimore

Weitzmann 1976 = K. Weitzmann, *The Monastery of Saint Catherine at Mount Sinai. The Icons, I. From the Sixth to the Tenth Century*, Princeton, N.J.

Weitzmann 1980 = K. Weitzmann, *Byzantine Book Illumination and Ivories*, London

Weitzmann 1992 = K. Weitzmann, "An Ivory Plaque with Two of the Forty Martyrs of Sebaste in the Glencairn Museum, Bryn Athyn, Pa.," in *Euphrosynon. Aphieroma ston Manole Chatzedake,* Athens, 704–12

Wentzel 1971, 1973 = H. Wentzel, "Das byzantinische Erbe der ottonische Kaiser. Hypothese über den Brautschatz der Theophano," *AachKb* 40, 15–49; 43, 11–96

Wessel 1967 = K. Wessel, *Byzantine Enamels from the 5th to the 13th Century,* Greenwich, Conn.

Williamson 1982 = P. Williamson, *An Introduction to Medieval Ivory Carvings*, London

Wilson 1975 = N. G. Wilson, "Books and Readers in Byzantium," in *Byzantine Books and Bookmen*, Washington, D.C.

Wilson 1983 = N. G. Wilson, *Scholars of Byzantium*, London

Wixom 1981 = W. D. Wixom, "A Middle Byzantine Liturgical Pyxis," *Gesta* 20, 45–49

Zastrow 1978 = O. Zastrow, *Museo d'arti applicate. Gli avori.* Milan

Notes

Notes to the Introduction

1. A. Danto, *The Philosophical Disenfranchisment of Art* (New York, 1986), p. 44f.
2. Cf. the subtitle of Hans Belting's book, *Bild und Kult: eine Geschichte des Bildes vor dem Zeitalter der Kunst* (Munich, 1990).
3. Petersen 1990, *s.v.* Ivory.
4. A phrase that I owe to David H. Wright.
5. Thus Weitzmann saw two triptychs now dismembered and reassembled on the altar of St. Willibrord in the treasury at Trier (G-W II, 116) as "offenbar von derselben Hand."
6. On this point, Vikan 1989.
7. Cutler 1994a.
8. Thus, under another aspect, Lemerle 1977, p. 251.
9. Thus I exclude almost entirely from consideration the objects in G-W II's "Frame group." This is not because I consider them all to be "Italo-Byzantine" (cf. Keck 1930) but because the focus of this book is on objects that are, in my view, *indubitably* Byzantine, whereas the techniques, styles, content, and/or provenances (not to speak of the Latin inscriptions on some) of the "Frame group" raise doubts about the Eastern origin of these ivories. Weitzmann pointed to some of their technical peculiarities, even while arguing that others, because of their resemblance to his "Nikephoros group," must have been produced under the direct impact of Byzantine models and therefore in Byzantium. He included them in his corpus; for his opinion that they "mit grösster Wahrscheinlichkeit für Byzanz zu entscheiden," see G-W II, p. 20f. Yet given the number of Byzantine ivories, especially members of the "Nikephoros group," that were already in the West before the middle of the 11th century and then and there reused on bookcovers (ibid., p. 19), this argument against the Western origin of many pieces in the "Frame group" is not compelling.
10. C. Ginzburg, "Morelli, Freud and Sherlock Holmes," *History Workshop* 9 (1980), p. 23.

Notes to Chapter I

1. See below, pp. 56–58.
2. See below, pp. 42, 53.
3. On the relative hardness of ivory, see Kalavrezou-Maxeiner 1985, p. 19.
4. Volbach 1976, no. 137.
5. A. Didron, "La fausse monnaie archéologique," *Annales archéologiques*, 18 (1858), pp. 301–9.
6. G-W II, no. 62.
7. Cf. figs. 46, 136, 158. On the Vienna Andrew and Peter plaque (G-W II, no. 44; our fig. 139) Peter blesses in what Didron called the "Latin" manner, perhaps in contrast with the gesture made by Andrew who was held to be the founder of the church of Constantinople. For limits on the signifying value of such iconographical variants, see below e.g., pp. 70, 178
8. The price realized at auction for a plaque now in a Swiss private collection (fig. 46) in 1978 was £630,000 plus 10% buyer's fee (*The Robert von Hirsch Collection*, II. *Works of*

Art [sale catalogue], Sotheby, Parke Bernet and Co. [London, 21–22 June 1978], lot no. 273). By contrast, the Apotheosis plaque (Volbach 1976, no. 56) was bought in 1857 along with other objects for £200; two Joseph plaques (G-W I, nos. 96 & 97) were bought at Sotheby's in 1901 for £150. I am indebted to David Buckton of the British Museum for these figures. For comparable prices (e.g., the Veroli Casket [our figs. 61, 128] bought in Verona in 1865 for £420), see G. Reitlinger, *The Economics of Taste* (London, 1961), pp. 515–20.

9. G-W II, no. 227. For other arguments in favor of the plaque's authenticity, see V. H. Elbern in *JWAG* 27–28 (1964–1965), pp. 45–47.

10. Rather than the attitude of dismissal that it might seem to the modern observer, the gesture of the right hand should be seen as party to that made with the left. It recurs in G-W II, no. 231, which Weitzmann sees as a "Wiederholung" of our ivory. The Baltimore panel is, however, epigraphically quite distinct and a much finer piece than this fragmentary reproduction in Paris.

11. Cutler 1985, pp. 5, 13, 18.

12. For "panel" and other terms which are used henceforth in specific senses, see the Glossary on pp. 286f.

13. See below, p. 28.

14. Cutler 1985, p. 47f and fig. 38.

15. On this phenomenon, see below, p. 45.

16. S. Boyd and G. Vikan, *Questions of Authenticity among the Arts of Byzantium* (Washington, D.C. 1981), no. 11.

17. The fact that both these luminaries are here rendered as a sun could suggest either the mediocrity of the carver or ignorant restoration. Between the foot of the cross and Mary a new, rhomboid piece of ivory has been inserted much as on the Baltimore Crucifixion (fig. 5).

18. G-W II, no. 231. Weitzmann doubted the authenticity of this fragment on the grounds that it too closely reiterated aspects of the Baltimore Crucifixion (our fig. 5). In fact, deviations in the Paris plaque—the presence of archangels instead of luminaries and a more generous treatment of the Virgin's mantle, not to speak of epigraphic differences—rule out the notion of direct copying even while they fail to prove the authenticity of either work.

19. G-W II, no. 27. See also below, chapter 3, note 19.

20. Cutler 1985, pp. 7–10; St. Clair—McLachlan 1989, p. 1f.

21. Cutler 1985, pp. 3, 5.

22. See Glossary.

23. See below, p. 141.

24. G-W II, no. 70.

25. Cf. Cutler 1985, p. 5 and fig. 8.

26. Weitzmann 1972, no. 26.

27. G-W II, no. 52.

28. On questions of orthography, see below pp. 72f.

29. Weitzmann 1976, no. B1.

30. M. M. Mango, "The Sevso Treasure Hunting Plate," *Apollo*, June 1990, p. 10.

31. E.g., the images of SS. Basil and Nicholas in the narthex of the H. Anargyroi at Kastoria (S. Pelekanides and M. Chatzidakis, *Kastoria* [Athens, 1984], p. 27, figs. 4, 5). I am grateful to Linda Safran for suggesting this example.

32. L. Khuskivadze, "Vizantijskaja plastinka slovonoj kozi iz cerkvi Korogo," *VV* 27 (1967) 258–65. Even more conspicuous than the wires that hold together this ivory are the cramps implanted in the Liège Hodegetria (our fig. 243).

33. Cutler—Oikonomides 1988, pp. 82, 85f.

34. Weitzmann 1972, no. 23; Cutler 1985, p. 35f.

35. Cf. the remarks on "velveted caskets" of J. Ruskin, *The Seven Lamps of Architecture* (London, 1880), p. 26.

36. G-W II, pl. XXXVIII (nos. 99, 100).

37. Beckwith 1962. A rare exception, with a (faintly) smiling child, is in Hamburg (G-W II, no. 49).

38. Delbrueck 1929, pp. xxxiv–xlvii; supplemented by Cutler 1987, pp. 431–34, 437–42.

39. M.-H. Fourmy, M. Leroy, "La vie de S. Philarète," *Byzantion* 9 (1934), p. 137. 30–31. On the other hand, there is no reason to suppose that the ivory and bone knickknacks mentioned at the end of the eighth century by Theodore of Stoudios (on which see p. 59, below) are anything but contemporary.

40. For the sources, see R. Guilland in *Byzantion* 34 (1964), pp. 329–46.

41. *Syntagma de alimentorum facultatibus*, ed. B. Langkavel (Leipzig, 1868), p. 119. 3–4. I owe knowledge of this text to J. Scarborough and M. Harstad who have pointed out to me its relationship to Dioskorides' *de materia medica,* ed. M. Wellman, I (Berlin, 1958), p. 171. 5–9.

42. *Commentari ad Homeri Iliadem* ed. M. van der Valk, II (Leiden, 1976), p. 152. 1–2.

43. *Alexiade*, ed. B. Leib, I (Paris, 1937), p. 112. 21f.

44. On the absence of carving datable in the twelfth century, see below, pp. 217f.

45. E.g., Michael Attaleiates, *Historia,* ed. I. Bekker (Bonn, 1853), pp. 48.13–49.16.

46. On this genre, see A. Cutler in *ODB*, p. 1005 *s.v.* Inventory.

47. C. Astruc, "L'inventaire dressé en Septembre 1200 du trésor et de la bibliothèque de Patmos," *TM* 8 (1981), p. 21.25f.

48. MM II, p. 569. 4f.

49. This despite the fact that the combination of the Dormition of the Mother of God and the Nativity is unknown on any extant Byzantine ivory. For the citation itself, see M. J. Gedeon, "Diatheke Maximou monachou ktetoros tes en Lydia mones Kotines," *Mikrasiatika chronika* 2 (1939), p. 282. 1f.

50. G-W II, no. 77.

51. See below, p. 213.

52. G-W II, nos. 160, 155, 25, respectively. On this last, see now D. Kötzche, *Der Quedlinburger Schatz wieder vereint* (exhib. cat.) (Berlin, 1992), no. 8.

53. Ibid., no. 116. Cf. no. 136, 169.

54. Ibid., nos. 1, 65, 66, 134, 151. The value of the book covers as chronological evidence was subjected to critical review by Keck—Morey 1935, p. 401f. See below, pp. 215–17.

55. Despite suggestions to the contrary in 1934 (G-W II, nos. 82f, 85, 100, 102, 149f, 171, 201–6, 221, 224). Kurt Weitzmann agreed to this proposition in conversation in October 1989.

56. G-W II, no. 94.

57. For the sources, see Cutler 1987, p. 467.

58. Among these are "the movement of actors, the form of women, the splendor of gems, clothing, metals and so on." This and similar passages are collected by M. J. Rouët de Journel and J. Dutilleul, *Enchiridion asceticum,* 4th ed., (Freiburg im Breisgau, 1947), no. 461 and passim. I am indebted to Daniel Sheerin for drawing my attention to this passage.

59. *Digenes Akritas*, ed. J. Mavrogordato (Oxford, 1956), Book 4. 275–81, 851f; Book 5. 105–13; Book 6. 38–41, 783–85; Book 7. 14–45.

60. PL 182, col. 914D. Some impression of this Western response may be gleaned from a miniature in the mid-fourteenth-century Life of St. Hedwig of Silesia (Malibu, J. Paul Getty Museum, Ms. Ludwig XI 7, fol. 12v) showing the saint clutching a diminutive image of the Virgin and Child while she is adored by Ludwig I, Duke of Liegnitz and Brieg, and his consort Agnes von Glogau. For a reproduction see *The J. Paul Getty Museum Journal* 12 (1984), p. 297, fig. 79.

61. PL 182, col. 915B.

62. *Historia,* ed. J. van Dieten (Berlin-New York 1975), pp. 653–8. Alexander Kazhdan drew my attention to this and the two passages that follow.

63. Ibid., p. 183.87.

64. Ibid., p. 517.92.

65. *AASS Nov.* IV, col. 226 A-B. I owe this reference to the kindness of Henry Maguire.

66. Niketas was a well-placed official during the reign of Romanos I who married his daughter to the emperor's son. On this class, see below Chapter VI.2.

67. *Barlaam and Ioasaph,* trans. G. R. Woodward and H. Mattingly (London, 1967), p. 262.

68. G-W II, no. 59. Weitzmann convincingly argues that, although the icon may have had a counterpart showing six other scenes from this cycle, it was neither one leaf of a diptych nor the central panel of a triptych.

69. A. Grabar, M. Manoussacas, *L'illustration du manuscrit de Skylitzès de la Bibliothèque nationale de Madrid* (Venice, 1979), color pl. XI.

70. G-W II, 34. Weitzmann begins his description of the ivory's condition by stressing the abrasion to the imperial couple which he documents with a detail photo of the emperor. Kalavrezou 1977, fig. 25 a-c, usefully presents other details although in

her text ignores the wear that they have suffered.

71. For this information I am indebted to Fr. John Cotsonis.

72. Also omitted, of course, are the many more occasions on which the Gospel book is kissed.

73. G. Vikan, "Pilgrims in Magi's Clothing: the Impact of Mimesis on Early Byzantine Pilgrimage Art," in *The Blessings of Pilgrimage,* ed. R. Osterhout (Urbana and Chicago, 1989), pp. 97–107.

74. PG 94, col. 777A.

75. Mansi XIII, col. 377 D-E.

76. T. F. Mathews, "The Sequel to Nicaea II in Byzantine Church Decoration," *Perkins Journal* 41 (July 1988), p. 12f. For the touching of icons in the eleventh century, see below, pp. 27f.

77. R. S. Nelson, "The Discourse of Icons, Then and Now," *Art History* 12 (1989), p. 151f.

78. R. Cormack, "Painting after Iconoclasm," in *Iconoclasm,* ed. A. Bryer & J. Herrin (Birmingham, 1977), p. 151 and fig. 34.

79. PG 100, col. 1490A.

80. The whole topic is beautifully treated by J. Herrin, "Women and the Faith in Icons," in *Culture, Ideology and Politics,* ed. R. Samuel and J. Stedman Jones (London, 1982), pp. 65–83.

81. Skyl, p. 52.72–93. I am grateful to Robert Browning for the translation.

82. Among many such passages, see John of Damascus, *Imag.* III,8 (*Die Schriften des Johannes von Damaskos. III. Contra imaginum calumniatores orationes tres,* ed. B. Kotter [Berlin—New York, 1975], p. 82.41–45). My thanks to Stephen Gero for this reference.

83. G-W II, nos. 91–94, 97, 146–49.

84. A similar image of Stephen occurs among the saints for November in the Paris Menologion, Bib. Nat. gr. 580, fol. 2v (Omont 1929, pl. CII). On the type, see D. Mouriki, *The Mosaics of the Nea Moni on Chios* (Athens, 1985), p. 157.

85. S. Der Nersessian, *L'illustration des psautiers grecs du moyen âge. II. Londres, Add. 19.352* (Paris, 1970), fig. 193.

86. See p. 93 below.

87. G-W II, no. 37.

88. Ibid., no. 36.

89. Cf. p. 150 below.

90. Weitzmann 1972, no. 24, p. 57f.

91. There is no way of identifying the material of which the leaves are made. The figures on the diptych are drawn in black on a gold ground—a scheme that could represent panels of wood, enamelled metal, or ivory.

92. To cite only ivories in G-W II, see nos. 28, 35, 76, 95f, 117, 139, 157, 167, 179, 199, 231. This list does not include plaques in which the background has been cut away to leave only the figurative subject, as is the case with the Virgin in the Metropolitan Museum (G-W II, 48; our fig. 244) and the Hamburg Hodegetria (II, 49; our fig. 112).

93. E.g., ibid., no. 53.

94. Ibid., nos. 5, 59. It is likewise hardly coincidental that two of the most conspicuous restorations are the heads of Christ in the Berlin Washing of the Feet (fig. 81) and Virgin and Child statuette in the Victoria and Albert Museum (fig. 60).

95. From among many examples in cognate realms, one might select the story of Luke, a youth with a paralyzed jaw, who was cured after kissing the coffin of St. Nikon of Sparta (d. *ca.* 988) and rubbing the affected area with oil that exuded from the saint's image. See *The Life of St. Nikon Metanoiete,* ed. D. F. Sullivan (Brookline, Mass., 1987), p. 216. 47–70.

96. G-W II, no. 21. The suspension hole and cord in the casket plaque from Saraçhane (fig. 63) likewise suggests its use as a talisman or amulet. Belief in the wonder-working power of "ivory" persisted among Anatolian Greeks until the early part of the 20th century. For an example, see H. Rott, *Kleinasiatische Denkmäler aus Pisidien, Pamphylien, Kappadokien und Lykien* (Leipzig, 1908), p. 199.

97. At 150 *denarii* per Roman pound, the unit cost of ivory was one-fortieth of that of bullion silver. For further discussion, see Cutler 1987, p. 434.

98. Pegolotti, p. 141.

99. G-W II, no. 76. See also below, p. 102.

100. Weitzmann 1972, no. 27; Cutler 1987, pp. 5, 28, 46f. I am grateful to Stephen Zwirn for weighing this piece for me.

101. G-W II, 9; Bank—Popova 1977, no. 592. For the triptych in context, see Cutler, 1994a.

102. The maximum thickness of the main panel is
11 mm and of each of the wings 10 mm.
103. See below, p. 143.
104. G-W II, no. 48.
105. See Glossary.
106. G-W II, no. 198.
107. Ibid., no. 106.
108. Connor 1991. See also pp. 144f. below.
109. See below, p. 80.
110. G-W II, no. 102.
111. St. Clair—McLachlan 1989, no. 5. On the
difference between the grain as used here and
in other instances, see below, p. 129.
112. On this composition and its variants, see
A. Cutler, "Under the Sign of the Deesis:
On the Question of Representativeness in
Medieval Art and Literature," *DOP* 41
(1987), pp. 145–54. Whether this
conventional term is used by scholars rightly
or, as I. Tognazzi Zervou (in *Milion* 2
[1990], pp. 391–422) would maintain,
wrongly, is irrelevant to the questions of
design and perception that I raise here.
Tognazzi Zervou sees in the Deesis a
Byzantine label for orant figures.
113. See the penetrating discussion by
G. Dagron, "Le culte des images dans le
monde byzantin," in *Histoire vécue du peuple
chrétien*, ed. J. Delumeau, I (Toulouse,
1979), pp. 133–60, reprinted in his *La*

romanité chrétienne en Orient (London, 1984),
study IX.
114. Ibid., p. 147.
115. Cf. A. Cutler in *ODB s.v.* Artists, and
below, pp. 157f.
116. This attitude, a topos of Byzantine rhetoric,
is documented in texts as various as
liturgies, epigrams, *ekphraseis*, and
chronicles. For one witness inscribed on
ivory, see below p. 236.
117. See A. Kazhdan—A. Cutler in *ODB s.v.*
Motion.
118. G-W II, 3. The drill holes in the frame
allow the possibility that the plaque was
either one leaf of a diptych or the central
portion of a triptych; if these holes are not
contemporary with its carving, it could have
served as an icon without any attached
members. Our experiment in perception
would not be invalidated whichever of these
three arrangements was the original one.
119. For the means whereby relief is achieved and
its effects, see below pp. 101–19.
120. It has not been recognized that each of the
children throws a tunic in the ass's path.
Among the ivories, this duplication of
garments is repeated only on a plaque in
Modena (G-W II, no. 223) Further on
implied motion, see below pp. 40, 249.

Notes to Chapter II

1. Volbach 1976, nos. 1–216a.
2. E. Kühnel, *Die islamischen
Elfenbeinskulpturen, VIII.–XIII. Jahrhundert*
(Berlin 1971).
3. A. Goldschmidt, *Die Elfenbeinskulpturen aus
der Zeit der karolingischen und sächsischen Kaiser
VIII.–XI Jhdt.*, 2 vols. (Berlin, 1914–
1918).
4. This (obviously round) number is arrived at
by subtracting from G-W I and G-W II
approximately 125 objects that are made of
bone and others which I do not believe to be
Byzantine, and adding pieces that have come
to light since this corpus was published.
5. Y. Petsopoulos, *East Christian Art* (London,
1987), no. 33.
6. See for example the lists, themselves

urgently in need of updating, of "changes of
address" in the reprints of G-W I, p. 75 and
G-W II, p. 97.
7. G. G. Litavrin, "Vosstanie v
Konstantinopole v Aprele 1042 g.," *VV* 33
(1972), pp. 33–46.
8. Frolow 1961, no. 276.
9. D. Jacoby, "La Population de Constantinople
byzantine: un problème de démographie
urbaine," *Byzantion* 31 (1961), pp. 81–109.
10. For some preliminary remarks, see Cutler
1985, pp. 32, 38f, 48f.
11. G-W II, no. 118.
12. Cutler 1985, p. 1; St. Clair—McLachlan
1989, p. 1.
13. G-W II, no. 124.
14. Ibid., no. 20.

15. On the choice of sections and the means of cutting panels from a tusk, see below pp. 79–93.

16. G-W II, no. 54.

17. Ibid., no. 43.

18. G-W I, 1. An alien lockplate has been removed since the photo in G-W I was taken. The pearls should be distinguished from the peg holes used to attach the plaque to its original wooden matrix. A similar juxtaposition of three distinct pieces of ivory was made in the case of a Joshua plaque in the Victoria and Albert Museum, London (ibid., no. 4). Ivory icons composed of two or more sections include the Ascension and Pentecost in the Vatican (G-W II, no. 221) and a quartet of "Feast" scenes in Ravenna (ibid., nos. 203–05). The best-known examples are the five long friezes on the Veroli casket (see figs. 61, 128).

19. Ibid., no. 70.

20. See Glossary, s.v. Dentine.

21. Since it is found only in areas that were not carved with figures, the cement is not often reproduced in most catalogues. It is, however, visible at the vertical extremities of a box at Dumbarton Oaks (Cutler 1985, fig. 25c; Weitzmann 1972, pl. IXB).

22. Cutler 1985, pp. 5, 47; Weitzmann 1972, no. 21.

23. Skyl 161. 89–95.

24. Psellos, p. 144. 1–5, II, pp. 61.1–63.18.

25. G-W II, no. 131.

26. Delbrueck 1929, p. 10. Further on this question see Cutler 1987, p. 436.

27. G-W II, no. 51. The next largest, and quite similar, figure in New York (ibid., no. 48), is 23.3 cm high.

28. E. g., following the victories of Nikephoros Phokas (963–969) and John I Tzimiskes (969–976) over the Arabs.

29. Skyl pp. 115.2–156.63.

30. See below, pp. 240–46.

31. K. Weitzmann, *Greek Mythology in Byzantine Art*, 2nd ed. (Princeton, 1984), pp. 152–86. Cf. Cutler 1984–1985.

32. G-W I, no. 21. A similar couple is found on another plaque in the same museum (ibid., no. 23). On the "classical" sources of Byzantine boxes, see K. Weitzmann, *Greek Mythology*, pp. 152–86. Cf. Cutler 1984–1985.

33. Volbach 1976, no. 66.

34. Cutler 1985, pp. 27–29. The maximum of 12 cm, which I postulated in the paper published as Cutler 1987, p. 438, must be corrected.

35. But see N. J. van der Merwe *et al.*, "Source-Area Determination of Elephant Ivory by Isotopic Analysis," *Nature* 346 (23 August 1990), pp. 744–46, and J. C. Vogel *et al.*, "Isotope Fingerprints in Elephant Bone and Ivory," ibid., pp. 747–49.

36. Excluding the plaques composed of more than a single piece of ivory (note 18 above), 120 of the 235 plaques in G-W II measure more than 11 cm across. These include the central plaques of most of the triptychs the wings of which, being smaller, are counted among the number of plaques smaller than 11 cm. If the wings were cut from the same tusk as their central plaques (see below pp. 84, 89), the balance would tip even more strongly in favor of African ivory. I take into account the dimensions of ivories not given in G-W.

37. P. Grierson, "The Monetary Reforms of 'Abd al-Malik, their Metrological Basis and their Financial Repercussions," *JESHO* 3 (1960), pp. 241–64.

38. D. Whitehouse, "Abbasid Maritime Trade: Archaeology and the Age of Expansion," *Rivista degli Studi Orientali* 59 (1985), pp. 339–47.

39. *The Chronography of Gregory Abû'l Faraj . . . commonly known as Bar Hebraeus,* trans. E. A. Wallis Budge (Oxford, 1932), p. 134. Bar Hebraeus reports an event of 1023—an Arab expeditionary force against the citadel of Kawâkir in India which resulted in offerings of 300 elephants, vast quantities of silver, apparel, and perfumes. Even if this tribute were maintained for only a brief period, the import of what may have been as many as 600 tusks would have furnished a healthy supply of ivory.

40. Al-Makkari, *Nafhu-t-Tib*, trans. P. de Gayangos as *The History of the Mohammedan Dynasties in Spain*, II (London, 1843), p. 191. Ivory, a substance very heavy in relation to its mass, has always been sold by weight. It is entirely possible that it traveled to Constantinople as ballast in boats carrying lighter cargo from Alexandria, much as mahogany first came to England in the mid-18th century in the holds of ships carrying

tobacco from Cuba and Honduras. Caribbean mahogany allowed Chippendale to create furniture, using this heavy material for shapes based on classical forms the demand for which, within 50 years, justified the import of the semitropical wood for its own sake.

41. Kazhdan—Constable 1982, p. 51.

42. C. Pellat, "Ğahiziana, I. *Le Kitab al-Tabassur bi-l-tiğara* attribué a Ğahiz," *Arabica* I (1954), p. 159.

43. Idem, "Al-Ğahiz: les nations civilisées et les croyances religieuses," *Journal Asiatique* 225 (1967), p. 86. For this text, Jāhiz' *Ar-Radd 'ala n-Nasara*, see I. S. Allouche in *Hesperis* (1939), p. 134.

44. Ibn Idhāri, *Histoire de l'Afrique du Nord et de l'Espagne musulmane*, ed. G. S. Colin and E. Lévi-Provençal, I (Leiden, 1948), pp. 256–58.

45. Cutler 1987, pp. 437–43, 454f.

46. *The Periplus of the Red Sea*, ed. G. W. B. Huntingford (London, 1980), p. 123.

47. *Zibaldone da Canal. Manoscritto mercantile del sec. XIV* (Venice, 1967), pp. 57, 63.

48. R. Conniff, "The Towns that Ivory Built," *Yankee Magazine* (November 1989), p. 150. Cf. above, note 40.

49. Treadgold 1988, p. 219.

50. John Diaconus, *Chronicon Venetum* s.a. 1001, cited (anonymously) by S. Bettini in *Venezia e Bisanzio* (Venice, 1974), p. 19. Bettini believed this to have been the Cathedra of Maximian.

51. P. Grimm in *Zeitschrift für Archäologie* 6 (1972), pp. 107–10. I am grateful to Michael McCormick for drawing my attention to this.

52. Bank 1978, p. 82.

53. Τὰ ἐλεφάντινα καὶ ὀστέϊνα κουμβία ἀπὸ τε τῶν μανδύων καὶ τῶν λωρῶν. See *Megale katechesis*, ed. A. Papadopoulos-Kerameus (St. Petersburg, 1904), p. 141. 8–10. I am indebted to Peter Hatlie for this reference.

54. Davidson 1952, p. 278f. The relative value of the two materials in the Byzantine period may be indicated by a curious bone tube, just over 10 cm long (ibid., p. 338, no. 2902 and pl. 138). This has the remains of an iron blade at one end and an ivory bird riveted at the other to allow it to move freely. The object is dated by Davidson "no later than the twelfth century;" like her, I have no idea of its purpose.

55. M. V. Gill in Harrison 1986, pp. 226–31, 258–62.

56. Ibid., pp. 230f (nos. 55–59, 67–69), 260 (nos. 496–500, 508).

57. Ibid. p. 231, no. 58 (here dated to the first half of the eleventh century. Cf. R. M. Harrison in *DOP* 22 [1968], p. 199f).

58. M. V. Gill in Harrison 1986, p. 231, nos. 60–63.

59. Ćurčić—St. Clair 1986, no. 39, where it is wrongly described as ivory. It was correctly recognized as bone in St. Clair—McLachlan 1989, no. 36.

60. Bank—Popova 1977, no. 594.

61. Ibid., no. 608, wrongly described as elephant ivory.

62. G-W I, no. 100.

63. See below, pp. 137–40.

64. Above, pp. 49f.

65. But see Bank 1978, p. 82f and Cutler 1984–1985, pp. 37–39.

66. St. Clair—McLachlan 1989, p. 7f.

67. *Foramina* are clearly evident in both the ornamental strips *and* the plaques on the box at Dumbarton Oaks (fig. 17). Their presence, too, on the strips that decorate the wooden doors of the Olympiotissa monastery near Larissa (Bouras 1989–1990), and at the Protaton (S. Pelekanides in *Archaiologike Ephemeris* [1957], pp. 50–67) and Hilandar on Mount Athos (D. Bogdanović, V. J. Djurić and D. Medaković, *Hilandar* [Belgrade, 1978], pl. 36) also allows one to recognize this ornament as bone. In ways that remain to be investigated, the decoration of these doors is bound up with the serial production of the "rosette caskets."

68. Kalavrezou 1985.

69. Cutler 1985, fig. 34.

70. Weitzmann 1972, no. 23.

71. On the significance of this predominance, see below pp. 249f.

72. *The Anatolian Civilisations. II, Greek/Roman/Byzantine* (Istanbul, 1983), p. 193, no. C103.

73. A similar pose is maintained by Paul on the wings of triptychs in Liverpool (our pl. VI), Bonn, St. Petersburg, etc. (G-W II, nos. 155, 182–84, 186–89).

74. Above, p. 14.

75. G. Bovini, "Gli avori del Museo Nazionale di Ravenna e del Museo Civico di Bologna," *FelRav* 3rd ser., 20 (1956), p. 75, no. 7; G. Bovini and L. B. Ottolenghi, *Catalogo della mostra degli avori dell' alto medioevo*, 2nd ed. (Ravenna, 1956), no. 99, noting some hesitations on iconographical grounds of W. F. Volbach. The relationship of the plaque to the Hirsch ivory was first observed by Graeven 1900, p. 10. On the history of the debate over the inauthenticity of this and other pieces, see Nikolajević 1991, pp. 33–44.

76. L. Courajod in *GBA*, April 1875, p. 377.

77. This does not mean that we should impose on such a system the notion of a Rembrandt-style workshop in which the master signed the work of his pupils in order to produce "Rembrandts" for a market that prized, and therefore would pay more for, products that came from his hand. With few exceptions—notably the twelfth-century painter Eulalios—there is no evidence for a "star" system in the history of Byzantine craftsmanship. On the question of artistic identity, see below, chapter IV.2.

78. For the boxes, see pp. 151f. below; on the making of consular diptychs, Cutler 1984a.

79. I ignore neither the existence of slave labor, nor the possibility that ivory was supplied to craftsmen by their customers. The first of these is suggested by Theodore of Stoudios, the second in the *Book of the Eparch*. See below, p. 247.

80. A. P. Rudakov, *Očerki vizantijskoj kul'tury po dannym grečeskoj agiografij* (Moscow, 1917), p. 139f.

81. M. Acheimastou-Potamianou, *Byzantine and Post-Byzantine Art* (Athens, 1985), no. 130. My thanks to Nancy Ševčenko for drawing my attention to this picture.

82. T. Pazaras, *Anaglyphes sarkophagoi kai epitaphies plakes tes meses kai hysteres vyzantines periodon sten Hellada* (Athens, 1988).

83. G. Eichner, *Die Werkstatt des sogenannten dogmatischen Sarkophag* (Mannheim, 1977).

84. *Eparchikon biblion*, p. 84.194f.

85. On the nature and supervision of the imperial *armamenton* in the tenth century, see J. F. Haldon, *Byzantine Praetorians* (Bonn, 1984), pp. 320–22.

86. Theoph p. 469.3f; TheophCont p. 892.14f.

87. On which see note 51 above. In rural Serbia, at Debrac on the River Sava, court workshops existed in the time of Dragutin (1276–1282).

88. Beckwith 1962, captions to figs. 4–7. On this question, see below, p. 233.

89. *Vitae duae antiquae sancti Athanasii Athonitae* (Turnhout 1982), pp. 122.1–123.48.

90. In the eleventh century, a skilled, unnamed artist, engaged by the Peloponnesian noble John Malakenos to paint a picture of St. Nikon Metanoiete, went home (οἰκάδε) to execute the commission. See S. Lampros in *Neos Hellenomnemon* 3, 3 (1906), pp. 175.10–31.

91. G. R. Davidson, "A Medieval Glass-Factory at Corinth," *AJA* 44 (1940), pp. 297–324.

92. The text (note 84, above), it must be noted, is a fragment and does not mention potters even though such craftsmen certainly existed in the city: for polychrome ceramics found in late tenth–early eleventh centuries deposits at Saraçhane, see R. M. Harrison and N. Firatli in *DOP* 22 (1968), p. 201.

93. See below, pp. 158–74.

94. On the term *ergasterion*, used to indicate a retail outlet as well as a worksite, see Oikonomides 1972b; for the larger setting, H. G. Beck, "Konstantinopel zur Sozialgeschichte einer frühmittelalterliche Hauptstadt," *BZ* 58 (1965), p. 20f. The small size and family-based organization of scribal workshops is emphasized by R. S. Nelson, *Theodore Hagiopetrites. A Late Byzantine Scribe and Illuminators* (Vienna, 1991), pp. 120–23.

95. Ed. H. van der Berg (Leiden, 1947). I am indebted to Eric McGeer for drawing my attention to this text.

96. Ibid., pp. 47.5–48.11.

97. Ibid., pp. 49.17–50.7.

98. See below, pp. 222–24.

99. Cf. Kalavrezou 1985, p. 51.

100. Wixom 1981. For the Apostles box at Dumbarton Oaks, see Weitzmann 1972, no. 30; Cutler 1985, p. 36, and below, fig. 237.

101. R. Koechlin, *Les Ivoires gothiques français* I (Paris, 1924), pp. 531–40. For a useful discussion of Etienne de Boileau's account of the Parisian guild system and in particular of sculptors working "in bone, ivory, wood or any other kind of material," see M. Blindheim, *Main Trends of East Norwegian*

Wooden Figure Sculpture in the Second Half of the Thirteenth Century (Oslo, 1952), pp. 88–92. I am grateful to Paul Williamson for drawing this to my attention.

102. Randall 1974.
103. Ibid., pp. 288, 294.
104. G-W II, no. 207.
105. Ibid., no. 23.
106. See above, note 54.
107. See above, note 55.
108. Kalavrezou 1985, p. 43.
109. Maguire 1981 and, for particular case studies, idem, "The Depiction of Sorrow in Byzantine Art," *DOP* 31 (1977), pp. 123–74.
110. Giusti 1981, p. 48.
111. Keck 1930, p. 151f.
112. See below, pp. 202f.
113. G-W II, p. 11.
114. Kalavrezou 1985, p. 50.
115. Ibid.
116. Ibid., p. 52.
117. On whom see below pp. 154f., 232–46.
118. See, e.g., G-W II, nos. 65, 126,
119. Ibid., nos. 35, 69f, 73
120. Keck—Morey 1935, p. 405. Their purist blasts are directed at such spellings as I ΑΝΑΛΗΨΗ(ϛ) and 'Η ΚΥΜΗϹΙϹ (G-W II, nos. 205f).
121. Thus I ΓΕΝΗϹΗ(ϛ), I ΒΑΥΠΤΙϹΗ(ϛ), and ΤΟ ΧΕΡΕΤΕ.
122. Ratkowska 1965, p. 96.
123. Mazzucchi 1978. Once again I am indebted to Eric McGeer for this reference.
124. Thus on a seal of Constantine VII and Zoe of 918–919 (Oikonomides 1986, no. 58) the regent Zoe is described as δεσπύη. See also nos. 60, 61, 65–67, on the last of which οἰκειακῶν is spelt ὑκ[ια]κῶν.
125. E. Diez and O. Demus, *Byzantine Mosaics in Greece. Hosios Loucas and Daphni* (Cambridge, Mass., 1934), fig. 94. The inscription here reads 'Ο ΝΕΙΠΤΗΡ. Cf. John 13:5 and our fig. 81.
126. Madigan 1987.
127. See p. 29 above.
128. P. 59 above.
129. Davidson 1952, nos. 1299–1305 and pl. 80f. The supposition that lions drinking from a chalice is necessarily Christian iconography could be made only by someone who had never see the Mschatta façade.
130. Cf. ibid., p. 179f.

131. Ibid., no. 2903.
132. Bank—Popova 1977, no. 608.
133. E.g., G-W I, nos. 20, 26f, 33, 43f.
134. Bank 1978, p. 86.
135. G-W I, no. 62.
136. C. V. Bornstein in *The Meeting of Two Worlds: the Crusades and the Mediterranean Context,* ed. C. V. Bornstein and P. P. Soucek (Ann Arbor, 1981), no. 41. The possibility that these could just as well have come from "Romania," the European provinces of the Empire where Venetians, Pisans, and Genoese were well established by the middle of the twelfth century, does not seem to have been entertained.
137. Bank—Popova, no. 605.
138. Bank 1978, p. 82f.
139. G-W II, no. 35.
140. Ibid., no. 152; Khuskivadze 1986. I am indebted for photographs to Mrs. L Khuskivadze.
141. See p. 222.
142. Mišakova 1978.
143. Randall 1985, no. 198. Cf. G-W I, no. 101, where an Italian provenance is mooted.
144. Cutler 1991.
145. See p. 259 n.9 above.
146. Keck 1930. It may seem odd to take up an argument now more than sixty years old. In fact there has been no response to Keck's claims other than Weitzmann's observation (G-W II, reprint, p. 3) that only further research will test them. To date, as I suggest below, no such proof has been forthcoming.
147. Ebitz 1986.
148. These connections are now much better understood than in Keck's day. See especially Laiou 1982, Harvey 1989, and below, p. 219.
149. Keck 1930, pp. 148, 156. This manner of argumentation is reverted to in Keck—Morey 1935, p. 405: "the style [of the 'Border Group'] is coarse, heavy, provincial, anything but Greek."
150. Cf., e.g., G-W II, no. 14.
151. G-W II, no. 6. G-W II, no. 6. The original struts evident in the detail-photograph are much wider than the nails driven into the hands visible in a frontal view (pl. V). They must be distinguished from the peg that pierces Christ's right arm as the result of rather brutal, modern restoration.

152. Keck 1930, p. 148f.
153. G-W II, no. 17. See pp. 114, 161.
154. G-W I, no. 89.
155. Keck 1930, p. 155f and fig. 15 (the "Clephane horn").
156. H. Wentzel, "Das Medaillon mit dem Hl. Theodor und die venezianische Glaspasten in byzantinischen Stil," in *Festschrift für Erich Meyer* (Hamburg, 1959), pp. 50–67.

Notes to Chapter III

1. Cutler 1985, pp. 7–11, 42.
2. See below, pp. 129–31.
3. Cutler 1985, pp. 3,5.
4. St. Clair—McLachlan 1989, p. 1 and fig. 2.
5. See pp. 15, 83.
6. Engemann 1987, pp. 180–82.
7. See Chapter V, below.
8. I am indebted to Aalo-Annike Cutler for useful discussion on these points.
9. G-W II, no. 23.
10. *Contra* Delbrueck, who argued that such reductions are the result of human intervention, see Cutler 1984, p. 79f.
11. I am indebted to Peter Kuniholm for this information.
12. For one such waster, or rather jettisoned trial piece, see below, p. 95 and fig. 95.
13. G-W II, no. 164.
14. See above, p. 45.
15. G-W I, no. 4.
16. Poplin 1976 (with reference to G-W II, no. 99f). These plaques, which Weitzmann believed to have been bookcovers, remain questionable on both technical and stylistic grounds. I know of no Byzantine ivory in which the strata from the outer edges of the tusk appear to pass, as they do on the Apostles plaque, through the lateral figures. The double bevel of these plaques' edges is also known only on these two examples. Such details as the ornament of the titulus panel above Christ's head, and the form and position of his toenails and those of the figures below are without parallel in the "Nikephoros group" to which it has been assigned.
17. See Chapter II.3.
18. G-W II, no. 4; Cutler 1988.
19. G-W II, no. 19, here cited in a previous collection.

157. Laiou 1982, p. 18f. Unlike Byzantine documents, those studied by Laiou are quite specific about the objects of trade. Neither raw nor worked ivory is mentioned.
158. The models proposed by Ebitz 1986 for his Byzantinizing bookcover are enamels, not ivories.

20. Twice because a similar panel could have been cut from the other side of the pulp cavity.
21. See above, pp. 31f.
22. Notable exceptions include the Vatican Nativity (G-W II, no. 17; our fig. 105), the Ezekiel in the British Museum (II, no. 16; our fig. 98), the Liège Virgin (II, no. 47; our fig. 243) and the Houston Dormition (Schrader 1972–1973; our fig. 234).
23. I borrow this terminology from Shelton 1982. The choice of side is no less evident in the Metropolitan Museum's Demetrios (fig. 126) which has lost a portion of the lower frame through desiccation. The concave form of this area shows that the side on which the figure was carved faced the core of the tusk, while its obverse faced the rounded husk.
24. This is further confirmed by the presence of extensive cement on the reverse of the plaque. But there are exceptions to the rule. The grain on the bottom edges of a Christological diptych in St. Petersburg (G-W II, no. 122; Bank—Popova 1977, no. 585) shows that the scenes of the left leaf are carved on the "belly" side while those of the right leaf come from the husk side. Despite this, the similar myriad fissures in the plaques suggest that they issued from a single tusk.
25. G-W II, no. 84.
26. Although all three members have been truncated at the top and bottom, the central plaque is better preserved than the wings, the crosses of which have been planed down. Nonetheless, two large cracks descend from holes drilled in its upper frame. The upper edges of both wings and the outer edge of the left wing contain replacement areas, while the inner edge of the left wing has a

triangle of new ivory corresponding in position to damage to the inner border of the right wing. That these lateral injuries are not due to the first set of hinges is indicated by the cuttings for this set on either side of the Virgin plaque.

27. The dimensions reported by G-W (note 25, above) are corrected by Randall 1982, no. 182. The main plaque measures 12.1 × 11.6 cm, the wings each 10.8 × 5.6 cm.

28. See note 26, above.

29. Cutler 1985, p. 3.

30. G-W II, no. 24.

31. Ibid., no. 53a.

32. It occurs on numerous painted panels of the 6th century and later. See Weitzmann 1976, passim.

33. These are the chronological divisions used by W. L. Goodman, *The History of Woodworking Tools* (London, 1964), esp. p. 9.

34. E.g., P. Walker, "The Tools Available to the Medieval Woodworker" in *Woodworking Techniques before A.D. 1500* (= *BAR International Series*, no. 129) (Oxford, 1982), pp. 349–56. Despite the title of this paper, it is more useful to the student of surgical tools.

35. Cutler 1987, pp. 443–45.

36. *Anthologia graeca*, VI, no. 205, ed. H. Beckby, I (Munich 1965), pp. 544–46.

37. *Histoire des moines de Syrie* II, ed. P. Canivet and A. Leroy-Molinghen (= SC 257) (Paris, 1979), p. 248.19f.

38. In *Transactions of the Royal Historical Society*, 5th ser., 9 (1959), p. 129.

39. Thus the copper scissors found in the environs of the Church of St. Achilleios near Prespa (N.K. Moutsopoulos, *He basilike tou Hagiou Achilleiou sten Prespa*, I [Thessalonike, 1989], pp. 99, 176 and pls. 19, 50, 51).

40. 40. See L. J. Bliquez, "Two Lists of Greek Surgical Instruments and the State of Surgery in Byzantine Times," *DOP* 38 (1984), pp. 187–204, and, most recently, R. Jackson, "Roman Doctors and their Instruments: Recent Research into Ancient Practice," *JRA* 3 (1990), pp. 5–27.

41. A. Mallwitz, *Olympia und seine Bauten* (Munich, 1972), p. 259.

42. See above, p. 73.

43. N. Asgarı, "Roman and Early Byzantine Marble Quarries of Proconnesus" in *Proceedings of the Xth International Congress of Classical Archaeology* (Ankara 1978) I, pp. 467–86, esp. 475–78; J.-P. Sodini, A. Lambraki, T. Koželj in *Aliki II* (Paris 1980), pp. 81–137.

44. *Il Menologio*, p. 374.

45. Ibid., pp. 68, 295, 356. See also Adam's metalworking tools in fig. 132, below.

46. G-W II, no. 46.

47. See also above, note 22.

48. G-W II, no. 156.

49. P. Williamson, *The Thyssen-Bornemisza Collection. Medieval Sculpture and Works of Art* (London, 1987), no. 20. The reverse of this triptych is unpublished.

50. Cutler 1985, p. 44 and fig. 41.

51. G-W II, no. 83.

52. It is interesting to note that even in so repetitive a job as making billiard balls in the early twentieth century, Parisian machinists were given a design to be executed with a metal template on the surface of a section of ivory. See T. A. Marchmay, "Making Billiard Balls from Ivory," *Scientific American Monthly* 3 (1921), pp. 316–18, a reference kindly provided by David Shayt.

53. Theophilus, *De diversis artibus*, ed. and trans. C. R. Dodwell (London, 1961), p. 166. Theophilus is often identified with the eleventh-century goldsmith, Roger of Helmarshausen.

54. A. Heikel, "Ignatii diaconi, vita Tarasii archiepiscopi Constantinopolitanae," *Acta societatis scientiarum Fennicae* 17 (1891), p. 416. 10–14. Henry Maguire kindly drew my attention to this passage.

55. See, e.g., the *Life of St. Nikon* (chapter I, note 95, above), p. 154.44f.

56. See below, p. 117.

57. Above, p. 30.

58. Weitzmann 1972, no. 27.

59. Ibid., color pl. 7.

60. See Glossary.

61. G-W II, no. 41.

62. G-W II, no. 40.

63. See below, pp. 227–31.

64. Chapter II, note 151.

65. See, e.g., G-W II, nos. 48, 62, 63, 81, 93, 217, and Durand 1992, no. 152.

66. G-W II, no. 49.

67. Weitzmann 1972, no. 26; Cutler 1985, p. 7 and figs 9, 31.

68. Kalavrezou 1985, pp. 27, 37.

69. Above, note 51.

70. G-W II, no. 147.

71. G-W II, no. 148.

72. See below, pp. 164f.

73. As is perhaps evident in the oblique view of the Entry from the right (fig. 39), the sculptor similarly reduced the width of the further garment thrown by the children. The original cutting for the left side of this tunic can be seen higher on the ground between the ass's forelegs.

74. Thus in the *ekphraseis* of Manuel Philes (*Manuelis Philae carmina*, ed. E. Miller, 2 vols. [Paris, 1855–1857]). For the rich tradition behind such descriptions, see Maguire 1981, pp. 22–52.

75. See Glossary. The term "chip carving," on which see Petersen 1990, vol. 2, p. 207, is used of a woodworking technique that is altogether more superficial than the deep and often complex cuts that I am describing.

76. G-W I, no. 18.

77. Above, p. 40.

78. G-W II, no. 72.

79. See below, pp. 149f.

80. See below, pp. 120–35.

81. Kalavrezou 1989, p. 380.

82. Cutler–Oikonomides 1988. See also below, p. 201 and chapter V, notes 57 and 60.

83. This is not meant to imply that these adjustments were afterthoughts. Similar "inhabited cuts" became common particularly on box plaques. See, e.g., G-W I, nos. 28, 33, 37–40.

84. H. Schnitzler et al., "Mittelalterliche Kunst der Sammlung Kofler-Truniger, Luzern," *AachKb* 31 (1965), no. 57 and pl. 5.

85. G-W II, no. 16. On the historical circumstances of this plaque's creation, see Cutler 1992.

86. G-W II, nos. 110, 114, 117, and passim.

87. Thus on the Houston Dormition (fig. 234).

88. Thus the angel hovering above the Presentation of the Virgin in the Temple in Berlin (G-W II, no. 11; our fig. 238).

89. See above, Chapter II, note 32.

90. J. Camón-Aznar, "Un cofre de marfil bizantino," VIII CEB (Palermo, 1953), II, pp. 100–02, who does not question the authenticity of the object.

91. See above, p. 14.

92. See, e.g., the support to which the lost foreleg of a circus horse was attached on a plaque in St. Petersburg (Delbrueck 1929, no. 18; Volbach 1976, no. 19), said to have been part of an Anastasius diptych.

93. G-W II, no. 232; this plaque is still dated "XI-XII vv (?)" in Bank—Popova 1977, no. 597.

94. Weitzmann 1972, no. 40; Cutler 1985, pp. 45f and figs. 44f.

95. This sort of stroke is pervasive on a Crucifixion (G-W II, no. 27) in the British Museum, the authenticity of which I have already questioned. See p. 15 above.

96. G-W I, no. 93. The same marks occur on a smaller plaque from the same box (ibid., no. 92).

97. Weitzmann 1967.

98. For the use of small files in confined situations, see above, p. 98.

99. G-W II, 65.

100. Ibid., no. 151.

101. G-W I, no. 99; Gaborit-Chopin 1988, pp. 28–33.

102. Wixom 1981.

103. Lowden 1988, p. 89.

104. Although for an iconographical explanation of variety in portraits of Christ, see A. Cutler, "The Dumbarton Oaks Psalter and New Testament: the Iconography of the Moscow Leaf," *DOP* 37 (1983), pp. 35–45.

105. G-W II, no. 44.

106. Ibid., no. 107.

107. Ibid., nos. 77, 78, 79, 86, 92, in addition to the three examples cited immediately above.

108. Ibid., no. 158. Arne Effenberger of the Staatliche Museen in Berlin suggested to me (in private correspondence) that he does not believe this plaque to be Byzantine. On the ground of techniques discussed here and below (pp. 137, 165f.) I must disagree with this view.

109. This is clearly true in the case of the two major images of the Forty Martyrs: in the Berlin version (G-W II, no. 3) Christ has lost his right forearm; the similarly undercut limb in St. Petersburg (our fig. 28) is preserved.

110. In the only example of a Dormition in which the Virgin's soul was held by Christ in *two* undercut hands (Schrader 1972–1973 and our fig. 234), both members are lost.

111. So, too, on the Metropolitan Museum Deesis (G-W II, no. 154). Crucifixions damaged in

this way include ibid., nos. 83, 105, 108, 156, 158–161, 163, 166, 169f and 194.

112. Thus, e.g., on G-W II, no. 194. Hands attached with crampons are familiar in late antique marble sculpture. See J.-P. Sodini in Durand 1992, no.4.

113. Randall 1974, p. 294.

114. G-W II, 39.

115. See above Chapter II, note 140.

116. See above, note 74.

117. See Glossary.

118. G-W II, no. 45.

119. Ibid., no. 33; D. Gaborit-Chopin in Durand 1992, no. 149.

120. G-W II, no. 1. The splendid condition of this plaque is no doubt due to the conservation of the Gospels of Otto III, which it decorates, as one of the *cimelia* of the Munich Staatsbibliothek. The vertical crack in the baldachin is the only serious damage that it has sustained, although, as fig. 155 demonstrates, much dust has adhered to greasy areas on the ground of the ivory. That the detailed carving of the columns followed the modeling of the figures is evident from the profile of the left shaft, the "entasis" of which enters the space between the bodies of two apostles.

121. See also G-W II, nos. 80, 134, 144f.

122. Ibid., no. 156.

123. The combination of drill and pick was presumably also used to fashion the rosettes on boxes such as the Veroli casket (fig. 61). But the texture of the bone here, as on less perfectly finished boxes, prevents the identification of tool marks.

124. G-W I, no. 225.

125. The only useful contribution of which I am aware is C. Mango, "Byzantine Epigraphy, 4th to 10th Centuries," *Paleografia e codicologia greca. Atti del II Colloquio Internazionale* (Berlin-Wolfenbüttel, 17–21 ottobre 1983) (Alessandria 1991), I, pp. 235–49.

126. For this, see Cutler 1991.

127. Cutler—Oikonomides 1988, p. 82f.

128. For a translation see below, p. 236.

129. G-W II, no. 88. On this supposed use, see the hesitation expressed, long before Arnulf 1990, by A. Pertusi in *SettStu* 23 (1976), p. 510 note 70, and below, pp. 200f.

130. Corrigan 1978, p. 409, ably expounded the ideological role of these inscriptions

although, by translating XPICT[ε] as "Lord," obscured the interplay of the verbal and visual imagery on the front of the object.

131. For one exception, see A. Cutler, "The Marginal Psalter in the Walters Art Gallery," *JWAG* 35 (1977), p. 43 and fig. 5.

132. See above, pp. 72f.

133. The lack of such incisions and, more anomalously, the fact that the letters of Christ's name are carved at the same level as the ground, allow the suspicion that the inscription on the Berlin Footwashing (fig. 81) is a later addition.

134. See below, p. 213.

135. St. Clair—McLachlan 1989, p. 5.

136. *Il libro dell' arte*, ed. F. Brunello (Vicenza 1971), p. 125: "E per lo simile, con i tuo' ferretti va' radendo cornici e fogliami, e va' pulendo sì come fusse un avorio."

137. G-W II, no. 232.

138. For one suggestion on this score, see below p. 249.

139. See above, chapters I, note 116, and III, note 74.

140. Above, p. 32.

141. Cutler 1985, p. 50.

142. Connor 1991.

143. This is often the most promising place to search for paint. For its use in this area and elsewhere on ivories in Florence and the Victoria and Albert Museum, see below, pp. 173f.

144. Green stain is likewise found on the fronts (and backs!) of a pair of panels in London depicting the half-length Christ and the Virgin (G-W II., nos. 149f.).

145. Ibid., no. 215.

146. Ibid., no. 138.

147. On box plaques, for example, red is used on inscriptions on an Archangel Michael in London (G-W I, no. 91) and on Adam and Eve at the Forge (our fig. 32).

148. G-W II, no. 22. By confusion, the wings of this triptych, now reemployed on the back cover of *Clm* 6832, are said by Weitzmann to be on the same MS as the Passion scenes. Both books were presented by Bishop Ellenhard of Freising to a church of St. Andrew in 1051. It is worth noting that the six scenes of the wings lack any inscription.

149. G-W II, no. 153.

150. Ibid., no. 159. Cleaning is of course part of an object's "biography." Perhaps the most telling example of the impact of provenance on the appearance of plaques is the case of the Hanover Crucifixion and Deposition (fig. 223) and the Dresden Chairete and Anastasis (fig. 110). Originally leaves of the same diptych, the front of the former is now bone white while the latter retains a warm, *café au lait* hue.

151. Severin 1987.

152. See above, note 142.

153. G-W II, no. 32. For a detailed account of the color, see M. E. Frazer in *The Vatican Collections. The Papacy and Art,* exhibition catalogue (New York, 1983), no. 40, where, however, what I see as green flecked with gold is described as gold.

154. Haloes of this color are found in enamel on the Esztergom cross reliquary (Wessel 1967, no. 49). The palette used on ivory tends to be realistic or at least to refer to supposed properties of the objects represented. Thus, much red is used behind Satan and Dives and on the river of fire that descends toward them in the Victoria and Albert Museum's Last Judgement (G-W II, no. 123).

155. P. Williamson and L. Webster, "The Coloured Decoration of Anglo-Saxon Ivory Carvings," in *Early Medieval Wall Painting and Painted Sculpture in England*, ed. S. Cather, D. Park, and P. Williamson, *BAR* British Series no. 216 (Oxford 1990), pp. 177–94.

156. For this chronological hypothesis, see below p. 150.

157. Keck—Morey 1935, p. 402.

158. Maguire—Duncan-Flowers 1989, no. 31.

159. Buschhausen 1971, nos. B12, C2 and C12.

160. Weitzmann 1976 no. B13. Later examples include nos. B37 and B55.

161. Ibid., no. B45.

162. See above, p. 28.

163. Delbrueck 1929, p. 19.

164. Cutler 1984a.

165. G-W II, pls. IXa, Xd. On the mechanics of this lock, see G. Vikan and J. Nesbitt, *Security in Byzantium. Locking, Sealing and Weighing* (Washington, D.C., 1980), p. 7 and fig. 15.

166. The handle, depicted in G-W II, pl. Xe, has since been removed.

167. See above, p. 18.

168. In most instances, the wood has been largely or entirely replaced while the revetment endures.

169. Cutler 1984–1985, pp. 39, 41. I must here correct the captions to figs. 6, 9, 10, 12 and 17 in this article, written by an unknown hand and mistakenly suggesting that the objects they identify are clad in ivory. In each case the revetment is of bone.

170. G-W I, no. 59. Here the photographs of both this and a similar fragment from the same box (ibid., no. 58) are printed in reverse.

171. Ibid., no. 32.

Notes to Chapter IV

1. On the ninth- or tenth-century distinction between goods (clothing) purchased *ex agoras* and those made in imperial workshops, see *Constantine Porphyrogenitus, Three Treatises on Imperial Military Expeditions*, ed. J. F. Haldon, Vienna 1990, p. 112.290,293.

2. See chapter II, notes 84–86.

3. An assumption often made about church decoration and no less often ignored with respect to smaller creations. To suppose a connection between the size of the artifact and the size of the patron's investment is not necessarily invalidated by the fact that the same relationship often prevails in the modern world.

4. R. Cormack, "Patronage and New Programs of Iconography," in *17th CEB* (Washington, D.C. 1986), pp. 609–27.

5. G-W I, no. 125; C. B. Heller in *Splendeur de Byzance*, no. Iv. 26.

6. A. Cutler, "The 'Mythological' Bowl in the Treasury of San Marco in Venice," in *Near Eastern Studies . . . in Honor of George C. Miles*, ed. D. Kouymjian (Beirut 1974), pp. 236–54, reprinted in my *Imagery and Ideology in Byzantine Art* (Aldershot, 1992),

study IX. In the addenda to this reprint I have responded to the observations of I. Kalavrezou-Maxeiner, "The Cup of San Marco and the 'Classical' in Byzantium," in *Studien zur mittelalterlichen Kunst, 800–1250. Festschrift für Florentine Mütherich* (Munich, 1985), pp. 167–74.

7. H. Maguire, *Earth and Ocean. The Terrestrial World in Early Byzantine Art* (University Park, Pa. 1987), p. 2 and passim.

8. A liturgical interpretation was offered by Kantorowicz 1942; for a less restricted reading see Asano 1988. See also chapter V, note 97.

9. On the relationship between the choice of "timeless" scenes and historical situations, Cutler 1992b, and, on the triptych's date, below, pp. 208f.

10. Frazer 1974.

11. Cutler 1992b.

12. TheophCont, p. 450.12–20.

13. See Chapter II, note 89.

14. *ODB*, pp. 196–201 *s.v.* Artists (A. Cutler).

15. Philes (above, Chapter III, note 74) I, nos. CLXI, CLXVIII and *passim*; II, nos. XLV, CXXVII and *passim*.

16. See Introduction, note 8.

17. N. Oikonomides, "The Holy Icon as Asset," *DOP* 45 (1991), pp. 35–44, esp. p. 43. It is clear that the value was, at least in part, ideological. At the Council of Ferrara in 1438, Gregory Melissennos, the confessor of John VIII Palaiologos, claimed that because he could not identify the saints depicted in a Latin church, he could not revere them. He would not revere even Christ who, though he recognized him, was inscribed in terms that Melissenos could not read. See V. Laurent, *Les 'Mémoires' du grand ecclésiarque de l'Eglise de Constantinople Sylvestre Syropoulos sur le Concile de Florence* (Rome 1971), p. 250. 24–26.

18. See below, p. 210 and Cutler 1992a.

19. The other example is a Crucifixion showing an unidentified bishop with a book at the foot of the Cross (G-W II, no. 102). I do not believe the Otto and Theophano plaque in Paris (Caillet [1985]), no. 64; our fig. 235), on which the prostrate figure is sometimes supposed to be Philagathos Kerameus, to be Byzantine; on this, see below, p. 215.

20. On the exceptional nature of the Cortona cross-reliquary in this respect, see Cutler 1991, p. 656.

21. The inscription on the other example, on the left wing of the diptych in Warsaw (fig. 221), specifically enjoins the spectator to admire not the craftsman's art but the "acute mind" of the *epistates* (master or administrator) who "made" it. See Ratkowska 1965, p. 96 and below, chapter VI, pp. 235f.

22. H. Hunger, "On the Imitation of Antiquity in Byzantine Literature," *DOP* 23–24 (1969–1970), pp. 15–38.

23. Cutler 1992b.

24. See below, pp. 217–19.

25. E. Garrison, *Studies in the History of Medieval Italian Painting,* 4 vols. (Florence, 1953–62).

26. J. Beazley, *Attic Red-Figure Vase-Painters*, 2nd ed. (Oxford, 1963). Cf. the review by M. Robertson in *JHS* 85 (1965), p. 99f.

27. *Vita Eligii; passiones vitaeque sanctorum aevi merovingici*, ed. B. Krusch (= MGH, *Scriptores rerum merovingicarum*), (Hanover—Leipzig 1902) IV, pp. 663–741. For this craftsman's products and travels, see H. Vierck, "Werke des Eligius" in *Studien zur vor- und frühgeschichtlichen Archäologie. Festschrift für Joachim Werner*, ed. G. Kossack and G. Ulbert (Munich, 1974), II, pp. 309–80.

28. See above, pp. 71–78.

29. M. Panayotidi, "The Character of Monumental Painting in the Tenth Century" in *Constantine VII Porphyrogenitus and his Age. 2nd International Byzantine Conference, Delphi, 22–26 July 1987* (Athens, 1989), pp. 285–331.

30. Compare, e.g., the masterpiece of expressionist fantasy that is Cranach's Crucifixion of 1502 with his trenchantly realistic portrait of Luther as an Augustinian friar, painted in 1520. It is conceivable that the eighteen-year interval between these works did not exceed the span of a Byzantine carver's working life. To argue from this analogy, however, would beg the question of the difference between the self-consciousness of a sixteenth-century artist and that of a medieval craftsman, and ignore other dissimilarities between the cultures in which each worked.

31. M. Baxandall, *Patterns of Intention. On the Historical Explanation of Pictures* (New Haven, 1985), p. 67.

32. In much the manner that a skilled modern cabinet maker or silversmith is often the best source of information on techniques that are no longer practiced.

33. Kalavrezou 1989, p. 380, offers a different approach to the carving of this ivory.

34. Above, p. 146.

35. G-W II, nos. 91, 92, 94, 97, 146–49. A ninth version, described by G-W, no. 93, as on the Munich art market in 1907, appears to be lost. On the parameters of the term Pantokrator, see J.T. Matthews, "The Byzantine Use of the Title Pantocrator," *OCP* 44 (1978), pp. 442–62.

36. For this reason, too, it would be wrong to read too much significance into the gap between the blessing hand and the left frame in St. Petersburg (fig. 116), a distance obviously greater than that in either Paris or Cambridge. The lateral frames of this last plaque have been removed, perhaps at the same time as the projecting palmette friezes were added. Weitzmann was surely correct in seeing these ornaments as Western additions.

37. G-W II, no. 149. Heavily restored in green-painted plaster, Christ here has many of the same features as on the plaques in Cambridge, St. Petersburg, and Paris, but wears a *nimbus cruciger* and holds a scroll instead of a book.

38. Ibid., II, no. 186.

39. This so puzzled some later possessor of the Leipzig plaque that a more conventional umbilicus has been drilled below the original semi-lunar form.

40. Unremarked by Weitzmann, G-W II, no. 156, a large area at the foot of the cross is stained green. I take this to be a modern addition, independent of the flecks of color elsewhere on the plaque.

41. Ibid., II, no. 114.

42. Above, pp. 101f.

43. G-W II, no. 86. I am indebted to Charles Dempsey for his observations on the restoration. A similar piece (but without the donor) has since come to light. See Randall 1985, no. 193.

44. The plaque is first recorded by J. O. Westwood, *A Descriptive Catalogue of the Fictile Ivories in the South Kensington Museum* (London, 1876), p. 97, no. 219.

45. Both the controversy and the older literature are cited in G-W II, no. 28, to which add, above all, the work of the Danish epigrapher, E. Moltke, *Runes and their Origin, Denmark and Elsewhere* (Copenhagen, 1985), p. 456. Weitzmann, rightly in my view, argued for the Byzantine origin of the plaque, although he suggested its production at a center on the Black Sea.

46. See above, pp. 86f.

47. See above, p. 137.

48. See above, p. 124.

49. G-W II, no. 68; Williamson 1982, p. 28.

50. A. Grabar, "L'Hodigitria et l'Eléousa," *Zbornik za likovne umetnosti* 10 (1975), pp. 3–14.

51. Of the twenty images listed in G-W II, one (no. 80) is lost and unknown to me save through a photograph. The remaining five are either discussed below or will appear in a new corpus of Byzantine ivory carvings that I am preparing.

52. V. Lasareff, "Studies in the Iconography of the Virgin," *ArtB* 20 (1938), p. 46.

53. On the varieties, and varying significance, of proskynesis, see A. Cutler, *Transfigurations. Studies in the Dynamics of Byzantine Iconography* (University Park, Pa., and London 1975), pp. 53–110.

54. See above, note 19.

55. G-W II, no. 98.

56. Ibid., no. 87.

57. Wentzel 1973, p. 15f and fig. 10. I am informed by the conservator, Dr. Davide Banzato, that the fragment which measured 12.2 × 8.5 cm, was stolen from the museum in 1964.

58. G-W II, no. 81; Bank—Popova 1977, no. 582. The figures have been cut out along the contours originally scored around them, from a plaque that probably measured *ca.* 15 × 11 cm.

59. A particularly direct confrontation is evident in the lost ivory from the collection of J. J. Marquet de Vasselot (above, note 49). The Berlin icon reproduced in fig. 197 was published by H. Schlunk in Berliner Museen, *Berichte aus den preussischen Kunstsammlungen* 60 (1939), pp. 5–7 and fig. 5.

60. G-W II, no. 134. See now M.-P. Laffitte in Durand 1992, no. 161.
61. K. N. Ciggaar, "Une Description de Constantinople traduite par un pèlerin anglais," *REB* 34 (1976), p. 249. 4–5.
62. G-W II, no. 87a.
63. Above, p. 53.
64. See above, Chapter III, note 49.
65. G-W II, no. 132.
66. Ibid., II, no. 133.
67. Ibid., II, no. 129.
68. A detail curiously missing in ivories of the standing Hodegetria and one which

contributes to the affective, personal quality of the half-length images.
69. For the presence of these folds in late antique and early medieval ivory carving, see Cutler, 1984b, p. 52.
70. Above, p. 100.
71. A suggestion for which I am grateful to William Tronzo.
72. Above, p. 14.
73. Weitzmann 1972, no. 28; Cutler 1985, pp. 16, 28.

Notes to Chapter V

1. Above, pp. 161f.
2. G-W I, G-W II.
3. Thus, for example, by Caillet 1985, the most careful and least dogmatic of many museum catalogues of the last quarter of a century.
4. G. Kubler, *The Shape of Time. Remarks on the History of Things* (New Haven, 1962), p. 67.
5. Ibid., p. 125.
6. Below, p. 191.
7. This variety is of course subject to exponential multiplication if the characteristics of *individual* specimens are taken into account in the manner of Goldschmidt and Weitzmann. Logically, the species to which any particular potato may be attached is the equivalent of the "group" into which particular ivories have been inserted. What is remarkable is the scientific consensus that attends a classification involving some 230 categories as against the problems raised by a system with only five categories.
8. See the comments on G-W II, nos. 74, 75, 127, 181. A further logical difficulty lies in the circularity of the method by which the "groups" came into being: the system whereby the ivories were classified is said to be derived from the objects themselves, yet these are then inserted into "groups" according to the "group" characteristics that they are held to display. This problem may be insuperable since it inheres in all large-scale systems of interpretative classification.
9. Weitzmann 1972, no. 27, p. 66f.

10. Ibid., p. 18. This position is endorsed by Kalavrezou 1985, p. 50.
11. Weitzmann 1972, p. 68.
12. See above, pp. 66–71.
13. G-W II, p. 10.
14. Beckwith 1962, p.2. G-W II, p. 10, entertained the possibility of distinguishing between hands and occasionally (see I, nos. 86, 116) use this terminology. On the problem of Palace workers, see below, p. 233.
15. Caillet 1985, p. 151 note 2. On differences between the St. Petersburg and Berlin plaques see Cutler 1994a.
16. See above, p. 182, and below, p. 223.
17. Kalavrezou 1977, esp. pp. 320–25. My objections to this revision are set out in Cutler 1994b, and more discursively below in chapter VI.2.
18. This thesis, originally set out in G-W II, p. 13, is more fully treated (and expanded to include the "rosette caskets") in Weitzmann 1971a, p. 3. It is accepted as "quite possible" and summarized by Kalavrezou 1989, p. 389: "the models were painted icons and in creating the relief the artists transferred the lines and outlines of the paintings to the ivory producing something close to engravings rather than sculptures."
19. Above, pp. 99–101.
20. Weitzmann 1971a, p. 3; Kalavrezou 1989, p. 380.
21. Weitzmann 1971a, pl. 3, 2.
22. Weitzmann 1976, no. B56.

23. This is apparent in the disposition of the haloes raised in low relief but still attached to the rear wall, rather than turning variously in space as do the heads to which they belong.

24. G-W II, p. 13.

25. In this respect, the cautionary words of D. Mahon, *Studies in Seicento Art and Theory*, Studies of the Warburg Institute, 16 (London, 1947), p. 8 note 8, remain important. G-W II, p. 10, uses the notion of the sculptural as a taxonomic device, while Kalavrezou 1989 regards it as an indicator of chronology.

26. His mantle is a military not a "priestly" garment, as in G-W II, no. 19. Lois Drewer was kind enough to inform me that in her view the saint in question is not Eustratios the Wonderworker (*Thaumatourgos*) but the leader of the "Holy Five". On these and Eustratios' costume, see A. P. Kazhdan and N. Ševčenko in *ODB*, p. 789, *s.v.* Five Martyrs of Sebasteia.

27. G-W II, no. 18. Smaragdos is flanked by Meliton in the mid-tenth-century decoration of Tokalı kilise and precedes in the list of Forty Martyrs in various synaxaria. Weitzmann 1992, p. 705, proposed that Smaragdos' companion is Klaudios, who accompanies him in *Synax.CP*, p. 522.44. On the original setting of the Bryn Athyn plaque, see below, chapter VI, note 18.

28. Weitzmann 1972, no. 40. See also Cutler 1985, p. 45f and figs. 44f.

29. See Glossary.

30. Below, pp. 200, 213.

31. Caillet 1985, no. 61.

32. Jacobs van Merlen 1948, p. 13f.; J. Lafontaine—Dosogne in *Splendeur de Byzance*, no. Iv. 14.

33. *Contra* Jacobs van Merlen and my own position, the notion of an identifiable master in this instance was denied by J. de Coo, *Museum van den Bergh. Catalogus 2, Beeldhouwkunst, plaketten, antiek* (Antwerp 1969), p. 69.

34. As of early April 1993, I have no assurance that the triptych has survived recent battles in Southern Ossetia.

35. G-W II, no. 154.

36. Other analogues between the Tskhinvali triptych and the New York Deesis include the double line on the hem of the Virgin's

himation, the forms of the knot and fur trimming of John's *melote*, the ornament of Christ's book, and the way that he holds it.

37. Unless the Tskhinvali plaque was also a commission for the emperor, a reverse relationship between the two objects is unlikely.

38. Above, p. 100f.

39. On the other hand, there are reasons to believe that many "caskets" were produced by team work. On these, Cutler 1984–1985, and above, pp. 150f.; below, p. 223.

40. Above, pp. 19f.

41. G-W I, no. 100.

42. See above, pp. 124f.

43. Schrader 1972.

44. Kalavrezou 1989, pp. 386, 396, places the Washington plaque in the ninth century, at a date unspecified but after 860. On this question see below, pp. 201f.

45. See below, p. 216f.

46. F. Hermanin, "Alcuni avori della collezione Stroganoff," *L'Arte* I (1898), p. 10. For the dating of these objects, see below, pp. 203–11.

47. *Einhardi annales*, ed. G. H. Pertz, *MGH, Scriptores* I (Berlin, 1826), p. 191.13f.

48. *Gesta episcoporum Cameracensium*, ed. L. C. Bethmann, I, chap. 42, *MGH, Scriptores* VII (Hanover, 1846), p. 416.46–50. This passage elaborates upon Einhard's account of the same mission to Constantinople (ibid., p. 415.13–15).

49. P. Riché, "Trésors et collections d'aristocrates laïques carolingiens," *CahArch* 22 (1972), p. 40. Less prodigious references in these documents are to "Hebore indico" and "tabulas sarascinicas." Theodulf of Orleans, *Contra judices*, in MGH, *Poetae latinae* I, p. 497, speaks of "Gangetis eburnea."

50. On this question, Cutler 1987, pp. 437–42.

51. The use of ivory for bookcovers seems to have been unknown in Byzantium. See below, note 112.

52. Above, pp. 57f. Even so, accounts of Arab merchants from the Persian Gulf prospecting for ivory along the east coast of Africa (in the "bilad al-zanj") date no earlier than 916. See G. F. Hourani, *Arab Seafaring in the Indian Ocean in Ancient and Early Medieval Times* (Princeton, 1951), pp. 79–82.

53. That some small-scale carving took place is suggested by the interdiction on ivory and bone buckles of Theodore of Stoudios. See above, Chapter II note 53. It is worth noting that the dated ivory jars and caskets from Ummayad Spain are no earlier than the second half of the ninth century. On these see J. Ferrandis, *Marfiles arábes de occidente* I (Madrid, 1935) and J. Beckwith, *Caskets from Cordoba* (London, 1960).

54. *Theodori Studitae epistulae*, ed. G. Fatouros (CFHB, 31, Berlin 1992), I, p. 26.64–68. For the date, see the commentary on p. 150*.

55. Treadgold 1988.

56. Thus Arnulf 1990 on the thesis of Weitzmann 1971, p. 11. Weitzmann's arguments for Leo V are iconographic and stylistic. He observes that the emperor on the ivory is short-bearded, unlike Leo VI on the narthex mosaic of H. Sophia who is shown with the "long beard of a philosopher." But, as Stephen Gero has pointed out to me, in the literary sources Leo V is repeatedly described as having "a long graying beard" or "a full beard." See I. Dujčev, "La chronique byzantine de l'an 811," *TM* I (1965), p. 216.90, and (the pseudo-) Symeon magister, ed. I. Bekker (Bonn 1838), p. 603.4–5. On his coins, nonetheless, Leo V invariably appears with a short beard. In the face of such inconsistency, any iconographical reasoning is pointless. Weitzmann's stylistic argument is, however, unconvincing. The "double-line" folds that he sees as characteristic of this ivory (and of some silver and the MS, Paris, B.N. gr. 923 which he puts in the early ninth century) are illusory. It is true that the object displays an "all-over linear treatment," but, as our detail (fig. 158a) shows, folds consist variously of double, triple, and even quadruple "parallel" lines.

57. Cutler-Oikonomides 1988; H. Maguire in *ArtB* 70 (1988), pp. 88–90; Kalavrezou 1989, esp. pp. 394–96.

58. G-W II (reprint), p. 2, suggesting nonetheless that the diptych is later than the Leo ivory but still older than the earliest pieces in either the Romanos or Nikephoros "groups." On the object itself, see Ratkowska 1965 who places it in a

"provincial monastic milieu in the XI–XII centuries."

59. As a result of undercutting, both leaves have suffered considerable losses. While no figure projects beyond the frames of the diptych, much of the Virgin's bench (fig. 221) and a branch of the tree in the Entry into Jerusalem (fig. 73) have disappeared. The relative security of forms produced by Kerbschnitt is indicated by the wings of the angels in the Annunciation, the Women at the Tomb, and the Ascension.

60. In Cutler 1994a I have set out the reasons for preferring this dating to that of Maguire and Kalavrezou (above, note 57), who both wish to see in the iconography of the box echoes of the life of Basil I (867–886). These views are to be rejected because, in essence, they ultimately depend upon the misreading of the inscription by Guillou 1979, pp. 207–9, pointed out in Cutler—Oikonomides 1988. We read the lid of the box as a reference to one of Leo VI's marriages. Kalavrezou objected that the inscription makes no mention of such a marriage. Indeed it does not. Nor do those on countless images of the *dextrarum iunctio*, the joining of the wedding couple's right hands by Christ. Rather, they allude to it obliquely, direct reference being as unnecessary in these instances as on the box in the Palazzo Venezia.

61. Kalavrezou 1989.

62. Cutler 1994a.

63. Kalavrezou 1989, p. 387.

64. Further on this contrast, see above, p. 115.

65. Below, pp. 207–14.

66. Weitzmann 1971a, p.3.

67. Mišakova 1975.

68. Above, pp. 195–97.

69. As proposed again by Kalavrezou 1977.

70. Cutler 1994b. See also D. Gaborit-Chopin in Durand 1992, no. 148.

71. Unfortunately, too little is known of the provenances of these pieces to warrant a guess as to their early history. Before 1805, the Romanos plaque was part of the cover of a Greek lectionary in the church of St. John in Besançon. Stylistic similarities between the two ivories are noted by Kalavrezou 1977, p. 324.

72. Above, pp. 104–106.

73. Cutler 1991, p. 653. The third ivory with this feature is the Liverpool Prodromos (fig. 13). A detached ivy leaf appears in both the text and as a terminal to captions in miniatures in the Paris Psalter (Cutler 1984c, fig. 249). The lower cross-brace of the throne in the former Hirsch Christ (fig. 46) is decorated not with detached leaves but with a rinceau of ivy, as is the cushion of Christ's throne on the Harbaville triptych (fig. 170).

74. The inscription *Basileus tes doxes* ("King of Glory") on the triptych was described as an epithet of the eleventh century by A. Büchler, *16th Annual BSC*, Abstracts (Baltimore, 1990), p. 68, suggesting that this is its earliest use in conjunction with the Crucifixion. This may be so, but, as C. Bertelli has noted (in *Atti del 10° Congresso internazionale sull'alto medioevo* [Spoleto 1986], p. 343), the Greek epithet was applied to the enthroned Christ in the apse mosaic of Sant'Ambrogio in Milan, restored in the fourth decade of the ninth century.

75. Above, p. 104.

76. G-W I, 122. The association is due originally to H. Peirce and R. Tyler, "Deux mouvements dans l'art byzantin du Xe siècle," *Aréthuse* 4 (1927), p. 41.

77. Weitzmann 1976, no. B58.

78. On this, see below, pp. 250f.

79. P. Grierson, *DOC* III, 1 (1973), pp. 120–22.

80. E.g., the Paris Chrysostom MS, B.N. Coislin 79 (fol. 1 [2 bis]) of *ca.* 1078.

81. G-W II, no. 75.

82. The older form of the garment continued to be displayed by loros-wearing archangels. Thus the Gabriel at Dumbarton Oaks (see Chapter III, note 94) and the same archangel on a triptych wing in the Benaki Museum, Athens (L. Bouras in *Splendeur de Byzance*, no. Iv.20) cannot be dated by this means. I have connected the latter ivory with the Romanos plaque in a paper to appear in a volume of studies in memory of Laskarina Bouras.

83. C. Morrisson and G. Zacos, "L'image de l'empereur byzantin sur les sceaux et les monnaies," in *La Monnaie, miroir des rois* (Paris 1978), pp. 57–72.

84. Above, pp. 163–65. Christ's right hand is held in the same position on the Hirsch ivory in Switzerland (fig. 46). The first known numismatic instance is on a solidus of Alexander, 912–913 (Grierson, *DOC* III, p. 2 and pl. XXXV.2).

85. Above, pp. 132–34.

86. Oikonomides 1994.

87. TheophCont 447.1–450.11.

88. Oikonomides 1994.

89. Further on this ideological context, see above, p. 159.

90. See above, pp. 137f.

91. G-W II, no. 58. See below, p. 220.

92. I borrow the phrase from C. Mango's paper cited above in Chapter III, note 125. See also the discussion in Cutler 1991, pp. 645, 650. The abundance of diacritical signs on the Baptist plaque in St. Petersburg, whose authenticity is questioned by G-W II, no. 225, argues for a "late" date but assuredly not that it is a forgery. It is accepted as authentic by Bank—Popova 1977, no. 593, an opinion with which I agree following direct examination of the piece.

93. G-W II, nos. 32f.

94. For a selection, see ibid., pl. LXIII.

95. Cutler 1991, p. 652 and pl. 6b.

96. On the date, cf. below, note 104. Such serrated borders are found on a number of ivories after their appearance on Christ's footstool on the Romanos plaque (pl. IV). See G-W II, nos. 38, 50, 60, 78. The first of these the authors of the corpus sought to relate to Anna, daughter of Romanos II, who married Vladimir of Kiev in 988, on the grounds that Joachim and Anna, the parents of the Virgin, are depicted on the back of this triptych's wings. For the possibility that G-W II, no. 38 was carved for a woman, see below, chapter VI note 44.

97. The selection of saints would seem more fruitful an approach to the destination, if not the patron, of each of the three triptychs than the liturgical interpretation undertaken by Kantorowicz 1942 or the analogies with monumental art drawn by Asano 1988. An iconographical study of this sort would involve the nexus between the (largely known) dedications of Constantinople's churches and the (largely unknown) devotions of historical individuals.

98. V. von Falkenhausen, "San Pietro nella religiosità bizantina, " *SettStu* 34 (1988), pp. 655–58.

99. Cf. Kalavrezou 1977, pp. 321–24.
100. G-W II, nos. 47–49.
101. Thus the unmistakable damage to the Berlin Presentation, ibid., no. 11 (our fig. 238).
102. G-W I, no. 13.
103. Above, p. 126.
104. While assigning the carving of the front of the plaque to this reign (Cutler 1991, p. 658), on the basis of mistaking the elaborate script in which the text is written I assigned the carving of the reverse to the reign of Nikephoros III (1078–1081). I withdraw this observation unreservedly and am glad to acknowledge the correction of Oikonomides 1994.
105. G-W II, no. 92. The cover is now in a depository of the Diocesan Museum at Udine.
106. Ibid., no. 91. I would distinguish his hand from that which carved the half-length Christ in Munich (fig. 19) whose differently shaped head is set against a cross with bars in two registers, and whose nose is much thicker. The double-register cross without an enclosing nimbus recurs on several pieces (figs. 116–18) otherwise unrelated to the Munich ivory. On these, see above, pp. 107–109.
107. See above, pp. 170f.
108. Caillet 1985, no. 64. The only other exception is a Koimesis with eight saints in the Victoria and Albert Museum (G-W II, no. 111), distinguished by its crudely cut lettering.
109. Kalavrezou 1977, p. 316 note 53.
110. This curiosity is also to be found in the Last Judgement plaque in London. D. Denny's view (*Speculum* 57 [1982], p. 536) that this piece is a forgery is evidently not founded upon unmediated examination of the ivory.
111. Kalavrezou 1977, p. 316.
112. I know of no mention of ivory book covers later than that of Vrt'anes K'ert'ogh (seventh century), cited by S. Der Nersessian, *Études byzantines et arméniennes* (Louvain, 1973), p. 385. The passage seems to refer to ivory worked in this way in Byzantium for export. To my knowledge, no Byzantine source reports on such a usage, nor is it required by the physical evidence that we possess.
113. Above all by Keck—Morey 1935, p. 401f.
114. Above, p. 198.
115. Spatharakis 1981, no. 24 and fig. 56. This form of *mu* is standard in the captions above pictures in the Menologion of Basil II (976–1025).
116. See above, note 41.
117. See the list drawn up in Keck—Morey, as in note 113.
118. Above, note 48.
119. Cutler 1984c, no. 58 and fig. 413.
120. Keck—Morey 1935, p. 401.
121. *Il Menologio*, p. 284.
122. On the lack of technological development in ivory carving, see above, p. 82 and below, p. 249.
123. Thus Beckwith 1962 on the openwork plaque with John the Baptist and other saints (our fig. 60).
124. While to my knowledge it has not been published as a piece of the eleventh century, this date was assigned to the object when on loan to Dumbarton Oaks on the basis of its resemblance to the Romanos ivory (pl. IV).
125. The second such piece is in the Victoria and Albert Museum (G-W II, no. 63).
126. Grierson, *DOC* III, 1, p. 159 and pl. LVIII, 2.
127. This ivory, listed as in the Louvre (G-W II, 61), is on deposit at the Musée de Cluny. See D. Gaborit-Chopin in Durand 1992, no. 162.
128. G-W II, no. 114. Cf. Keck 1930, p. 162. For the date of Leningrad (now St. Petersburg) gr. 105, see A. W. Carr, "A Group of Provincial Manuscripts from the Twelfth Century," *DOP* 36 (1982), p. 55. Since the date of this MS is a criterion applied by Keck to the "school of carving" that in G-W is called the "Frame group," his chronology for many of its constituents is similarly called in question.
129. G-W II, no. 29. The authors ascribed the piece to southern Russia, partly on account of the runes on the reverse which they could not read. Through the kindness of Dr. Olafia Einarsdottir, I can now report that the inscription notes the gift of one Rakke to "Boalin my sister." The runes are later than *ca.* 1000 but not otherwise datable. On these, see Moltke (as in Chapter IV, note 45), p. 486.
130. Bank 1978, p. 85f. She concludes (p. 88) that most ivories found on the territory of the then U.S.S.R. are to be assigned to the tenth or eleventh century.

131. Above, p. 59.
132. M. Gill in Harrison 1986, nos. 54f, 57.
133. Cutler 1985, p. 34. The most useful study of Komnenian sponsorship of art is P. Magdalino—R. Nelson, "The Emperor in Byzantine Art of the Twelfth Century," *ByzF* 8 (1982), pp. 123–83.
134. Generally on this question, see P. Schreiner, "Untersuchungen zu den Niederlassungen westlicher Kaufleute im byzantinischen Reich des 11. und 12. Jhdts.," *ByzF* 7(1979), pp. 175–91.
135. R.-J. Lilie, *Handel und Politik: Zwischen dem byzantinischen Reich und den italienischer Kommunen Venedig, Pisa und Genua in der Epoche der Komnenen und der Angeloi (1081–1204)*, (Amsterdam, 1984).
136. Above, p. 200.
137. Above, pp. 58f.
138. The collections of the Archivio di Stato in Venice, invaluable for this period and topic, were published in part by R. Morozzo della Rocca and A. Lombardo, *Documenti del commercio veneziano nei secoli XI–XIII*, I (Turin, 1940). The few commodities specified in these contracts include wine, oil, and honey. Ivory is similarly missing from a richer list of goods available in Constantinople and Pera in the decades between 1310 and 1360 (Pegolotti, pp. 32–54).
139. Keck 1930; Ebitz 1986.

140. Bank 1981. See also chapter II, n. 148.
141. Above, note 87.
142. Above, note 91.
143. Including the anchor-shaped abbreviation of John Chrysostom's Christian name, for which a perfect parallel exists in the wall paintings of Tokalı kilise, roughly datable to the middle of the century. See Cutler 1991, p. 654.
144. G-W II, nos. 38, 60, 78.
145. G-W I, no. 101.
146. On this abbreviation, and against the belief that it is a regional sign (Randall 1985, no. 198), see Cutler 1991, pp. 647f.
147. G-W II, p. 17 and comments on no. 72. See also Weitzmann 1971a, p. 3; Weitzmann 1972, p. 46f; and idem, *The Icon* (New York, 1978), p. 60.
148. Cutler 1984–1985 and above, pp. 151f.
149. Noted, for example, in G-W I, no. 41.
150. Above, pp. 61, 64.
151. Weitzmann 1972, no. 30. The statement here that the Virgin and and a pair of apostles are carved in "a lower grade of ivory" is incorrect. See Cutler 1985, p. 36.
152. Cutler 1988.
153. G-W II, nos. 197, 207, 211, 215. See my Introduction, note 9.
154. Above, p. 150.
155. Kalavrezou 1989.
156. Caillet 1985, p. 151 and note 2.

Notes to Chapter VI

1. Cutler 1984–1985, p.46.
2. On this problem, Baxandall 1980, p. 50, and passim.
3. Here and in what immediately follows it will be obvious that I have learned much from Conkey 1982.
4. E.g., Weitzmann 1971a; Kalavrezou 1989.
5. Kazhdan—Constable 1982, p. 88f.
6. The "Elfenbein-Ikone" in Baltimore to which G-W II, p. 11 and fig. 1, pointed as an example of how a plaque was framed in another material is, in fact, not ivory.
7. Kalavrezou 1985, p. 29.
8. Above, pp. 112–15.
9. G-W II, no. 60.

10. See also the reverses of the central plaques of the triptychs in the Vatican and the Palazzo Venezia (G-W II, pls. XII and LXIIIf).
11. G-W II, no. 14. The association between these plaques was made by Weitzmann 1972, pp. 45–47.
12. On this manner of "reading" an icon, see above pp. 39f.
13. Above, pp. 102–106.
14. See P. Gautier, "Le typikon du Christ Sauveur Pantocrator," *REB* 32 (1947), index *s.v.* κανδῆλα. Gautier's translation "devant," to indicate where lamps were placed vis-à-vis icons, receives no authorization from the Greek text where the preposition used invariably is ἔν.

15. The principal literature on this question is assembled by L. Bouras in *ODB* p. 2023f, *s.v.* Templon.

16. The critical, and overlooked, datum is a passage in TheophCont, p. 330.21–23, describing the chapel of St. Clement built by Basil I in the Great Palace: "The entire beam that rests on the columns' capitals consists of pure gold and is covered everywhere with the whole array of the wealth of India; in many parts of the beam the figure of our Lord, the God-Man, is rendered in enamel." The "wealth of India" could refer to either gems or ivory. I am grateful to Ihor Ševčenko for allowing me to cite his as yet unpublished translation of this text.

17. See Mathews 1982 and esp. p. 138 note 10.

18. Weitzmann 1967; idem 1972a; idem 1972, pp. 102–5. Weitzmann 1992 elaborated this suggestion, postulating on the basis of a plaque showing two full-length saints an epistyle adorned with 21 others of this sort as the source of the Bryn Athyn ivory. One difficulty with this hypothesis is the disappearance without trace of the 20 remaining plaques. It seems more likely that the plaque in question was a discrete icon on the order of the George and Theodore plaque in Venice (Fig. 44).

19. Weitzmann 1972, p. 105. The belief that the plaques were made for an architrave is shared by Bank—Popova 1977, no. 583.

20. See above, chapter II, 3.

21. See above, p. 220.

22. Weitzmann 1972, p. 72.

23. For this taste, see G-W II, p. 12f.

24. Above, p. 42.

25. Stethatos, *Vie*, chapters 151.25–152.10.

26. It is noteworthy that the list of craftsmen (stonemasons, carpenters, goldsmiths, silversmiths, etc.), whom this emperor is said by TheophCont (447.1–450.11) to have "corrected," does not include ivory workers. Nor does this text suggest that these craftsmen had ateliers in the Palace.

27. See above, chapter II, p. 67 and note 84.

28. W. Watson, *Chinese Ivories from the Shang to the Qing* (London 1984), pp. 121–25.

29. Ibid., p. 122.

30. Above, pp. 205f.

31. G-W II, pl. LXIII, figs. 31f, 155b, 182c. The construction of the Dresden and Hanover crosses resembles, however, that on the back of the Turin Christ and Peter icon (ibid., fig. 53b) where the legend IC XC NIKA recurs.

32. According to G-W II, no. 60, the sections brutally cut across both leaves, and the numerous holes drilled in them, were to allow their parts to be later attached to several reliquary chests.

33. Ibid. This observation would seem to refer to the commemorations inscribed in the Middle Ages on the insides of consular diptychs. The practice of inscribing names on *diptycha* is attested in 1162 in the *typikon* of the Bithynian monastery of the Virgin Heliou Bomon. See Dmitrievskij I, p. 754.3–5. Wentzel 1971, p. 27, refers to the diptych as a "Notizbuch" without further ado.

34. As is probably the case with the arcade and suspended crown incised on the back of the central plaque of a triptych in the British Museum (G-W II, no. 78).

35. Cutler 1985, p. 53. After making this suggestion, I found that it had earlier been advanced by J. Flemming, *Byzantinische Kunstexport*, ed. H. L. Nickel (Halle, 1978), p. 191.

36. Oikonomides 1972a, pp. 93.23, 95.23. Cf. pp. 127.25–127, 129.4–5, 22–24. The objects are described as πλάκες ἐλεφάντιναι κεκοσμημέναι.

37. Ibid. pp. 94.1, 95.23: this action is confirmed by *De cer.*, pp. 249.22, 251.3–4, and 260.15 (this last with reference to the patriarch of Constantinople) where the material of the plaques remains unidentified.

38. M. C. Ross—G. Downey in *JWAG* 19–20 (1956–1957), p. 22f.

39. Thus in 796 Constantine VI distributed parts of what was alleged to be the body of St. Euphemia; twenty years later Leo V sent the body of St. Zacharias to the Venetian doge Agnellus. See Treadgold 1988, pp. 106, 219.

40. I. Kalavrezou in *ODB*, p. 534, *s.v.* Coronation: representation in art.

41. G-W II, no. 38. See above Chapter V note 96 and, below, note 44.

42. Lemerle 1971, pp. 251. Cf. above, Chapter IV note 21. The translation that follows I owe to Jeffrey Featherstone.

43. For the very few references in monastic documents see above, p. 20. Given the specificity in inventories and lists of donations concerning the materials of which artifacts are made, the absence of ivory from such documents as the will of Eustathios Boilas (1059) and the *typikon* of Gregory Pakourianos (before 1086) is remarkable.

44. Apart from the ubiquitous Virgin, Eve, Helena, and reigning empresses like Bertha-Eudokia (pl. IV), the only named females are SS. Anne, Barbara and Thekla on the wings of the British Museum triptych, on which see above, note 41. The very exceptionality of the triptych in this respect encourages the belief that it was made for a woman.

45. For these concepts, see A. Kazhdan in *ODB*, p. 468f, *s.v.* Class structure.

46. As Fr. John Cotsonis demonstrated in his unpublished Ph. D. dissertation, *A Society and its Images: the Religious Iconography of Byzantine Lead Seals* (University Park, Pa., 1992), between the ninth and twelfth centuries 17 of 111 female seal owners chose an image of either Christ or a male saint.

47. TheophCont pp. 325–29.

48. *De cer.* pp. 118.1, 121.3.

49. P. Noailles—A. Dain, *Les Novelles de Léon VI le Sage* (Paris, 1944), p. 23.4–25.6. We know that, at least in Leo's reign, the so-called Ivory Gate (see above pp. 19f.) led to a chapel dedicated to St. Athenogenes. See P. Karlin-Hayter, ed., *Vita Euthymii Patriarchae CP* (Brussels, 1970), p. 45.5. For the history of the private chapel, see J. P. Thomas, *Private Religious Foundations in the Byzantine Empire* (Washington, D.C., 1987), esp. pp. 133–84. Odo of Deuil (*De profectione Ludovici VII in orientem*, ed. and trans. V.G. Berry [New York, 1948] pp.54–56), an eyewitness to the Second Crusade (1147–1149), noted of the powerful in Constantinople that "all have their own chapels, so adorned with pictures, marble and lamps that each might justly say 'O Lord, I have cherished the beauty of thy house.'")

50. TheophCont p. 452.3–11.

51. T. Macridy et al. in *DOP* 18 (1964) 249–315. On relations between the liturgy and the size and decoration of such chapels, both in and beyond the capital, see Mathews 1982.

52. E.g., Symeon the Theologian, for whose lavish refurbishing of the imperial monastery of St. Mamas *ca.* 980, see Stethatos, *Vie*, chapters 30, 34.

53. A. Kazhdan—A. M. Talbot in *ODB* p. 521f, *s.v.* Constantinople, Patriarchate of.

54. W. Seibt, "Die Darstellung der Theotokos auf byzantinischen Bleisiegeln, besonders im 11. Jahrhundert," in *Studies in Byzantine Sigillography*, ed. N. Oikonomides (Washington, D.C., 1987), pp. 41,47.

55. The grounds of both the Utrecht and Liège plaques are no more than 2 mm thick, allowing the translucency that we have noted on the finest triptychs. The latter, which G-W II, no. 47, confess to knowing only from a poor photograph, has dowel holes at the corners of its reverse of which the authors of the corpus were unaware and which clearly indicate the provision of triptych wings.

56. Notably the small-headed *rho* and barred *upsilon*, on which see Cutler 1990, p. 651.

57. The stepped recess in the reverse of this figure (which is 1.2 cm thick) obviously represents a later stage in the object's "biography." Quite apart from the crudeness with which it is cut, in contrast to the fineness of the obverse, such treatment (according to G-W II, no. 48, intended for relics) is not found in any other Byzantine ivory.

58. Writings on the *parakoimomenos* and his artistic and literary interests are legion. See Mazzucchi 1978 and, most recently, J. Koder in *Constantine Porphyrogenitus and his Age* (Athens, 1989) pp. 165–84.

59. Lemerle 1971, pp. 254f.

60. Ibid., p. 288.

61. Beaton 1989, p.19.

62. Lemerle 1971, p. 260.

63. The most ample analysis of these teachers is provided by Lemerle 1971, pp. 255–300, and Mazzucchi 1978.

64. G-W I, no. 24.

65. Cf. ibid., no. 39.

66. For this reason no single, indiscerptible theme can be found on the Darmstadt casket (fig. 174).

67. Ibid., no. 39.

68. Cutler 1984–1985, p.44.

69. *Bibliotheke* cod. 70, cited by Wilson 1983, p. 104.

70. Stethatos, *Vie*, chapter 93, p. 128.12–16.

71. Thus C. Jolivet-Lévy, "L'Image du pouvoir dans l'art byzantin à l'époque de la dynastie macédonienne (867–1056)," *Byzantion* 57 (1987), p. 464. But see Cutler 1992b.

72. G-W I, no. 10.

73. H. Kannheimer in *MünchJb* 40 (1989), p. 247f.

74. G-W I, nos. 68 (Leningrad), 69 (Darmstadt). The arrangement of the plaques on the Leningrad casket has been disturbed: the metalworkers occupy the right end of the plaque, while Ploutos with his moneysack sits between Adam and Eve grieving for their expulsion.

75. The literature on this question is assembled by Lowden 1992, p. 117 note 73. For the concept and its problems, see A. Kazhdan in *ODB*, p. 1783, *s.v.* Renaissance.

76. As in the inscription on the Palazzo Venezia triptych, above, p. 158.

77. E. Simon, "Nonnos und das Elfenbeinkästchen aus Veroli," *JDAI* 79 (1964), pp. 279–336.

78. K. M. Kiefer in Ćurčić—St. Clair 1986, no. 20. Cf. too the heraldically displayed lion-headed griffons of ibid., no. 21 with those on the back and sides of the Detroit casket (our fig. 75).

79. K. McK. Elderkin in *AJA* 30 (1926), pp. 150–57. See also Ćurčić—St. Clair no. 27 and G-W I, p. 11.

80. E. Kitzinger in *Gatherings in Honor of Dorothy Miner*, ed. U. McCracken, L.M.C. Randall and R. H. Randall, Jr. (Baltimore, 1974), pp. 10–12.

81. M. Piccirillo, *Madaba. Le chiese e i mosaici* (Milan, 1989), p. 59.

82. Volbach 1976, pl. 72f.

83. H. Maguire, *Earth and Ocean. The Terrestrial World in Byzantine Art* (University Park, Pa., 1987), fig. 10.

84. Buschhausen 1971, pls. A15, B24–27 (Projecta Casket), B30–32 and passim.

85. Dufrenne—Canart, fols. 2r, 3v.

86. Volbach 1976, no. 109.

87. W. Müller-Wiener, *Bildlexikon zur Topographie Istanbul* (Tübingen, 1977), fig. 46, but better Dumbarton Oaks negative no. H63.234. This analogy to G-W II, no. 81f. was kindly pointed out to me by Eunice Maguire.

88. See also G-W II, no. 7.

89. E.g., in the *Agrimensores* MS in Wolfenbüttel (K. Weitzmann, *Ancient Book Illumination* [Cambridge, Mass., 1959], fig. 132).

90. Frazer 1976.

91. *De cer.* I, p. 4.14–15.

92. Among late antique ivories this form occurs on the Lampadiorum leaf (Volbach 1974, no. 54). For its diffusion in the tenth and eleventh centuries, Cutler 1991, p. 647.

93. See A.P. Kazhdan in *ODB*, p. 997f, *s.v.* Innovation, and the volume of papers, *Originality in Byzantium*, ed. A. R. Littlewood, in press.

94. Grierson in *DOC* III, 1, p. 454.

95. Such as the ivory diptych in the treasury of Milan cathedral (Volbach 1976, no. 119) and the Rossano Gospels. The "doubling" of the children is represented in the Entry scene at Tokalı kilise, where they are identified as *paides ton Ebraion*, and in the eleventh-century gospelbook, Florence, Laur. 6.23, fol. 42r.

96. Paris, B.N. gr. 510, fol. 52v. We await the forthcoming study of this MS by Leslie Brubaker.

97. This was pointed out by G-W I, no. 1.

98. Lowden 1992, p. 118f. On the iconography of the defeated king of Ai (G-W I no. 2), see now O. Kresten In *SbWien* 126 (1989), pp. 111–29; and on the bone "Joshua" plaques in Milan, which he removes from the inspiration of the Rotulus and attributes to Western craftsmen, Zastrow 1978, no. 21.

99. If Arethas of Caesarea is a fair representative, then intellectuals were extraordinarily ignorant of materials. Referring to Aristeides' mention of such "ivory" statues as the Olympian Zeus and an Athena then in Athens, Arethas (*Peri exorchoumenon*, ed. G. Dindorf [Leipzig 1829], II, p. 556.15–16) suggested that the latter was the same as that which in his own days stood in the Forum of Constantine, despite the fact this was bronze. On the Athena, destroyed by the people of the capital in 1203, see C. Mango, "Antique Statuary and the Byzantine Beholder," *DOP* 17 (1963), pp. 62, 67.

100. Above, chapter I. 2.

101. Mango 1972, pp. 63, 69, 84, 85f.

102. P. Gautier in *REB* 39 (1981), p. 89.1177–82.102.

103. Lemerle 1977, p. 24.133. His bequests also included a *kamptritzin*, a little box for relics. For a mid-twelfth-century example of a beloved artifact, a walrus or whalebone *pyxidion* used as an inkstand, see J. Shepard, "Tzetzes' Letters to Leo at Dristra," *ByzF* 6 (1979), pp. 196, 215–21.

104. Cf. Leo VI's description of the Church of Stylianos Zaoutzes (Mango 1972, pp. 203–5).

105. E. W. Leach, in *AJA* 96 (1992), p. 551.

106. G. Sauron, "Templa serena, " *MEFRA* 92 (1980), pp. 277–301; M. R. Wojcik, *La villa dei Papiri ad Ercolano* (Rome, 1986), pp. 259–84.

107. Thus E. Weigand's suggestion (in a review of G-W I in *BZ* 32 [1932], p. 378) that the predilection for naked figures on the caskets and boxes showed that these objects were intended as wedding presents. By contrast, Zastrow 1978 (see above, note 98) argued that what he perceived as their overt sexuality prevented them from being Byzantine creations.

108. Noting that the text on the back of the Cortona cross-reliquary (pl. II) records its offering to a monastery, Keck—Morey 1935, p. 404, opposed G-W II, no. 71's identification of the emperor named in the inscription as Nikephoros II on the grounds that legislation of his reign forbade donations to such institutions. In fact, Nikephoros II's decree (Novel 19 in J. and P. Zepos, *Jus graecoromanum* II [Athens 1931], pp. 249–52) is expressly limited to gifts of land.

109. Thus Jolivet-Lévy (as in note 71 above).

110. With this attitude in mind, Kalavrezou 1989, p. 389, argued that the technique of undercutting figures was abandoned in favor of a "flat" style of carving. The problem with this thesis is not so much that undercutting persisted as a technique in the tenth century as that, if a fear of idolatry were in the air, one would expect it to bear generally on all artistic production of the time. Indeed, the minimal attention paid to the material of which a work is made in all genres of Byzantine literature save for inventories suggests an aspect of mentality that transcended the historical circumstances of Iconoclasm.

111. *Eparchikon biblion*, p. 138.789f.

112. Wilson 1975, pp. 3–5; G. Ostrogorsky, "Löhne und Preise in Byzanz," *BZ* 32 (1932), p. 295. This latter article remains the prime source for much of the little that we know about wages and prices.

113. Above, pp. 157f., 236.

114. Shipments of carved ivory weighing 500 pounds cost the same as 600-pound loads of unworked material. See R. Sprandel in *Lexikon des Mittelalters* III (1986), col. 1812f, *s.v.* Elfenbein.

115. Above, p. 236.

116. On this, C. Renfrew in *The Social Life of Things. Commodities in Cultural Perspective* ed. A. Appadurai (Cambridge, 1986), pp. 141–68.

117. See above, pp. 61, 64.

118. Other cultures made different choices, as the early history of printing witnesses. The *cartolai* of the Italian Renaissance printed luxurious books on vellum for the few, and larger editions on paper for ordinary customers. While icons may have been made *en série* by ivory carvers for the market place, these products did not involve a surrogate material.

119. See above, p. 70. The contrast between Byzantium and other cultures in this respect is striking. Three (presumably walrus) ivory dice constituted the annual rent for five acres of land in Glamorgan just after the middle of the twelfth century and were considered precious enough to be the object of an aristocrat's deed of gift. See *Earl of Gloucester Charters*, ed. R. B. Patterson (Oxford, 1973), no. 65. Along with silver, a pair of knives with ivory handles was accepted as security for a loan made in Ragusa in April 1439. See B. Krekić, *Dubrovnik (Raguse) et le Levant au moyen âge* (Paris-The Hague, 1961), p. 319, no. 933. Elaborate secular objects in our material are the stuff of fiction: thus the gold and ivory scabbard in Sir Walter Scott's novel of Constantinople, *Count Robert of Paris* (London, 1880), p. 31.

120. For the cultural significance of "technological style," see Lechtmann 1977. I am grateful to Elizabeth Boone for drawing my attention to this stimulating paper.

121. The lid of the "Palaiologan pyxis" (Weitzmann 1972, pl LII B) was turned with a lathe. So are some of the Middle Byzantine spools and spindles found at

Saraçhane (Chapter II, note 55).

122. I know of no Byzantine equivalent to the account of Reginald, a monk of Durham, of *ca.* 1175 (see P. Lasko, "The Comb of St. Cuthbert," in *The Relics of St. Cuthbert*, ed. C. F. Battiscombe [Oxford 1956], p. 340). Recalling the translation of relics into the new cathedral some seventy years earlier, Reginald noted of the saint's comb that it was "finely proportioned to the breadth, for the length is almost equal to the breadth, except that for effect the one differs a little from the other." He goes on to record how "its natural appearance of white bone is changed by its great age now suffused with a reddish tinge."

123. Above, pp. 19–39.

124. P. Gautier, "Un Discours inédit de Michel Psellos sur la Crucifixion," *REB* 49 (1991), pp. 5–66, esp. 65.1411–13.

125. *Ep.* 211 (*Michaelis Pselli Scripta minora* ,ed. E. Kurtz II (Milan, 1941), p. 247.21–25;

on this letter see A. Cutler—R. Browning in *BMGS* 16 (1992), pp. 22–24.

126. Baxandall 1980, p. 102.

127. See also G-W II, nos. 22, 122, 127.

128. The fullest analysis is provided by Cotsonis, as in note 46.

129. Above, pp. 174–84.

130. Beaton 1989, p. 10.

131. Once again, the Darmstadt casket (G-W II, no. 125; our fig. 174) is the exception that proves the rule.

132. E.g., the "*doux* of Mesopotamia" (Oikonomides 1972a, p. 263.28).

133. *De cer.* 4.23–5.9.

134. For incisive observations on the interplay of material circumstances and ideology in the situation of Western medieval craftsmen, see A. J. Gurevich, *Categories of Medieval Culture* (London, 1985), pp. 206–08, 262f, and passim.

Glossary

Bevel	The angle formed by a surface when joined to another that is not perpendicular to it; used especially of the splayed *frame* that encloses a *plaque*.
Blocking out	The technique by which the sculptor, more or less closely following his *drafting lines*, roughs out a figure or other form before finishing it.
Chamfer	A rounded edge, of natural origin or worked by the carver, especially as on the reverse of a *plaque*.
Contour	An outline incised after a figure or other form has been carved in order to define its volume.
Dentine	The dense, calcareous tissue constituting the body of the tusk and harder than the cement (enamel) and fibrous husk that enclose it.
Diminished corners	The corners of a *panel* or *plaque*, which, in their recession in one or more planes, express the natural curvature of the tusk along its longitudinal axis.
Drafting line	A preliminary guideline incised on the *ground* before *blocking out*.
Edge	The narrow surface running horizontally or vertically between the obverse and reverse of a *plaque*.
Frame	The projecting border, usually rectangular or splayed, that encloses a *plaque* and is homogeneous with it.
Ground	On the obverse of a *plaque*, the physical plane that is farthest from the beholder. To be distinguished from the "background," often an illusion created by the sculptor, although of course the two may coincide.
Kerbschnitt	A manner of carving whereby a figure or other form is cut back at an oblique angle to the *ground*. It is related to chip carving, a technique often used on bone. In chip carving, however, the planes are worked in such a way as to leave facets which, in metalwork, lend brilliance to the design. On ivory, Kerbschnitt is a means of suggesting depth and volume.
Minimal cluster	A set of artifacts identifiable as the work of a particular craftsman. It *excludes* objects possibly carved by his hand, as well as others said to belong to the same "group" of ivories.

Pan	A carved area, particularly in the representation of cloth, created by the removal of material between the arrises of a fold.
Panel	A section of ivory cut normally with its vertical axis parallel to the longitudinal axis of a tusk. As used here, it refers to a section, sometimes subdivided before it is carved.
Plaque	A rectangular section, normally between 4 and 10 mm thick, prepared, sometimes by subdivision, from a *panel*. After detailing and finishing, it is ready for use as an icon or for attachment to a box.
Reduction	A foreshortening technique by means of which forms, usually the heads of figures ("reduced heads"), intended to be read in a three-quarter view, are rendered as two planes joining at an obtuse angle.
Scorper	An arc-bladed tool, often called a gouge or inshave and described as "between an adze and a drawknife" (Petersen 1990, p. 860), used to remove material from behind a figure or other form.
Step	On the obverse of a *plaque*, the distance between the frontal plane, which is often that of the *frame*, and the *ground*.

Sources of Illustrations

Harry Schaefer 1; Veneranda Fabbrica del Duomo, Milan 2; Staatliche Museen Preussischer Kulturbesitz 3a, 3b, 39, 40, 56, 83, 84, 211, 238; Bodleian Library, Oxford 4; Walters Art Gallery 5, 6, 64, 91, 235; Trustees of the British Museum 9, 10, 90, 98, 127, 173, 213, 242; Bayerisches Nationalmuseum 11, 12, 188–190; Liverpool Museum 13, 14, color pl. VI; Historical Museum, Tbilisi 16; Dumbarton Oaks 17, 24, 46, 47, 57, 58, 96, 97, 109, 171, 208, 225, 237; D. Thomassin 18; Bayerische Staatsbibliothek 19, 155, 212, color pl. VI; Hermitage Museum 20, 116, 181a, 181b, 240; Klaus G. Beyer 25, 201, 204, 226, 239; Foto Marburg 28, 195; Princeton University Art Museum 36, 66; Universitätsbibliothek, Erlangen 43; Soprintendenza archeologico per il Veneto, Padua 44; Metropolitan Museum of Art, gift of J. Pierpont Morgan 50; Photohaus Hirsch, Nordlingen 59; R. Martin Harrison 63; Hessisches Landesmuseum 65; Marlia Mango 70; Museo Civico Medievale, Bologna 71; Cleveland Museum of Art, purchase from J. H. Wade Fund 72; Z. Tomaszewska 73, 221; Réunion des Musées Nationaux 74, 214, 233; Detroit Institute of Arts 75; Ann Münchow 81, 93, 124, 144, 199, 205, 209, color pl. VII; Germanisches National-museum, Nuremburg 86; Musée du Louvre 87; Rijksmuseum Het Catharijneconvent 99; Biblioteca Apostolica Vaticana 105, 169; Bibliothèque Nationale, Paris 115, 200; Fitzwilliam Museum, Cambridge 117, 180; Fundacion Lázaro Galdiano 129; Staatsbibliothek Bamberg 134–136, 207; Kunsthistorisches Museum, Vienna 139; Soprintendenza ai Beni Artistici e Storici, Naples 141; Grassi Museum, Leipzig 145; L. Khuskivadze 148, 216; Victoria and Albert Museum, Department of Sculpture 158a, 187; Kestner Museum, Hanover 185, 223; Foto Lazzeri, Florence 193; Museo Civico, Padua 197; Historisches Museum, Bamberg 203; Michigan-Princeton-Alexandria Expedition to Mount Sinai 210; Rheinischen Amt für Denkmalpflege 246; Prähistorische Staatssammlung, Munich 247; Anthony Cutler 7, 8, 15, 21, 23, 26, 27, 30–35, 37, 38, 41, 42, 45, 48, 49, 51–55, 60–62, 67–69, 76–80; 82, 85, 88, 89, 92, 94, 95, 100–104, 106–108, 110–114; 118–123, 125, 126, 128, 130–133, 137, 138, 140, 142, 143, 146, 147, 149–154, 156, 157, 158b–168, 170, 172, 174–179, 182–184, 186, 191, 192, 194, 195, 198, 202–206, 215a, 215b, 217–220, 222, 224, 227–232, 234, 236, 241, 243–245, plates I–V

Index

Aachen, Domschatz: Hodegetria plaque, 181, fig. 205

Abydos, 29, 73

Alexandria, 58, 59, 219

Alexios I Komnenos, emperor, 218

American ivory carving, 59

Anglo-Saxon ivories, 149. *See also* English ivories

Anna, daughter of Romanos II, 278 n. 96

Anna Komnene. *See* Komnene, Anna

Anonymus de obsidione toleranda, 68

Antwerp, Museum Mayer van den Bergh: triptych fragment, 193f., fig. 215

Arethas of Caesarea, 283 n. 99

Arnhem, Gemeentemuseum: bookcover with Crucifixion plaque, 166, 216, pl. III, fig. 143

Aspasmos. See Kissing

Athens, Benaki Museum: triptych wing, 278 n. 82

Athos, Mount, 265 n. 67

Attaleiates, Michael, 246, 261 n. 45

authenticity, 12–15. *See also* Forgeries

Baghdad, 57

Baltimore, Walters Art Gallery: box plaque with John Chrysostom and another saint, 222, fig. 235; box with warrior and putti, 59, fig. 64; Crucifixion plaque, 13, 17, 24, 260 nn. 9, 17, 18, fig. 5f.; Hodegetria triptych, 88f., 121, 149, 169, 182, 194, 221, 224, 233, figs. 91f., 206; MS W. 733 (Psalter), 271 n. 131; Nativity plaque, 44, 51, 191, fig. 42

Bamberg, Historisches Museum: Hodegetria plaque, 181f., fig. 203; Staatsbibliothek: bookcover (Msc. Lit. 1) with Hodegetria, 182, fig. 207; Christ and Virgin plaques, 122, 208, 231, fig. 135f.; Peter and Paul plaques, 121, 231, figs. 133f.

Bar Hebraeus, 264 n. 39

Barlaam and Ioasaph, 23

Basil I, emperor, 52, 55, 237

Basil the Nothos, *parakoimomenos*, 239

Belonas, Theophilos, *patrikios*, 237

Berlin, Staatliche Museen: Christ and Virgin diptych, 11, 81, figs. 3, 84; Crucifixion plaque, 34, 128, fig. 34; Crucifixion triptych, 114, 121, 139, 149, 212, 222, figs. 124, 134, 159f.; Crucifixion with donor, 34, 273 n. 19; Entry into Jerusalem plaque, 39f., 109, 112, 124, 136, 198, 224, 245, figs. 39f., 56, 138; Forty Martyrs plaque, 187, 221, 270 n. 109, 271 n. 133; Hodegetria plaque, 178, 183, figs. 199, 209; Leo ivory ("scepter tip"), 135, 138, 193, 200f., 211, 220, 224, 249, fig. 158; Presentation of Virgin, 229, 270 n. 88, 279 n. 101; Raising of Lazarus, 230; Virgin and child with angels, 218; Washing of the Feet, 79f., 132, 188f., 240, 262 n. 94, 271 n. 133, figs. 81, 83, 149, 211

Bernard of Clairvaux, 22

Bernward of Hildesheim. *See* Hildesheim

beveling, 117, 286

Boilas, Eustathios, 246

Bologna, Museo Civico Medievale: plaque (bone) with Christ enthroned, 64f., fig. 71

bone carving, 59, 61, 62–65, 68, 223, 248, 271 n. 123, 272 n. 169

bookcovers, hypothesized Byzantine, 215f., 268 n. 16, 276 n. 51, 279 n. 112

bookcovers (Western), ivories on, 21, 107, 145, 169, 178, 190, 193, 200, 213, 215f., 259 n. 9, 271 n. 148

Book of Ceremonies, 251, 281 n. 37

Book of the Eparch, 67, 68, 233, 247

booty, 54

boxes, 18, 59f., 151f., 222f., 227, 240, 270 n. 83, 284 n. 107. *See also* specific objects by location

Brescia, Museo Civico: Lampadiorum diptych leaf, 283 n. 92; "Loving Couples" diptych, 56, fig. 62

Bryn Athyn, Glencairn Museum: St. Smaragdos and another saint, 191

Cambridge, Fitzwilliam Museum: Christ plaque, 107, 163f., 208, 245, figs. 117, 180

carving techniques, 4, 15, chapters III, IV passim, 212, 286f. *See also* beveling, chamfering, Kerbschnitt, polishing, straight cutting, undercutting

caskets. *See* boxes

Castagnola, Thyssen-Bornemisza collection: triptych, 98, 181f., fig. 202

Caucasian origin of ivories, hypothesized, 74, 76

"cement", 51f., 80, 85, 86, 264 n. 18, 268 n. 24

Cennini, Cennino, 141

chamfering, 31, 286

chapels, private, 237

Chersonese, 59, 74

Chinese ivories, 233

Choniates, Niketas, 22

chronology of Byzantine ivories, 197–225, 247

Cleveland, Cleveland Museum of Art: Apostles pyxis, 69, 124, fig. 72

clientele, 38, 71, 154f., 232–46, 278 n. 97

Constantine VI, emperor, 281 n. 39

Constantine VII Porphyrogennetos, emperor, 207, 209f., 220, 233, 237, 240, 245

Constantine IX, emperor, 52

Constantinople: Great Palace, 42, 68, 237, 281 n. 16; Hagia Sophia, 20, 83; Hagia Sophia, inventory of, 20; Ivory Gate, 19f., 282 n. 49; Obelisk base of Theodosios, 244. *See also* Istanbul

consular diptychs, 66, 150, 270 n. 92, 281 n. 32, 283 n. 92

Copenhagen, Nationalmuseet: Crucifixion, 171–73, 190, fig. 191f.

Corinth, 59, 70, 73, 76; Museum: trial piece, 73, 92, fig. 95

Cortona, S. Francesco: cross reliquary, 20f., 36f., 125f., 140, 169, 192f., 214f., 221, 235, 251, 284 n. 108, pls. I, II, figs. 37f., 140, 232

Damietta, 219

Danelis, 52

Daphni, mosaic at, 73

Darmstadt, Hessisches Landesmuseum: Box with Genesis scenes, 61, 283 n. 74, fig. 65; Box with "mythological" and oriental themes, 137, 155, 282 n. 66, 285 n. 131

De ceremoniis. See Book of Ceremonies

Detroit, Detroit Institute of Arts: box with animal battles and putti, 74, 283 n. 78, fig. 75

Digenes Akritas, 22

Dioskorides, 20, 261 n. 41

diptychs, 28, 150, 281 n. 33. *See also* consular

diptychs and specific objects by location

Donauwörth, Schloss Harburg: bookcover with Hodegetria, 176, 178, 179, fig. 195; triptych, 64, 85, 122, 165, 181, fig. 59

Dresden, Grünes Gewölbe: diptych leaf with Chairete and Anastasis, 104f., 129, 206f., 211, 234f., 245, 272 n. 150, figs. 110f., 147; John the Evangelist and Paul, 153, 208, 220, figs. 151, 226; Joseph box plaque, 212, fig. 229; Meleager plaque, 111f., 241, fig. 120f.

Edict of Maximum Prices, Diocletian's, 29

Eirene, empress (797–802), 200

enameling, 146, 272 n. 154

English ivories, 284 n. 119, 285 n. 122. *See also* Anglo-Saxon ivories

Eparchikon biblion. See Book of the Eparch

epigraphy, 14, 62, 138–40, 158, 208–10, 221, 222, 238, 245

Erlangen, Universitätsbibliothek: bookcover (cod. 9) with Hodegetria, 44, fig. 43

Eulalios, mosaicist, 266 n. 77

Florence, Bargello: Apostles box, 124, 137, 173, figs. 137, 193; Ascension plaque 210, 220

forgeries, 11, 12, 64f., 117–19

Fortunatus, patriarch of Grado, 199

George of Nikomedeia, 25

Gérard of Cambrai, 217

glass making, 78

Gotha, Schlossmuseum: diptych leaf with Christ, 28, 150, 221, 235, figs. 25, 241

Gothic ivory workers and merchants, 54, 66, 69, 70, 128, 218, 266 n. 101

grain (ivory), 15, 34, 79f., 82, 85, 86, 105, 129, 131

Great Palace. *See* Constantinople

Greek Anthology, 92

"groups" of ivories, 4, 71, 72, 185–97, 225, 232f., 259 n. 9, 275 n. 8

hair styles in carving, 124–25, 198

Halberstadt, Cathedral treasury: diptych, 229, 235, fig. 239

Halitcharius, bishop of Cambrai, 199f.

Hamburg, Museum für Kunst und Gewerbe: Hodegetria plaque (fragment), 105f., 212, 260 n. 37, 262 n. 92, figs. 112f., 228

Hanover, Kestner Museum: (large) Crucifixion plaque (inv. no. 411), 98, 106, fig. 114; (small) Crucifixion plaque (inv. no. 1893.2), 98, 136, 144, 166, figs. 101, 157, 184; Cruci-

fixion and Deposition diptych leaf, 104f., 205f., 211, 221, 234f., 272 n. 150, fig. 223

Harbaville triptych. *See* Paris, Louvre

Harburg triptych. *See* Donauwörth

Heliou Bomon, monastery of the Virgin, 281 n. 33

Hildesheim, Cathedral treasury: Crucifixion (Bernward's "Small Gospelbook"), 34, 126, 244, fig. 33; Deesis plaque, 122

hinges, 149f.

Hirsch ivory. *See* Switzerland, private collection

Hisham II, caliph, 58

Houston, Museum of Fine Arts: Dormition plaque, 198, 216f., 268 n. 22, 270 n. 87, fig. 234

iconographical distribution 175, 237, 249–51

icons (wood panels), 25–27, 39, 67, 188, 228–31, 269 n. 32. *See also* specific objects by location

Ignatios the Deacon, 101

inscriptions. *See* epigraphy

inventories, 20, 92

Islamic ivories, 41, 247, 277 n. 53

Istanbul, Archaeological Museum: plaque with sainted bishop, 59, fig. 63; saint plaque (bone), 64, 262 n. 96, fig. 70; Saraçhane Camii, 59, 218. *See also* Constantinople

Italian origin of boxes, hypothesized, 74, 76, 267 n. 143

ivory: carving techniques, *see* carving techniques; chronology, *see* chronology; color on, *see* polychrome; cost of, 52f., 247, 262 n. 97; grain, use of, *see* grain; quality of, 42–54, 280 n. 151; quantity of, 41, 42, 246; sources of, 56–59, 171, 200, 219, 276 n. 49, 276 n. 52; weighing of, 29, 264 n. 40

Jāhiz of Basra, 58

Jena, Universitätsbibliothek: bookcover (cod. Elect. fol. 3), 179, fig. 201

Jerome, St., 22

John I Tzimiskes, emperor, 264 n. 28

John Diaconus, author of *Chronicon Venetum*, 265 n. 50

John of Damascus, St., 25, 262 n. 82

Kastoria, Hagioi Anargyroi, 260 n. 31

Kerbschitt, 111–15, 132, 152, 161, 181, 184, 277 n. 59, 286

Kissing (*aspasmos*) of ivories and other objects, 25f.

Kletorologion, 235

knitting, 82

Komnene, Anna, 20

Komnenian emperors, 218, 280 n. 133

labor, cost of, 247, 248

Leipzig, Grassi Museum: Crucifixion plaque, 127–29, 137, 165f., figs. 142, 145, 182; Universitätsbibliothek: bookcover (cod. Rep. I. 57) with Hodegetria, 181, fig. 204

Leo V, emperor, 59, 200, 281 n. 39

Leo VI, emperor, 200, 220, 221, 247, 284 n. 104; *Novellae* of, 237

Leo, *patrikios* and *sakellarios*, 240

Liège, Cathedral treasury: Hodegetria plaque, 206, 212, 238, 260 n. 32, 282 n. 55, fig. 243

Lips, Constantine, 237

Liverpool, Liverpool Museum: John the Baptist plaque, 17, 208, 210, 221, 278 n. 73, fig. 13f.; triptych, 144f., 149, 165f., 191, 265 n. 73, pl. VI, fig. 183f.

London, British Library: Add. MS 19.352 (Theodore Psalter), 27, fig. 23; MS Stowe, 3, 145, fig. 167; British Museum: Archangel plaque, 244; Borradaile triptych, 235, fig. 242; box plaques with hunting scenes, 151, 243, fig. 172f.; Crucifixion plaque, 15, 270 n. 95, fig. 9f.; Crucifixion triptych 278 n. 96, 282 n. 44; Deesis plaque, 146; Ezekiel plaque, 87, 94, 98, 117, 157, 191, 210, 234, 268 n. 22, figs. 90, 98, 127; Hodegetria triptych, 281 n. 34; Joseph box plaques, 260 n. 8; Nativity plaque, 191, 192, fig. 213; oliphant with Hippodrome scenes, 78; Victoria and Albert Museum: Ascension plaque, 169, fig. 137; Christ enthroned, 279 n. 125; Crucifixion, Dormition and Entombment, 82; Dormition with eight saints, 279 n. 108; Hodegetria statuette, 18, 54, 262 n. 94, fig. 60; John the Baptist and four apostles, 173f., 192, 279 n. 123, fig. 194; Joshua plaque, 84, 240, 264 n. 18; Last Judgment, 272 n. 154, 279 n. 110; six scenes from life of Christ, 33, 76, 143f., 187, figs. 31, 165; Veroli casket, 56, 59, 63, 117, 150, 151, 187, 224, 241, 243, 260 n. 8, 264 n. 18, figs. 61, 128; Visitation and Presentation plaque, 29, fig. 26f.; Y. Petsopoulos collection: triptych wing, 41, 248, fig. 41

Luton Hoo, Wernher collection: Eustratios plaque, 86f., 191, fig. 88

Lyon, Musée des Beaux-Arts: Genesis plaques, 50f., 224, figs. 53–55, 162; Christ plaque, 214, 221, fig. 231

Madaba: floor mosaics, 244
Madrid, Biblioteca Nacional: cod. vitr. 26–2
 (Skylitzes), 24, 25f., 163, fig. 21; Museo
 Lázaro Galdiano: copy of Veroli casket, 117–
 19, fig. 129
Malibu, J. Paul Getty Museum: MS Ludwig XI,7,
 261 n. 60
Maximos of Skoteine. See Skoteine
metalwork, 18, 149, 150, 160, 235, 244, 269 n.
 45, 281 n. 26, 283 n. 84
Michael II, emperor, 199
Michael IV, emperor, 217
Michael V, emperor, 42
Milan, Biblioteca Ambrosiana: cod. B119 sup.,
 73; Castello Sforzesco: "Joshua" plaques, 283 n.
 98; Sant'Ambrogio: apse mosaic, 278 n. 74;
 Tesoro del Duomo: Christological diptych, 8,
 23, 33f., 72, 111, 217, 245, figs. 2, 32; Tri-
 vulzio collection (former), 65
Modena, Galleria Estense: Christological plaques,
 263 n. 120
Moscow, Pushkin Museum: Coronation of Con-
 stantine, 76, 131, 142, 195–97, 203, 208,
 235, 251, figs. 76, 164, 217f.; Hodegetria
 triptych, 76, 222, figs. 8, 77, 85, 236
Mschatta, 267 n. 129
Munich, Bayerisches Nationalmuseum: Deesis
 plaque, 16, 128, fig. 11f; Hodegetria with do-
 nor, 170f., 175, figs. 188–90; Prähistorische
 Staatssammlung: Herakles plaque, 242, fig.
 247; Staatsbibliothek: bookcover (Clm 4453)
 with Dormition, 135f., 137, 143, 190f., 217,
 233, figs. 155f., 212; bookcover (Clm 6831)
 with Crucifixion, Deposition and Entombment,
 145f., 161, 190, pl. VII, figs. 17f., 168,
 177f.; bookcover (Clm 6832) with Christologi-
 cal scenes, 271 n. 148; bookcover (Clm 22021)
 with fragment of a Christ triptych, 21, fig. 19
Mu'tasim, caliph, 58

Naples, Museo di Capodimonte: Crucifixion
 plaque, 126f., fig. 141
New York, Metropolitan Museum of Art: box
 with Deesis and Apostles, 62, 146, figs. 68,
 219; Genesis box plaques, 121, fig. 132; Cruci-
 fixion plaque, 77, 99, 157, 172, 176, 244,
 249, pl. V, fig. 78; Demetrios plaque, 117,
 119, 122, 268 n. 23, figs. 126, 130; Deesis
 plaque, 196f., 270 n. 111; Hodegetria plaque
 (fragment), 32, 131, 262 n. 92, 264 n. 27,
 figs. 30, 244; Joshua plaques, 49, 62f., 84,
 147–49, 240, figs. 50–52, 69; killing of King
 of Hazor, 78, 141, figs. 79f, 163

Nikephoros II Phokas, emperor, 213, 264 n. 28,
 284 n. 108
Nikephoros III Botaneiates, emperor, 279 n. 104
Niketas Magistros, 23
Nikon Metanoiete, St., Life of, 262 n. 95, 269 n.
 55
Nikopolis, Dumetios basilica, 244
Nonnos of Panopolis, author of Dionysiaka, 243
Nuremburg, Germanisches Nationalmuseum:
 Crucifixion plaque, 83, 93f., 128, fig. 86

olive oil, price of, 54
orthography, 17, 72f.
Otto II, Holy Roman Emperor, 215
Otto III, Holy Roman Emperor, 59, 216
Oxford, Ashmolean Museum: Hodegetria plaque,
 30, 102, 217, fig. 107f; Bodleian Library:
 Christ enthroned (fragment on bookcover), 11,
 49, 107, 167, 217, fig. 4

Padua, Museo Civico: Hodegetria (lost fragment),
 176, 178, fig. 197
Pakourianos, Gregory, typikon of, 282 n. 43
"Palace workshops," 187, 233, 272 n. 1, 281 n.
 26
Pantoleon, icon painter, 157
Paris, Bibliothèque nationale: bookcover (MS lat.
 10514) with Hodegetria plaque, 178f., fig.
 200; MS gr. 139 (Psalter), 278 n. 73; MS gr.
 580 (Menologion), 262 n. 84; MS Coislin 79
 (Chrysostom), 278 n. 80; Cabinet des
 Médailles: Crucifixion plaque, 14, 260 nn. 10,
 18; Crucifixion triptych, 205f., 210, 211, 221,
 234, figs. 146, 222; Romanos ivory, 24f., 27,
 106, 199, 203–5, 210, 211, 220, 233, 234,
 235, 238, 251, pl. IV, figs. 22, 115; Cluny
 Museum: bookcover with fragments of a trip-
 tych, 193f., fig. 214; box with warriors, 73,
 fig. 74; Christ plaque, 109, 163f., 208, 245,
 figs. 118, 179; Otto and Theophano plaque,
 215f., 273 n. 19, fig. 233; Louvre: box plaque
 with Herakles and Meleager, 241, fig. 245;
 Harbaville triptych, 135, 149, 199, 211, 221,
 230, 244, 249, figs. 152f., 170, 227; Nativity
 triptych, 85, 224, figs. 82, 87; Marquet de
 Vasselot collection (former), 41
Paros, 199
"patrons." See clientele
Periplus maris Erythraei, 58
Pesaro, Museo Civico: box plaque, 80, fig. 82f.
Philaretos, St., 19
Philes, Manuel, 270 n. 74, 273 n. 15
Philotheos. See Kletorologion

Photios, patriarch of Constantinople, 241
photography of ivories, 8, 10, 189
polishing, 32f., 121, 141–44
polychrome on ivories, 35, 144–49, 173f., 272 n. 153
Prespa, St. Achilleios, 269 n.39
Princeton, Princeton University Art Museum: Crucifixion plaque, 34, 98, 129, figs. 35f., 102; John the Evangelist plaque (bone), 61f., fig. 66
Psellos, Michael, 53, 249

Quedlinburg, Stiftskirche: four scenes from the life of Christ, 149, 212, 224, pl. VIII, fig. 104

Ragusa (Dubrovnik), 284 n. 119
Ravenna, 59; Museo Arcivescovile: cathedra of Maximian, 244; Museo Nazionale: plaques with Nativity, Deposition and Entombment, Dormitions of Virgin and Ascension, 264 n. 18
"restoration" of ivories, 16–19, 260 n. 32, 267 n. 151, 268 n. 26, 272 n. 150, 273 n. 37
Romanos I, emperor, 229, 261 n. 66
Romanos II, emperor, 278 n. 96. See also Paris, Cabinet des Médailles, Romanos ivory
Romanos ivory. See Paris, Cabinet des Médailles
Romanos the Melode, 244
Rome, Biblioteca Apostolica. See Vatican; Museo Sacro. See Vatican; Palazzo Venezia: David casket, 115, 137, 210, figs. 125, 220; triptych, 157, 158, 201–3, 208, 210f., 220, 251, 280 n. 10, fig. 176; Stroganoff collection (former), 41
"rosette caskets," 18, 62, 223, 243, 265 n. 67, 271 n. 123, 275 n. 18

sarcophagi, 67, 93
Sarkel (Crimea), 73, 76
seals, lead, 208, 237, 245, 250, 267 n. 124
Seth, Symeon, 20
silver. See metalworking
Sinai, Monastery of St. Catherine: Abgar icon, 207; icon of Washing of the Feet, 188f., fig. 210
St. Petersburg, Hermitage Musem: box with Genesis scenes, 283 n. 74; Christ plaque, 107, 163f., 208, 245, fig. 116; Christological diptych, 268 n. 24; comb from Sarkel, 73; Crucifixion plaque, 146; Deposition plaque, 119, 141, 270 n. 93; Forty Martyrs triptych, 30–32, 85, 146, 187, 212, 221, 270 n. 109, fig. 28f.; Hodegetria plaque (fragment), 176, 179, 182, 215, fig. 198; Luke plaque (bone), 61f.;

Presentation of Christ child diptych, 146, 231, fig. 240; six scenes from life of Christ, 23, 24, 76, fig. 20; John the Baptist plaque, 278 n. 92; triptych wings with angels and saints, 165, fig. 181; warrior plaque (bone), 61, fig. 67; Public Library: cod. gr. 21 (Lectionary), 188; cod. gr. 105 (Gospelbook), 279 n. 128
St. Sauveur-de-Redon, abbey, 119
steatite, 63, 67, 228
Skoteine, monastery of Virgin, 20
Stephen, skeuophylax, 235
straight cutting, 119
Stephen the Younger, St., 27f.
Stuttgart, Württembergisches Landesbibliothek: bookcover, 169, 176, fig. 196; Württembergisches Landesmuseum: Ascension box, 93, 191, 208, 220, fig. 93
Switzerland, private collection: ex-Hirsch plaque, 45, 65, 84, 94, 99, 167, 207, 217, 259 n. 8, 278 nn. 73, 84, figs. 46f., 96f., 103, 186, 224
Symeon the Theologian, Life of, 233, 241

Tbilisi, Historical Museum: Hodegetria plaque, 18, fig. 15f.
Theodora, empress, 25f.
Theodore of Stoudios, 59, 200, 260 n. 39
Theodoret of Cyrrhus, 92
Theoktiste, 25f.
Theoktiste of Lesbos, Life of. See Niketas Magistros
Theophano, Holy Roman Empress, 215
Theophilos, emperor, 25
Theophilus Presbyter, 101
Theophylaktos, patriarch of Constantinople, 238f.
Tilleda castle, 59, 68
Tokalı kilise (Göreme), 280 n. 143, 283 n. 95
tools, 91–94, 120f., 249
touching and handling of ivories in Byzantium, 22–29
Trier, Cathedral treasury: portable altar, 21, 233, 259 n. 5, fig. 18
triptychs, 21, 27, 150, 229. See also specific objects by location
Troyes, Cathedral treasury: box, 207
Tskhinvali, Museum of Southern Ossetia: triptych, 76, 128, 131, 195–97, figs. 148, 216
Turin, Galleria Sabauda: plaque with Christ and Peter, 91, 106, 281 n. 31, fig. 94

Udine, Museo Diocesano: bookcover with Christ, 213f., 221, fig. 230
undercutting, 117, 119, 132, 152, 191, 212,

277 n. 59, 284 n. 110

Utrecht, Rijksmuseum Het Catherijneconvent: Hodegetria plaque, 18, 94, 109f., 111, 112, 206, 211, 229, 282 n. 55, figs. 99f., 119, 154

Vatican, Biblioteca Apostolica: Vat. gr. 1613 (Menologion), 93, 217, 279 n. 115; Vat. Reg. gr. 1 ("Leo Bible"), 239f., 244; Museo Sacro: Ascension plaque, 218, 264 n. 18; Nativity plaque, 77, 114f., 161, 191, 268 n. 22, fig. 105; triptych, 147f., 210f., 221, 280 n. 10, fig. 169

Venice, 59, 76, 78, 218f.; Biblioteca Marciana: cod. gr. 17 (Psalter), 217; Museo Archeologico: plaque with Theodore and George, 44f., 101f., 112f., 117, 120, 125, 191, 197, figs. 44, 106, 122f.; plaque with John the Evangelist and Paul, 48, 98, 132f., 208f., 220, fig. 48f.; Treasury of S. Marco: "mythological" bowl, 155, 240, fig. 175

Vienna, Kunsthistorisches Museum: Andrew and Peter plaque, 125, 140, 208f., 220, 259 n. 7, figs. 139, 150, 161

Warsaw, National Museum: diptych, 72, 138, 149, 201, 235f., 248, 273 n. 21, figs. 73, 221

Washington, D.C., Dumbarton Oaks: Apostles casket, 223f., fig. 237; Constantine triptych wing, 208; Crucifixion plaque, 13f., 44, fig. 7; Virgin between John Chrysostom and Basil (fragment), 16, 106; Descent from the Cross plaque, 102, 186, 217, fig. 109; diptych leaf with emperor, 28, 150, 208, 221, 235, fig. 24; Doubting Thomas, 52, 131, 198, 230, fig. 57f.; Gabriel (fragment), 119, 192, 278 n. 82; Hodegetria plaque 183, fig. 208; Palaiologan pyxis, 284 n. 121; "rosette casket," 18, 223f., 265 n. 67, figs. 17, 171

weapons, production of, 67f.

woodworking, 67, 68, 83, 149, 150, 243, 264 n. 40, 270 n. 75

"workshops," 2, 66–71, 197, 221. *See also* "Palace workshops"

Xanten, Cathedral treasury: box, 242, fig. 246

Zangenfalten, 181, 207

Zuglio. *See* Udine, Museo Diocesano